American Art at Dartmouth:

Highlights from the Hood Museum of Art

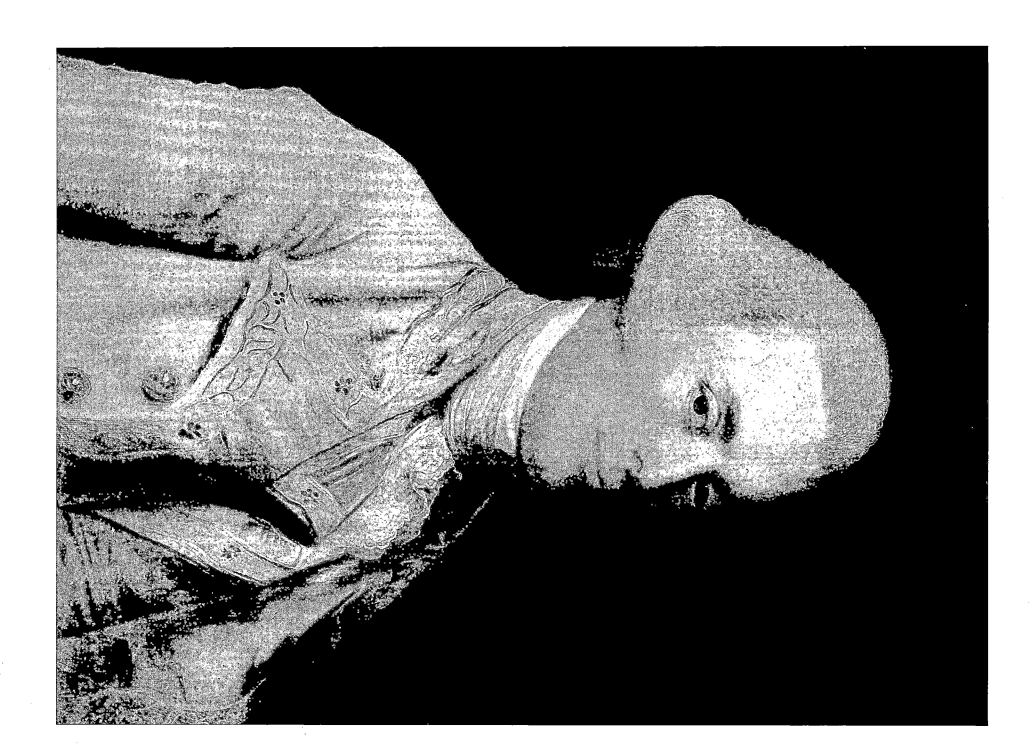

American Art at Dartmouth:
Highlights from the Hood Museum of Art

Barbara J. MacAdam

Hood Museum of Art, Dartmouth College
HANOVER, NEW HAMPSHIRE

University Press of New England
HANOVER AND LONDON

Published by
Hood Museum of Art, Dartmouth College,
Hanover, NH 03755
www.hoodmuseum.dartmouth.edu
and
University Press of New England,
One Court Street, Lebanon, NH 03766
www.upne.com

American Art at Dartmouth: Highlights from the Hood Museum of Art was published to coincide with an exhibition of the same title held at the Hood Museum of Art from June 9 through December 9, 2007. Some of the objects in this publication did not appear in the exhibition.

This publication and its related exhibition were organized by the Hood Museum of Art, Dartmouth College, and generously funded by the Bernard R. Siskind 1955 Fund, the Hansen Family Fund, the Leon C. 1927, Charles L. 1955, and Andrew J. 1984 Greenebaum Fund, and a generous gift from Jonathan L. Cohen, Class of 1960, Tuck 1961.

Edited by Nils Nadeau.
Designed by Dean Bornstein.

All object photography is by Jeffrey Nintzel except cat. 84,
by Susan Byrne.
Color separations by Pre Tech Color, Hartford, Vermont.
Printed and bound by CS Graphics Pte., Ltd., Singapore.

Front cover: Thomas Sully, *George Ticknor,* 1831 (cat. 12)
Frontispiece: John Singleton Copley, *Governor John Wentworth,* 1769 (cat. 103)
Opposite the foreword: Daniel Henchman, monteith, 1772–73 (cat. 162)
Opposite the essay: Thomas Doughty, *Rowing on a Mountain Lake,* c. 1835
 (cat. 17)
Back cover: Maxfield Parrish, *Hunt Farm (Daybreak),* 1948 (cat. 85)

Library of Congress Cataloging-in-Publication Data

Hood Museum of Art.
American art at Dartmouth : highlights from the Hood Museum of Art /
Barbara J. MacAdam.
 p. cm.
"Published to coincide with an exhibition of the same title held at the Hood Museum of Art from June 9 through December 9, 2007. Some of the objects in this publication did not appear in the exhibition"—T.p. verso.
Includes bibliographical references and index.
ISBN-13: 978–1–58465–667–8 (cloth : alk. paper)
ISBN-10: 1–58465–667–0 (cloth : alk. paper)
ISBN-13: 978–1–58465–668–5 (pbk. : alk. paper)
ISBN-10: 1–58465–668–9 (pbk. : alk. paper)
1. Art, American—Catalogs. 2. Art—New Hampshire—Hanover—Catalogs.
3. Hood Museum of Art—Catalogs. I. MacAdam, Barbara J., 1954– II. Title.
N6505.H65 2007

709.73'0747423—dc22 2007009413

CONTENTS

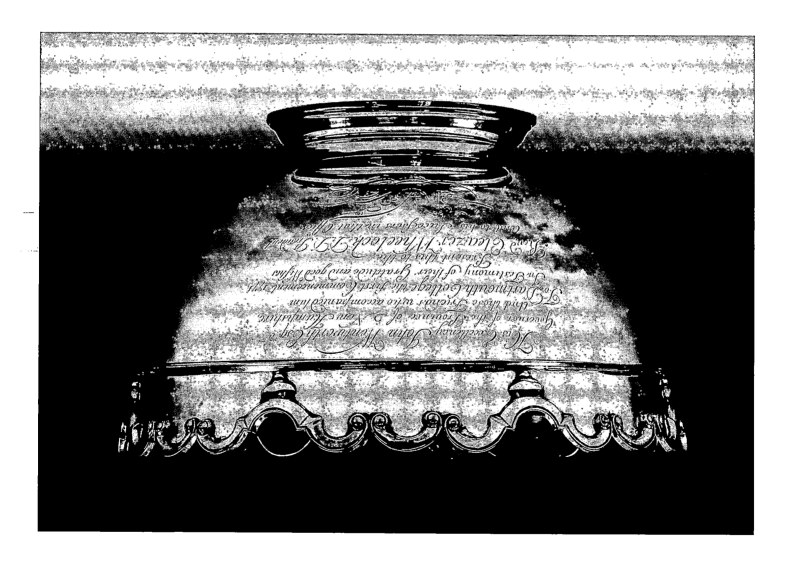

FOREWORD

When in 1773 Royal Governor John Wentworth gave Dartmouth's first president, Eleazar Wheelock, "and to his Successors in that Office" a gift in honor of the College's first commencement, he selected a Boston-made silver monteith (cat. 162), a luxurious form popular in the late seventeenth century. His choice thereby linked Wheelock's fledgling college in the wilderness to prestigious traditions of the past. At the same time, the bowl's engraved reference to Wheelock's successors pointed to Wentworth's faith in the institution's long and bright future. What the royal governor could not have foreseen was that the silver bowl he donated would become the foundation for what is today Dartmouth's collection of more than eight thousand examples of American art.

Although several other Hood Museum of Art publications have highlighted aspects of these rich holdings—most recently a catalogue of American drawings and watercolors—this volume is by far the most comprehensive, featuring roughly two hundred objects made in a wide range of media and dating before 1950. It is the first in a planned series of publications and related exhibitions that will highlight the Hood's major collection areas. The next, scheduled for publication in 2008, will celebrate the museum's holdings of European art. A catalogue of postwar and contemporary art is also planned, as is a volume devoted to the museum's important Native American holdings. Collection strengths in particular areas are also receiving attention in exhibitions and accompanying catalogues, for example, artifacts of historic significance in Fred Wilson's *SO MUCH TROUBLE IN THE WORLD—Believe It or Not!* and the Hood's Arctic collections in *Thin Ice: Inuit Traditions within a Changing Environment.* These publications and exhibitions will make better known the museum's greatest resource, its permanent collections—only a small fraction of which can be on public view at any given time. The idea for the major collections series grew out of a strategic planning process that the institution's board of overseers and staff undertook in 2006, the twenty-first anniversary of the Hood Museum of Art. During those discussions, it was resolved that one of the museum's primary goals in the coming years would be to make ever more effective use of its collections. Although works not on view in the galleries are used extensively for teaching (each year typically about four thousand objects are brought out for class use in the museum's Bernstein study-storage area), public awareness of the museum's holdings remains limited.

It is fitting that such an ambitious series should begin with the American collections, which are among the museum's largest holdings from a single geographic area, and which have the longest association with the College's history. As evidenced in this publication, some of the strengths of these collections—portraits of Dartmouth luminaries, and landscapes and decorative arts associated with the region—reflect the Hood's association with the College and its location in northern New England. Works in other genres important to a broad survey of American art, such as history painting and still life, have tended not to find their way to Dartmouth in equal quantity and await further development.

In witnessing the completion of this project I am grateful, as always, for the very genuine interest and tangible support for the arts demonstrated by Dartmouth's administration and the Hood's board of overseers. I extend warm thanks to President James Wright and Provost Barry Scherr in this regard, as well as to each of our overseers. The chairman of this talented and energetic board, Jonathan L. Cohen, Class of 1960, Tuck 1961, deserves particular thanks for his extraordinary dedication and leadership, and for his exceptional generosity in endowing the Hood's curatorship of American art. I deeply appreciate his further donation toward the cost of publishing this important volume. This publication and its related exhibition could not have reached fruition without the contributions of the museum's talented staff. I would like to echo the thanks expressed to the entire museum staff by this catalogue's author, Barbara MacAdam, in her acknowledgments that follow.

Barbara MacAdam, known to us all as Bonnie, was appointed curator of American art in 1983, two years before the opening of the Hood Museum of Art. The remarkable growth of the collections in the past two decades is due in outstanding measure to her foresight, planning, scholarship, research, and connoisseurship, and to the respect she has won from so many collectors, art dealers, academics, and museum scholars throughout America, the country to whose art she has devoted her professional life. Many gifts of American art works have come to the Hood because we have such a talented curator as colleague and friend. In this publication, Bonnie points out the American collections' strengths and the areas in need of improvement. We know Dartmouth's extraordinarily loyal and generous alumni body will take notice.

On behalf of all of us who enjoy and benefit from the excellent and instructive collections we celebrate in this volume, I would like to pay tribute to the donors of objects and of acquisitions funds that have helped form them. As with Wentworth's auspicious gift in the eighteenth century, this publication looks both to the past and to the future. It honors the rich histories of these objects and the previous development of the collections while suggesting what we hope to be an even more promising future for American art at Dartmouth.

BRIAN P. KENNEDY
Director

ACKNOWLEDGMENTS

Although only one name appears on its title page, this publication reflects the contributions of many individuals, past and present, from within and beyond Dartmouth College. They include donors, museum staff, Dartmouth faculty, outside scholars, and various specialists in book production. First and foremost, I owe a debt of gratitude to the leadership of the Hood Museum of Art. Brian P. Kennedy, director, initiated and enthusiastically supported this endeavor, designating significant institutional resources toward its timely completion. I am honored that he selected Dartmouth's American art holdings before 1950—which include some of the earliest objects acquired by the College—as the first of several collection areas to receive renewed scholarly and public attention. He offered generous support and wise counsel at all stages of the project, as did Katherine W. Hart, associate director and Barbara C. and Harvey P. Hood 1918 Curator of Academic Programming, and Juliette Bianco, assistant director.

The research contained within this volume, much of it gathered over decades, is a credit to Dartmouth's superlative library system. Overseen by Jeffrey Horrell, the Dartmouth College Library offers outstanding resources and services for its scholarly community. I am grateful for the helpful assistance of all library staff members, but especially visual arts librarian Laura Graveline, visual arts information specialist Agnes Zephyr, staff members of the interlibrary loan office, and the resourceful personnel of Rauner Library, directed by special collections librarian Jay Satterfield. At Rauner, I benefited from the aid of Barbara Krieger, Patricia Cope, and especially Sarah Hartwell, who cheerfully answered innumerable research queries and directed me time and again to important documentation surrounding nineteenth- and early-twentieth-century gifts of art to the College. The material Sarah unearthed added vital depth to my introductory account of the collection's development.

I relied heavily on the curatorial expertise of two scholarly consultants in the preparation of this publication and exhibition. Philip Zea, president of Historic Deerfield, assisted with the selection of pewter and furniture for inclusion in the publication and offered invaluable suggestions on my corresponding catalogue entries. Kirk Nelson, executive director of the New Bedford Museum of Glass, similarly evaluated the glass collection and guided us as we strove to enhance the Hood's representation of American glass in advance of this volume going to press. I am very grateful for his assistance in this regard and for his substantive contributions to the catalogue entries pertaining to glass.

Several Dartmouth students and a recent graduate assisted with research and other tasks related to this project. I am particularly indebted to Catherine Roberts ('05), who returned to Hanover after earning a master's degree at Oxford to assume a term position as a curatorial assistant. She did a superb job of researching and writing drafts of the entries for the photography section of the catalogue, which benefited enormously from her thorough research and perceptive observations. Eliza Gonsalves ('09) provided critical support with research and a host of administrative tasks over the past two years. Katherine Harrison ('06) also proved an especially able researcher during her role as Homma Family Curatorial Intern.

Many individuals beyond Dartmouth provided much-appreciated assistance with research, including Helen Plummer, the Amon Carter Museum of Art; Paula Glick; Mary Ann Haagen; Michael Epstein, HurrellPhotos.com; Theresa Leininger-Miller; Joel Rosenkranz; Martha Sandweiss; Jean Burks, the Shelburne Museum; Catherine O'Sullivan, reference archivist at the Smithsonian Institution; Mark A. Vieira, George Hurrell biographer and proprietor of the Starlight Studio, Los Angeles; and David Wheatcroft.

No single individual can take full credit for the scholarship that has gathered around a collection as old as Dartmouth's holdings of American art. Many present and former staff members of the Hood Museum of Art and Dartmouth's earlier art-collecting entities deserve special credit for their significant work in this regard. Several are listed in the citations for individual entries, the bibliography, and, in the case of unpublished source material, the note to the reader on page 19. They include such former staff members as curator Arthur Blumenthal, director Derrick Cartwright, assistant curator Margaret Lind ('02), curatorial assistant Mark D. Mitchell, research curator Diane Miliotes, and registrar Margaret Moody (Stier). Seminal historical accounts of Dartmouth's galleries and museums by former directors Jacquelynn Baas and Churchill P. Lathrop remain extremely useful. Among the current Hood staff, I am grateful for the scholarly contributions of Katherine W. Hart, associate director and Barbara C. and Harvey P. Hood 1918 Curator of Academic Programming; Brian P. Kennedy, director; and Barbara Thompson, curator of African, Oceanic, and Native American art.

Our collective understanding of the American collections has been shaped in significant ways by several generations of Dartmouth faculty from many academic departments. I am grateful to all of them for freely sharing their knowledge and insights, especially with our primary audience, Dartmouth students. Former art history professors and distinguished American art scholars John Wilmerding and Robert L. McGrath worked particularly closely with the American collections over the course of their influential teaching careers at Dartmouth. Professor Wilmerding taught at Dartmouth from 1965 to 1977 and is now the Christopher B. Sarofim '86 Professor of American Art at Princeton. Most recently he

contributed an insightful historical essay entitled "Dartmouth and American Art" to our 2005 exhibition catalogue *Marks of Distinction: Two Hundred Years of American Drawings and Watercolors from the Hood Museum of Art*. Professor Emeritus McGrath, who taught in the department from 1963 until 2003, guest-curated numerous American art exhibitions for the museum and developed particular expertise in the area of White Mountain landscape painting, one of the collection's great strengths. Current art historians teaching with regularity from the American collections include assistant professor Mary Coffey, senior lecturer Marlene Heck, professor Jim Jordan, associate professor Angela Rosenthal, and Andrew W. Mellon Postdoctoral Fellow Phoebe Wolfskill. We owe a debt of gratitude to all of the Dartmouth faculty members who, via the perspectives of their various disciplines, have inspired several generations of Dartmouth students through the study of American art.

Members of the present Hood staff played key roles in planning and implementing this project. I must give particular thanks to Kathleen O'Malley for expertly organizing and overseeing in a short period of time the enormous amount of new object photography required for this publication. Jeffrey Nintzel, who has provided the museum's photography for over thirty years, worked tirelessly over a period of seven months in order to create the beautiful object photographs that are such a key component of this book. Nils Nadeau greatly refined the catalogue text and skillfully ushered the publication through production, Kellen Haak facilitated the conservation of several objects, Deborah Haynes answered innumerable queries regarding the collection and its documentation, and Amy Driscoll and Lesley Wellman effectively served as education department liaisons for the accompanying exhibition. Patrick Dunfey created the exhibition's handsome design, and John Reynolds and Matt Zayatz worked on all aspects of its planning and installation. Mary Ann Hankel assisted with programming details, Sharon Reed successfully promoted the exhibition, and Nancy McLain carefully attended to all financial matters surrounding the project. As ever, I feel deeply fortunate to work with such talented and dedicated colleagues.

This publication's elegant appearance and timely production benefited from the polished design skills of Dean Bornstein and the diverse talents of our colleagues at the University Press of New England, guided by acting director Mike Burton. We appreciate the Press's copublication of this book and their expert handling of the many details surrounding its production and distribution. We also extend thanks to Jim Otranto and his team at Pre Tech Color for their meticulous prepress preparation of the catalogue images.

We were fortunate to be able to conserve several objects featured in the publication in advance of their photography and exhibition. Conservators at the Williamstown Art Conservation Center in Massachusetts, including Mary Catherine Betz, Tom Branchick, Hugh Glover, Katie Holbrow, Rebecca Johnston, and Sandra Webber, sensitively treated many objects under tight time restrictions. Jonathan Schechtman of Meeting House Furniture and T. Jeffrey Georgantes from Dartmouth's jewelry student workshop assisted with additional furniture conservation and the casting of replacement brass trim, while Greg Elder, from Dartmouth's woodworking student workshop, helped with wood identification.

On a personal level, I am deeply grateful to my husband, Doug Tifft, and our children, Rosa and Will, for their understanding and support as this publication project impinged on family time and domestic obligations. For their patience, love, and many accommodations, I am more thankful than I can say.

All of us who have enjoyed engaging with American art at Dartmouth owe our greatest debt of gratitude to the many donors of funds and objects who, for more than two centuries, have supported the collection's growth. These benefactors range from Dartmouth alumni and associates to area residents and collectors nationally. Far too numerous to list here, the names of object and fund donors appear in the corresponding catalogue entries. Given that Dartmouth's American art collections before 1950 number more than eight thousand objects, the process of choosing works for this publication and related exhibition was, by necessity, highly selective and, at a certain level, somewhat arbitrary. Although one might wish for even broader representation of the American holdings and their respective donors in such a publication, documentation for the entire Hood collections is available through the museum's Web site (www.hoodmuseum.dartmouth.edu).

I must extend particular thanks to a benefactor of extraordinary generosity, Jonathan L. Cohen, Class of 1960, Tuck 1961, whose passion for Dartmouth, the Hood, and American art led him to endow the museum's curatorial post for American art in 2004. Serving as the first Jonathan L. Cohen Curator of American Art has been a tremendous professional honor and personal pleasure. We can all be thankful for his additional generous support of this publication, the most comprehensive survey of Dartmouth's American collections to date.

BARBARA J. MACADAM
Jonathan L. Cohen Curator of American Art

Dartmouth Collects American Art, 1773–2007

Barbara J. MacAdam, *Jonathan L. Cohen Curator of American Art*

WHEN the Hood Museum of Art opened twenty-two years ago (fig. 1), Dartmouth College already boasted a large and rich collection of American art, acquired since the early decades of the institution's founding in 1769. Areas of particular strength included portraits of Dartmouth luminaries—many of them commissioned by the College—New England landscapes, Massachusetts silver, and a wide representation of works on paper. Such holdings reflected the College's long and venerable history, its setting in northern New England, and the extraordinary generosity of Dartmouth alumni and friends, who donated the vast majority of objects in the museum's care. Several publications have summarized aspects of the early history of the American collections.[1] This essay reviews that history while exploring in greater depth the dramatic growth of the American collections since 1985. It also considers how these more recent acquisitions of works of American art made before 1950 have built on the vitally important holdings developed during the previous two centuries while responding to changes in museum practices, the Dartmouth community, and academia at large.

The evolving character and utility of the American collections over time reflects transformations in the social fabric and academic offerings of Dartmouth over the past several decades, as well as shifts in academic methodologies and interests internationally. Beginning with Dartmouth's recommitment in 1970 to its founding purpose

FIG. 1. Hood Museum of Art, opened 1985, Charles W. Moore and Chad Floyd, architects.

of providing higher education opportunities for Native Americans and continuing through the introduction of coeducation two years later, the College has served a far more diverse student body in the last thirty-five years than at any point previous. At the same time, the College has developed a host of new academic programs, departments, institutes, and centers that reflect and promote that diversity, while scholarly approaches to art and material culture have become increasingly interdisciplinary, theoretical, and concerned with social and political context. Whereas the College's fine arts and non-Western collections have long been used intensively by faculty in the departments of art history, studio art, anthropology, and classics, now faculty in such departments as philosophy, English, French and Italian, Spanish and Portuguese, history, mathematics, computer science, and women's and gender studies frequently draw on the collections for teaching and their own scholarship.[2] Special programs have also been developed recently with faculty and graduate students in Dartmouth's Tuck School of Business and the Dartmouth Medical School.[3]

Many factors have contributed to the dramatic recent growth of the American collections dating before 1950 (the cut-off date for this exhibition and publication) and to their increased use by faculty and students. In 1983, just two years before the museum's opening, the College added to the museum staff the first curator devoted exclusively to American art, thereby enabling the sustained stewardship and focused development of these collections. (This curatorial position has been secured for posterity through the generosity of Jonathan L. Cohen, Class of 1960, Tuck 1961, who endowed it in 2004). Furthermore, the increased visibility and activation of the American collections through a new permanent collection gallery (the Israel Sack Gallery, funded by Harold M. Sack, Class of 1932; figs. 2, 3) and numerous exhibitions and publications encouraged more alumni and friends to consider the Hood a fitting repository for their American holdings. The extensive use of the collections by faculty for curricular purposes, greatly facilitated by the opening of the museum's Bernstein Study-Storage Center in 1989 (fig. 4) and the addition of a curator of academic programming to the staff in 1990, had a similar effect. Perhaps even more importantly, however, significant gifts of acquisitions funds over the past two decades have enabled the museum to shape the American collections in a more deliberate fashion through more substantial purchases than had ever been possible previously.

The opportunity to make significant additions to the collection has prompted an ongoing analysis of the strengths and weaknesses

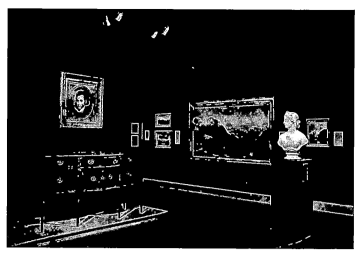

FIGS. 2, 3. Two views of the Israel Sack Gallery, Hood Museum of Art, 2007.

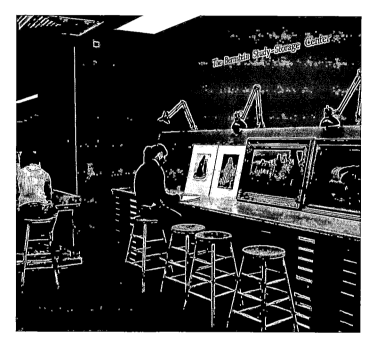

FIG. 4. The Bernstein Study-Storage Center, Hood Museum of Art, opened 1989.

of the existing holdings and the identification of areas of greatest need for development. These acquisition priorities have shifted over time, in response to the museum's resources, the philosophies and scholarly interests of various museum directors and curators, and the interests of faculty members, several of whom sit on the museum's acquisitions committee. Some areas of weakness only become apparent when one views the collection through a new lens, whether in preparation for a forthcoming exhibition or in considering ways to support new courses being offered at the College. "Wish lists" also must be balanced against often unexpected opportunities on the marketplace. Such has been the case, for instance, when a preparatory drawing for a painting already in the collection has become available, and vice versa (see cats. 67, 24), or when the rare appearance of a compelling work that fills a collection need further down in rank temporarily supersedes other priorities.

Far more challenging than identifying the many canonical artists or stylistic developments lacking in the collection has been the ongoing consideration of broader, more vexing issues regarding collection development in general and, more specifically, the purpose of such collections in an academic setting such as Dartmouth. To what extent, for instance, should the Hood build on the collection's strengths, versus filling its gaps? How should it balance honoring Dartmouth's history and northern New England setting with supporting a curriculum that teaches American art from a broad, interdisciplinary, multi-ethnic, and global perspective? To what extent should the museum shape its collection to reflect the College's present curricular focus or, on the other hand, complement that focus or anticipate curricular needs of the future? New methodologies and more interdisciplinary approaches to the study of art have provoked further questions as well. Should the museum look beyond well-established art historical figures to include greater representation of vernacular artists or so-called outsider artists? Should more emphasis be given to material culture and the decorative arts? How should culturally significant iconography be weighed against the aesthetic impact of prospective acquisitions? Many of the Hood's acquisitions of American art over the past twenty-two years reflect the museum staff's consideration of such issues and an ongoing evaluation of the collections, most of which took significant form long before the Hood's 1985 opening.

PAINTINGS
Portraits

As described in earlier museum publications, the American painting collection at Dartmouth stemmed from a long series of institutional portrait commissions that began in 1793, when the College trustees commissioned Dartmouth graduate Joseph Steward to paint both the College's retiring trustee John Phillips (cat. 4) and its founder and first president, Eleazar Wheelock (cat. 5). These impressive life-size likenesses established the precedent for the College's commission of and interest in portraits of Dartmouth associates, including

FIG. 5. Dartmouth gallery of paintings in Wilson Hall, c. 1890s. Courtesy Dartmouth College Library.

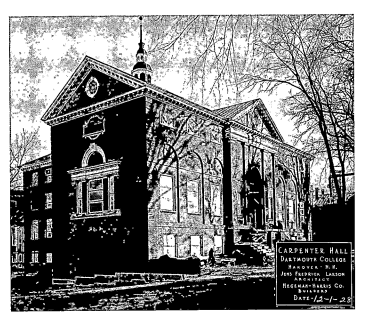

FIG. 6. Carpenter Hall in final stages of construction, 1928 (opened 1929), Jens Frederick Larson, architect. Courtesy Dartmouth College Library.

such illustrious alumni as Daniel Webster, Class of 1801 (cats. 7, 14, 87, 138, 165, 194). Following a long European tradition of institutional portraiture, these semblances were conceived less as fine art than as a legitimization of the institution's young history, a commemoration of its founding fathers, and a source of moral, civic, and intellectual inspiration for its students. In 1835 alumnus George Cheyne Shattuck arranged for and presented to the College especially accomplished portraits of Webster and the three other attorneys who assisted in the defense of the College's original charter in the famous, precedent-setting "Dartmouth College Case" of 1817–18 (cats. 13–16). Along with other forms of Websterania—from the statesman's papers to his clothing and personal possessions— portraits of Webster soon found their way to Dartmouth in great number, as did likenesses of Webster family members and other College associates. Among the most notable Dartmouth figures to eventually find representation in the portrait collection were Boston man of letters George Ticknor, Class of 1807 (cat. 12), and the founder of Dartmouth's Thayer School of Engineering, Sylvanus Thayer, Class of 1807 (cat. 11), both painted by Philadelphia artist Thomas Sully.

An important force in the development of the College's portrait collection during the late nineteenth century was Benjamin Franklin Prescott, Dartmouth Class of 1856, a lawyer who served as governor of New Hampshire and an ex-officio Dartmouth trustee from 1877 to 1879 and trustee from 1879 to 1895. Throughout this long period of service he wrote to countless esteemed faculty, officers, alumni, and benefactors of the College, requesting that they donate a portrait or have their portraits taken for Dartmouth. Unfortunately, aesthetic merit was not always the primary consideration in the execution of such paintings, many of which are of indifferent quality. Nonetheless, in 1880 one appreciative student responded to

the sizeable gathering of portraits, then in Reed Hall, in an article in the student newspaper: "Perhaps all are not valuable as works of art, . . . [but they represent] the great and good men who have loved this College. . . . [The portraits] lead [the student] to contemplate the highest ornaments of life; from these elevated plains he gathers culture and refinement, he adorns his scholarship."[4] Appropriately enough, the College administration asked Prescott to lay the cornerstone in 1884 for Wilson Hall, the new library, which would house more than one hundred Dartmouth portraits in a large skylit gallery on the second floor (fig. 5). They would continue to be housed in library facilities, many of them moving into the new Baker Library when it opened in 1928. From an aesthetic standpoint, the portrait collection improved considerably with the early-twentieth-century gifts and commissions of several handsome likenesses by well-established Boston school artists Frederick Porter Vinton and Joseph DeCamp (see, for instance, cats. 54, 55).

As the College's art department and art facilities expanded in the early twentieth century, so did campus interest in forming a collection that would go beyond documenting College luminaries. The 1929 opening of Carpenter Hall (figs. 6, 7), which housed the art department, studios, and galleries, inspired a spate of donations. The most important was Abby Aldrich Rockefeller's gift of over one hundred works of art in 1935. Discussed extensively elsewhere, this gift included primarily American paintings, watercolors, drawings, and sculpture representing both folk art and modernist traditions.[5] Rockefeller was strongly guided in her collecting by her primary dealer, Edith Halpert of the Downtown Galleries, a critically important champion of both artistic traditions, which she felt shared a stylistic affinity in their schematic forms and flattened perspective. Unusual in the Rockefeller donation was Thomas Eakins's more academic portrait—with no Dartmouth associations—of Philadelphia

3

FIG. 7. Carpenter Hall Galleries, 1950 (Thomas Eakins, *The Architect*, cat. 46, visible on far wall). Courtesy Dartmouth College Library.

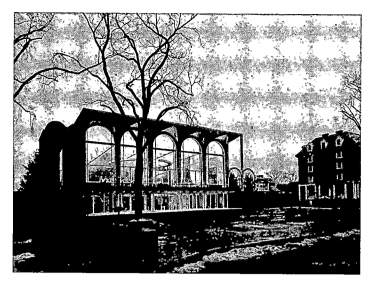

FIG. 8. Hopkins Center, opened 1962, Wallace K. Harrison, architect. Courtesy Dartmouth College Library.

FIG. 9. Hopkins Center Galleries, 1963 (exhibition organized by IBM [International Business Machines Corporation] and compiled from the corporation's permanent collection).

architect John Joseph Borie (cat. 46). This remains the Hood's most important likeness of the turn of the twentieth century and its only work by Eakins. After the 1962 opening of the Hopkins Center for the Arts (figs. 8, 9), which housed galleries and studios in addition to performing arts spaces, gifts of art increased once more, through donations far too numerous to detail here.[6] Most extraordinary among them was the 1977 gift from Mrs. Gordon Abbott of a work that would be the envy of any art museum but has fundamentally important historical associations with Dartmouth—John Singleton Copley's magnificent 1769 pastel portrait of Royal Governor John Wentworth, who granted the college its original charter (cat. 103). The work remains without peer in the Hood's American collections.

Since the 1985 opening of the Hood, relatively few likenesses have joined the already strong portrait collection. One purchase in 1990, a fashionable depiction of an unidentified woman painted by Ralph Earl in Windsor, England (cat. 1), has helped both to counter the predominance of male portraits in the collection and to represent late-eighteenth-century American portraiture in the British mode. In a fascinating twist on what is generally perceived as a more typical artistic progression, Earl worked in this painterly, technically proficient high-style manner early in his career and then seems to have deliberately adopted a tighter "plain style" upon his return to America in 1785. It was this seemingly untutored style that influenced Joseph Steward's linear approach to his Dartmouth commissions (cats. 4, 5). A pressing gap in this genre, however, is

portraiture from the early to mid-eighteenth century, the period before the College's founding.

The most noteworthy gifts to the American portrait collections since 1985 have been the evocative late portrait of Dr. Isaac Burnet Davenport by James McNeill Whistler (cat. 48), donated by Mr. and Mrs. Adolph Weil Jr., Class of 1935 (donors of the museum's outstanding prints by Rembrandt and other Old Masters), and the elegant likeness of Daniel Webster by Gilbert Stuart (cat. 7). This had been on long-term loan to the College since 1947 and was donated by members of the Parkman family and by Edward Connery Lathem in 1992. It is a superb example of Stuart's mature work and a vibrant, flattering likeness of the famed orator.

Although the portrait collection has not grown substantially in the past two decades, it has not been ignored. Selections from the collection have been on view on campus and in the museum, where

FIG. 10. Fred Wilson installation, *SO MUCH TROUBLE IN THE WORLD—Believe It or Not!,* Hood Museum of Art, 2005.

in 2005, for instance, artist Fred Wilson highlighted a daunting array of the Daniel Webster likenesses in various media as a major feature of his larger installation drawn from the collection titled *SO MUCH TROUBLE IN THE WORLD—Believe It or Not!* (fig. 10). Along the upper periphery of the Lathrop Gallery walls, which were crammed full of Webster images, Wilson arranged a line of the College's relatively few portraits of people of color. Represented by just one portrait, for instance, was Samson Occom, a Mohegan who was instrumental to the College's founding (the Adna Tenney portrait of Occom, visible at the far upper right, was arranged for and largely paid for by Prescott in 1872). An ordained minister and one of Wheelock's first students, Occom traveled from 1766 to 1767 in England, where he successfully raised funds for Wheelock's Indian Charity School. Much to Occom's disappointment, Wheelock reorganized the school as Dartmouth College and shifted its purpose away from educating Native Americans to training white men to become missionaries. Wilson's provocative interrogation of the museum's portrait collection revealed and posed questions about what is lacking, as well as what is abundantly represented, in the collection. More clearly and dramatically than any collections report could ever convey, Wilson pointed to the cultural values and prejudices embedded in the early formation of Dartmouth's portrait collection and in all museum collecting, past and present.

Landscapes

Like many New England colleges, Dartmouth privileged collecting portraits over landscapes during the nineteenth century. In contrast to Yale University, however, which opened its Trumbull Gallery at the early date of 1832,[7] Dartmouth's lack of an art gallery hampered the broadening of the collection's scope still further. In 1891 the Reverend John Edgar Johnson, Class of 1866, purchased as a gift for the College what is believed to be the collection's first landscape, Frederick Judd Waugh's *Entrance to Dartmouth Harbor, England,* 1890, which held obvious associative meaning.[8] The first non-Dartmouth landscape subjects by American artists did not enter the Dartmouth collection until 1917. These were two panoramic views of Italian, rather than American, scenery by George Loring Brown and William Louis Sonntag (cat. 26) that came as a bequest from Boston resident Annie B. Dore in memory of her husband, John Clark Dore, Class of 1847. In accepting the gift, President Ernest M. Hopkins lamented the College's lack of a formal art gallery and the necessity of hanging the paintings as adornments in administrative buildings. He admired the works and accurately predicted that they would "be more appreciated with the passing of years."[9] After the 1929 opening of Carpenter Hall and its galleries, donors presented far more landscapes to the College, including signature works by

5

FIG. 11. Exhibition *Winter's Promise: Willard Metcalf in Cornish, New Hampshire, 1909–1920*, Hood Museum of Art, 1999. The Hood's 1992 acquisition, Metcalf's *The First Thaw*, 1913 (cat. 52), is to the far right.

George Inness (cat. 42), given in 1948; Maxfield Parrish (cat. 85), donated by the artist in 1950; and Canadian artist Lawren Harris (cat. 64), who presented his monumental view of Lake Superior in memory of his uncle, a Dartmouth professor, in 1951. Harris had moved to Hanover quite suddenly in 1934 after divorcing his first wife and immediately remarrying. His several years as an informal artist-in-residence at Dartmouth proved to be a pivotal period in his career, during which he became increasingly committed to non-objective art.

In the 1950s and 1960s, Churchill P. Lathrop, then director of the Carpenter and Hopkins Center art galleries (hereafter Dartmouth "art galleries"), initiated a concerted effort to acquire New England landscapes, particularly images of New Hampshire's White Mountains. Dartmouth's special collections library had been collecting books, manuscripts, and photographs pertaining to the White Mountains since the 1920s and did so more intensively during the tenure of Walter Wright, chief of special collections from 1968 to 1980. Thus the development of Dartmouth's collection of White Mountains art can be seen as part of a larger institutional commitment to the region. This association can be traced back to the acquisition of land grants in northern New Hampshire in the late eighteenth and early nineteenth centuries, followed by the College's purchase in 1920 of a large tract of land on Mt. Moosilauke and the longtime use of the area by students and faculty as a place for recreation and scientific investigation. Artists represented by Lathrop's early White Mountain acquisitions include Thomas Doughty (cat. 17), Charles Octavius Cole, George Loring Brown, William M. Hart, Edward Hill (cat. 36), and Frank H. Shapleigh. Nearly all were purchased through what was then the art galleries' primary source of acquisitions support, the Julia L. Whittier Fund, established in 1940 through a major bequest from the daughter of an "old-time Dartmouth professor, Dr. Clement Long." The fund

more than doubled Dartmouth's art purchasing capabilities and continues to support acquisitions today.[10] In 1961 the galleries accepted as a long-term loan what has become one of the museum's most popular works, a sweeping panoramic interpretation of the Presidential Range by Frenchman Régis-François Gignoux (cat. 29). Happily, the Hood was able to purchase the work in 1984 with the financial support of Olivia H. and John O. Parker, Class of 1958.

Dartmouth's already sizeable commitment to building a collection of White Mountain landscapes—a collection that echoed the substantial holdings at the Dartmouth College library—allowed the Hood to be well-positioned in 1987 when White Mountain collectors Robert A. and Dorothy H. Goldberg from North Conway, New Hampshire, considered the museum as a possible repository for their large and impressive art collection. Beginning in 1987 and into the following year, the Goldbergs donated more than one hundred White Mountain paintings, prints, and drawings, including examples by John Frederick Kensett (cat. 27), Francis Seth Frost (cat. 28), George Loring Brown (cat. 35), and Samuel Lancaster Gerry (cat. 41). The collection is particularly strong in images depicting the vicinity of North Conway, which had been an especially popular destination for nineteenth-century landscape painters. To celebrate the Goldberg donation, Dartmouth art history professor and White Mountain art authority Robert L. McGrath offered a seminar devoted to organizing an exhibition of Dartmouth's newly expanded White Mountain holdings, supplemented by several loans. The resulting 1988 exhibition, *"A Sweet Foretaste of Heaven": Artists in the White Mountains, 1830–1930*, was accompanied by a fully illustrated catalogue with entries drafted by undergraduates.[11] In researching the publication, the museum consulted with another authority on New Hampshire paintings, Catherine H. Campbell, who lent two paintings from her fine collection and donated several more by gift and bequest (cat. 18).

With the museum's nineteenth-century landscape collection bolstered, the new Hood Museum of Art turned to developing its representation of works from around the turn of the twentieth century. American impressionism had been a particularly noticeable gap. Although the museum did not anticipate purchasing an impressionist landscape with local associations, such a situation presented itself when a quintessential landscape by Willard Metcalf, one of the premier American impressionists, became available in 1992. Painted in 1913 and titled *The First Thaw* (cat. 52), it features Blow-Me-Down Brook, which runs through Plainfield and Cornish, New Hampshire—towns that hosted one of the most vital art colonies of the period. Unlike most of the colony artists, who flocked to Cornish during the summers, Metcalf made it his preferred destination for painting the winter landscapes that had become his specialty. This major American acquisition (the most expensive made up until that time) provides an illuminating window onto the Cornish colony, Metcalf's career, and the cultural significance of the popularity of winter landscape painting in Metcalf's day. In 1999 the museum gathered sixteen of Metcalf's most masterful Cornish paintings,

mainly winter subjects, for the exhibition and related publication *Winter's Promise: Willard Metcalf in Cornish, New Hampshire, 1909–1920* (fig. 11).[12]

Other landscape acquisitions further enhanced the Hood's representation of turn-of-the-century painting, including two landscapes painted in New Hampshire's more southerly art colony in Dublin, Abbott Thayer's *Below Mount Monadnock* (cat. 51) and an early work by Thayer's then protégé Rockwell Kent, *A New England Landscape* (cat. 50). Such acquisitions were only possible because of substantial increases to the number and size of the museum's acquisitions endowments. More recently established funds include the Mrs. Harvey P. Hood W'18 Fund, instituted in 1981; the Robert J. Strasenburgh II 1942 Fund, established in 1983; the Miriam and Sidney Stoneman Acquisition Fund, founded in 1984; the Katharine T. and Merrill G. Beede 1929 Fund, established in 1987; the Virginia and Preston T. Kelsey '58 Fund, founded in 1994; and the Florence and Lansing Porter Moore 1927 Fund, established in 1997. With the 1989 founding of the museum's patron group, the Lathrop Fellows—named in honor of Churchill P. Lathrop, the beloved Dartmouth art historian and longtime director of the Dartmouth art galleries—annual membership dues have also financed major acquisitions. In the American field, the Lathrop Fellows funds have supported the acquisition of the Metcalf, Thayer, and Kent paintings, as well as the Mary Cassatt drawing acquired in 2003 (cat. 111).

Narrative, Figurative, and Genre Painting

When the Hood opened in 1985, the museum had little to represent narrative and genre painting. The most noteworthy exception was Frederic Remington's emotive nocturne *Shotgun Hospitality* (cat. 53), donated just a year after its completion in 1908. Judge Horace Russell, Class of 1865, purchased the Remington expressly for the College from the artist's acclaimed 1909 exhibition at Knoedler's. A prominent New Yorker, Russell held many distinguished positions, including Judge of the Superior Court of the City. He also, according to one memorial tribute, "was fond of the society of artists and loved artistic productions."[13] Although it is likely that he appreciated the work as one of Remington's most successful nocturnal compositions, he no doubt also deemed it appropriate for Dartmouth because of the College's early mission to train Native Americans. The painting hung in a dining facility, Thayer Hall, for many years before coming under the care of the art galleries by the 1960s.[14]

The museum's total lack of nineteenth-century genre paintings of any quality when the Hood opened posed severe limitations on the teaching utility of the collection. Genre paintings, or scenes of everyday life, lend themselves especially well to the more interdisciplinary art historical methodologies that were by then coming into favor, approaches that give greater emphasis to cultural context and issues of class, race, and gender. This is the area of the paintings collection that has grown most significantly since 1985, in part

through Edward Connery Lathem's magnanimous gift in 1997 of Winslow Homer's country idyll *Enchanted,* 1874 (cat. 37), and the addition of three significant purchases: George Cochran Lambdin's *In the Beech Wood,* 1862–64 (cat. 32), purchased in 1988; Lilly Martin Spencer's *The Jolly Washerwoman,* 1851 (cat. 23); and Eastman Johnson's *Back from the Orchard,* 1876 (cat. 38), both acquired in 1993. Perhaps no group of American paintings in the collection has been as useful for generating discussions among all audiences about cultural shifts in America during the second half of the nineteenth century—including the increase in Irish and Scottish immigrant servants at mid-century, the new cultural importance placed on the domestic sphere (Spencer),[15] the Civil War's impact on the home front (Lambdin), and the nostalgic post–Civil War identification with the innocence, promise, and opportunism of country boys (Homer and Johnson).

In terms of other figurative works, the museum acquired its first American history painting in 1993, Benjamin West's *Hannah Presenting Samuel to Eli,* 1800 (cat. 2). West's long career in London and international standing prompted the Hood's then-curator of European art, Richard Rand, to initiate the purchase. Totally different in character and dating from more than a century later, Frederick Carl Frieseke's *In the Library,* c. 1917 (cat. 57), was also painted by an American expatriate, this time working in Giverny, France. Composed with a postimpressionist eye for pattern and color, this artful interior was formerly owned by Mr. and Mrs. Harvey P. Hood, for whom the museum is named. Their son, Hood museum benefactor Charles Hood, Class of 1951, donated the work in 1991.

Still Life

With the College's historical focus on portraiture and, later, landscape painting, other genres had been somewhat overlooked. For example, no still lifes hung in the American gallery when it opened in 1985, and this genre is still under-represented. The 1987 purchase of a late-nineteenth-century tabletop still life by Levi Wells Prentice (cat. 39) helped to remedy the situation and could be obtained with the more limited funds available at that time. One of the most important additions to the collection over the past twenty-two years was the 1999 acquisition of *Iris at Dawn,* 1899, by Maria Oakey Dewing (cat. 45). An extraordinarily beautiful and original conception, it can be considered a still life, although one set outdoors. Dewing rejected the conventional elegant tabletop still-life format and adopted instead a worm's-eye perspective on her densely planted iris bed in Cornish. The painting reveals her deep, almost spiritual reverence for nature and, with its radical cropping and spatial complexity, an awareness of Japanese design principles. Like the acquisition of the Metcalf and Thayer paintings, the Dewing represents a mature expression of an artist of national importance who, happily, also worked locally. Such fortuitous confluences render moot the debate regarding the collection's regional, versus national, focus.

FIG. 12. *Exhibition of Cornish Artists*, Little Theatre, Robinson Hall, Dartmouth College, 1916. Reproduced in George Breed Zug, "Exhibition of Cornish Artists," *Art and Archaeology* 3 (April 1916): 207–11, photograph by A. B. Street.

Twentieth-Century Developments: Modernism, Social Realism, and Regionalism

Thanks to the generosity of adventurous collectors such as Abby Aldrich Rockefeller and the keen interest in contemporary art held by some members of Dartmouth's art faculty, early- to mid-twentieth-century stylistic developments in American art were well represented as the collection developed. George Breed Zug, a professor of modern art from 1913 to 1932,[16] organized some of Dartmouth's earliest exhibitions devoted to American art, including a widely publicized exhibition of work from the Cornish Art Colony in 1916 that, according to Zug, sparked "the real enthusiasm and interest of the undergraduates" (fig. 12).[17] This was the first of several exhibitions related to the colony that Dartmouth would present over the years.[18] Churchill P. Lathrop, who taught in the department from 1928 until 1974 and directed the galleries for most of that time, also taught modern art, invited contemporary artists to campus, and sought to build the modern and contemporary art collection.[19] He played a key role in bringing José Clemente Orozco to Dartmouth to paint his ambitious mural cycle *The Epic of American Civilization* from 1932 to 1934. During the 1930s Lathrop also invited other artists to Dartmouth as lecturers or short-term artists-in-residence, including Thomas Hart Benton, Charles H. Woodbury, and William Zorach. In 1935, for instance, the department mounted its "Symposium on the Issues of Modern Art," with such prominent lecturers as John Dewey, Frank J. Mather, and Max Eastman.[20] This was the same year that Abby Aldrich Rockefeller donated her large collection to Dartmouth, with its strong representation of modernist works, including paintings and works on paper by Max Weber (cat. 62), George Ault (cats. 74, 115), and Stuart Davis (cat. 116).

Lathrop can also be credited, in part, with strengthening the College's association with artist John Sloan (cats. 59, 60, 61, 75, 113), who was cousin to Dartmouth president John Sloan Dickey. In 1946, in honor of Sloan's seventy-fifth birthday, Lathrop organized a major exhibition of his work, from which the museum purchased *McSorley's Back Room*, 1912 (cat. 59), and *A Roof in Chelsea*, c. 1941 (cat. 75). Sloan ended up spending the summer of 1951 in Hanover and planned to return in the future, but sadly he died in

Mary Hitchcock Hospital that September.[21] Dartmouth organized a second major Sloan exhibition from late 1981 to 1982, and today the Hood's Sloan collection includes eight paintings, seven drawings, nineteen etchings, and three posters.[22]

Two bequests in the 1970s provided important mid-century representations of American art. These were the 1976 bequest of nearly one hundred works from Jay Wolf, Class of 1951 (including cat. 80), and the 1978 bequest of Lawrence Richmond, Class of 1930, which included Ben Shahn's social commentary *Photographer's Window*, 1939–40 (cat. 73), and Adolph Gottlieb's 1946 pictographic painting *Black Enigma* (cat. 83). Both Wolf and Richmond made provisions for the College well before their passing.[23] In 1956, Richmond wrote Dartmouth Dean of Admissions Albert I. Dickerson, "There are so many hungry art mouths these days . . . museums and educational institutions. Normally, a choice would be difficult to make. My first thought is of the College."[24]

Not all of the gifts in recent years have been from Dartmouth alumni and associates. One of the most significant gifts since 1985 was offered in 1993 by local residents M. Rosalie Leidinger and Louise W. Schmidt, who donated the museum's first work by Georgia O'Keeffe, *Taos Mountain*, 1930 (cat. 65). This was also the Hood's first major painting to represent the so-called Stieglitz circle—modernist artists of the 1920s and 1930s in the social and professional orbit of influential New York art dealer and photographer Alfred Stieglitz.

The most recent acquisition of an American painting is one that, in a long tradition of acquisitions, has strong ties to Dartmouth—in this case the College's Orozco murals. It is *Untitled (Bald Woman with Skeleton)*, c. 1938–41 (cat. 81), by Jackson Pollock, one of the twentieth century's most influential artists. It clearly derives from some of Orozco's panels for his Dartmouth mural, especially *Gods of the Modern World*, which Pollock drove to Hanover to see firsthand in 1936. Pollock's powerfully expressive early work makes an important and fitting addition to the collection. It has, first of all, obvious relevance for the teaching of American and Mexican art, the latter a more recent addition to the curriculum.[25]

The Hood inherited a strong group of works related to regionalism, American Scene painting, and historical book illustration—aesthetic modes that competed with and to some extent reacted against modernism during the 1930s and 1940s. Dartmouth's library holds the papers of historical fiction author Kenneth Roberts, who also gave the College the N. C. Wyeth painting that served as the cover illustration for his 1933 book *Rabble in Arms* (cat. 71). The Hood has become an important repository of the work of Ilse Bischoff (cats. 68, 69), who was originally active as an American Scene painter and spent her later years not far from Dartmouth in Hartland, Vermont. By far the largest group of regionalist works in the collection is that by Paul Sample, Class of 1920, who served as artist-in-residence from 1939 until his retirement in 1962 (cats. 76, 77, 79, 84). He donated his major 1939 painting *Beaver Meadow* (cat. 78) in 1943 and eventually left many of his personal papers

FIG. 13. Exhibition *Paul Sample: Painter of the American Scene*, Hood Museum of Art, 1988, with *Beaver Meadow*, 1939 (cat. 78), second from left.

the contents of his studio to Dartmouth. The Hood has become the de facto research archive for Sample's career.[26]

In recent years the Hood has been able to build on the museum's strong representation of works of this period. Another Kenneth Roberts book cover design—this one by Grant Wood (cat. 70)—came as a bequest in 1997, and the museum has received additional donations of works by Bischoff and gifts and promised gifts of works by Sample (cat. 84). Further aligning his career with Dartmouth, the Hood mounted a major retrospective of Sample's work in 1988 (fig. 13).[27]

SCULPTURE

The development of an American sculpture collection at Dartmouth very much followed the pattern for paintings. Throughout the nineteenth century these holdings consisted entirely of portrait busts that depicted College associates (especially Webster, cat. 87) and other distinguished figures, almost exclusively male. In 1916, Daniel Chester French donated his bust of Ralph Waldo Emerson (cat. 91), which had been included in the College's exhibition of the Cornish art colony that year (he had spent the summers of 1892 and 1894 in Cornish). French likely appreciated his recent recognition by the College but also perceived that a sculpture of the Massachusetts literary luminary would resonate especially well in a New England academic setting.

With the opening of Baker Library in 1928, Dartmouth sought out as a loan Cyrus Dallin's *Appeal to the Great Spirit*, 1912 (fig. 14), to exhibit as a centerpiece in the new library's spacious, wood-paneled reading room, the "Tower Room." As reported in the student newspaper, *The Dartmouth*, "The subject [of the bronze] is one of special interest because of its close connection with the primary object of Dartmouth's foundation, the Indian."[28] President Hopkins noted in a letter that it "has attracted constant interest and attention by visitors," some of who commented that it looked as if the room

FIG. 14. Tower Room, Baker Library, 1947, featuring Cyrus Edwin Dallin, *Appeal to the Great Spirit*, 1912, cast c. 1922 (cat. 97). Courtesy Dartmouth College Library.

"had been built around this bronze."[29] The aesthetic and associative appeal of the ennobling bronze, particularly in this contemplative setting, was so great that the College sought to purchase the work. It was able to do so with funds contributed by the Honorable Leslie P. Snow, Class of 1886. Like the purchase of Remington's *Shotgun Hospitality* (cat. 53), this acquisition for the College by an alumnus points to the potent appeal of the institution's founding story to alumni during an era in which Dartmouth had moved far from its original mission.

It wasn't until the Hopkins Center era—the 1960s and later—that a number of purchases and gifts broadened the scope and function of the sculpture collection. Alumnus Lawrence Marx Jr., Class of 1936, donated two cowboy bronzes by Remington in 1960 (cats. 95, 96), and the College purchased sculpture by Augustus Saint-Gaudens (cat. 92) and Bessie Potter Vonnoh (cat. 99) within the next few years. By far the most dramatic increases to the sculpture collection awaited the opening of the museum. The Hood was fortunate to be able to purchase several works that were formerly in the collection of prominent collector Paul Magriel, including pieces by Frederick William MacMonnies (cat. 93), Paul Manship (cat. 94),

and John Bernard Flannagan (cat. 101). The latter two have been particularly helpful in demonstrating the impact of modernism on early-twentieth-century American sculpture—a theme that had not been well-represented previously, despite modernist strengths in the painting collection.

Aside from Dartmouth's many neoclassical sculptural portrayals of its second founding father, Daniel Webster, the collection lacked a major neoclassical marble. Just as the curatorial staff began to explore the availability of such a work, the marble bust of *Medusa* by Harriet Hosmer (cat. 86) surfaced on the market. Known today only in two other marble examples (Detroit Institute of Arts and a private collection), this plaintive work depicts a romantic reinterpretation of the classical gorgon as a victim rather than a deadly agent. Its acquisition provided an opportunity to represent the leading American woman neoclassical sculptor of the nineteenth century with a work that invites investigation from a number of academic perspectives—from art history and classics to literature and women's studies. A focal point in the American galleries (see fig. 3), it points to a long tradition of varied artistic representations of Medusa, the influence of the romantic movement in literature and art, and issues surrounding female empowerment in art and society during the mid-nineteenth century.

Although the museum has a fairly broad representation of works by African American artists made after 1950—especially works on paper—the collection has been woefully weak in African American paintings and sculpture for the period covered in this publication and related exhibition. While painting before 1950 by artists of color remains a major gap, two recent purchases of sculpture have helped to address this area and at the same time give fuller representation to developments in early-twentieth-century art: Henry W. Bannarn's powerful *Midwife*, c. 1940 (cat. 102), and Augusta Savage's engaging *Gamin*, modeled in 1929 (cat. 100). Both artists played vital roles as teachers and mentors within Harlem's African American community in the 1930s and 1940s. The two works also suggest very different approaches toward representing African American subjects. Savage, one of the first African American sculptors to focus on African American physiognomy, rendered *Gamin* in a highly sympathetic, realistic manner, whereas Bannarn adopted a "primitivist" aesthetic based on early modernism and his exploration of African cultural and artistic traditions.

WATERCOLORS AND DRAWINGS

The museum's outstanding collection of American watercolors and drawings formed the focus of a 2005 publication and traveling exhibition entitled *Marks of Distinction: Two Hundred Years of American Drawings and Watercolors from the Hood Museum of Art*. The catalogue's two introductory essays addressed the history of this collection and its utility at Dartmouth. In the years leading up to the exhibition, works on paper became a major focus of the museum's acquisitions program, resulting in several important ad-

ditions to the collection, including works by John James Audubon (cat. 105), John William Hill (cat. 106), William Trost Richards (cat. 107), Mary Cassatt (cat. 111), Eastman Johnson, and several others that postdate the scope of this publication, such as examples by Joan Mitchell, Agnes Martin, and Eva Hesse. The Audubon, an exceptionally rare and majestic pastel by the artist, illustrates one of the most essential functions of drawing in early-nineteenth-century America, the meticulous depiction and cataloguing of the new world's flora and fauna. The Hill and the Richards represent two major figures associated with the mid-nineteenth-century American watercolor revival, while the Cassatt reveals this influential artist's bold compositional strategies during the most experimental period of her career.

Perhaps somewhat less expected in this recent collection survey was the inclusion of two works made outside of the conventional artistic mainstream, both acquired in 2003. The large drawing by Bill Traylor (cat. 120), a self-taught artist born into slavery, represents the museum's first foray into what many term "outsider art." At once humorous and hauntingly enigmatic, the iconography appears to draw both on American southern and Afro-Caribbean visual, cultural, and spiritual traditions. An 1880 ledger book drawing by a Kiowa artist included in the 2005 exhibition is one of several Native American drawings acquired by gift and purchase in the last few years (see cats. 108, 109) through the initiative of the Hood's curator of African, Oceanic, and Native American collections. These sheets demonstrate the artistic talent of their makers—many of them imprisoned warriors—but also the complex, often conflict-ridden intersections of European and Native American cultures in the nineteenth century.[30] The museum's Native American collections, which number more than four thousand objects and are particularly strong in Plains materials, will be highlighted with a publication and exhibition within the next few years.

Since the production of *Marks of Distinction,* significant gifts have enhanced these collections of drawings and watercolors, including a poignant pastel woodland interior, *Where the Trees Are Dying* by Robert Henri, given by Mr. and Mrs. Jack Huber, Class of 1963 (cat. 114). Most recently, the museum accepted an important gift of thirteen works representing the vitality of the California school of watercolors from the 1930s through the 1950s (cats. 118, 119). These were donated by Philip H. Greene, a Hanover resident with no official ties to Dartmouth but a sincere wish to acquaint an East Coast audience with a vibrant artistic tradition from the West Coast, where he lived for most of his life with his late wife and co-collector, Marjorie B. Greene.

PRINTS AND PHOTOGRAPHS

Original American prints have long been actively sought by the College's art galleries and used intensively in teaching, initially almost exclusively by members of the art history department. Having grown alongside Dartmouth's holdings of Old Master prints,

American prints before 1950 now number almost three thousand examples. As early as the 1920s, when the art department began making purchases, prints formed a high percentage of the works acquired. Although many were gifts, prints were generally less costly than paintings and often could be acquired with the department's then very modest acquisitions funds. Especially during the 1930s, Dartmouth took advantage of some of the print publishing organizations that offered relatively inexpensive contemporary prints geared for a wide market. For instance, between 1932 and 1939 the College acquired sixteen prints through the Woodcut Society, which offered annual presentation prints to members, and in 1932 it purchased four works from the International Print Guild. Through Associated American Artists, the College acquired lithographs by the most highly regarded regionalist printmakers of the 1930s and 1940s, including Thomas Hart Benton, John Steuart Curry, and Grant Wood (cat. 135). In the following two decades the department also expanded the nineteenth-century print collection with such acquisitions as wood engravings by Winslow Homer and large-scale naturalist prints and prints after genre paintings (cats. 124, 125). In 1973 Baker Library transferred to the art galleries a large number of satirical political prints from the Civil War era that have proven exceptionally useful for teaching American art as viewed through the lens of social and political history. This was followed in 1987 by another large transfer of library holdings—in this case twentieth-century war posters of various nationalities, which now number more than 2,300 images.[31] Among the original primary donors were Tuck School founder Edward Tuck, Class of 1862 (cat. 55, World War I posters), and Willis S. Fitch, Class of 1917 (World War II posters).

In 1954, Mrs. Hersey Egginton donated an impressive group of over seven hundred works, primarily American prints from the late nineteenth century to about 1950, in memory of her son, Everett Egginton, Class of 1921, who died of tuberculosis just a few years after graduating from Dartmouth. The gift also included several American drawings, watercolors, and European prints. Among the many prominent American printmakers represented by several works each were John Taylor Arms, Arthur B. Davies, Seymour Haden, Childe Hassam (cat. 130), Joseph Pennell, John Sloan, John Henry Twachtman, and James McNeill Whistler. In a sentiment frequently expressed by donors to the College, Mrs. Egginton made the donation with the students' interests foremost in mind. She wrote: "If [the works] bring the pleasure and satisfaction to the students that they did to us, I will be indeed pleased."[32] Another important gift was that of Alden Guild, Class of 1952, who donated forty-five Whistler prints beginning in 1979 (cat. 126).

The Hood has acquired many prints since its 1985 opening (cats. 129, 131, 132, 137), but since acquisitions funds enabled substantial purchases in areas less represented in the collection, prints have not made up as large a proportion of purchases as had been the case previously. Two exhibitions and related publications, however—*Picturing New York: Images of the City, 1890–1955* (1992, fig. 15), and *Looking for America: Prints from the 1930s and 1940s* (1994)—brought

FIG. 15. Exhibition *Picturing New York: Images of the City, 1890–1955,* Hood Museum of Art, 1992.

renewed attention to the Hood's exceptionally strong holdings of prints from the first half of the twentieth century.[33] Additionally, following their long tradition of having been used for curricular purposes, prints have remained a mainstay of innumerable teaching exhibitions and class discussions—now involving students and faculty from a range of disciplines—held in the museum's Harrington Gallery[34] and Bernstein Study Storage Center.

Photography, one of the more recent media in the history of art to obtain full status as an artistic expression, was not collected in a deliberate and concerted manner by the Dartmouth art galleries until the 1970s. Nonetheless, photographs found their way to Dartmouth beforehand, including images depicting Daniel Webster (cat. 138) and Hinmaton Yalakit ("Chief Joseph") of the Nez Perce (cat. 140), donated in 1850 and 1913, respectively. At the time of their acquisition, the virtues of these images were no doubt perceived primarily as historical and commemorative rather than aesthetic. Like many other photographs with a historical or ethnographic component, the image of Hinmaton Yalakit entered the Dartmouth College Museum collections. These collections were administered separately from the fine arts holdings until the two museum entities merged as the Dartmouth College Galleries and Collections in 1974.[35] The ethnographic and art collections remained physically separate, however, until 1985, when they were brought together in the newly constructed Hood Museum of Art.

The art gallery's emerging interest in photography is reflected in a 1972 letter that then-director Truman H. Brackett Jr. wrote to the recent donors of an acquisitions fund, Dr. and Mrs. Calvin Fisher (the Harry Shafer 1966 Memorial Fund, established in 1967 in memory of their son). Brackett stated that the galleries planned to use the funds "for the development of a teaching collection of fine photographs from the 19th century to present." This decision reflected, in Brackett's words, "the increasing recognition in recent years of photography as a legitimate art medium."[36] As demonstrat-

ed in this publication, the fund has since supported the purchase of some of the museum's most frequently used and admired photographs (see cats. 142, 144, 146, 148, 151). Most of the American photographs acquired through gift and purchase since the 1970s have been images dating to the 1930s and later. Many of these were made in conjunction with College-sponsored artist-in-residence or other exhibitions, such as those featuring the works of Ralph Steiner, Class of 1921, in 1975 and 1979 (cat. 142); Walker Evans in 1973 (cat. 146); and Lotte Jacobi in 1978 (cat. 151). Contemporary photographs, which lie outside the scope of this publication, have also entered the collection in quantity and are used intensively for exhibition and teaching. Several recently established acquisitions funds designated specifically for contemporary photography have made such additions possible.

In purchasing photographs in recent years, the Hood's curators have made a special attempt to acquire vintage prints, whenever possible, and images that would be useful for teaching not only the practice and history of photography but also any number of academic disciplines, including American history. Recently acquired iconic documentary photographs by Lewis Hine (cat. 141) and Dorothea Lange (cat. 145), for instance, serve not only as cornerstone images in the history of American photography but as key documents pertaining to child labor and the Great Depression, respectively.

Sizeable gifts have also shaped the museum's photography holdings, including recent donations from the Osman family of vintage depression-era studio photographs by the recently discovered Mike Disfarmer (cat. 149). In honor of longtime Dartmouth professor, screenwriter, film director, and producer Maurice Rapf, Class of 1935, Robert Dance, Class of 1977, donated fifteen vintage prints of Hollywood film stars that were taken primarily in the 1930s and 1940s by such figures as Arnold Genthe, Florence Vandamm, Clarence Sinclair Bull, and George Hurrell (cat. 150). Made at the same time as some of the documentary images of the Great Depression (cats. 145, 148), they, like the movies with which they were associated, evoke a world of luxury and glamour that offered escapist pleasure and psychological relief from the economic hardships of the period. This gift is all the more appropriate for Dartmouth given the prominence of its film society, founded by Rapf in the late 1940s, and its active film and television studies program.

Remaining gaps in the American photography collection range from survey photographs and scenic views of the American West to works by leading figures of the early twentieth century, including Alfred Steiglitz, Edward Weston, Charles Sheeler, Man Ray, and Imogen Cunningham.

DECORATIVE ARTS

The first object of artistic importance donated to the College was the elegant, Boston-made silver monteith that Royal Governor John Wentworth and his associates gave to Eleazar Wheelock "and to his Successors in that Office" in honor of the first commencement in

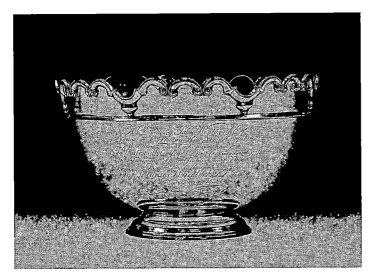

FIG. 16. Daniel Henchman, with engraving by Nathaniel Hurd, monteith, 1772–73 (cat. 162). Gift of John Wentworth, Royal Governor of New Hampshire, and Friends; M.773.1.

FIG. 17. Dick Hall's House, the College infirmary, 1953. Courtesy Dartmouth College Library, photograph by Adrian N. Bouchard.

FIG. 18. Poetry Room, Sanborn House, c. 1930s. Courtesy Dartmouth College Library, photograph by Paul J. Weber, Boston.

1771 (fig. 16). Fashioned by Daniel Henchman and engraved by Nathaniel Hurd, this luxurious and rare form (one of only three known American monteiths in silver) represented a tremendous vote of confidence in the fledgling institution. Not only a masterpiece of American silver, the bowl has come to signify the College's highest office and is passed down from outgoing to incoming president during inaugural ceremonies.

Despite this auspicious beginning, decorative arts at Dartmouth have long held somewhat marginal status from the perspective of fine arts programs at the College—both the art department and the art galleries. Until the mid-twentieth century, furniture and decorative arts were given to the College as mementos of their original owners who had ties to the institution. In 1936, for instance, a mid-eighteenth-century Connecticut side chair that is said to have belonged to Eleazar Wheelock and descended in his family was donated by William Chauncy Langdon, a distant relation.[37]

Many more furnishings were donated or purchased as enhancements to the historic ambience of Dartmouth's public buildings—both its early-nineteenth-century structures and those designed in the late 1920s by Jens Frederick Larson in the neo-Georgian style, especially Dick Hall's House, 1927, and Sanborn House, 1928. Dick Hall's House, the College infirmary (fig. 17), was donated by Mr. and Mrs. E. K. Hall, parents of Richard Drew Hall, Class of 1927, who died of polio during his sophomore year at Dartmouth. Personally selected by Mrs. Hall, the furnishings included a wide range of American antiques that suited the building's quasi-domestic layout and served as a reminder of Dartmouth's long history. The substantial 1928 bequest of Edwin Webster Sanborn (1857–1928), Class of 1878 and son of Dartmouth English professor Edwin David Sanborn (1808–1885), funded the construction of Sanborn House, the new home for the English department. In addition to a library devoted to English and American literature, it featured a poetry room that replicated Professor Sanborn's study (fig. 18),

and the Wren room, modeled after the salon at Belton House in Lincolnshire, England, whose design had formerly been attributed to Christopher Wren (1632–1723). In a desire to create a "home-like" atmosphere for students, Edwin David Sanborn also left the

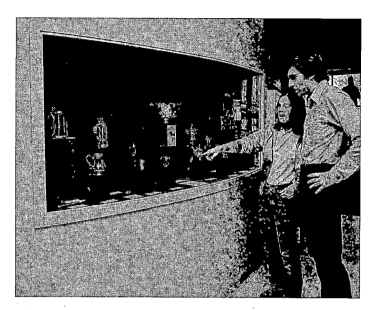

FIG. 19. Dartmouth students admiring the newly installed Hopkins Center silver case, built in 1976 through the generosity of Frank L. Harrington, Class of 1924. Courtesy Dartmouth College Library.

College some of his personal furniture, some of which likely had associations with the Webster family (Edwin David Sanborn married Mary Ann Webster, the daughter of Ezekial Webster, brother of Daniel Webster, Class of 1801).[38] Many of these furnishings are on extended loan to the Hanover Historical Society for its displays in "Webster Cottage," where Daniel Webster is said to have roomed during his last year at Dartmouth.

In 1946 the College had the good fortune to receive the library of Boston man of letters George Ticknor, Class of 1807 (cat. 12). The gift included not only books but also the room's neoclassical bookcases and furnishings (cats. 195, 196, 197), which were donated by Ticknor descendant Mrs. William Dexter. These stately pieces represent the absolute height of Boston's high-style furniture production in the early nineteenth century and speak to Ticknor's refined taste. Funds donated by another descendant, Thomas W. Streeter, Dartmouth Class of 1904, enabled the College to recreate an installation of the library's key features in a room, first located in Baker Library and, since 1988, in Rauner Library.[39]

In 1946 Dartmouth also received several Shaker objects (including cats. 198, 199, 200, 201) as part of the large bequest of primarily Native American materials collected by Frank C. and Clara G. Churchill of Lebanon, New Hampshire. Frank C. Churchill (1850–1912) had worked as Indian Inspector for the Department of the Interior from 1899 to 1909, during which time he amassed over fourteen hundred objects from more than one hundred Native American groups. The Churchills acquired the Shaker objects much closer to home, from the self-contained Shaker community in the neighboring town of Enfield, New Hampshire, where the couple built a summer home and became well acquainted with several of the members.[40] Perhaps because the Shaker materials were originally acquired by a collector of ethnographic material and their makers

could be perceived as cultural "others," these objects first entered Dartmouth's historical and ethnographic collections.

The Dartmouth College art galleries appear not to have acquired decorative arts at all until some English silver was donated in the late 1950s. Instead, the president's office, the College library, and in rare instances (as noted with the Shaker furniture) the Dartmouth College Museum received and/or distributed American furniture on campus. This collecting practice reflected not only the peripheral status that the decorative arts then held within the context of art history but also the function for which such gifts were intended by the donor and recipient. They were perceived less as aesthetically and culturally rich objects relevant to instructional purposes than as decorative props meant to beautify the historical campus and, especially in several more domestically inspired interiors, such as Dick Hall's House infirmary, to enhance Dartmouth's appeal to students as a comforting "home away from home."

The major turning point in this regard appears to have occurred in 1962, when newly appointed Dartmouth trustee Frank L. Harrington, Class of 1924, asked Churchill P. Lathrop whether the College galleries might be interested in his collection of Massachusetts silver. As president of the Paul Revere Life Insurance Company in Worcester, Massachusetts, Mr. Harrington had been purchasing silver by the company's namesake for the firm and examples by other early Massachusetts silversmiths for his personal collection since about 1957. In Lathrop's well-considered reply, he pointed out that the Dartmouth collection began with Wentworth's gift of the Henchman silver monteith, but that "as a colonial college we are, it seems to me, unfortunately weak in not now having a well-balanced collection of American colonial silver. The Wheelocks and other trustees and faculty families undoubtedly had silver in Hanover in the 18th c. They certainly were sensitive to the fine craftsmanship and esthetic value of this outstanding colonial art. Dartmouth should have and should proudly display a representative collection of colonial silver if only as a witness to the culture of her founders and of the era of her founding."[41]

Mr. Harrington began to donate a few pieces from the collection each year beginning in 1966. Ten years later, during the nation's bicentennial year, he gave the funds for an exhibition case especially designed for the silver (fig. 19) and an endowment fund to ensure that the collection would always be maintained. Beginning around the time of the Hood's 1985 opening, he began to finance the museum's purchase of highly important additions to the collection, selected in consultation with the Hood's curator (cats. 154, 158). In total, he gave Dartmouth, or allowed the College to purchase, over seventy-five pieces of American silver before his death in 1988. The following year, the Hood mounted an exhibition of the collection in the museum's Harrington Gallery, funded by Mr. Harrington and his family.[42]

Typical of many silver collectors of his generation, Mr. Harrington did not acquire works made after about 1820, but his generosity to Dartmouth provided the inspiration for one of his friends,

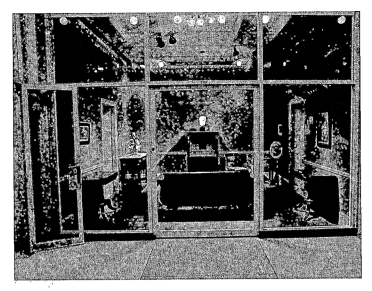

FIG. 20. Exhibition *American Decorative Arts at Dartmouth*, Dartmouth College Museum and Galleries, Hopkins Center, 1981, including furnishings formerly owned by George Ticknor, Class of 1807 (see cats. 12, 195, 196, 197).

FIG. 21. Exhibition *Grueby Pottery: A New England Arts and Crafts Venture: The William Curry Collection*, Hood Museum of Art, 1994.

the Honorable Bailey Aldrich, to donate Daniel Webster's ornate mid-nineteenth-century tea service (cat. 165) to the College in 1975. Aldrich wrote to Harrington about the service that year: "I have been debating with myself whether to give it to Dartmouth or to the Massachusetts Historical Society—knowing both to have many Webster pieces. Learning of what you have done for Dartmouth in this connection cemented my choice."[43]

Although by the 1960s silver apparently found a home in the College's art galleries, other proffered gifts of decorative arts prompted considerable debate as to where and by whom they should be stored and exhibited on campus. Such was the case in 1978, when Alice Runyon offered a large collection of primarily American clocks collected by her associate Hugh Grant Rowell, Class of 1915. By this time the College had only very recently decided to merge the Dartmouth College Museum with the fine arts collections and had received a major bequest from Harvey P. Hood that would help to fund the long-desired art museum. These timekeeping mechanisms, however, no matter how artistic their housing, were also deemed relevant to the College's fine collection of scientific instruments, which dated back to John Phillips's gift in 1772 of "philosophical apparatus."[44] Significantly, the choice appeared to be whether the clocks would be stewarded by the curator of scientific instruments or the curator of history and ethnography—a fine arts curator was not considered. The curator of scientific instruments prevailed, and these Rowell collection clocks have since been housed and occasionally exhibited with those holdings under the auspices of the physics department.[45] One imagines that if the same offer were made today, the conversations and even the resolution of the question could possibly take a different course.

Just a few years later, in 1981, Dartmouth's holdings of American decorative arts gained their first exhibition and a significant

publication, authored by the museum's then-registrar Margaret J. Moody. She researched, exhibited, and published fifty examples of silver and furniture, many of which had been in storage or scattered among various campus buildings (fig. 20).[46] The publication and the background research she provided have continued to be invaluable resources.

Since the hiring of the museum's first curator of American art in 1983 and the opening of the museum two years later, the question of how or if to further develop the decorative arts collection has come up repeatedly. Although the art history department does not offer a course devoted specifically to the decorative arts, more faculty members and students from a variety of disciplines have taken an interest in American material culture in recent years. This development reflects the softening of traditional art historical delineations and hierarchies established among media and, as noted elsewhere, the growing interest in the social context of art. The museum did purchase one example of documented Massachusetts cabinetmaking in 1984 (cat. 192) and welcomes judicious additions to its representation of New England furniture. Complementing the Hood's excellent holdings of Massachusetts silver, the museum has also acquired examples of American pewter, glass, and ceramics.

Much of the growth of these holdings has been a result of generous gifts. Having had no more than a handful of pewter pieces in the collection, the museum was delighted to accept in 1985, 1987, and 1991 important gifts from two pewter-collecting couples, Ethel and Robert E. Asher, Class of 1931, and Katharine T. and Merrill G. Beede, Class of 1929, examples of which are featured in this publication (cats. 166–177). The 2002 gift of eighteenth-century glass donated by Elizabeth E. Craig, Class of 1944W (cats. 179, 180), provided the inspiration for developing, through purchase, a modest teaching collection of glass used in America. Because glass

remains relatively undervalued when compared with other media in the American art market, it has been possible, with the guidance of a glass scholar, to acquire several significant examples for the museum within the last couple of years. This collection, though small in size, highlights important issues relevant to the study of American art and culture—from the impact of industrialization on the manufacture of home goods to the cross-fertilization of styles and techniques between the producers of glass in Europe and America.

Also since the opening of the Hood, curatorial collaboration with local and alumni collectors inspired two Hood exhibitions and related additions to the decorative arts collection through gifts and promised gifts. In 1984, the museum's purchase of a Boston Arts and Crafts–style vase made by the Grueby Faience Company caught the attention of one of the foremost collectors of Grueby pottery, William P. Curry, Class of 1957, who in 1986 and 1989 donated spectacular examples of Grueby's wares (cats. 202, 203). In 1994 the Hood presented an exhibition of more than 120 examples from Curry's renowned collection (fig. 21), and in 2005 it featured an example of Grueby's famous twelve-inch tile design of an evocative forest interior as a promised gift to the museum.[47] Through collaboration with local sampler collectors Joanne Foulk and her late husband, Ted Foulk, the museum mounted an exhibition of samplers made in the vicinity of Canterbury, New Hampshire. This exhibition and publication, *Lessons Stitched in Silk: Samplers from the Canterbury Region of New Hampshire,* encouraged the donation of a Canterbury sampler in 1990 and the purchase of another in 2006 (cat. 188). The latter, made by Apphia Amanda Young in 1838, will be joined by the promised gift from Joanne Foulk of an earlier sampler by the same young woman. No longer viewed merely as decorative evidence of a young woman's adeptness with a needle, American samplers are attracting serious scholarly inquiry. Dating from an era in which women had limited opportunities to further their artistic development along the same course as men, samplers and other traditional female arts provide illuminating windows onto the artistic and literary education of young women in the early nineteenth century. They also point to the development and dissemination of distinctive styles through influential schools, teachers, and families.

FUTURE DIRECTIONS

This retrospective survey demonstrates that the American collections at Dartmouth did not take a straight linear path from Governor Wentworth's gift of the silver monteith in 1773 to today's diverse holdings of more than eight thousand works dating before 1950. They have been shaped in fits and starts by various donors, museum personnel, faculty members, and college administrators working within the context of shifting cultural and academic perspectives on art and (or versus) artifacts. The proliferation of various academic viewpoints toward art has arguably been more dramatic in the past twenty years than during any other period of the museum's history.

FIG. 22. Hood docent Roland Kuchel introducing area schoolchildren to Régis François Gignoux's *White Mountain Landscape* (cat. 29), Israel Sack Gallery, Hood Museum of Art, 2005.

Shifts in the marketplace have been equally striking, particularly in the last decade. Despite substantial increases in the museum's acquisitions funds, the confluence of a shrinking supply of quality American works and a surfeit of passionate, enormously wealthy buyers has pushed prices of what one might call "destination paintings"—including works that have long topped the Hood's wish list—beyond the means of the Hood and, indeed, most museums.

How, then, to proceed? Despite such challenges, it is critical that the museum sustain the momentum of the American collection's growth during the past twenty-two years. To do so, the Hood—more than ever—needs to partner with donors of both objects and funds while seeking out relatively undervalued areas of the market that support the museum's teaching mission in important ways. The continued collecting of American art must respond to social and academic changes at Dartmouth while enhancing the museum's presentation of a cogent, visually compelling survey of key moments in our nation's artistic and cultural history—a presentation that is instructive and inspiring for the museum's diverse audiences, within and beyond Dartmouth (fig. 22). To that end we all owe a debt of thanks to past donors and Dartmouth staff who, for well over two centuries, have built one of the premier academic museum collections of American art in New England. Such rich holdings provide a firm foundation for the collection's continued growth in size and stature in the years to come.

NOTES

1. For additional histories of the Dartmouth collections see Jacquelynn Baas, "A History of the Dartmouth College Museum Collections," in *Treasures of the Hood Museum of Art, Dartmouth College* (New York: Hudson Hills Press, in association with the Hood Museum of Art, 1985), 10–20; Churchill P. Lathrop, "To Promote Interest and Education in Art," *Dartmouth Alumni Magazine* 43 (January 1951): 12–18, 82–84; Barbara J. MacAdam, "American Drawings and Watercolors at Dartmouth: A History," and John Wilmerding, "Dartmouth and American Art," in Barbara J. MacAdam, *Marks of Distinction: Two Hundred Years of American Drawings and Watercolors from the Hood Museum of Art* (Hanover, N.H.: Hood Museum of Art; New York and Manchester, Vt.: Hudson Hills Press, 2005).

2. Among those Dartmouth faculty members beyond the Hood's primary constituent departments who have drawn on the museum's collections for their recent scholarship are Katharine Conley (Professor of French), "Les Révolutions de Dorothea Tanning," *Pleine Marge* 36 (December 2002): 146–75; James A. W. Heffernan (Professor of English), *Cultivating Picturacy: Visual Art and Verbal Interventions* (Waco, Tex.: Baylor University Press, 2006); John V. Kulvicki (Assistant Professor of Philosophy), *On Images: Their Structure and Content* (New York: Oxford University Press, 2006); Siwei Lyu, Hany Farid (Professor of Computer Science), and Daniel Rockmore (Professor of Mathematics and Computer Science), "A Digital Technique for Art Authentication," *Proceedings of the National Academy of Sciences of the United States of America* 101, issue 49 (December 2004): 17006–10.

3. For example, management professor Punam A. Keller's social marketing class at Tuck made a case study in marketing the Hood Museum of Art to students, who made presentations and recommendations to the Hood staff. First-year students at Dartmouth Medical School have honed their observation skills—key to making accurate diagnoses—by learning how to look carefully at art in a new course entitled "The Art of Clinical Observation," taught in partnership with Hood staff. A second class focuses on non-Western art to help doctors understand cultural differences.

4. "Our Art Gallery and a New Hall," *The Dartmouth* 2 (Nov. 26, 1880), 129–30.

5. MacAdam, "American Drawings and Watercolors," 30–32.

6. Dartmouth's several twentieth-century gallery and museum entities went by a variety of names, beginning with the Carpenter Hall Galleries, opened in 1929, and the Hopkins Center Art Galleries, established with the opening of the College's Hopkins Center in 1962. As of September 1974, what were formerly called the Hopkins Center Art Galleries and the College Museum (which housed the anthropological and historical holdings) came to be known as the Dartmouth College Galleries and Collections and, in 1976, the Dartmouth College Museum and Galleries. In 1978, with the bequest of Harvey P. Hood, they were collectively renamed the Hood Museum of Art, although the fine arts and ethnographic collections were not physically integrated until the completion of the newly constructed Hood Museum of Art in 1985. The various permutations on these names are reflected in the reference citations in this publication.

7. Matheson, Susan B., *Art for Yale: A History of the Yale University Art Gallery* (New Haven, Conn.: Yale University Art Gallery, 2001), 15.

8. Johnson, a graduate of Chandler Scientific School, actually gave the Waugh painting to that institution, which operated separately on the Dartmouth campus from 1852 until 1893, when it was incorporated into the College. Notice of the gift appeared in an 1891 issue of *The Dartmouth* (vol. 12 [March 27, 1891], p. 242). The writer observed about the work, "It is now in the hall of the Chandler building and is well worth seeing, both for its intrinsic merit as a work of art and for the historical associations of the locality represented with the college, which bears its name." The painting's presence in the Wilson Hall art gallery is evidenced, however, by a circa 1890s photograph of the gallery (another view of which is illustrated in fig. 5), suggesting that it soon joined the College's larger collection.

9. Unsigned carbon copy of letter from President Ernest M. Hopkins to Henry C. Jackson, executor of the Dore estate, March 8, 1917, Dartmouth College Library, Treasurer's Papers—folder 6 of box 17 (DA-2) "Gifts."

10. MacAdam, "American Drawings and Watercolors," 34.

11. Robert L. McGrath and Barbara J. MacAdam, *"A Sweet Foretaste of Heaven": Artists in the White Mountains, 1830–1930* (Hanover, N.H.: Hood Museum of Art, Dartmouth College, 1988).

12. Barbara J. MacAdam, *Winter's Promise: Willard Metcalf in Cornish, New Hampshire, 1909–1920* (Hanover, N.H.: Hood Museum of Art, Dartmouth College, 1999).

13. "Necrology, Horace Russell," c. 1913, typescript, p. 2, Dartmouth College Library, Horace Russell Alumni File.

14. Lathrop wrote in 1951, "This picture . . . has always been popular with undergraduates and now hangs in Thayer Hall." Lathrop, "To Promote Interest," 18.

15. See "A Mini-Seminar on Two Hood Pieces: Dartmouth Curators and Professors Tell What They See in These Paintings," *Dartmouth Alumni Magazine* 88 (May 1996): 48–49. Highlighting the range of perspectives that can be brought to bear on art, this article featured brief commentary on the Spencer by two faculty members (Robert L. McGrath, Professor of Art History, and Marlene Elizabeth Heck, Visiting Assistant Professor of Art History and History) and two museum staff members (Barbara J. MacAdam and Katherine Hart).

16. Zug also offered the first courses in American painting, photography, and the graphic arts, in addition to his particular interest in city planning and architecture. Lathrop, "To Promote Interest," 18; Obituary, "George Breed Zug, Professor of Art," *New York Times,* February 13, 1943.

17. George Breed Zug to Mr. Knapp (probably Waldo Gray Knapp, Secretary of the College, 1912–17), January 23, 1916, Dartmouth College Library. George Breed Zug, "Exhibition of Cornish Artists," *Art and Archaeology* 3 (April 1916): 207–11.

18. Later Dartmouth exhibitions pertaining to the Cornish colony include *Saint-Gaudens' Shaw Memorial and Charles Ives* (1978); *A Circle of Friends: Art Colonies of Cornish and Dublin* (1985; organized by the University Art Galleries, University of New Hampshire, and the Thorne-Sagendorph Art Gallery, Keene State College); *Shaping an American Landscape: The Art and Architecture of Charles A. Platt* (1995); and *Winter's Promise: Willard Metcalf in Cornish, New Hampshire, 1909–1920* (1999).

19. For more on Churchill P. Lathrop's career at Dartmouth, see MacAdam, "American Drawings and Watercolors," 44n2.

20. Philip A. White, "Tenth Anniversary Report of the Carpenter Galleries," July 1939, 11, typescript, HMA archives.

21. For more on Sloan's association with Dartmouth, see MacAdam, "American Drawings and Watercolors," 34–35.

22. Hood Museum of Art, Dartmouth College, *John Sloan: Paintings, Prints, Drawings,* Hanover, N.H.: Hood Museum of Art, Dartmouth College, 1981. This loan exhibition of seventy objects traveled to five other venues.

23. For more on Jay Wolf and his bequest, see MacAdam, "American Drawings and Watercolors," 38.

24. Lawrence Richmond to Albert I. Dickerson, Oct. 26, 1956, HMA donor files.

25. For more on this acquisition, see Brian P. Kennedy, "Pollock and Dartmouth: A Visual Encounter," *Hood Museum of Art Quarterly*, Spring 2007, 6–7.

26. See MacAdam, "American Drawings and Watercolors," 35–36.

27. Robert L. McGrath and Paula Glick, *Paul Sample: Painter of the American Scene* (Hanover, N.H.: Hood Museum of Art, Dartmouth College, 1988).

28. "Mounted Statue Presented to College by Judge Snow," *The Dartmouth,* November 9, 1928.

29. Ernest Martin Hopkins to Leslie P. Snow, October 8, 1928, Dartmouth College Library.

30. See Barbara Thompson, *Picturing Change: The Impact of Ledger Drawing on Native American Art* (Hanover, N.H.: Hood Museum of Art, Dartmouth College, 2004). This brochure accompanied an exhibition of the same title held from December 11, 2004, through May 15, 2005.

31. The Hood featured nearly one hundred war posters in the 1999 exhibition *On All Fronts: Posters from the World Wars in the Dartmouth Collection,* which was accompanied by a brochure of the same title (Hanover, N.H.: Hood Museum of Art, Dartmouth College, 1999).

32. Cited in MacAdam, "American Drawings and Watercolors," 36–37.

33. Barbara J. MacAdam, *Picturing New York: Images of the City, 1890–1955* (Hanover, N.H.: Hood Museum of Art, Dartmouth College, 1992); MacAdam, *Looking for America: Prints from the 1930s and 1940s* (Hanover, N.H.: Hood Museum of Art, Dartmouth College, 1994).

34. The museum's Harrington Gallery, funded by Frank L. Harrington (see pages 14–15) and several members of his family, houses primarily exhibitions selected by faculty members to support instruction in specific classes.

35. See note 6 for a summary of the various changes in the names and administrative structures of Dartmouth's museum operations in the twentieth century.

36. Truman H. Brackett Jr. to Dr. and Mrs. Calvin Fisher, September 25, 1972, HMA donor files.

37. Margaret J. Moody, *American Decorative Arts at Dartmouth* (Hanover, N.H.: Dartmouth College Museum and Galleries, Hopkins Center, 1981), 2.

38. Moody, *American Decorative Arts,* iv.

39. Moody, *American Decorative Arts,* iii–iv.

40. Churchill wrote a thumbnail history of the Shakers and Mascoma Lake in his article "The Mascoma," *The Lebanonian,* August 10, 1898. I am grateful to Mary Ann Haagen, a board member of Enfield Shaker Village, for this reference and for additional information on the Churchills.

41. Churchill P. Lathrop to Frank L. Harrington, January 14, 1963, HMA donor files.

42. Barbara J. MacAdam, *New England Silver at Dartmouth College: A Tribute to Frank L. Harrington, Class of 1924* (Hanover, N.H.: Hood Museum of Art, Dartmouth College, 1989). See also Rachel Faugno, *Reflections on a Silver Collector: Frank L. Harrington* (Privately printed, 2002).

43. Bailey Aldrich to Frank L. Harrington, December 11, 1975, HMA donor files.

44. Baas, "A History," 10.

45. Alice Runyon file, HMA donor files. The Dartmouth College Museum and Galleries exhibited a selection of the American clocks in Wilson Hall in 1981.

46. Moody, *American Decorative Arts,* and Margaret J. Moody, "American Furniture at Dartmouth College," *The Magazine Antiques* 120 (August 1981): 326–33.

47. See Susan J. Montgomery, *Grueby Pottery: A New England Arts and Crafts Venture: The William Curry Collection* (Hanover, N.H.: Hood Museum of Art, Dartmouth College, 1994); Hood Museum of Art, Dartmouth College, *Celebrating Twenty Years: Gifts in Honor of the Hood Museum of Art* (Hanover, N.H.: Hood Museum of Art, Dartmouth College, 2005), 48–49.

Catalogue

Note to the Reader

This catalogue highlights selected American works from Dartmouth's collections, dating from the eighteenth century through 1950. Entries are organized in rough chronological order by medium. All dimensions are outside dimensions unless otherwise noted, with height preceding width, then depth (when applicable). Dimensions are to the plate for intaglio prints, and to the image for photographs, lithographs, and relief prints. Dimensions for drawings, watercolors, and paintings are to the outside edges of the support (paper, canvas, and so on).

Published sources relevant to each entry appear in abbreviated form at the conclusion of each entry, with full citations listed in the bibliography.

Several of the catalogue entries draw heavily on unpublished label copy or other texts drafted by Hood staff members and Dartmouth students, past and present. These include texts by Richard Rand (cat. 2), Diane Miliotes (cats. 60, 62, 68, 69, 73, 77), Brian P. Kennedy (cat. 81), Katharine G. Harrison '06 (cat. 82), and Barbara Thompson (cats. 108, 109). Special credit must go to curatorial assistant Catherine M. Roberts '05, who researched and provided initial drafts for all of the photography entries, cats. 138–151.

A complete inventory of the Hood's American collections, as well as the museum's other holdings, may be found through the museum's online catalogue, accessible via its Web site (www.hoodmuseum.dartmouth.edu).

Paintings

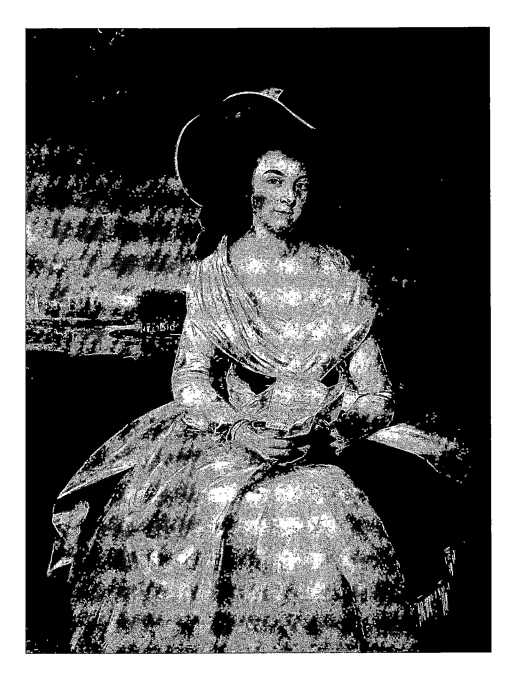

1. Ralph Earl, 1751–1801

Portrait of a Lady, 1784

Oil on canvas, 48 x 37 inches
Purchased through the Katharine T. and Merrill
G. Beede 1929 Fund, the Phyllis and Bertram
Geller 1937 Memorial Fund, the Mrs. Harvey P.
Hood W'18 Fund, the Guernsey Center Moore
1904 Memorial Fund, the Robert J. Strasenburgh
II 1942 Fund, the Julia L. Whittier Fund, the
Hood Museum of Art Acquisitions Fund, and
through gifts by exchange; P.990.43

During the eighteenth century American portraitists looked primarily to British painting for inspiration, as evidenced by this fashionable likeness by New England painter Ralph Earl. Originally from western Massachusetts, Earl began his career in the mid-1770s with limited artistic training, then was forced to leave America during the Revolution owing to his Loyalist sympathies. After arriving in London in 1778, he received instruction from the American expatriate Benjamin West (cats. 2, 104, 122) and saw firsthand the work of George Romney, Sir Joshua Reynolds, and John Singleton Copley (cat. 103).

In 1784, the year in which he painted this portrait, Ralph Earl was working in the company of West in Windsor, England. This work's somewhat generalized landscape, the sitter's gracefully tilted head, and the costume's fluid, painterly treatment all reflect the height of British taste in portraiture. Curiously, once Earl returned

to America he appears to have deliberately simplified his manner and adopted the more linear and seemingly untutored "plain style" popular among his provincial clients. Although the sitter for this portrait is unidentified, she is probably one of the many visitors to Windsor, a fashionable country retreat known for its beautiful scenery and fine game hunting. The landscape in the background is identical to that featured in several portraits Earl painted of female students enrolled in a nearby school. Her confident gaze and stylish attire indicate a prominent social background, and the letter she holds, which is only partially legible, may suggest the romantic attentions of a male admirer.

Purchased by the Hood in 1990, this painting is the museum's first portrait by Earl and one of very few eighteenth-century portraits depicting a woman. [Kornhauser 1991]

2. Benjamin West, 1738–1820

Hannah Presenting Samuel to Eli, 1800

Oil on canvas, 13¼ x 17¼ inches
Purchased through the Mrs. Harvey P. Hood W'18 Fund; P.993.24

Benjamin West (cats. 104, 122) was the first American artist to achieve an international reputation and influence artistic trends in Europe. He has been widely acknowledged as the foremost history painter working in England at the end of the eighteenth century and as a pioneer of the neoclassical and romantic styles. He also offered important instruction and encouragement to scores of American pupils, including Ralph Earl (cat. 1), Samuel F. B. Morse (cat. 6), and Gilbert Stuart (cat. 7). West painted this picture during his tenure as Historical Painter to King George III. At the time, he was working on the decoration of the Chapel of Revealed Religion that was planned for Windsor Castle.

Made for West's own collection and exhibited at the Royal Academy in 1801, this painting portrays Samuel, the Old Testament patriarch. Christians consider him to be a precursor of Jesus, and he figured prominently in the scheme developed by the artist for the Chapel of Revealed Religion. Here, Samuel's mother, Hannah, who was previously thought barren but has miraculously given birth, presents her young son to the High Priest Eli (1 Samuel 1: 24–28). Eli wears the traditional high priest's breastplate, which bears twelve gemstones representing the tribes of Israel and signals the presence of God at ritual occasions. In the background to the right are two of the heifers brought for sacrificing. West focuses on the exchange between the mother and the priest as Hannah, meek and humbled before the commanding Eli, nudges a tentative Samuel forward. The precise profiles of mother and son reflect West's earlier neoclassicism, while the painting's vigorous baroque flourish is in keeping with the artist's later manner. [Von Erffa and Staley 1986]

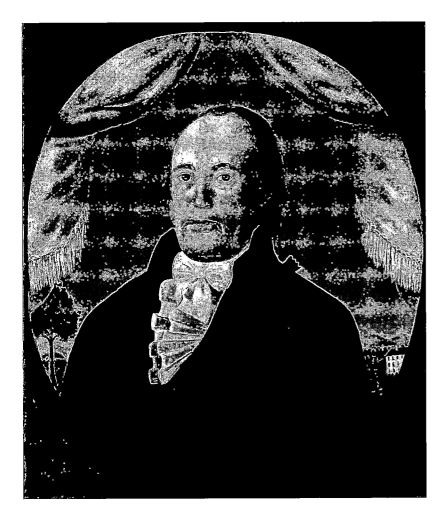

3. Joseph Steward, 1753–1822

Peter Olcott, c. 1790

Oil on canvas, 30⅛ x 26 inches
Gift of Mrs. Sarah Olcott Brinley; P.893.1

Originally from Connecticut, Peter Olcott (1733–1808) and his wife, Sarah Mills Olcott (1737–1810), moved to Norwich, Vermont, in 1772. Peter Olcott was a brigadier general of the Vermont militia and lieutenant governor of the state from 1790 to 1793. He also served as a Dartmouth trustee from 1788 to 1808. The Olcotts' son, Mills, graduated from Dartmouth College in 1790 and served as the College's treasurer from 1816 to 1822 (see cat. 190).

A graduate from Dartmouth in 1780, Joseph Steward took up painting in 1788, after illness interfered with his brief career in the ministry. For the most part self-taught, Steward initially painted portraits of sitters from the vicinity of Hampton, Connecticut, his home, as well as portraits of fellow ministers or Dartmouth graduates. In 1796, Steward moved to Hartford, where he opened a studio in the statehouse and, the following year, a museum of natural curiosities and paintings.

Steward is probably best known for his life-sized portraits of Eleazar Wheelock, Dartmouth College's founder, and John Phillips, a long-time trustee (cats. 5 and 4). In his more conventional bust-length likenesses, Steward frequently adopted an oval format, as seen here. It appears that another artist working in the manner of Steward may have painted the accompanying portrait of Sarah

Mills Olcott (fig. 23) at a later date. Not only is her portrait less skillfully handled than its companion piece, but it is also painted more thickly and on a canvas of a different weave. The barren tree in the background to the left, which contrasts with the tree in full leaf to the right and in the pendant portrait, may suggest that the likeness was painted posthumously, or perhaps in Sarah Olcott's last two years of life following her husband's death in 1808. [Harlow 1981]

FIG. 23. Unknown, American, *Sarah Mills (Mrs. Peter) Olcott,* c. 1800–1810, oil on canvas, 30⅛ x 26⅛ inches. Gift of Mrs. Sarah Olcott Brinley; P.893.2.

4. Joseph Steward,
1753–1822

John Phillips, 1794–96
Oil on canvas, 79¼ x 68½ inches
Commissioned by the Trustees of
Dartmouth College; P.793.1

A major benefactor of Dartmouth College, John Phillips (1719–1795) served as trustee from 1773 to 1793. Through his gift of funds in 1772 for the purchase of a group of scientific teaching devices known at the time as "philosophical apparatus," Phillips was instrumental in developing what was to become the College's early museum collection. He graduated from Harvard in 1735 and settled in Exeter, New Hampshire, where he gained substantial wealth, in part through real estate speculation. He is best known for having founded Phillips Exeter Academy in 1781 (his nephew, Samuel Phillips Jr., had founded Phillips Andover Academy in Andover, Massachusetts, three years earlier).

To honor Phillips's retirement as a Dartmouth trustee, on August 28, 1793, his fellow board members voted to commission Joseph Steward, Class of 1880 (cats. 3, 5), to "take a whole length portraiture of the honorable John Phillips, LLD to be deposited in one of the public chambers of this University at the expence of this board." Steward began this likeness from life the following February in the sitter's hometown of Exeter.

Steward's lack of artistic training is evident here in the misunderstood proportions of the figure and the idiosyncratic interpretation of linear perspective. Yet he convincingly models Phillips's features and meticulously renders such colorful interior details as the stenciled floor cloths and walls, the tasseled drapery, and the green-paneled woodwork. By placing Phillips in such a cheerful, informal setting (probably based on the artist's own home in Hampton, Connecticut, where the portrait was completed), Steward provides us with an approachable portrait of the distinguished trustee and adds a lively, decorative dimension to the composition. [Harlow 1981; Little 1976: 160 (quotation), 161]

5. Joseph Steward,
1753–1822

*The Reverend Eleazar
Wheelock*, 1793–96

Oil on canvas, 79⅛ x 69⅞ inches
Commissioned by the Trustees of
Dartmouth College; P.793.2

The Dartmouth College trustees commissioned this portrait of Eleazar Wheelock (1711–1779), founder and first president of the College, in 1793, about thirteen years after Wheelock's death. This painting and the portrait of College trustee John Phillips (cat. 4) represent the first in a long series of commissioned works depicting Dartmouth presidents, trustees, faculty, and students.

The founding of Dartmouth represented the culmination of the Reverend Eleazar Wheelock's long struggle to incorporate and expand "Moor's Charity School," which he established in Lebanon, Connecticut, in 1754 for the purpose of educating and converting Native Americans. Wheelock underestimated the cultural complexities of his mission, however, and, as enrollment declined in the 1760s owing to attrition and illness, he altered his original mission and began recruiting young white men to be trained as missionaries to the Indians. With this new goal, he moved the school to Hanover in 1770 and began his modest operations, initially holding classes in crude temporary dwellings. He guided the school through these rugged early years and the tumultuous period of the Revolution, serving as the College's president until his death in 1779.

Joseph Steward may have painted his former instructor from memory or from a now-lost earlier miniature. Ludovicus Weld, parson of Hampton, Connecticut, Steward's hometown, is said to have sat for the lower half of the picture. Steward depicts Wheelock in clerical garb, holding the Dartmouth College charter granted him in 1769 by the royal governor of New Hampshire, John Wentworth (cat. 103). The artist likely based the interior on features of the artist's own home in Hampton, whereas the landscape outside the window appears to be imaginary. The view may represent, however, Wheelock's aspirations for bringing his ideals of civilization and enlightenment to the Hanover Plain. [Harlow 1981; Little 1976: 162–63]

6. Samuel Finley Breese Morse, 1791–1872

Erastus Torrey, 1816

Oil on millboard, 11 x 9 inches
Gift of Ellen Cabot Torrey; P.930.4

Dr. Erastus Torrey (1780–1828) graduated from Dartmouth Medical School in 1805 and practiced medicine in nearby Cornish, New Hampshire, and later Windsor, Vermont, where Samuel F. B. Morse painted his likeness. Morse had studied in London under Benjamin West (cats. 2, 104, 122) and hoped initially to paint lofty historical subjects in the European manner. Like many American artists, he found little patronage for such ambitious works upon his return to this country. He resorted instead to portraiture, which he considered a relatively lowly pursuit. Unable to compete in Boston with the more successful portraitist Gilbert Stuart (cat. 7), Morse found a ready market for his talents in more rural regions, where he typically produced small likenesses for a modest fifteen dollars apiece. Characteristic of these affordable works is this portrait's half-length pose (omitting the hands) and its dark, neutral background, adorned solely by the scrollback of a chair. Morse's works from this period reveal his painterly, academically honed technique, moderated by a simplicity that appealed to his country patrons. Here Morse only minimally suggests Torrey's slack figure, but he fluently models his face in delicate rosy tones reminiscent of the work of Stuart. Morse's frustrations with the artistic climate in this country continued, however, and he gradually abandoned painting for science, later inventing the magnetic telegraph for which he is now famous. [Staiti 1989]

7. Gilbert Stuart, 1755–1828

Daniel Webster, 1817–20

Oil on wooden panel, 22½ x 19⅜ inches
Presented in memory of Francis Parkman (1898–1990) by his sons—
Henry, Francis Jr., Theodore B., and Samuel—and by Edward Connery
Lathem in tribute to Elizabeth French Lathem; P.992.21

A graduate of Dartmouth in 1801, Daniel Webster (1782–1852) was adopted as the College's "second founder" when in 1818 he eloquently and successfully defended its original charter in the United States Supreme Court, arguing against those who wished to have the private institution restructured as a state university (see cats. 13–16). Webster eventually served as a United States congressman (1813–17), senator (1827–39 and 1845–50), and secretary of state (1841–42).

The most successful portraitist of America's early national period, Gilbert Stuart had mastered the British grand manner style during an eighteen-year stay in London and Dublin. After returning to America in 1787, he worked initially in New York and Washington,

painting likenesses of the nation's most prominent citizens and political leaders, including George Washington. After 1805 he worked in Boston, where he painted this dashing and penetrating likeness of Webster. As is evident in this work, Stuart took tremendous pleasure and interest in capturing a sitter's likeness and especially in his later years often chose not to complete the background, which he viewed as of secondary importance. Although unfinished, this portrait is remarkable for its vibrancy and ease of execution. It is also among the most sympathetic images of Webster, who was depicted by artists more often than any other figure of his generation. The countless portraits painted later in the great statesman's career tended to accentuate, sometimes to the point of caricature, his imposing public presence. This portrait, by contrast, captures a gentler and more introspective side of the legendary "Black Dan," portraying him as an individual capable of private emotions as well as public pronouncements. It is one of hundreds of images of Webster and objects associated with him owned by Dartmouth College (cats. 7, 87, 138, 165, 194). [Barber and Voss 1982; Barratt and Miles 2004]

8, 9. John Brewster, 1766–1854

John Colley, c. 1820

Oil on canvas, 30¼ x 25⅛ inches
Gift of the Estate of Lydia G. Hutchinson, wife of Paul L. Hutchinson,
Class of 1920; P.985.17.5

Martha Colley, c. 1820

Oil on canvas, 30¼ x 25⅛ inches
Gift of the Estate of Lydia G. Hutchinson, wife of Paul L. Hutchinson,
Class of 1920; P.985.17.6

John Brewster Jr. was born a deaf-mute in Hampton, Connecticut. At the age of twenty-five, he received instruction from the portrait painter Joseph Steward (Dartmouth College Class of 1780), who also resided in Hampton (cats. 3, 4, 5). Brewster likely met Steward through local pastor James Cogswell, whose portrait Steward would paint. In 1790 the Reverend Cogswell recorded his impressions of Brewster in his diary: "He has a Genius for painting & can write well, & converse by signs so that he may be understood in many Things." Beginning in 1796, Brewster made his home in Buxton, Maine. From there he traveled throughout New England and eastern New York State in search of portrait commissions. To date, more than one hundred portraits have been ascribed to the artist, whose ability to support himself through painting is all the more remarkable in light of his physical handicap. In 1817 he enrolled in the first class of the Connecticut Asylum for the Deaf and Dumb in Hartford. After three years of study, he returned to portraiture, which he pursued until at least the early 1830s.

John Colley served in the first New Hampshire legislature in 1831–32. He and his wife, Martha, lived near the Maine border in Effingham Falls, New Hampshire. These portraits reflect Brewster's hallmark style in their precise and delicate brushwork, their plain dark backgrounds, and the serene expressions of the sitters. Although at times inclined to the severe, Brewster here showcases his flair for the decorative in the meandering line of ruffled lace trim that frames Martha Colley's face. The large eyes and direct gazes of both subjects—features also typical of his work—may reflect the special value Brewster placed on eyes in his attempts to understand others, and to be understood himself. [Lane 2004; Little 1960: 18 (quotation)]

10. Chester Harding, 1792–1866

Mrs. Daniel (Grace Fletcher)
Webster, c. 1828

Oil on canvas, 36 x 29 inches
Gift of the William L. Bryant Foundation;
P.953.28

Considering his humble beginnings as a sign painter and his initial lack of formal training, Chester Harding (cat. 15) achieved remarkable success as a portraitist in his lifetime. His extraordinary popularity—described during his day as "Harding fever"—brought him over one thousand portrait commissions. He began his career in the frontier towns of Kentucky and, following study abroad for three years, established a studio in Boston. Particularly after Gilbert Stuart's death (cat. 7) in 1828, he became the city's most prominent portraitist. He painted two presidents and many other statesmen, including Daniel Webster, Dartmouth Class of 1801 (cats. 7, 14, 87, 138, 165, 194), whom he painted more than twenty times. Concerned primarily with likeness, Harding came to achieve great accuracy in his direct, restrained portraits.

Harding's renderings of female sitters are perhaps his most sympathetic, as demonstrated in this becoming portrait of Webster's first wife, Grace Fletcher Webster (1781–1828). Harding accords lavish attention on her fashionable costume, which she wore for the cornerstone-laying ceremonies of the Bunker Hill monument in Charlestown, Massachusetts, in 1825. Webster's oration on that occasion has long been considered the most eloquent summary of the principles behind the American Revolution. This work is one of two virtually identical replicas of what is likely the original life portrait, completed in December 1827 and now in the Massachusetts Historical Society. Mrs. Webster died just weeks later, on January 21, 1828. Webster wrote to her brother, James William Paige, in February regarding the painting: "I cannot tell you how I value it. It was a most fortunate thing, that we had it done." Harding also completed numerous portraits of Daniel Webster, including a life-size image of the orator that measured nearly nine by six feet and now hangs in the Boston Athenaeum. [Lipton 1985: 94 (quotation)]

11. Thomas Sully, 1783–1872

General Sylvanus Thayer, 1832

Oil on canvas; 30 x 25⅛ inches

Gift of General Sylvanus Thayer, Class of 1807; P.867.1

Although members of the Dartmouth community revere Sylvanus Thayer (1785–1872) as the founder of the College's Thayer School of Engineering, he is more widely known as the "father" of the United States Military Academy at West Point. After graduating from Dartmouth College in 1807, Thayer enrolled in the Engineering Corps at West Point. He served as the academy's superintendent from 1817 until 1833, during which time he transformed the fledgling school into one the most distinguished academies in the world. He attained the rank of brigadier-general in the army and in 1867, applying much of what he achieved at West Point, undertook to found Dartmouth's Thayer School of Engineering. With his sub-

stantial financial support, the now well-established school opened four years later.

Thomas Sully (cats. 12, 16) began this portrait of a dashing, forty-five-year-old Thayer at West Point in September 1831 and completed it in his Philadelphia studio the following January. Sully enlivened the relatively static composition with lush, fluid brushstrokes that describe the soft waves of his tousled hair, the sweep of the drapery behind him, and the glint of the buttons and trim of his jacket. The delicate, almost summary treatment of Thayer's features and the bravura handling of the medium are characteristic of Sully's romantic portrait style, which had been shaped more than twenty years earlier during studies in London under Gilbert Stuart (cat. 7) and Sully's British teacher, romantic portraitist Sir Thomas Lawrence. Just one month before Sully completed this likeness he painted an especially handsome portrait of Thayer's Dartmouth College classmate and life-long friend George Ticknor (cat. 12). [Fabian 1983; MacAdam 1989]

12. Thomas Sully, 1783–1872

George Ticknor, 1831
Oil on canvas, 36 x 28 inches
Gift of Constance V. R. White, Nathaniel T. Dexter, Philip Dexter, and Mary Ann Streeter; P.943.130

Thomas Sully's likeness of George Ticknor (1791–1871) displays the mix of refinement and vigor that characterizes the artist's most memorable portraits (see also cats. 11, 16). It captures this erudite man of letters with an earnest, dreamlike expression as he looks out and beyond the viewer, apparently absorbed in noble thoughts. His abundant untamed curls and the billowing drapery and clouds in the distance appear animated as much by his intellect as by Sully's fluid hand. In his mastery of expressive brushwork, the dramatic pose, and the idealization of form, Sully reveals not only his admiration for his early mentor, Gilbert Stuart (cat. 7), but also the debt owed to his British teacher, romantic portraitist Sir Thomas Lawrence.

Boston native George Ticknor spent part of his youth in Hanover, New Hampshire, and later attended Dartmouth College (Class of 1807). In 1815, after having studied Latin and Greek privately and read for the law in Boston, he studied for nearly two years at the University of Göttingen. Ticknor served as Harvard's first professor of modern languages from 1817 to 1835 and in 1849 published his most renowned work, the monumental *History of Spanish Literature*. He served on the boards of innumerable cultural and civic institutions, including the Boston Public Library, of which he was a founder. Beginning in 1829 the patrician scholar resided with his family in a four-story neoclassical townhouse, designed in 1803 by Charles Bulfinch, which overlooked the Boston Common. His descendants donated this painting and the contents of his extensive library, including its furnishings (see cats. 195, 196, 197), to Dartmouth College in 1943. [Fabian 1983; Tyack 1967]

13. Francis Alexander, 1800–1880

Jeremiah Smith, c. 1820–35

Oil on canvas, 30 x 25 inches
Gift of Dr. George C. Shattuck, Class of 1803; P.836.4

This and the following three portraits (cats 14, 15, 16) were commissioned for Dartmouth in commemoration of the legal counsel who defended the College in the case of *The Trustees of Dartmouth College v. William H. Woodward.* A landmark in the history of Dartmouth College and in the arena of contract law, this case was argued in the New Hampshire courts in 1817 and ultimately before the United States Supreme Court in 1818. It pitted the College against those who attempted to alter Dartmouth's original charter and convert the institution into a state university. In gratitude for the favorable resolution of the case, Dartmouth initially engaged Gilbert Stuart (cat. 7) in 1819 to paint portraits of the counsel members. He failed to complete the commission before his death in 1828, however, and

the project languished until Boston alumnus George Cheyne Shattuck (1783–1854), Class of 1803, arranged for the portraits and donated them to Dartmouth.

Along with Jeremiah Mason (cat. 15), Jeremiah Smith (1759–1842) defended the College trustees in the New Hampshire courts in 1817. A native of Peterborough, New Hampshire, Smith pursued an illustrious public career. He was elected to the Second Congress in 1790 and later served as a district attorney in Exeter, a judge of probate, a judge of the United States circuit court, a chief justice of New Hampshire, and, for one term, as governor.

As noted by Thomas Mitchie in his study of the counsel portraits, only after much persuasion did Smith finally agree to sit for an artist. In this likeness by Francis Alexander (cat. 14) he confronts us directly with his gaze, his folded arms and somewhat haughty expression suggesting perhaps his skepticism towards the commissioning of his portrait. [Mitchie 1983]

14. Francis Alexander, 1800–1880

Daniel Webster (Black Dan), 1835

Oil on canvas, 30 x 25 inches
Gift of Dr. George C. Shattuck, Class of 1803; P.836.3

A graduate of Dartmouth in 1801, Daniel Webster (1782–1852; cats. 7, 87, 138, 165, 194) was adopted as the College's "second founder" when in 1818 he eloquently and successfully defended the College's original charter in the United States Supreme Court, arguing against those who wished to have the private institution restructured as a state university (see cat. 13). Webster's renowned persuasive oratory was recognized during his student days at Dartmouth and later given full expression through his career as a lawyer and statesman.

In what is by far the most theatrical and penetrating of the countless surviving portraits of Webster, Alexander sets the swarthy orator, known as "Black Dan," against an energized, fiery sky. Via a low vantage point he accentuates Webster's immense forehead, disheveled hair, and fervent gaze, suggesting at once the statesman's electrifying presence and celebrated powers of reason. The popularity of phrenology during this era makes it almost certain that viewers would have found a direct correlation between the size and shape of Webster's famously large head and his prodigious intellectual capabilities (see also cat. 138).

Francis Alexander (cat. 13) studied briefly at the Academy of Fine Arts, New York, and received encouragement from Gilbert Stuart (cat. 7), probably around 1825. About 1827 he settled in Boston, where he became one of the city's leading portraitists. Alexander acquired his dramatic mode—which went beyond even Stuart's romanticism—during an extended trip to Italy from 1831 through 1833. In 1853, Alexander returned with his family to Florence, Italy, where he remained for the rest of his life. [Mitchie 1983]

15. Chester Harding, 1792–1866

Jeremiah Mason, 1835

Oil on canvas, 30 x 25 inches
Gift of Dr. George C. Shattuck, Class of 1803; P.836.2

Along with Jeremiah Smith (cat. 13), Jeremiah Mason (1768–1848) initially represented the College in the Dartmouth College Case in the New Hampshire courts in 1817. Despite their eloquent arguments, New Hampshire's highest court did not view the College's original charter as a contract and ruled in favor of Dartmouth University. Born in Connecticut and a graduate of Yale in 1788, Mason moved to Portsmouth, New Hampshire, in 1797 and became one of the leading lawyers in the state. In 1802 he was named state attorney general, and he was elected to the United States Senate in 1813, resigning in 1817. Mason's keenest competitor in New Hampshire

legal circles was Daniel Webster (cats. 7, 14, 87, 138, 165, 194), who arrived in Portsmouth in 1807 and regularly represented the opposing view in the more important legal cases.

Chester Harding's forthright likeness of Mason makes no attempt to diminish his large proportions. The portly lawyer looks comfortable and kindly, if somewhat stolid. Harding (cat. 10), an exceedingly popular portraitist in his day, characteristically painted in a visually pleasing, polished style that rarely emphasized the personality of the sitter. Harding's contributions to the art world extended beyond his factual portraiture. He operated an informal gallery out of his Boston studio, which served as an auction house and an important exhibition space for local talent. [Lipton 1985; Mitchie 1983]

16. Thomas Sully, 1783–1872

Joseph Hopkinson, 1835

Oil on canvas, 30 x 25 inches
Gift of Dr. George C. Shattuck, Class of 1803; P.836.1

Along with Daniel Webster, Philadelphia lawyer and congressman Joseph Hopkinson (1770–1842) defended the College's case in the United States Supreme Court in 1818. From 1814 to 1819, Hopkinson served in Congress as a Federalist. In 1828, President John Quincy Adams commissioned him judge of the federal district court for the eastern district of Pennsylvania, a position he retained until his death in 1842.

Thomas Sully's portrait of Hopkinson is the only painting of the four counsel members to include any props or clues as to the occupation of the sitter. Hopkinson is seated at his desk, quill pen in hand, before him a sheet inscribed: "Mr. Webster / Inviolability of Charters / affects every College." A volume labeled "Constitution and Laws of U. States" and a rolled paper marked "Dartmouth College. Rights of Corpor[ation]." are also on the desk. Hopkinson gazes upward, apparently deep in thought. His contemplative expression, refined features, and elegant pose corroborate Webster's reference to "the ripe and beautiful culture of Hopkinson." Given Sully's favored reputation as a portraitist well beyond his Philadelphia environs (cats. 11, 12), it is not surprising that his $125 fee for this work was considerably higher than that of Alexander ($75) and Harding ($100). [Mitchie 1983: 19 (quotation)]

17. Thomas Doughty,
1793–1856

*Rowing on a Mountain
Lake,* c. 1835

Oil on canvas, 17 x 14 inches
Purchased through the Julia L. Whittier
Fund; P.967.88

Thomas Doughty distinguished himself as one of the first American artists to concentrate solely on landscape painting. After devoting himself exclusively to painting in 1820, he attracted commissions primarily for views of estates and public architecture in the environs of his native Philadelphia. He resided in Boston intermittently beginning in 1829 and turned his attention increasingly to landscape painting, which was then gaining popularity. Boston served as his base for regular sketching trips to the White Mountains, the Catskills, and the coasts of Massachusetts and Maine. Through such artfully composed, sylvan landscapes as *Rowing on a Mountain Lake,* Doughty played a key and early role in helping to popularize the White Mountains of New Hampshire as a destination for artists, sportsmen, and tourists.

This luminous canvas probably depicts Echo Lake in Franconia Notch, with the cliffs of Cannon Mountain in the background. Its visual appeal derives not only from the inherent drama of the site but also from Doughty's reliance on longstanding landscape practices (especially those established by seventeenth-century French painter Claude Lorraine) and late-eighteenth-century British aesthetic theories that characterized the Sublime and the Picturesque in landscape. Upholding such conventions, Doughty's carefully balanced composition exhibits a central, mirrorlike body of water that leads our eyes into the distance, strong contrasts between lights and darks, and a mixture of rough and smooth contours. Its vertical format and low vantage point accentuate the height of the rocky precipices, which dwarf the small boating figure. The blasted tree and the threatening clouds over Cannon Mountain add further tension to this otherwise placid composition, emphasizing the awe-inspiring, sometimes destructive, forces of nature. [Carbone 2006: 469–70]

18. Samuel Lancaster Gerry, 1813–1891

Whiteface in the White Mountains, 1849

Oil on canvas, 24½ x 29½ inches
Gift of Catherine H. Campbell; P.989.42.1

Whiteface in the White Mountains depicts in its distance a little-known peak that lies near Waterville Valley, New Hampshire, and dominates what was then a relatively unpopulated region. Breaking from earlier, rather fearsome approaches to the American wilderness (cat. 17), Samuel Lancaster Gerry often included reassuring figures that travel through or recreate in the landscape, as seen here. The compositional structure of this work—a "closed" view of the anglers and stream at the left that gives way to an open landscape at the right—is a format that Gerry favored at this time and one that derives from baroque painting conventions. By the late 1840s the White Mountains had not yet been fully opened to tourists and tended to attract only the more adventurous sportsmen and artists.

After his early experience as a decorative artist and a four-year study trip through Europe, Gerry opened a studio in his native Boston in 1840. He proved to be a versatile painter of portraits, genre scenes, marines, and landscape. Prominent in the Boston art community, Gerry was a founding member of the Boston Art Association (later the Boston Art Club) and served as its president beginning in 1858. He made regular sketching trips to the White Mountains from the late 1840s through the rest of his career, generally favoring the vicinity of West Campton and Franconia Notch. In contrast to this light-filled, tightly rendered composition that reveals the influence of Hudson River school artists, especially Asher B. Durand, his later work (cat. 41) reveals his growing interest in the darker tonalities and broader brushwork of the French Barbizon school.

This painting was bequeathed to the museum by Catherine H. Campbell, whose 1985 book, *New Hampshire Scenery,* remains an invaluable reference work on art of the region. [Campbell 1985: 65–69]

19. George Peter Alexander Healy, 1813–1894

Caroline LeRoy Webster, c. 1845

Oil on canvas, 30¼ x 25⅛ inches

Purchased through the Julia L. Whittier Fund; P.954.6

In 1829, Caroline LeRoy (1797–1882), the daughter of a prominent New York merchant, became the second wife of the famed orator and statesman Daniel Webster (1782–1852), Dartmouth College Class of 1801 (cats. 7, 14, 87, 138, 165, 194). Webster's first wife, Grace Fletcher (1781–1828; cat. 10), had died almost two years earlier. A month before he remarried, Webster described his fiancée as "amiable, discreet, prudent, with enough personal comeliness to satisfy me, and of the most excellent character and principles."

From a humble beginning in Boston as the son of a bankrupt sea captain, George Peter Alexander Healy became an internationally famous portrait painter. His delicate yet realistic manner demonstrates the influence of French realist painter Jean-Auguste-Dominique Ingres, whose portraits Healy would have known from extended periods spent in France. In this becoming portrait Healy lavishes care not only on Caroline Webster's demure expression but also on her fashionable accessories, particularly the gold-trimmed lappet she wears over her head. Its delicate beaded fringe glistens in the light, providing a halolike frame for her artfully coifed head. Over the years Healy painted many members of what he described as Webster's "large home circle." These paintings included images of Webster himself, the best known of which is his monumental *Webster Replying to Hayne* (1851) now hanging in Boston's Faneuil Hall. Dartmouth College owns several likenesses by Healy (see also cat. 20), many of them depicting Webster's family members and Boston associates. [Introduction by Claude M. Fuess in Webster 1942: xiii (quotation)]

20. George Peter Alexander Healy, 1813–1894

George Perkins Marsh, c. 1845

Oil on canvas, 29⅞ x 24⅞ inches
Bequest of Mrs. George Perkins Marsh; P.901.4

Lawyer, diplomat, and author George Perkins Marsh (1801–1882) was one of the pioneers of the American conservation movement. Born in Woodstock, Vermont, he practiced law in Burlington after graduating from Dartmouth in 1820. He later served in Congress from 1842 to 1849 and held diplomatic posts as minister to Turkey and Italy. Although a brilliant scholar in many fields, he is probably best remembered for his influential book *Man and Nature; or, Physical Geography as Modified by Human Action* (1864), in which he cautioned: "Man has too long forgotten that the earth was given to him for usufruct alone, not for consumption, still less for prof-

ligate waste." Marsh also built an extensive collection of European prints that was the first art purchased by the Smithsonian.

A portraitist of international renown who resided for long periods in France, George Peter Alexander Healy (cat. 19) painted this likeness for the sitter while the artist was in Washington, D.C., working on a series of American statesmen for the French king Louis Philippe. In his characteristically forthright manner, Healy presents a reticent, slightly disheveled Marsh, who sports the longer locks and wide, unwieldy cravat fashionable in the 1840s. His direct, bespectacled gaze suggests Marsh's intelligence as well as, perhaps, his sympathy for the artist, who became a lifelong friend. [Marsh 1864: 5 (quotation)]

21. Edmund C. Coates, 1812–1871, after William Henry Bartlett, British, 1809–1854

Passamaquoddy Bay, 1854

Oil on canvas, 20⅛ x 24⅛ inches
Purchased through the Julia L. Whittier Fund; P.965.88

Beginning in the late 1830s, the wide circulation of engravings after William Henry Bartlett's American vistas helped to satisfy the hunger for American landscape imagery in this country and abroad. E. C. Coates was one of many American artists who relied on Bartlett's prints—published in bound form in N. P. Willis's *American Scenery*, 1839—as the basis for his oil paintings. Closely adhering to eighteenth-century British landscape conventions, Bartlett's engravings typically feature distant vistas taken from an elevation, with framing elements to either side. A comparison between Coates's painting and the engraving after Bartlett of Eastport and Passamaquoddy Bay (fig. 24) reveals both the American painter's heavy reliance on the print and his deviation from it in certain details. Coates's composition follows the engraving's essential topography closely, but whereas the print accentuates the scene as a site for human commerce and recreation, Coates omitted the most prominent sailing vessels, diminished the scale and extent of Eastport in the distance, and eliminated the picnickers in the foreground. He features instead just three figures that stand with their backs to the viewer, apparently entranced by the scene. He imbues the overall composition with radiant light and autumnal color (the original prints were uncolored) and, significantly, presents the composition in an oval format—one traditionally used for religious subjects. The overall effect is an accessible but serene landscape, presented as an object of reverent contemplation.

Relatively little is known about E. C. Coates, who was born in England and by 1837 was in New York City, where he occasionally exhibited landscapes and marines. He developed a distinctive style, in which he rendered foreground foliage with pronounced stipple-like brushwork that sits upon the otherwise smooth, stroke-free surfaces of his paintings. [catalogue entry by Nancy Thompson in Stier 1982: 26–27]

FIG. 24. Charles Cousen, British, 1813–1889, after William Henry Bartlett, British, 1809–1854, *East Port and Passamaquoddy Bay*, c. 1839, handcolored engraving on wove paper, 4⅞ x 7¹⁄₁₆ inches (image). Hood Museum of Art, Dartmouth College; PR.X.986.96.

22. James Henry Cafferty,
1819–1869

Preparing to Fish, c. 1846
Oil on canvas, 20 x 16 inches
Gift of Frank P. Stetz in memory of
David Stewart Hull, Class of 1960;
P.2004.83.12

In many nineteenth-century American genre paintings, the image of the country boy served as a metaphor for the youth, cunning, and unharnessed potential of the new nation itself. This rural scene of three boys also appears to offer a commentary on the stages of childhood. Placed in the center, the eldest boy commands the scene with his erect posture and direct gaze. Sporting a military-style cap and jacket, he baits the fishing line while assertively holding the rod like a staff. The next oldest child wears a similar outfit but a more boyish, country-style hat. He sits to one side with a dull expression and passively holds the basket of bait for his brother. The youngest boy, who wears simpler, less manly clothes, has apparently cast off his straw hat, which lies behind him. He does not engage in the fishing preparations but sits directly on the ground alongside a lamb—a symbol of gentleness and, in the Christian tradition, of Jesus Christ

and his suffering. The youngest boy can thus be viewed as exhibiting certain freedoms from societal constraints and a greater proximity to nature and even to God. Like many mid-nineteenth-century images of children, this painting reflects a new appreciation of childhood as a distinct phase (or series of phases) of development. No longer viewed from birth as little adults, children were believed instead to come into the world with a beatific innocence that was to be nurtured and cherished for its own sake. Only gradually should a child assume the responsibilities and conventions of adulthood.

In 1846, New York painter James Henry Cafferty exhibited this painting at the American Art-Union, a subscription organization that took pride in presenting works that would appeal to a wide national audience. [Hull 1986; Perry 2006]

41

23. Lilly Martin Spencer, 1822–1902

The Jolly Washerwoman, 1851

Oil on canvas, 24½ x 17½ inches
Purchased through a gift from Florence B. Moore in memory of
her husband, Lansing P. Moore, Class of 1937; P.993.25

Lilly Martin Spencer was one of the very few women artists of
her era to earn her livelihood and achieve national recognition
as a painter. Through the sale of her works she supported, albeit
with difficulty, her husband and thirteen children (seven of whom
survived to maturity). As is evident in this work, she admired the
longstanding traditions of European genre painting and the tight
realism of mid-nineteenth-century German art that was then very
much in vogue.

 The Jolly Washerwoman depicts Spencer's own servant at close
range, cheerfully doing the household laundry. Giving monumental
status to such a seemingly mundane and female-associated subject
marked a dramatic departure from prevailing conventions in Ameri-
can genre painting (or scenes of everyday life). Typically such works
had depicted male activities, set either outdoors or in more public
spaces. Spencer's rendering of a household labor—a painting of a
woman by a woman—demonstrated a new emphasis on the impor-
tance of the domestic sphere, a cultural development that would be-
come increasingly prominent as the century progressed. As in other
kitchen scenes by Spencer, the subject engages the viewer with a
direct gaze and broad, toothy smile, an expression rarely found in
paintings of upper-class subjects. Despite the servant's good cheer,
her muscular, chapped arms and the slight tear in her bodice be-
speak the exertion required of her duties. She is surrounded by an
artful arrangement of the tools of her trade—tubs, pans, soap, wash-
board, and clothespins. These create an utterly convincing still life
while summarizing the many steps of the daylong laundry process.
[Bolton-Smith and Truettner 1973; Johns 1991; O'Leary 1996]

43

24. James Bard, 1815–1897

The Menemon Sanford, 1855

Oil on canvas, 29½ x 50 inches
Purchased through the Florence and Lansing Porter Moore 1937 Fund;
2005.41

James Bard was America's foremost painter of inland and coastal steamboats during the mid-nineteenth century, when such vessels provided a vital means of transportation and symbolized technological prowess in the popular imagination. After dissolving an early painting partnership with his twin brother around 1849, Bard worked successfully on his own for the next four decades. His meticulously crafted ship portraits attracted a network of patrons among New York's most prominent shipbuilders, captains, and owners (including Cornelius Vanderbilt)—clients who repeatedly commissioned him to depict their prized vessels.

In this characteristic work the *Menemon Sanford,* built in 1854 by John Englis of New York, gleams as it heads toward its destination, flags unfurling and water spraying in its wake. Curious figures sporting top hats and frock coats populate the deck and add a convivial note to the composition. In typical fashion Bard has built up elements of the boat's rigging in slight relief in order to heighten the work's realism and decorative appeal. The handsome *Menemon Sanford,* as fate would have it, endured a brief, arduous life. She was originally built for E. H. Sanford's New York and Philadelphia

coastal line. After running aground in the northern waters on two occasions, she met her final demise off the Florida Keys in 1862, while chartered by the U.S. War Department.

Bard frequently made highly detailed, full-sized drawings of his planned compositions, most likely to present to a client for approval. This recently acquired painting joins its elaborate related drawing, which had been in the museum's collection for more than forty years (fig. 25). [Peluso 1997; MacAdam 2005]

FIG. 25. James Bard, 1815–1897, *The Steamer, Menemon Sanford,* 1854–55, graphite heightened with watercolor and white chalk on wove paper. Purchased through the Julia L. Whittier Fund; D.964.133.

44

25. William Mason Brown, 1828–1898

Summertime, 1853
Oil on canvas, 40½ x 56⅝ inches
Gift of Mr. and Mrs. M. R. Schweitzer; P.967.15

Although William Mason Brown is best known as a painter of realistic still lifes, prior to the 1860s he painted landscapes in a broad, romantic style that recalled the early work of Thomas Cole and Jasper Cropsey, both leading members of the so-called Hudson River school. Like them, Brown shared an affinity for the awe-inspiring scenery and compositional conventions set forth by seventeenth-century French painter Claude Lorrain. Here Brown relied on such Claudian devices as enframing elements, highly detailed foreground vegetation, and a spotlit central clearing to move the viewer's eye through the composition and toward the distant mountains and radiant sky. The watering cattle in the center seem incongruous in this otherwise wild setting, bordered by fantastic craggy peaks that

bear no resemblance to the weathered mountains of the American Northeast. Clearly, this sweeping landscape does not depict a particular place but rather an Edenic vision of nature in a state of unrestrained growth and profusion.

A native of Troy, New York, Brown took up landscape painting after his move in 1850 to Newark, New Jersey. Eight years later he moved to Brooklyn, New York, where he came under the influence of the American Pre-Raphaelites. Devoted to British critic John Ruskin's "truth to nature" philosophy, these artists adopted an extremely tight, precise style. Brown applied this manner first to site-specific landscapes and then to what would become his specialty, tabletop still lifes of fruit. [Ferber and Gerdts 1985]

26. William Louis Sonntag, 1822–1900

Italian Lake with Classical Ruins, 1858

Oil on canvas, 35¾ x 60 inches
Bequest of Annie B. Dore, in memory of her husband, John Clark
Dore, Class of 1847; P.917.3

Rich in historical and artistic associations, Italy held great romantic appeal for aspiring nineteenth-century American artists. Like many of his contemporaries, William Louis Sonntag made frequent and extended pilgrimages there, attracted more by the romanticized ideal of Italy's past than by the realities of its complex and less glamorous present. This poetic scene, which includes the temple of Vesta in Tivoli, was probably painted from sketches Sonntag made during his yearlong Italian sojourn in 1855–56. The Roman temple, from about 100 BCE, is the only identifiable structure, but scattered ruins, fragments of aqueducts, and colorfully dressed peasants further locate the scene in Italy. The natural setting is an artful pastiche of lush forest, rocky precipice, and luminous sky and water—

all arranged in the Claudian landscape mode (see cat. 25). Sonntag painted at least two other versions of the same scene, including one of identical size in the collection of the Corcoran Gallery of Art, Washington, D.C.

Sonntag was raised in Cincinnati but moved to New York by 1857. From there he traveled not only to Italy but also to American scenic locales, especially the White Mountains. His landscapes retained his distinctive animated touch but gradually became more intimate in size and subject, reflecting the influence of the mid-nineteenth-century French Barbizon style. [Blumenthal 1993: 42–43; Moure 1980; Stebbins et al. 1992]

27. John Frederick Kensett, 1816–1872

Mount Washington, New Hampshire, c. 1854

Oil on canvas, 9⅛ x 17¾ inches
Gift of Robert A. and Dorothy H. Goldberg in honor of Harold M.
Friedman, M.D.; P.987.34.30

One of the most prominent artists to paint in the White Mountains, John Frederick Kensett first visited the region in 1850, when he stopped in North Conway with Boston painter Benjamin Champney, whom he had first met when studying in Rome. Kensett returned to the White Mountains many times throughout the decade, joining fellow New York and Boston artists including Champney, who by 1854 had purchased a summer home in North Conway. Painted from sketches made during his first visit, Kensett's monumental *Mount Washington from the Valley of Conway* (1851, Davis Museum, Wellesley College) was widely reproduced in print form and became the single most effective mid-nineteenth-century advertisement for the scenic value of the region.

This more modest painting, with Mount Washington visible in the distance, is probably a study for a larger composition. It is nonetheless typical of Kensett's work from the mid-1850s in its subdued grayish-green palette, hazy pearlescent light, and direct interpretation of a closely observed scene. By the 1860s, Kensett would move still further from the majestic and balanced paintings associated with the Hudson River school to create hauntingly still and reductive compositions—particularly coastal scenes—bathed in glowing light.

This is one of many works depicting the White Mountains that North Conway collectors Robert A. and Dorothy H. Goldberg donated to the museum in 1986 and 1987. [Driscoll et al. 1985; catalogue entry by Carol Troyen in Howat et al. 1987: 148–151; McGrath and Mac-Adam 1988]

28. Francis Seth Frost, 1825–1902

Moat Mountain, Intervale, New Hampshire,
c. 1860s

Oil on canvas, 12 x 18 inches
Gift of Robert A. and Dorothy H. Goldberg; P.987.34.17

This composition depicts the northwest slope of Moat Mountain as viewed from the broad Saco River bottomland known as the Intervale in North Conway, New Hampshire. Boston painter Francis Seth Frost has turned away from an emphasis on the sublime aspects of the setting, which had appealed to an earlier generation of painters of the White Mountains, toward the more subdued, intimate approach to the landscape associated with the luminist style. This is most noticeable in the carefully rendered details, clarified lighting, and compositional structure based on a series of horizontal bands. While subservient to the artist's chief aesthetic interest in lighting effects, the seated figure and distant farmhouse remind us that the White Mountains region was no longer an untouched wilderness. As is evident from this work, artists would increasingly capitalize on the area's more pastoral qualities, in keeping with the shifting aesthetic interests of the late nineteenth century.

Frost exhibited White Mountain landscapes as early as 1854. By then he had already spent two years in California (1849–51), returning to his native Massachusetts with gold dust reportedly worth four years' wages and sketches of Western scenery. He became close friends with and a likely student of the more established Albert Bierstadt, whom he accompanied to the American West with Frederick W. Lander's survey party in 1859. Upon their return, Frost continued to paint both New Hampshire and Rocky Mountain scenes with modest success until his death, while also practicing photography and running a major artist's supply store, Frost & Adams, in Boston. Despite his apparent productivity as a painter, relatively few of his works have been located. [Houston 1994]

29. Régis François Gignoux, French (active in the United States), 1814–1882

New Hampshire (White Mountain Landscape), c. 1864

Oil on canvas, 48 x 83¾ inches
Purchase made possible by a gift of Olivia H. and John O. Parker,
Class of 1958, and by the Julia L. Whittier Fund; P.961.1

Trained in Lyons and Paris, Régis François Gignoux worked in America from 1840 to 1870. Like the Hudson River school painters already established here, he traveled deep into the wilderness of the Adirondacks and the White Mountains in search of subjects. Although suggestions have been made as to the exact location depicted in New Hampshire, this majestic landscape is more likely a romanticized composite view inspired by Gignoux's visits to the Presidential Range in New Hampshire's White Mountains, liberally embellished for dramatic impact. Its sweeping vista, deep recession into space, and mastery of atmospheric effects reveal Gignoux's admiration for his more influential contemporaries Frederic Edwin Church and Albert Bierstadt, both of whom were fellow tenants at the Tenth Street Studio building in New York City. The exaggerated height and ruggedness of Gignoux's White Mountains may reflect the artist's desire to imbue this venerable wilderness area with the theatrical drama associated with such exotic locales as the Rockies and the Andes, which had been more recently popularized by Bierstadt and Church, respectively. The widespread appeal of such optimistic, panoramic canvases suggests not only a vogue for grandeur but also an abiding faith in Manifest Destiny—the nineteenth-century belief that America had a God-sanctioned mission to expand its territories and influence throughout the continent. In Gignoux's work such nationalistic sentiments become tangible in the American eagle that soars through the valley toward the distant horizon. [McGrath 2001: 86]

30. Thomas Hill, 1829–1908

Mountain Landscape, late 19th century

Oil on canvas, 9½ x 10⅝ inches
Gift of Mr. and Mrs. Peter A. Vogt, Class of 1947, in memory of
Edward N. Marlette, Class of 1941; P.991.42.1

Thomas Hill is best known for his large, panoramic landscapes of the
White Mountains and the American West, particularly the vicinity
of Yosemite Valley in California. Like his brother Edward (cat. 36),
Thomas emigrated from England to the United States in 1844, ini-
tially working as a decorative artist in Massachusetts. In 1853 he en-
rolled at the Pennsylvania Academy of the Fine Arts, but two years
later he returned to the Boston area, where he became active in art
circles. In 1861 ill health forced Hill to move to San Francisco, and
he made his first sketching trip to the Yosemite Valley the following
year. His ambitions for his landscape paintings grew through his
studies in Paris in 1866–67 with German painter Paul Meyerheim,
who encouraged his efforts in this genre. In 1871, Hill moved back
to San Francisco, where he became one of the best-known painters
of the West. He is said to have painted over five thousand views of
Yosemite during his career, supplying a demand for painted souve-
nirs that was created by an influx of tourists to the region.

Many of Hill's paintings from the early 1870s onward were small,
on-the-spot sketches that he would use as studies but also exhibit
and sell alongside his larger works. Both in the United States and
abroad, artists and patrons during this period were gaining a greater
appreciation for the sense of immediacy and the artist's touch con-
veyed by painted sketches. Although modest in scale, this landscape
effectively captures the grandeur and majesty of a Western mountain
scene. Its pastel palette, loose brushwork, and hazy aerial perspec-
tive point toward Hill's nascent interest in impressionism, whereas
the painting's subject and composition clearly demonstrate Hill's
debt to his better-known contemporary Albert Bierstadt, who so
successfully promoted the West through his large, theatrical can-
vases. [Arkelian 1980; Dreisbach 1997]

31. Worthington Whittredge, 1820–1910

Near Greycourt, New York, c. 1872–75

Oil on canvas, 19⅛ x 16⅛ inches
Gift of Robert and Mary Schmid; P.989.5

Originally based in Cincinnati, Worthington Whittredge first developed his approach to painting through his early exposure to the work of the Hudson River school, followed by study in Düsseldorf, Germany, the international center for academic painting in the 1850s. In 1859, after spending three years painting in Italy, he established a studio in New York's Tenth Street Studio building (see cat. 29). In response both to his European sojourn and to the second generation of American landscapists, which included Asher B. Durand and John Frederick Kensett, Whittredge adopted a softer, more naturalistic style that he applied to his paintings of the American West in the late 1860s—works that highlighted the region's gentler, more pastoral beauty over its spectacular topography. Whittredge painted *Near Greycourt* back east, in Orange County, New York, where he completed some of his finest works during the mid-1870s. By this point he had mastered delicate outdoor lighting effects and begun to incorporate picturesque elements into his scenes, such as old farmhouses and rural laborers working or returning home from the fields. Whittredge's agrarian motifs and broader, *plein-air* style reveal his admiration for the French Barbizon school, which was gaining favor among American artists. In this painting the hazy, golden light of late afternoon casts long shadows in the field and gives a poetic, reverential feel to this scene of a farmhand herding his charges homeward. [Janson 1989]

32. George Cochran Lambdin, 1830–1896

In the Beech Wood (In the Woods), 1862–64

Oil on canvas, 22 x 18 inches
Purchased through the Julia L. Whittier Fund and the Mrs. Harvey P.
Hood W '18 Fund; P.988.4

Like many genre painters of his time, George Cochran Lambdin referred to the Civil War in his art by focusing on soldiers at rest or at home with their families rather than in combat. His first work in this vein was *The Consecration* (1861, Indianapolis Museum of Art), in which a soldier's leave-taking from family takes on a ritualistic importance. Completed in 1864, *In the Beech Wood* builds on this theme in its suggestion of the impending separation of a young, presumably married, couple (she wears a ring). Here the woman and her beloved, possibly a recruit, meet in a forest, where he carves their initials into a beech tree—a smooth-barked species long favored for this practice. The cathedral-like woodland setting, with its radiant clearing beyond, appears to sanctify this act of devotion. Their contrasting postures—the man erect as he forcibly carves the initials and the woman seated and watching as the writing unfolds—suggest gender expectations of the period. His commanding stance evokes his readiness for the front, while her proximity to the ground and alignment with the glowing light beyond imply her association with the restorative natural setting. Lambdin's better-known contemporary, Winslow Homer, painted a related work, *The Initials*, the same year. Although it is not certain which came first, Homer's painting seems to conclude the narrative suggested in Lambdin's composition. In Homer's version, a young woman, alone in the woods, mournfully retraces the initials carved in a tree by her departed lover. [Giese 1986; Weidner 1986]

33. Edith W. Cook, active 1860s–70s

Lake Placid at Twilight, 1868

Oil on canvas, 8¾ x 18 inches
Purchased through the Julia L. Whittier Fund; P.960.61

Relatively little is known about Edith Cook, who was one of the few professionally established female landscape painters of her generation. More commonly, female artists of the era selected subjects accessible from the home or studio—portraits, genre scenes (cat. 23), allegorical imagery, or still lifes. In Cook's day, a woman exploring the mountainous regions of the Northeast in search of painting subjects would still have been considered unconventional. Cook resided in Hoboken, New Jersey, between 1864 and 1875, during which time she exhibited at the National Academy of Design and the Pennsylvania Academy of the Fine Arts, where she presented this painting in 1868. Titles of works shown at these exhibitions suggest that she painted not only in the Adirondacks but in the Catskills and White Mountains and on Cape Ann, Massachusetts. According to family tradition, Cook was a friend of the sister of Sanford Robinson Gifford, the celebrated American landscape

painter to whom Cook's work is clearly indebted and from whom she likely received some training. Pointing to their close association, another twilight composition by Cook in a private collection, done very much in the manner of Gifford, is said to have descended in the Gifford family. Like Cook, Gifford also painted in the Adirondacks and produced at least one canvas (1863) of Mount Whiteface from an almost identical vantage point on Lake Placid. Taken from a slightly greater distance, Cook's painting shares with Gifford's a sharply horizontal format, a low vantage point, and an interest in the play of late afternoon light on the mountain's shoulders and the glassy surface of the lake. The subtle accent of figures in a boat—another Gifford feature—offers the only human presence in this otherwise untouched Adirondack landscape. [Alexander Gallery 1986, cat. no. 26; Gerdts 1964; Gerdts 1989; Weiss 1987]

34. Norton Bush, 1834–1894

Lake Nicaragua, 1871

Oil on canvas, 20¼ x 36 inches
Purchased through the Julia L. Whittier Fund; P.970.56

Norton Bush was a prolific California artist who specialized in tropical landscapes painted in the luminist style. *Lake Nicaragua* exemplifies this aesthetic tradition through its meticulously rendered detail, spare composition, and enveloping, crystalline light. Like the tropical subjects painted by Bush's more renowned contemporaries Martin Johnson Heade and Frederic Edwin Church, *Lake Nicaragua* reflects North America's political, scientific, artistic, and commercial interest in Latin America during the nineteenth century. Several of Bush's major patrons had business concerns in Latin America, including Henry Meiggs, who commissioned the artist's 1875 trip to South America to obtain sketches of his mining operations. Nicaragua held particular importance as a key route between the Atlantic and Pacific Oceans (partially via the San Juan River and Lake Nicaragua) for east–west sea travelers through-

out the nineteenth century. This same route was one of four seriously considered for the interoceanic canal that now traverses the Isthmus of Panama. Bush would have found an eager market for his Nicaraguan scenery among the many people who traveled the route, particularly in transit to and from California. In this work, he used delicate brushwork and rich coloring to convey the sultry atmosphere and exotic allure of Central America. It includes certain stock features that recur in his tropical paintings—a smoking volcano in the distance, palm trees dripping with tangled vines, tropical birds in flight, and a smooth lake accented with a small, indigenous boat—all of it, as one writer put it, "thoroughly permeated with tropical warmth." [Manthorne 1989; *Sacramento Daily Record-Union,* August 5, 1893 (quotation); Wilson 1984]

35. George Loring Brown, 1814–1889

*Autumn. Windy Day (View at Gorham,
New Hampshire)*, 1862–63

Oil on canvas, 18 x 24 inches
Gift of Robert A. and Dorothy H. Goldberg; P.987.34.3

George Loring Brown spent many years absorbing cosmopolitan influences abroad before returning to paint the American landscape. In the early 1830s he studied in Antwerp, London, and Paris (with romantic landscapist Eugène Isabey). He lived in Italy from 1841 to 1859, when a financial crisis diminished the American tourist market that had sought his views of Italian scenery. Returning home, he became determined to revitalize American art with his bold colors and active brushwork. During the 1860s and 1870s, Brown made numerous sketching trips to the White Mountains, painting throughout the region. As seen in this painting, his works from this period demonstrate less of an interest in recording the physiognomy of a particular place than in capturing the transitory effects of nature.

Using a compositional format very different from that favored by most of his contemporaries, Brown here obscures the mountains in the distance with a screen of trees, providing few visual clues as to the locale; only an inscription on the reverse tells us that the scene is set in Gorham, New Hampshire. In the hands of another artist the swollen river, felled trees, and patch of dark clouds might have served, in the Hudson River school tradition, as solemn reminders of nature's unforgiving powers. Instead, the scene reads as an expression of Brown's pre-impressionist interest in active brushwork and the fleeting effects of wind, water, and light. It is perhaps not surprising that one of his pupils, Willard Metcalf (cat. 52), would become prominent among the American impressionists. [Thomas W. Leavitt in Robert Hull Fleming Museum 1973]

36. Edward Hill, 1843–1923

The Gathering Storm, from the Outlet of Profile Lake, 1878

Oil on canvas, 18⅛ x 14⅛ inches
Hood Museum of Art, Dartmouth College;
P.X.57

Profile Lake, located between Eagle Cliff (seen here in the background) and the Old Man of the Mountain (see cat. 41), was one of the primary tourist attractions of the White Mountains. The dramatic quality of the landscape, combined with the historical legends associated with this area, strongly appealed to the romantic sensibilities of nineteenth-century Americans. Inspired by much earlier American landscape painters, including Thomas Doughty (cat. 17) and Thomas Cole, Hill composed this work according to traditional academic formulas, using such conventional motifs as jagged stumps, autumnal foliage, and storm clouds to express nature's force and its eternal cycles of death and regeneration. In contrast to the more broadly painted, often synthetic compositions of a previous generation, Hill's paintings conveyed a higher level of particularized detail, influenced perhaps by the growing popularity of commercial scenic photography.

A native of England, Edward Hill began his career as a decorative painter in Gardener, Massachusetts, and later moved to Nashua, and then Warren, New Hampshire. For fifteen years beginning in the mid-1870s he occupied a studio at one of the grand hotels in the White Mountains, the Profile House in Franconia Notch. This common practice provided tourists with painted souvenirs of local landmarks. Hill worked at additional hotel studios as well, including the Glen House (1884), the Waumbek Hotel (1885), Bethlehem (1892), and the Flume House (1894). Despite his considerable artistic skills, Hill's career was overshadowed by that of his older brother Thomas Hill (cat. 30), who became well known for his paintings of Yosemite and other scenic highlights of the American West. Edward Hill also moved west in 1900, but with changing aesthetics and modes of tourism, his landscapes fell out of favor. [Vogel in Art Gallery, Plymouth State College, 1985; McGrath 1989]

37. Winslow Homer, 1836–1910

Enchanted, 1874

Oil on canvas, 12 x 21 inches
From the Estate of Tatiana Ruzicka (1915–1995). Presented by
Edward Connery Lathem in memory of Rudolph Ruzicka (1883–1978);
EL.P.997.36

One of the most admired American artists of the late nineteenth century, Winslow Homer is perhaps best known for his powerful late marines, which serve as metaphors for mankind's primal relationship with nature. During a trip to Europe in 1866, following his early career as an illustrator, he came under the influence of the Barbizon school, which fostered his interest in idyllic rural subject matter.

During the 1870s, a period of national healing following the Civil War, Homer celebrated the pleasures and innocence of childhood through innumerable images of barefoot country boys at play. Rural lads held a special place in the nineteenth-century American imagination. Rambunctious and carefree, they represented our nation's youth and promise, as well as its seemingly simpler agrarian past. Set in a sun-filled Long Island meadow, this painting features two idling boys prostrate before a seated girl, who is the object of their rapt attention and seeming admiration. In a lighthearted manner, Homer thus touches not only on the happy abandon of rural youth but also on the theme of courtship, which figured prominently in his images of adult interactions during the same period. In this childhood idyll, the relationship between the sexes lacks the strain of his adult exchanges, in which awkward stances and unmet gazes likely reflect Homer's own unrequited love in the early 1870s. As he often did during this period, Homer explored the imagery of this composition in a cluster of closely related works. This appears to be an abandoned preliminary version of his 1874 painting *Enchanted* (private collection); it also relates to a drawing, a wood engraving for *Harper's Weekly*, and another, more tightly cropped painting, *Boys in a Pasture* (Museum of Fine Arts, Boston), which features just the two boys. [Burns 2002; Cikovsky et al. 1995; Goodrich 2005]

38. Eastman Johnson, 1824–1906

Back from the Orchard, 1876

Oil on board, 19⅞ x 11⅞ inches
Purchased through the Katharine T. and Merrill G.
Beede 1929 Fund; the Mrs. Harvey P. Hood W'18
Fund; a gift from the Estate of Russell Cowles, Class
of 1909; and a gift from Jose Guerrero, by exchange;
P.993.26

Eastman Johnson was one of the most cosmopolitan and sought-after painters of the late nineteenth century, known for his work in genre painting and for his later portraits of leading figures in politics and finance. After artistic study in Düsseldorf, The Hague, and Paris in the late 1840s and early 1850s, Johnson established himself in New York. Like Winslow Homer (cat. 37), he became known for his endearing, seemingly spontaneous views of American rural life—harvest scenes, maple sugaring camps, and children at play in farmyard settings. Many of these, including this work, were painted on Nantucket, where he built a summer home in 1871. Images of carefree country children—full of innocence and potential—were particularly comforting during the years following the nation's traumatic Civil War.

Dating from 1876, America's centennial year, this painting is particularly rich in national associations. The abundance of contemporary paintings of children, especially mischievous boys, suggests a national identification with not only the innocence of childhood but also the independence and youthful opportunism of orchard robbers, street urchins, and errant schoolboys. Furthermore, the apple, a ubiquitous American crop, is also emblematic of our national identity, as reflected in the popular expression "as American as apple pie." In this work, these gigantic, perfectly round fruits spill out of the boy's pockets, suggesting the bounty of the American land and its long-held identification as the new Eden. The visual impact of this work derives in part from the starkness of the composition, its lack of anecdotal background detail, and especially the figure's isolation in space. Johnson has thereby given a quiet monumentality to this seemingly commonplace moment in which a youth triumphantly bites into his prized apple. [Carbone and Hills 1999; Perry 2006; Weber 1993]

39. Levi Wells Prentice, 1851–1935

Cherries and Raspberries in a Basket, 1891

Oil on canvas, 12¼ x 19¼ inches
Purchased through the Miriam and Sidney Stoneman Acquisition
Fund, a gift from the Estate of Russell Cowles, Class of 1909, and
through gifts from John W. Thompson, Class of 1908, and Dorothea M.
Litzinger, by exchange; P.987.8

Self-taught artist Levi Wells Prentice grew up on a farm in upstate New York, and by 1873 he was listed in the Syracuse city directories as a landscape painter. He was best known at that time for his hard-edged, panoramic landscapes of the Adirondacks. After four years in Buffalo, New York, he moved to Brooklyn in 1883. There Prentice joined the several Brooklyn artists who specialized in still life, including William Mason Brown (cat. 25) and Joseph Decker, both of whom worked in a tight, realistic manner. Departing from the elegant still lifes popular at mid-century that featured exotic fruits displayed in vessels fashioned of glass, silver, or porcelain, Prentice typically arranged relatively common, humble fruits in everyday containers such as baskets, tin pails, and felt hats, often set out-

doors. Such subjects had widespread appeal for members of a growing middle class who were eager to decorate their homes with art.

In this tabletop composition Prentice presents an artful arrangement of three splint berry baskets that are full, half full, and empty, perhaps suggesting the passage of time. He compresses the background with a screen of cherry branches and pushes the composition forward into the viewer's space with leaves that curl over the front edge of the table. Prentice's linear, idealized style (evidenced by the larger-than-life, pristine raspberries) and brilliant coloration seem in some ways naïve. Yet the sophisticated lighting effects and carefully contrived composition belie the artist's apparent lack of formal training. [Jones 1993]

40. Elihu Vedder, 1836–1923

The Fisherman and the Mermaid, 1879
Oil on canvas, 16½ x 28½ inches
Gift of Dana and Miroslav J. Polak; P.982.53

Elihu Vedder worked in Italy for most of his career. His melancholic and highly personal interpretations of stories drawn from traditional folklore and his own imagination distinguish his work from the strictly historical subjects of many of his late-nineteenth-century contemporaries. Vedder's dreamlike paintings generally centered on archetypal themes such as death and love, often played out in maritime settings.

Mermaids have a long and varied role in folklore and were commonly portrayed as seductive figures who lure fishermen to fatally dangerous waters. Vedder recounted in his autobiographical narrative, *The Digressions of V.,* a disturbingly vivid dream of his youth that may have inspired his later preoccupation with mermaid themes. In it, he floated on a skiff until it grounded on a beach, where he encountered a "beautiful but sad girl" whom he kissed. She then led him into "the invading waves," painfully grasping him and dragging him through a storm until he suddenly awoke.

The mood of this painting is more wistful than disturbing. In it, a fisherman attempts to bring ashore a beautiful, bejeweled mermaid that he has caught in his net. The troubled look on his face points to the futility of love between mortal man and the half-human, seabound mermaid. Here, as in other works, Vedder achieves his visionary effects through the use of dramatic lighting, metallic colors, and a bold, sinuous line recalling the work of such English Pre-Raphaelite painters as Dante Gabriel Rossetti.

Vedder painted three versions of *The Fisherman and the Mermaid* (one presently owned by the Harvard University Art Museums), suggesting the widespread popularity of this myth in the late nineteenth century. The mermaid's pose is clearly based on his nude composition of the previous year titled *The Venetian Model* (1878, Columbus Museum of Art). [Baas 1983: 22 (quotation); Dijkstra 1986; Soria 1970; Vedder 1910]

41. Samuel Lancaster Gerry, 1813–1891

Old Man of the Mountain— A Sketching Trip, c. 1890
Oil on canvas, 20 x 14 inches
Gift of Robert A. and Dorothy H. Goldberg;
P.987.34.20

This painting depicts in its distance the Old Man of the Moun-tain—the granite ledges high in the cliffs of Franconia Notch that appeared as the craggy profile of a man's face. Long an iconic sym-bol of New Hampshire, this "Great Stone Face" appeared to many nineteenth-century Americans as evidence of the hand of God in nature; some believed it was His face. Statesman and orator Daniel Webster, Dartmouth Class of 1801, viewed the profile less literally, as an emblem for God's shaping of mankind. He is frequently said to have observed, "Men hang out their sign indicative of their re-spective trades; . . . up in the mountains of New Hampshire God Almighty has hung out a sign to show that here he makes men."

By the time Boston painter Samuel Lancaster Gerry painted this work, with its convivial sketching expedition in the foreground, the Old Man of the Mountain had become a popular, easily accessible destination for tourists and artists. Up until recently it had also been a favored site for generations of Dartmouth students and faculty, who typically enjoy the White Mountains region as a splendid out-door classroom and as a place for recreation. This iconic landmark unexpectedly collapsed on May 3, 2003, saddening many within and beyond the Granite State.

In contrast to the tight, proto-luminist manner of his earlier works (cat. 18), Gerry here employs a looser brushstroke and darker palette influenced by the subdued tonalities and atmospheric ap-proach of the French Barbizon style. As did many of his contem-poraries, Gerry painted not only in the White Mountains but also at other vacation destinations—in his case, the beach communi-ties north of Boston. Such locales enabled artists to combine work with pleasure while providing ready access to a tourist market eager for painted souvenirs. [Catalogue entry by Robert L. McGrath in New Hampshire Historical Society 2006: 56–59]

42. George Inness, 1825–1894

In the Gloaming, 1893
Oil on canvas, 22 x 27¼ inches
Gift of Clement S. Houghton; P.948.44

George Inness grew up in Newark, New Jersey, and received early artistic training with Régis-François Gignoux (cat. 29). He initially painted pastoral American and Italian scenery in the classical Claudian tradition, but his two-year stay in Europe beginning in 1853 exposed him to the more subdued, atmospheric landscapes associated with the French Barbizon school. As a result, he adopted freer brushwork and sought out more intimate, non-topographic bits of rustic scenery as painting subjects. This work dates from Inness's fruitful late years, during which he painted the rural environs of Montclair, New Jersey, and pushed his Barbizon tendencies toward a more expressive style. In an unconventional manner, he rubbed broad swaths of pigment into the canvas and scratched through other areas of heavy pigment, probably with the tip of a brush handle, to create swirling indented lines ("All over the canvas,

rub, rub, dig, scratch," observed critic Elliott Daingerfield of this idiosyncratic process). Typical of Inness's work of this period, *In the Gloaming* exhibits a subdued palette and rich layers of glazing, which produce an effect of enveloping mist that almost obscures form. Although Inness clearly concerned himself with the effects of light and atmosphere, he scorned the analytic approach of his impressionist contemporaries. His poetic canvases reflect instead an intensely personal, even mystical exploration of the larger significance of the landscape. Like many artists of his and later generations (including Willard Metcalf, cat. 52), Inness took a keen interest in spiritualism, particularly the teachings of Emanuel Swedenborg (1688–1772). Although his complex Swedenborgian beliefs are not explicit in his iconography, Inness attempted to convey the continuity between the material and spiritual realms through his art. In this work the figures and forms almost dissolve in their mysterious twilight world, transcending physicality to appear as vague recollections. [DeLue 2004: 221 (quotation)]

43. Dennis Miller Bunker, 1861–1890

Sails and Nets Drying, c. 1880–82

Oil on canvas, 14½ x 21 inches
Gift of Jeffrey R. Brown, Class of 1961; P.2004.76

When Dennis Miller Bunker painted this oil sketch in the early 1880s, he was fresh from studies at the Art Students League and the National Academy of Design, where he had been enrolled almost steadily from 1876 to 1882. At this time he concentrated on coastal subjects that he found on Long Island and especially Nantucket, where he spent childhood summers. His surviving paintings from this period almost invariably depict abandoned boats and fishing gear at low tide. Here, the rolled-up sails and suspended nets suggest manual labor, perhaps reflecting the growing nostalgia for a simpler, pre-industrial age. Unlike many of his counterparts on both sides of the Atlantic, however, he rarely included figures in these compositions. Here, the sunlit furled sails and suspended nets drape across the canvas like a rhythmic frieze, which is echoed in

miniature by the broad, irregularly spaced strokes that animate the otherwise vacant foreground. The work's horizontal registers, punctuated by vertical accents, can be likened to musical notation—a fitting analogy for this music-loving artist. When Bunker painted this fresh, daringly modern oil sketch, he likely felt that it did not meet contemporary standards of finish and so signed it with prominent initials rather than the tidy, less conspicuous signature he used for works intended for exhibition and sale. By the time the St. Botolph club in Boston mounted his memorial exhibition in 1891, however, his peers felt quite otherwise and featured this work among a group of sixteen early sketches by the artist.

Dennis Miller Bunker's brilliant painting career spanned just one decade owing to his untimely death, apparently from cerebro-spinal meningitis. Although best known as an impressionist, Bunker experimented continuously during the 1880s with different stylistic approaches. [Hirshler 1994; catalogue entry by MacAdam in Hood Museum of Art 2005: 40–41]

64

44. William Merritt Chase,
1849–1916

The Lone Fisherman, 1890s
Oil on panel, 15 x 11⅞ inches
Gift of Mr. and Mrs. Preston Harrison;
P.940.40

William Merritt Chase was one of the most influential American painters of his generation. His early studies in Munich in the 1870s were particularly formative, as were later trips to Europe that brought him into contact with the French impressionists. This broadly painted, sun-filled landscape depicts Chase's father fishing along the canal in Shinnecock, Long Island, where Chase operated his important summer school for art from 1891 to 1902. Chase's primary compositional interest in the work, however, would appear to be the dramatic depth of perspective created by the low vantage point and surging diagonal of the canal wall toward a high horizon. In his bold manipulation of space, Chase was indebted to the work of such European impressionists as Edgar Degas, who in turn frequently drew upon the compositional devices of Japanese prints.

Through his instruction at his summer school, the Art Students League of New York, the Pennsylvania Academy of the Fine Arts, and his teaching tours of Europe, Chase exerted a powerful influence on hundreds of students. Several eventually became leaders of American modernism, including Charles Demuth, Charles Sheeler, and Georgia O'Keeffe (cat. 65).

This is one of several works that Los Angeles–based collector William Preston Harrison donated to Dartmouth. He had no direct ties to the College but became interested in its art galleries after hearing about Abby Aldrich (Mrs. John D.) Rockefeller's donation in 1935 (cats. 46, 74, 89, 90, 115, 116; her son, Nelson, had graduated from Dartmouth in 1930). In 1938, Harrison wrote to then gallery director Churchill P. Lathrop, "Mrs. Rockefeller had the right ideas—gave me my cue—so I took it up with Dartmouth." [Atkinson and Cikovsky 1987; Gallati 1995; Harrison 1938 (quotation)]

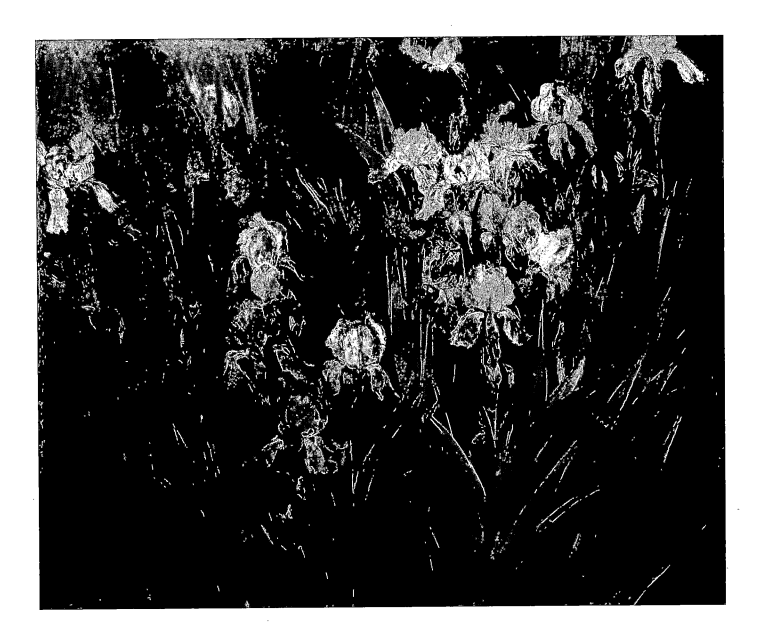

45. Maria Oakey Dewing, 1845–1927

Iris at Dawn (Iris), 1899

Oil on canvas, 25¼ x 31¼ inches

Purchased through the Miriam and Sidney Stoneman Acquisition Fund and the Mrs. Harvey P. Hood W'18 Fund; P.999.11

Originally a figure painter, Maria Oakey Dewing became one of the most accomplished and admired painters of flowers at the turn of the century. She painted *Iris at Dawn* in her luxuriant flower garden in Cornish, New Hampshire. There, she and her husband, the painter Thomas Wilmer Dewing, figured prominently in the artistic and social life of the Cornish art colony during the summers of 1885 to 1903. Maria Dewing's most original creations were her outdoor still lifes, which she began to produce in 1891; *Iris at Dawn* is one of the few surviving examples of these compositions, characterized by their lack of horizon line and close vantage point, which elicit in the viewer the sensation of being immersed in a flowerbed. By portraying the iris in various stages of bloom and in its natural habi-tat—rather than in a tabletop arrangement—Dewing accentuates the plant's vitality and distinctive growth habits. She abhorred, for instance, the artificiality of the Dutch still-life tradition, which featured rare and exotic varieties that would never be found growing together or blooming at the same time. She believed instead that a painter of flowers must know the subject firsthand by engaging in a "long apprenticeship in the garden." While remaining faithful to nature, Dewing aimed to avoid "mere representation" and instead engage in "the art of picture-making." Her severe cropping of the image draws our eyes to the two-dimensional surface of the painting, revealing her awareness of Japanese design principles. Following in the tradition of her former teacher, John La Farge (who collected Japanese prints), she imbued her floral compositions with a poetic, almost mysterious quality suggestive of larger themes such as the transience of life and the hope of renewal. [Dewing 1915: 262, 257 (quotations); Foshay 1984; Hobbs 2004]

46. Thomas Eakins, 1844–1916

The Architect (Portrait of John Joseph Borie, III),
1896–98
Oil on canvas, 79½ x 41½ inches
Gift of Abby Aldrich Rockefeller; P.935.1.19

Although today he is the most admired American realist painter of the late nineteenth century, Philadelphia native Thomas Eakins adopted an austere, psychologically probing approach to portraiture that held little appeal for potential clients. He more often chose his sitters from among family members and acquaintances, many of them highly accomplished in their occupations. He revealed his admiration for their pursuits by titling several of his late portraits with his sitters' professions, such as *The Cello Player, An Actress,* and, as seen here, *The Architect.*

This elongated, full-length portrait—a format inspired by the work of Velázquez—depicts John Joseph Borie III (1869–1926), who is listed in the Philadelphia city directories of 1896 through 1899 as an architect. According to family records he worked for the firm of Cope & Stewardson, probably as a draftsman, and practiced in New York before permanently moving to England in 1906 or

1907. He reportedly knew Thomas Eakins through the artist's close friend Samuel Murray. In this work, which Eakins inexplicably left unfinished, Borie rests assuredly against a drafting table, suggesting his full command over his profession. Whereas his dark, somewhat rumpled suit almost disappears into the background, his face and hands stand out in sharp contrast. Eakins thereby draws our eye to Borie's deeply thoughtful expression and his heavily veined, muscular hands—tools of his trade and markers of his character.

This painting's donor, Abby Aldrich (Mrs. John D.) Rockefeller, acquired this painting through an intermediary from John Joseph Borie's cousin, the painter Adolphe Borie (1877–1934), who had received it as a gift from the artist. [Arntzen 1989; Johns 1983; Sewell et al. 2001]

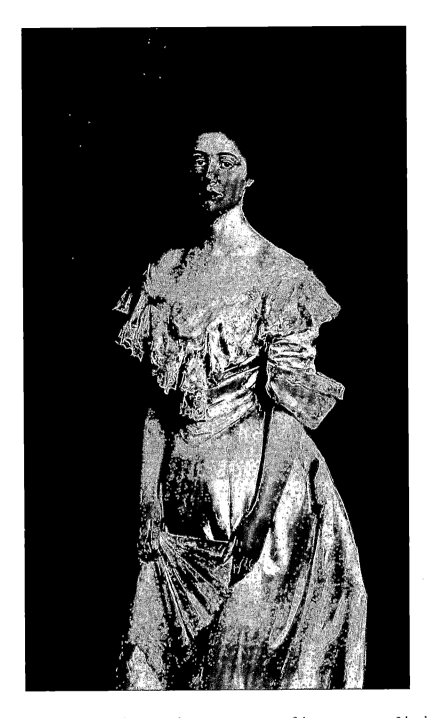

47. Irving Ramsey Wiles, 1861–1948

Emily Henderson Cowperthwaite, 1902
Oil on canvas, 62 x 43 inches
Gift of Emily Henderson Graves Jones, granddaughter
of the sitter; P.2004.37

Irving Ramsey Wiles enjoyed a career as a successful society portraitist in the first decades of the twentieth century, working in a painterly style similar to that made popular by John Singer Sargent a decade earlier. After receiving initial art training from his father, Lemuel Maynard Wiles, he studied at the Art Students League in New York under Thomas Wilmer Dewing and William Merritt Chase (cat. 44) and for two years in Paris, primarily in the studio of Carolus-Duran. He returned to America in 1884 and secured his career as a portraitist in 1902, when he exhibited his portrait of the famous actress Julia Marlowe at the National Academy of Design to overwhelming acclaim.

Wiles painted this portrait in 1902 as a wedding present for Emily Henderson and Walter Bernard Cowperthwaite. The newlyweds became prominent figures in New York City society and on Long Island, where they also maintained homes. Wiles depicted Emily Cowperthwaite outdoors, surrounded by greenery, in a shimmering white dress embellished with lace. She holds a partially closed fan that highlights both her fashionable taste and her feminine modesty. Wiles renders Mrs. Cowperthwaite's face, neck, and shoulders very delicately, carefully blending his paint to suggest the smoothness of her skin. Within the dress, however, his large expressive brushstrokes give a sense of immediacy and truthfulness, as if the portrait were taken on the spot, without any time for pretense. Wiles experimented with impressionism in the landscapes and harbor scenes that he produced for his own pleasure, but otherwise he remained committed to traditional portraiture in the bold style that attracted so many patrons. [Catalogue entry by Margaret W. Lind in Hood Museum of Art 2005: 46–47]

48. James McNeill Whistler, 1834–1903

Dr. Isaac Burnet Davenport, 1895–1902/3
Oil on canvas, 20 x 12⅝ inches
Gift of Mr. and Mrs. Adolph Weil Jr., Class of 1935; P.986.86

James McNeill Whistler (cats. 110, 126, 127), perhaps the most influential American artist of his generation, spent most of his career in Europe, dividing his time between Paris and London. Born in Lowell, Massachusetts, Whistler moved to Paris at the age of twenty-two and studied briefly in the atelier of academic painter Charles Gleyre, but he was soon attracted to the work of the English Pre-Raphaelites and to the practices of more avant-garde artists, such as Edouard Manet and Edgar Degas. Later in his career, Whistler devoted himself primarily to portraiture, producing emotive likenesses in which spectral, thinly painted faces emerge from dark backgrounds.

The subject of this affecting portrait is Dr. Isaac Burnet Davenport (1854–1922), an American dentist living in Paris. He established one of the largest dental practices in Europe and was brother to Whistler's own Parisian dentist, Dr. W. S. Davenport. Whistler

shared the admiration for American dentists widely held among Parisians during the late nineteenth century. Of the brothers Davenport he said, "Their operating was just like the flutter of a butterfly in [one's] mouth." This ethereal portrait makes no allusion to the sitter's occupation or prominent social standing. Instead, it suggests a deeply introspective individual concerned more with the life of the mind than material pursuits. As documented in correspondence between the artist or his assistant and the sitter (now in the collection of Dartmouth College Library), Davenport sat innumerable times for this portrait. Whistler worked on it sporadically for a period of about twelve years, repeatedly rubbing it down. The canvas was finally varnished and delivered to Davenport after the artist's death and was lent by Davenport to the 1905 memorial exhibition held at the Ecole des Beaux-Arts in Paris. [Dorment and MacDonald 1995; Slocum 1908: 350–55; Sotheby's 1986: entry for lot 144 (quotation)]

49. Ernest L. Major, 1864–1950

The Closed Door, c. 1914

Oil on canvas, 24 x 30⅛ inches
Gift of the niece of the artist, through William J. Kaula; P.951.82

Ernest Major spent most of his career in Boston, following training at the Corcoran School of Art and then the Art Students League of New York; in Paris under Boulanger and Lefebvre; and in Boston with his contemporaries Edmund Tarbell and Joseph DeCamp (cats. 54, 55), leading figures in the so-called Boston school. Members of this group were known for their modified impressionist style, which they frequently applied to genteel domestic interiors, figure studies, and portraits. Beginning in 1896, Major taught at the Massachusetts State Normal Art School, where he remained an instructor for fifty-three years.

In its evocative title, theatrical staging, and attention to decora-tive details, *The Closed Door* owes much to works by Major's fellow Boston school artists Tarbell, Frank Benson, and William McGregor Paxton, as well as to the romantic canvases of their nineteenth-century precursor, Belgian painter Alfred Stevens. Here, an elegantly dressed woman appears to react to distressing news as she slumps on a seat and holds what seems to be a letter, its envelope fallen to the floor. Her melancholic expression suggests that the "closed door" of the painting's title refers less to the door in the composition than to the close of a life, a phase, or a love relationship. Major successfully captures in this setting the eclectic decorative taste of early-twentieth-century Boston. The room features what appears to be a Chinese vase, a Japanese fan tucked above an American tonalist landscape, an early-nineteenth-century American fancy chair (see cat. 194), an ancestral portrait, and what is apparently a copy of a portrait of King Philip IV of Spain by Velázquez, then especially in vogue among artists. [Dugan 1995]

50. Rockwell Kent, 1882–1971

A New England Landscape, 1903

Oil on canvas, 28 x 30¼ inches

Purchased through gifts from the Lathrop Fellows; P.2000.26

A celebrated painter, printmaker, and illustrator, Rockwell Kent is known especially for work inspired by extended stays in northern regions of the world. He was also a political activist who supported the causes of organized labor, civil liberties, and peace and friendship with the Soviet Union. He initially studied architecture, but for three summers beginning in 1900 he enrolled in the summer painting classes of William Merritt Chase on Long Island (cat. 44) and then in the so-called Chase School in New York, where he came under the influence of Robert Henri (cats. 58, 114) and fellow painter George Bellows (cats. 112, 132).

When the young Kent painted *A New England Landscape* in 1903, his artistic mentor was Abbott Thayer (cat. 51), with whom he lived and worked for an extended summer stay in Dublin, New Hampshire. Thayer's almost mystical appreciation for nature and his finely honed powers of observation deeply affected Kent. This painting reflects that influence but also points to characteristics associated with Kent's mature style, including a strong sense of graphic design and a fascination with the transforming effects of light. Kent later observed in his art a ceaseless quest "to arrest [light's] transient moods, to hold them, capture them. And to that end, and that alone, I painted." The square format of this work and its artfully arranged pictorial elements suggest that he shared at this early date an affinity with the then-popular Arts and Crafts aesthetic. [Richard V. West in Martin 2000: 18 (quotation); Wien 2005]

51. Abbott Handerson Thayer, 1849–1921

Below Mount Monadnock, c. 1913

Oil on panel, 9 x 7 ⁵⁄₁₆ inches
Purchased through gifts from the Class of 1955 and the
Lathrop Fellows; P.997.22

Abbott Thayer's deep reverence for the New England landscape first took hold during his boyhood in Keene, New Hampshire. After a long interval of urban life, consisting of studies and work in New York and Paris, he returned to the region in the 1890s, settling in nearby Dublin, New Hampshire—first for summers and then permanently in 1901. The burgeoning art colony of Dublin provided the ideal locale for him to paint his beloved New Hampshire hills—particularly Mount Monadnock—and to embrace the rustic outdoor life he relished.

As one contemporary recalled, "Thayer shaped his life and the life of his family on Monadnock. [It] was their totem, their fetish, the object of their adoration." One of many views of the mountain painted by Thayer from his Dublin studio, this landscape captures the peak at dawn, with the sun just catching the summit and the

ground covered with a blanket of purifying snow. Thayer reverses earlier landscape traditions, rendering in sharpest focus the most distant point, the peak of the mountain, while the spruces in the midground are loosely delineated in bold calligraphic strokes. This unconventionally expressive manner evokes the peak's transcendent powers and reveals Thayer's familiarity with Asian ink paintings, which he admired through the collection of his chief patron, Charles Lang Freer.

The painting is inscribed in its frame as a gift to James Allison, a prominent citizen of Dublin who aided Thayer's successful efforts, beginning around 1910, to protect Mount Monadnock from development. The work's gilt "frame" is not separate but, together with the central image, rendered on the back of a wooden lid for a box of "Teddy Roosevelt" brand toilet soap. Thayer cut several grooves across the panel, most likely to prevent it from warping. In the process he defaced the image of his arch-nemesis, Roosevelt, with whom he had engaged in an extended acrimonious debate about Thayer's theories of protective coloration in nature. [Anderson 1982; Hobbs 1982: 27 (quotation); Nemerov 1997]

52. Willard Leroy Metcalf, 1858–1925

The First Thaw, 1913

Oil on canvas, 26½ x 29 inches
Purchased through the Mrs. Harvey P. Hood W'18 Fund; the Miriam and Sidney Stoneman Acquisition Fund; and the Julia L. Whittier Fund; and through gifts from the Lathrop Fellows and, by exchange, from the estate of Russell Cowles, Class of 1909; Robert A. and Dorothy H. Goldberg; Mr. and Mrs. Donald A. MacCormack, Class of 1929, in memory of Artemas Packard; Mr. and Mrs. Charles F. MacGoughran, Class of 1920; Paul McKennie; Mr. and Mrs. Charles Wiltse; and Jay R. Wolf, Class of 1951; P.992.14

One of the most widely admired American impressionists active during the first decades of the twentieth century, Willard Metcalf was well known for his lyrical renderings of the New England landscape in winter. He painted *The First Thaw* in Cornish, New Hampshire, which, beginning in 1909, was to become the artist's preferred painting ground during the winter. He returned to Cornish again and again between 1909 and 1920, creating there some of his most direct and unaffected paintings.

The First Thaw is characteristic of Metcalf's work of the period in its nearly square format, high horizon, and strong diagonal created by the brook receding into the distance. While his brushwork in this painting is unusually robust and varied, Metcalf, like so many American impressionists, does not dissolve or flatten out forms in the manner of his French counterparts, whose work he knew from extended periods abroad. Metcalf's devotion to the particularities of a specific locale and adherence to conventional means of depicting space reveal, instead, his grounding in the realist tradition of nineteenth-century American landscape painting and his lifelong avocation as a naturalist.

Metcalf's characteristically close vantage point in this work calls attention to the visual and symbolic characteristics of a secluded icebound brook. While the course of water and its thrust into the distance implies a sense of movement and change, Metcalf's title alludes to another process, the transformation of ice to water. Within the context of the artist's spiritualist beliefs and transcendentalist leanings, the regeneration of water from ice likely served as a metaphor not only for the coming of spring but also for a rebirth or release of the spirit. [MacAdam 1999]

53. Frederic Remington, 1861–1909

Shotgun Hospitality, 1908

Oil on canvas, 27 x 40 inches
Gift of Judge Horace Russell, Class of 1865; P.909.2

Although Remington achieved unprecedented success as an illustrator of the American West early in his career, he did not receive critical attention as a painter until his final years. *Shotgun Hospitality,* completed a year before his death, reflects the changes in Remington's style that brought him wider acclaim. In Remington's preference for nocturnes and for exploring the subtle modulations of a unifying hue, he reflected the aesthetic interests of many contemporary American landscape painters, especially the impressionists. Yet he remained devoted to depicting the figure and to subjects that, while increasingly contemplative, still appealed to an audience eager for nostalgic images of life in the American West.

Rather than focusing strictly on action and narrative detail, this enigmatic nighttime scene explores mood, atmosphere, and the psychological tension surrounding an encounter between an independent or "shotgun" freighter, who travels alone on the prairie transporting cargo, and three Plains Indians. The painting is virtuosic in its daring color scheme and dramatic lighting effects. (Remington noted in his diary, "Firelight and moon—very difficult.") The imposing central placement of the Native American visitor's deeply shadowed back is equally bold. We are left to surmise his critically important facial expression and the next exchange in this prairie meeting.

Judge Horace Russell, Class of 1865, purchased this painting for Dartmouth from Remington's 1908 exhibition at Knoedler Gallery in New York, which included nine nocturnes. No doubt he found the painting's subject matter particularly appropriate for the College, given Dartmouth's founding mission to instruct Native Americans. Remington expressed elation with the critical response to the Knoedler exhibition, which he dubbed "a triumph. I have landed among the painters and well up too." [Anderson et al. 2003: 170–71 (quotations)]

54. Joseph Rodefer DeCamp, 1858–1923

Benjamin Ames Kimball, c. 1904

Oil on canvas, 44½ x 39½ inches
Gift of Benjamin A. Kimball, Class of 1854; P.919.2.1

A graduate of Dartmouth College in 1854, Benjamin Ames Kimball (1833–1920) became a major public figure in New Hampshire business and politics and an important donor to his alma mater. He was a member of the New Hampshire House of Representatives and president of the Concord and Montreal Railroad, the Cushman Electric Company, and the Mechanics National Bank of Concord. He served as a College trustee from 1895 until his death.

Joseph DeCamp (cat. 55), a prominent Boston artist, produced numerous formal portraits of New England's business and civic leaders during an era in which the American society portrait was at

its height in popularity. In this likeness he diverged from his usual head-on pose by presenting Kimball in full profile, thus distancing the viewer from the sitter and adding to the painting's introspective mood. With its seated profile pose, subdued palette, and artful juxtaposition of geometric shapes, this painting recalls one of the most famous portraits of the nineteenth century, James McNeill Whistler's 1871 likeness of his mother, *Arrangement in Grey and Black*. DeCamp apparently took pride in the work, as he debuted it in the 1905 exhibition of the Ten (Ten American Painters, a group of largely impressionist artists) in New York and Boston. He subsequently featured it in several additional exhibitions. In response to the 1915 exhibition of the Ten in New York, critic Royal Cortissoz admired the "easy dignity, the 'finish' without hardness of the outstanding portrait . . . Mr. De Camp's 'Benjamin A. Kimball.'"

[Buckley 1995; Cortissoz 1915: 9 (quotation); Pearson 1920]

78

55. Joseph Rodefer DeCamp,
1858–1923

Edward Tuck, 1919

Oil on canvas, 41¼ x 51 inches
Gift of Edward Tuck, Class of 1862;
P.920.4

In 1937, a year before the death of Edward Tuck (1842–1938), Dartmouth Class of 1862, a writer for the *Dartmouth Alumni Magazine* hailed him as "Dartmouth's greatest benefactor and most eminent living graduate." After serving as vice consul in Paris in 1865, Tuck began his enormously lucrative career in international banking the following year. He retired in 1881 and moved to France permanently in 1889. Thereafter he pursued his diverse philanthropic interests in the United States and Europe. The most notable of his many Dartmouth benefactions was his founding of the Amos Tuck School of Business Administration, named for his father, Dartmouth Class of 1835.

Here Joseph DeCamp vividly captures an erect and assured Tuck, probably in the sitter's chateau outside Paris, gazing directly at the viewer. Tuck clasps what is likely an enameled box and wears a small red lapel pin that may be an informal, discreet reference to

his receipt of France's highest honor, the Grand Cross of the Legion of Honor. As DeCamp did with the framed picture in his portrait of Benjamin Ames Kimball (cat. 54), he uses architectural moldings and furnishings to add structure and visual interest to this portrait. Here Tuck stands in front of an ornate French pier table and a late-eighteenth-century Beauvais tapestry after François Boucher, *La Peche.* A couple of years after he sat for this painting, Tuck gave the majority of his art collection—then valued at over five million dollars—to Paris's Petit Palais. A 1930 *Time* magazine description of the newly opened Tuck gallery in the museum referred to "cabinets of… porcelain, jeweled watches, Battersea enamel, signed furniture from the great French *ebenistes* [cabinetmakers], [and] a priceless series of tapestries from cartoons by Boucher." This is one of six DeCamp portraits of Dartmouth associates in the museum's collection. [Buckley 1995; Childs 1906 (quotation 1); *Time* 1930 (quotation 2); Tuck 1910]

79

56. Ernest Lawson, 1873–1939

The Boat House, not dated

Oil on canvas, 20⅝ x 28⅛ inches
Gift of Mrs. Daisy V. Shapiro in memory of her son, Richard David
Shapiro, Class of 1943; P.960.57.4

Competing with modernist and realist trends of the early twenti-
eth century, Ernest Lawson attempted to revitalize the impression-
ist style through robust brushwork, bright colors, and strategically
employed architectural elements that provide a bold underlying
structure for his painterly canvases. In this work Lawson builds up a
complex web of overlapping, fluid strokes that unite land, buildings,
and water to create an overall tapestry-like pattern. The more solidly
rendered dock and the boathouse define the space and provide a foil
for the transient, shimmering effects of reflections on water. Lawson
took full advantage of his studio location in northern Manhattan,
where he had easy access to the interface between the built environ-
ment and the Harlem River, which would be a predominant theme.

Although Lawson frequently depicted scenes in or just outside New
York City and he associated with William Glackens, Robert Henri
(cats. 58, 114), and other urban realists, relatively few of his works
have the gritty subject matter or darker palette of the realists. As
evident in this work, he for the most part remained stylistically
indebted to his early impressionist colleagues and instructors, es-
pecially John Henry Twachtman. Like them, Lawson stayed fasci-
nated with light, color, and broken brushwork, and he would often
return to a subject again and again, painting in different seasons of
the year. This, for instance, is one of several boathouse subjects he
painted throughout his career, both in summer and winter.

　　Mrs. Daisy V. Shapiro donated this painting to Dartmouth as
part of a distinguished group of art works offered in memory of her
son, Richard Davis Shapiro, Class of 1943, who a year after gradu-
ating died in action in the Battle of Leyte, one of the largest naval
battles in history. [Karpiscak 1979; Leeds 2000]

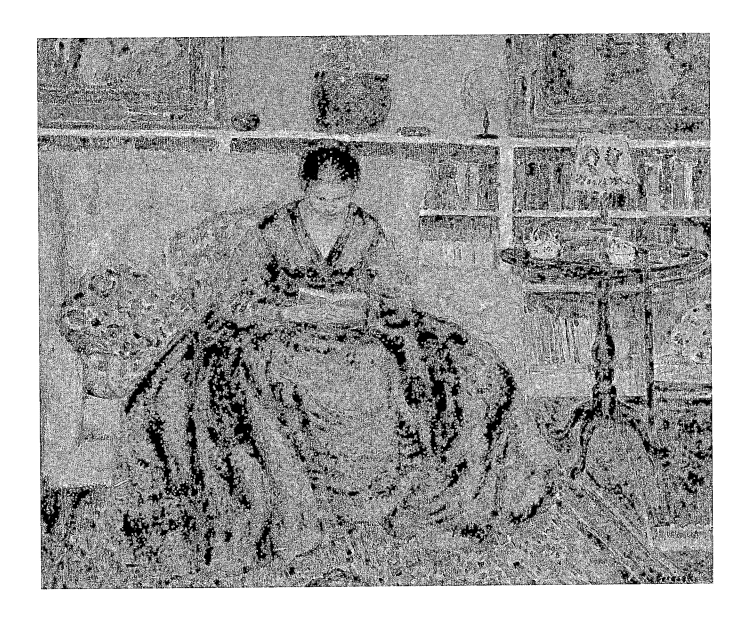

57. Frederick Carl Frieseke, 1874–1939

In the Library, c. 1917

Oil on canvas, 29 x 36½ inches
Gift of Charles H. Hood II, Class of 1951; P.991.56

One of America's leading expatriate painters in the early decades of the twentieth century, Frederick Carl Frieseke first traveled to Paris in 1898 and began to study in Giverny, home of French impressionist Claude Monet, around 1900. Influenced less by Monet than by his contemporaries Pierre Auguste Renoir and Pierre Bonnard, Frieseke generally painted women in leisurely poses, in either gardens or intimate domestic interiors.

Set in his Giverny home and depicting a local model, *In the Library* exhibits the artist's postimpressionist interest in decorative color and pattern. He unified the classically ordered composition through a harmonious palette of blues, pinks, and violets that suffuses even the flesh tones. In characteristic fashion, he portrays the woman in a meditative moment, her head modestly bowed toward her book. A favorite motif among the impressionists, such a pose alluded to the imaginative life of women, whose opportunities for education had grown during the nineteenth century. The subject also enabled the artist to capture a sitter seemingly unaware of the artist or viewer, giving the work a sense of informality and intimacy that is not unlike a candid photograph. In this painting, however, the subject of reading appears subordinate to Frieseke's highly structured composition and controlled palette. With the model's face angled downward and her features barely visible, her head reads as yet another perfectly round object in the composition. Her enclosed, symmetrical pose and voluminous skirt form a striking silhouette and accentuate her role—perhaps social as well as aesthetic—as an integral element of the genteel décor. Frieseke painted a watercolor and a smaller oil of this same composition, with slight variations. Three generations of the Hood family, key benefactors of the Hood Museum of Art, owned this version. The painting's original owner, Charles H. Hood, founded Boston's Hood Dairy. [Kilmer et al. 2001; Kilmer 2002]

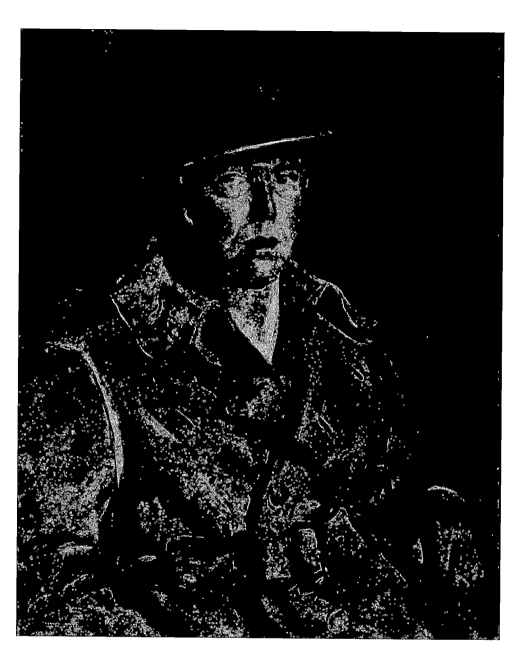

58. Robert Henri, 1865–1929

Captain Henry G. Montgomery,
1921
Oil on canvas, 32 x 26¼ inches
Gift of Mr. and Mrs. M. R. Schweitzer;
P.962.193

Predominantly a portraitist and figure painter, Robert Henri (cat. 114) was also one of the most influential American art teachers of his generation. Trained at the Pennsylvania Academy of the Fine Arts and in Paris, he settled in New York in 1900 and painted street scenes, seascapes, and especially portraits, using broad brushstrokes and rich, dark colors in the tradition of Manet and Hals. Henri played a key role in encouraging several somewhat younger artists, including John Sloan (cats. 59, 60, 61, 75, 113), William Glackens, and Everett Shinn, to move from newspaper illustration to painting. Together they formed the core of the so-called Ashcan school, which endorsed a seemingly spontaneous approach to painting unpretentious urban subjects. Through his various teaching posts, Henri also mentored George Bellows (cats. 112, 132), Rockwell Kent (cat. 50), Stuart Davis (cat. 116), and Edward Hopper (cat. 133).

This portrait of an adult male in military garb is something of a rarity in Henri's oeuvre, as he was better known for his images of women and children of diverse ethnic backgrounds. As he does in other portraits, however, he uses costume as a key marker of identity. This likeness, probably a commission, suggests the military accomplishments of the rather stern-faced Henry Granville Montgomery (1888/89–1945), who in 1916 organized and became captain of the First Armored Motor Battery of the New York National Guard. He also served as a major overseas with the Twenty-seventh Division (its insignia is displayed on his helmet) and received the Distinguished Service Medal for bravery in the war. Henri represents him in uniform even though by this portrait's date Montgomery was presumably immersed in his career as a stockbroker. His bulky jacket fills most of the canvas and flattens out through Henri's broad, crisscrossing strokes. The vivid reds and greens reflect the brighter, more systematic color palette that Henri adopted after about 1909, under the influence of color theories by artist and theoretician Hardesty Maratta. [Leeds 1995; *New York Times* obituary "Maj. H. G. Montgomery," March 24, 1945; Perlman 1991]

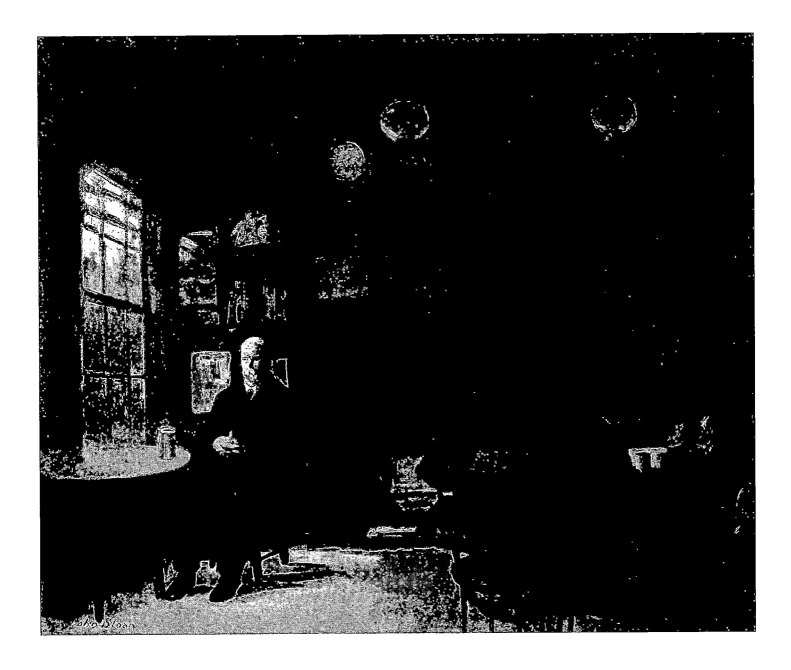

59. John Sloan, 1871–1951

McSorley's Back Room, 1912

Oil on canvas, 26 x 32 inches
Purchased through the Julia L. Whittier Fund; P.946.24

After studying at the Pennsylvania Academy of the Fine Arts from 1892 to 1894, John Sloan (cats. 60, 61, 75, 113) worked as a newspaper and magazine illustrator before concentrating more fully on easel painting. His journalistic experience honed his ability to capture quickly the vital, sometimes less glamorous, aspects of everyday urban life. He relished his role as an observer of modern life as played out on the streets, on the rooftops, and at local gathering places, including restaurants and bars.

Between 1912 and 1930, John Sloan produced several works depicting McSorley's "Old House at Home," a New York tavern on East Seventh Street. Founded in 1854, it is still in business today.

According to Sloan, McSorley's was frequented by "quiet working men who sip their ale and look as if they are philosophizing." The hushed, contemplative mood of this painting echoes Sloan's description of the bar as an oasis "where the world seems shut out—where there is no time, nor turmoil." The tavern's founder was no longer living when Sloan discovered the place, but through this painting and a related etching Sloan appears to pay homage to John McSorley, who, according to his son, always sat there in the sun. The tavern remained an all-male domain until the 1970s.

Dartmouth purchased this and two other paintings by Sloan (including cat. 75) from a 1946 exhibition that the College organized in honor of the artist's seventy-fifth birthday. Sloan was a cousin to the College's president, John Sloan Dickey, and in 1951 returned to spend a summer painting in Hanover, where he died that fall. The museum now holds thirty-seven works by Sloan. [Elzea 1991: 118; Holcomb 1983; Zurier et al. 1995: 182 (quotation 2), 186 (quotation 1)]

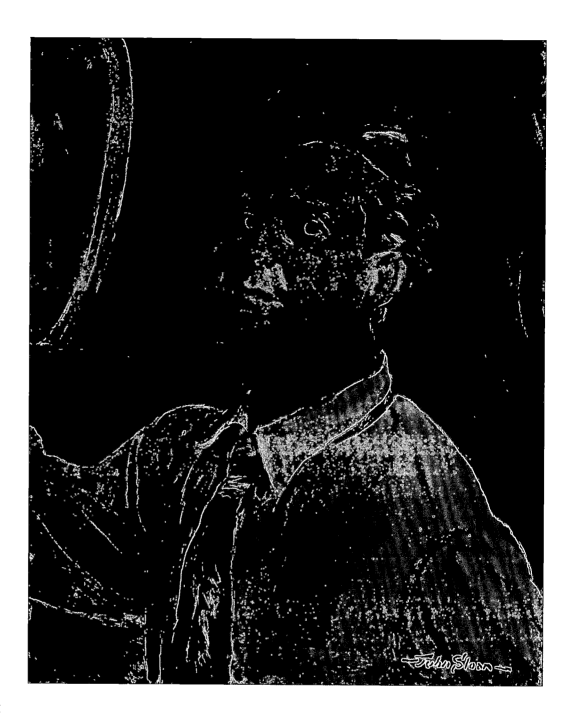

60. John Sloan, 1871–1951

Self-Portrait, Working, 1916

Oil with Windsor & Newton Copal Varnish and
wax finish on canvas, 22 x 18 inches
Gift of John and Helen Farr Sloan; P.952.43

Around 1913, John Sloan started to focus largely on portraits and figure studies, as opposed to the narrative paintings of everyday urban life for which he previously had been known (cat. 59). This jaunty self-portrait (one of several he made in 1916) reflects not only Sloan's fascination with the genre but, through its bold composition and vivid colors, his growing respect for the stylistic innovations of European postimpressionism. The artist's intense gaze and confident pose in this work convey the seriousness of Sloan's professional ambitions, while his tousled hair and flamboyant tie suggest the more casual, slightly bohemian persona he adopted among his circle of friends in New York's Greenwich Village. The image contrasts with two other self-portraits he painted the same year, both of which are more static in composition and conservative in their representation of one of New York's more progressive artists and liberal thinkers. Helen Farr Sloan—herself an artist—gave this portrait to Dartmouth in both her name and her husband's a year after Sloan died in Hanover, in recognition of his close association with the College (see also cat. 113). [Elzea 1991: 199]

61. John Sloan, 1871–1951

Floyd Dell, 1914
Oil and tempera with Weber Picture
Copal Varnish and wax finish on
canvas, 24 x 20 inches
Gift of John Sloan Dickey, Class of
1929; P.959.141

The novelist and playwright Floyd Dell served as managing editor of *The Masses* from 1914 until its demise in 1917. This leftist literary magazine featured illustrations by major urban realists, including John Sloan (cats. 59, 60, 75), George Bellows (cats. 112, 132), and Robert Henri (cats. 58, 114). Sloan joined the staff of the magazine as art editor in 1914, the year he contributed one of the most magazine's most searing cover illustrations (cat. 113) and painted Dell's portrait. This work reflects the radical change in Sloan's painting style that took place after the 1913 Armory Show in New York. That exhibition introduced him to the work of such artists as Vincent Van Gogh and Henri Matisse, whose stylistic influence can be seen here in Sloan's broad, loose brushwork and bold palette. Around this

time Sloan began to explore the color theories of Hardesty Maratta (1864–1924). Accordingly, he orchestrated his brighter chromatic schemes with a pre-set palette of forty to sixty color "notes" unique to each canvas. The daring color scheme is especially suited to the subject, since Dell was known not only for his revolutionary politics but for his unconventional lifestyle as well. Despite Sloan's socialist activities during this period, he eventually found the socialist editorial content of *The Masses* too hard line. Like several of his fellow artist contributors to the magazine, Sloan also resented Dell's tendency to change and overpoliticize the captions for his drawings, and he resigned his position as art editor in 1916. [Clayton 1994; Elzea 1991: 154; Zurier 1988]

85

62. Max Weber, 1881–1961

Portrait, c. 1911
Oil on canvas, 18⅛ x 15¼ inches
Gift of Abby Aldrich Rockefeller; P.935.1.74

Born in Russia, raised in the United States, and trained in Paris, Max Weber became one of the earliest American proponents of modernism. While abroad from 1905 to 1908, he studied the work of such avant-garde artists as Cezanne, Picasso, Braque, and Matisse, and toured important collections of non-Western art. Weber encountered a harsh artistic climate in New York when he returned in 1909. Traditional critics derided his 1911 exhibition at Alfred Stieglitz's gallery "291," including *New York Globe* critic Arthur Hoeber, who found his works "strange, crude, awkward, appalling" and deplored his "travesties of the human form."

In this composition, Weber drew upon the fragmented forms of cubism to create an unconventional psychological portrait. This tubular, almost mechanical body and the chiseled facets of the mask-like face make this figure appear heavy and impenetrable, while her downcast head and closed, compact pose evoke a pensive and melancholy mood. Weber further heightens these effects through the somber palette, which is relieved only by the saturated colors and decorative flatness of the small still life in the upper right corner.

Some of the most important early advocates of modernist American art previously owned this painting. It was first acquired by American artist Arthur B. Davies, who championed Weber's work and collected his paintings from the outset. Davies played a major role in organizing the watershed 1913 Armory Show, which introduced modernism to a wide American audience. He later sold this painting to the Downtown Galleries, a pioneering gallery that promoted both modernism and folk art. In turn, the gallery sold it in 1929 to one of its major patrons, Abby Aldrich (Mrs. John D. Jr.) Rockefeller, who donated it to Dartmouth along with more than one hundred other works in 1935, five years after her son, Nelson, graduated from the College. [North 1982; North 2000: 73 (quotation)]

63. Preston Dickinson, 1891–1930

Industrial Landscape, 1919

Oil on canvas, 24⅛ x 19⅞ inches
Purchased through the Julia L. Whittier Fund; P.950.64

Although Preston Dickinson began his training in New York City, his stay in Paris from 1912 to 1914 was critical in the evolution of his mature style. There he became acquainted with such modernist innovations as cubism, futurism, and synchromism, styles that he drew upon in expressing his developing machine aesthetic. Dickinson firmly believed that technology was beneficial to mankind and was one of the first American artists to explore industrial themes in his art. He and other so-called precisionists, including Charles Sheeler, Niles Spencer, and Joseph Stella, found the underlying geometry of industrial subjects ideally suited to their distilled, sometimes fractured, compositions. Rejecting the traditional academic subjects associated with the Victorian era, they attempted to gain cultural and artistic relevancy by embracing technological "progress" as one of America's defining twentieth-century features.

This work compresses a range of industrial elements—water tanks, factory buildings, smokestacks, and vents—into a vertical space, creating a dynamic interplay of varied masses and angles highlighted with clear, bright color and the random reflections of light. The result is less a transcription of a specific industrial scene than an exaltation of machine power. [Montclair Art Museum 1994]

64. Lawren Stewart Harris, Canadian (active in the United States), 1885–1970

Lake Superior, c. 1948

Oil on canvas, 34⁵⁄₁₆ x 40½ inches
Gift of the artist, Lawren S. Harris, in memory of his uncle, William
Kilborne Stewart, through the Friends of Dartmouth Library; P.951.77

Lawren Harris was a pioneer member of the Canadian Group of
Seven, a loose association of modern Canadian landscape painters.
He is best known for his stark and powerful northern landscapes
with a pronounced mystical aura. Like many early-twentieth-cen-
tury artists and intellectuals, Harris explored different approaches
to spirituality. During the early 1920s he began to embrace theoso-
phy, a philosophy that emphasized the unity and order of the uni-
verse—a concept that held great appeal for artists experimenting
with abstraction. Harris believed that an artist should reflect this
core union in his or her art and inspire a sense of elevated spiritu-
ality in the viewer. In his spare compositions, with their stylized,
closely related forms, he used light as a metaphor for pure spiritu-
ality and specific colors and shapes as indicators of emotions and
states of being.

Harris was deeply affected by the austere, haunting setting of
Lake Superior when he first saw it in 1921, and it became a favorite
subject. Here the repeated arclike shapes representing rocks, clouds,
and reflections on water integrate the composition visually and
invoke Harris's belief in the underlying harmony of the universe.
The color blue, associated with faith and spirituality, predominates,
while the radiant golden light suggests a transcendent presence.

Harris spent from 1934 to 1938 as an informal artist-in-residence
at Dartmouth College, where his uncle, William Kilborne Stewart,
was professor of comparative literature. This period marked a piv-
otal transition in Harris's style from topographic realism to the use
of more abstract, geometric forms. When Professor Stewart died in
1951, Harris gave the College this painting in his memory. [Hunter
2000]

65. Georgia O'Keeffe, 1887–1986

Taos Mountain, New Mexico, 1930

Oil on canvas, 16 x 30 inches

Gift of M. Rosalie Leidinger and Louise W. Schmidt; P.993.62

Like several artists in the circle of photographer and dealer Alfred Stieglitz, Georgia O'Keeffe abstracted form in order to capture the essence of her subjects. She attempted to imbue all of her works— from her schematic images of the New York skyline to her magnified, closely cropped flower paintings—with an expressive, organic vitality. She was drawn increasingly to painting nature, especially the expansive, light-bathed landscape of the Southwest, which she first visited in 1929 and to which she moved permanently in 1949.

O'Keeffe painted *Taos Mountain* during her second summer in New Mexico. There she discovered a spiritual affinity for the rugged terrain that would inspire some of her most celebrated works. In this painting as in others, O'Keeffe retained the integrity of the landscape she so admired, yet she rounded its contours, compacted its space, and intensified its colors with a fresh palette of vivid

greens and soft violets, creating a painting that is at once representational and abstract. As had Abbott Thayer in his painting of Mount Monadnock (cat. 51), O'Keeffe pushed the mountain's summit up against the top edge of the canvas, thereby accentuating its monumental presence, aspiring height, and transcendent significance beyond appearance. After this second season in the Southwest, she wrote to a friend, "The Mountain calls one and the desert—and the sagebrush—the country seems to call one in a way that one has to answer it." O'Keeffe's fluid, feathery rendering of the sagebrush reflects the more expressive brushwork that she adopted for a brief period around 1930—a manner that contrasted sharply with the smooth-surfaced, hard-edged work that both preceded and followed this period. [Lynes 1999; Lynes et al. 2004]

66. Jared French, 1905–1988

Street Fight, c. 1935
Tempera with oil glaze on canvas, 15⅝ x 20⅞ inches
Gift of Ilse Martha Bischoff; P.950.32.5

During the depression era, many American artists sought to capture in a highly legible fashion the rich diversity and sometime gritty vitality of the "American Scene"—whether on the streets of New York or the farms of the Midwest. Reacting against pure abstraction, they looked toward the Old Masters as a source for compositional strategies, modeling techniques, and the revival of certain media, such as tempera. Jared French likely came to this approach through his lover and lifelong friend Paul Cadmus (cat. 67), whom he met as a fellow student at the Art Students League and with whom he traveled through Europe and later shared a studio. After briefly working in the social realist manner represented by this early painting, French adopted a "magic realist" style in which he deployed pristine, blocky figures in disconcertingly mysterious, dreamlike tableaux.

In *Street Fight,* French portrayed a seedy side of city life, set in a working-class neighborhood, presumably lower Manhattan. It is a painting full of contrasts, from the diversity of the building types and the range of human responses to the central action to the overall disparity between the crudity of the subject and the elegance of French's treatment. The dramatic pose of the central figure, who has just received a blow, hearkens back to Renaissance models, as does the complexity of the figural grouping and the emphasis on musculature (even as perceived through clothing). This work was donated by Ilse Bischoff (cats. 68, 69), who was close friends with both French and Cadmus and whose work is extensively represented in the Hood's collection. [Grimes 1993; Weschler 1992]

90

67. Paul Cadmus, 1904–1999

Francisco, 1933 and 1940

Oil on canvas, 15 x 12 inches
Gift of the Estate of C. Morrison Fitch,
Class of 1924; P.969.64.4

FIG. 26. Paul Cadmus, *Factory Worker: Francisco,* 1933, graphite on news-
print, 12⅞ x 9⅞ inches. Purchased through gifts by exchange; D.996.18.

This portrait of the factory worker Francisco Femenias is an early
example of Paul Cadmus's precise, stroke-by-stroke painting style,
which he began to develop while living with Jared French (cat. 66)
on the Spanish island of Majorca in 1932–33. He based the painting
on a life drawing (fig. 26), which is one of several Cadmus recalled
having made of the handsome Majorcan factory worker Francisco
Femenias. The bold, gestural drawing shows a reversal of the sub-
ject's hair and sideways glance, suggesting that Cadmus may have
used the drawing to transfer key contours to this canvas. In both
works, the subject's closeness to the picture plane and severe, fron-
tal pose evoke a monumental presence that reflects the influence
of Old Master painting on the artist (Cadmus and French had just
completed a whirlwind art tour of Europe before their Majorcan
idyll). The work also owes a debt to Old Master technique in its
highly controlled, meticulous handling. The image is nonetheless
strikingly modern in its stylization of forms and its haunting, intro-
spective mood. Such qualities are hallmarks of the so-called magic
realist style associated with Cadmus and his artistic circle beginning
in the 1930s. [Kirstein 1984; MacAdam 2005: 166–67]

68. Ilse Martha Bischoff, 1901–1990

Harlem Loge, c. 1934

Oil on canvas, 46 x 50 inches
Gift of the artist; P.948.35

The migration of black Americans from the South to the north-
ern cities was arguably the most significant demographic change
experienced by New York in the twentieth century, and one that
had far-reaching economic and cultural consequences. While Har-
lem came to comprise some of the poorest neighborhoods in the
city, it also blossomed as a center of extraordinary artistic activity,
particularly in music and theater. *Harlem Loge* acknowledges this
vitality, which greatly appealed to Ilse Bischoff (cat. 69) and many
of her contemporaries during the interwar years. For artists eager
to capture everyday Americans out on the town, a theater's high
balcony provided an ideal stagelike setting of its own. Bischoff's
rounded, generalized, and exaggerated figures reflect the predomi-
nant style of the period, as seen in works by Jared French (cat. 66)

and Paul Sample, for instance (cats. 76, 77, 78, 79, 84). Despite her
abiding and sympathetic interest in portraying African Americans,
Bischoff's figures in this work might today be perceived as convey-
ing a caricatural undertone. This painting, which Bischoff exhib-
ited widely, garnered her an award at the second annual *Portrait of
America* exhibition in 1945–46, a juried competition sponsored by
the Pepsi-Cola Company under the auspices of Artists for Victory,
Inc. (an organization of artists wishing to be of service in the war
effort).

Although little known today, Ilse Bischoff was an accomplished
painter, draftsman, book illustrator, and printmaker. Born in New
York City to wealthy German American parents, she studied cos-
tume design in the early 1920s and later attended the Art Students
League, where she met fellow students Jared French (cat. 66) and
Paul Cadmus (cat. 67). She began her association with Dartmouth
College after purchasing in the early 1940s a magnificent Federal-
style home in Hartland, Vermont, where she eventually moved per-
manently.

69. Ilse Martha Bischoff, 1901–1990

Picnic on the River, 1937
Tempera on canvas laid on Masonite, 21 x 36 inches
Gift of the artist; P.959.108

Ilse Bischoff (cat. 68) painted mostly urban genre scenes in the 1930s and later turned to still life and portraiture. *Picnic on the River* is somewhat atypical for Bischoff in terms of its pastoral setting, but she inhabits the scene with her more customary urban types, who have escaped the city for a rustic summer excursion. The painting is in many ways a recasting of a traditional artistic subject in contemporary guise. It not only recalls Renaissance pastoral and mythological scenes—especially those devoted to bacchanals or feasts of the gods—but also draws upon Renaissance pictorial devices in its serpentine composition, numerous registers of action, and balanced poses. But instead of gods, nymphs, and satyrs, Bischoff presents us with people engaging in quite human leisure and amorous play. The decidedly twentieth-century tenor of her complex and witty composition is further underlined by the replacement of the traditional fruit and wine, riches of the earth, with luxury items from contemporary consumer society—bonbons, Lucky Strikes, and *Life* magazine. Initially trained as a costume designer, Bischoff here reveals her flair for rendering colorful clothing and accessories, some of them, such as the box of candies, repeated from *Harlem Loge* (cat. 68). She also frequently portrayed African Americans in individual portraits and genre scenes. Here three black youngsters stand off to the side, one of them mooring the boat. Apparently country locals rather than city day-trippers, they appear ancillary to the group, reflecting the still largely segregated and subordinate status of African Americans in depression-era American society. [MacAdam 2005: 200–201]

70. Grant Wood, 1892–1942

Oliver Wiswell, 1940

Oil on Masonite, 12 x 13½ inches
Bequest of Eileen P. Barber; P.997.46.1
Art © Estate of Grant Wood / Licensed by VAGA, New York, NY

Grant Wood (cat. 135) painted this image as an illustration for the book jacket of Kenneth Roberts's historical novel *Oliver Wiswell,* published in 1940. Set during the American Revolution, this account explores the Loyalist point of view through its fictional protagonist, Wiswell, a recent Yale graduate torn between his allegiance to the crown and his sympathy for his fellow colonists. In this image, for which the artist's secretary-assistant served as a model, Wood makes clear Wiswell's distress in response to the mounting conflict. Although Wiswell's head is turned toward the British troops clustered in the upper right of the composition, his furrowed brow and clenched hands reveal his divided sympathies and his distaste for violence of any kind.

Best known for his regionalist paintings and prints of Midwestern agrarian life, Grant Wood turned increasingly to book illustrations late in his career. His legible style, storytelling abilities, and widespread name recognition made him a natural choice for authors and publishers. When Malcolm Johnson from Doubleday, Doran and Co. solicited Wood to paint the illustration, he offered him "more money than I think we have ever paid for a wrapper. . . . I have long felt that he is the foremost American painter of our generation." Kenneth Roberts (1885–1957) authored the popular *Northwest Passage,* 1937, and several other novels set in the colonial period. Dartmouth College presented him with an honorary doctorate in 1934, a gesture that boosted his national recognition and gave him critical encouragement during a low moment in his career. In gratitude, Roberts donated to the College his voluminous papers, now housed at Rauner Library. The author was so pleased with Wood's painting that he purchased it in 1940; the owner who acquired it after Roberts's death donated it to Dartmouth. [Bales 1993; Johnson 1940 (quotation); Corn 1983]

71. Newell Convers Wyeth, 1882–1945

Benedict Arnold and Men, 1933

Oil on canvas, 36 x 36 inches
Gift of Kenneth Roberts; P.937.23

The colonial American historical fiction of Kenneth Roberts (see cat. 70) and the stylized, theatrical imagery of Newell Convers (N. C.) Wyeth ideally suited the populist, nationalistic sentiments of 1930s America. In order to highlight what was distinctive about the nation, writers and artists often mined its history, which they incorporated into novels, mural designs for post offices, large-edition prints, and popular illustrations.

When Kenneth Roberts and his publishers commissioned N. C. Wyeth (father of Andrew Wyeth) to provide a cover illustration for Roberts's *Rabble in Arms,* 1933, Wyeth had already gained acclaim through his classic illustrated editions of *Treasure Island* (1911), *Robin Hood* (1917), and many other projects. Although Roberts greatly admired Wyeth ("there's nobody who can touch him") and

had worked with him previously, the author carefully oversaw this jacket design in order to be certain of its appeal and accuracy. Wyeth closely followed Roberts's suggestion that he depict "the retreating rabble army, exhausted, tattered . . . All of them except the sick turning to look behind. In their rear, . . . Arnold on horseback, also partly turned toward the rear—his horse turned half-front, under restraint, moving sideways to give the feel of vitality, of pulling, of conflict. . . . [Arnold would] have looked reckless, confident, determined—a derisive Roosevelt–Douglas Fairbanks sort of face." Adopting his characteristic style, Wyeth gave the work dramatic impact by building up the composition with intersecting curving forms that grow larger in scale toward the horizon and culminate in the arcing cumulous clouds that frame the protagonist's face and animate the sky. Under raking light one can barely make out the traces of the book's title for the cover and spine in the sky, which Wyeth later covered over to make the work more appealing as a painting in its own right. [Nemerov 1992; Roberts 1933 (quotations)]

72. William Gropper, 1897–1977

Three Men and a Dog, c. 1937

Oil on canvas, 16 x 26¼ inches

Gift of the Estate of C. Morrison Fitch, Class of 1924; P.969.64.1

Artists during the social and economic crisis of the 1930s typically either buoyed up viewers by celebrating national history and characteristics (as in cat. 72) or exposed what they believed to be injustices in America's policies and class structure. During this period William Gropper produced a large body of satirical work critiquing the political and economic establishment. He likely painted *Three Men and a Dog* (original title unknown) in response to the many labor disputes of the 1930s, especially the violent strike of steelworkers in Youngstown, Ohio, in 1937, which he reported on and illustrated for *The Nation* that year. Here he employed his typical caricatural style to suggest a confrontation between a pudgy, well-dressed capitalist and two burly laborers. Although the precise nature of the conflict is unclear, the dominant position of the workers on the canvas, as

well as their menacing stances, would seem to give them the upper hand, at least temporarily. The cowering businessman, on the other hand, looks up in fear, but his open-jawed dog provides him with a measure of protection—and possible retaliation.

Nicknamed the "American Daumier" for his biting critiques, Gropper's progressive views and artistic philosophy stemmed from his experience growing up in a poor immigrant family in New York, his early instruction under urban realists Robert Henri (cats. 58, 114) and George Bellows (cats. 112, 132), and his work beginning in the late 1920s as a political cartoonist for newspapers and magazines. In 1936 he began to exhibit his paintings, which were known for their acerbic characterizations, assured, economical lines, and subdued palettes. [Gropper 1937; Freundlich 1968; Lozowick 1983]

73. Ben Shahn, 1898–1969

Photographer's Window, Contemporary American Photography 1935, 1939–40

Tempera on paper mounted on board, 24 x 32¼ inches
Bequest of Lawrence Richmond, Class of 1930; P.978.165
Art © Estate of Ben Shahn / Licensed by VAGA, New York, NY

Through his paintings, photographs, and lithographs, Ben Shahn provided some of the most biting social critiques of his time, including his famous images protesting the 1927 executions of Sacco and Vanzetti, two immigrant anarchists. Shahn's treatment in *Photographer's Window* of an unexpected, even counterintuitive subject—the painted representation of photographs—allowed him to make self-reflective social commentary that would have been difficult through either his conventional painted works or photographs alone. Between 1935 and 1938, Shahn photographed extensively throughout the South and Midwest for the Resettlement/Farm Security Administration (RA/FSA) as part of Franklin Delano Roosevelt's New Deal programs. This experience produced some

six thousand photographs and intensified Shahn's profound sense of social concern. *Photographer's Window* is based on a snapshot he took in 1936 showing a New York City storefront window display of formal portraits of aspiring couples posed for wedding and anniversary photographs. In his painted version, Shahn disrupts this image of comfortable lives untouched by the depression by inserting subjects derived from photographs of the less fortunate that he had made in 1935 while working for the RA/FSA. Three of these images appear in the central row and are at first indistinguishable from the others in their cropping and presentation—perhaps a self-critical gesture equating them in function and commercial value to the studio pictures. Yet Shahn contrasts the seemingly unsanitized views of his rural subjects with the artificiality of the uniform poses and forced smiles of the studio portraits. He thereby underlines not only the striking social and economic inequities of the period but the distance between idealized representations and the realities of American life. [Kao et al. 2000; Katzman 1993]

74. George Copeland Ault,
1891–1948

Roofs, 1931
Oil on canvas, 25½ x 19½ inches
Gift of Abby Aldrich Rockefeller;
P.935.1.3

For George Ault (cat. 115) the city's artistic appeal lay not in its bustling activity but in the pristine geometry of its architecture. In this image, as in most of his works, he ignored the illustrious skyscrapers for which New York is best known, focusing instead on the anonymous roofs and facades of its tenements and warehouses, here seen from a rooftop in his neighborhood of Greenwich Village. Ault's formal approach to the urban landscape was shared by many of his contemporaries, especially fellow precisionists Charles Sheeler, Louis Lozowick, and Preston Dickinson (cat. 63). Unlike their celebratory images of technology and urbanization, however, Ault's city depictions reveal a tinge of melancholy and desolation. *Roofs,* for instance, exhibits flat lighting and a subdued palette with browns and blacks predominating. The interplay of rectangular facades and blackened windows creates a complex and satisfying pattern of rectangles, but the physical space of the city is compressed and impenetrable, with no sign of life or motion. The heaviness of the scene may reflect the artist's dark psychological mood as well. He suffered from various mental disorders, including depression, which only intensified with the death of most of his family members in a short span of time. By 1929 he had lost both parents and three brothers, who committed suicide. Ault was also ambivalent about the social ramifications of the city, which he referred to as "the Inferno without the fire." Despite the city's visual appeal to Ault, he retreated in 1937 to the rural art colony of Woodstock, New York, where he turned primarily to nature for solace and artistic inspiration. [Louise Ault in George Ault Papers, reel D247, frame 17; Lubowsky 1988]

75. John Sloan, 1871–1951

A Roof in Chelsea, New York, c. 1941, with additions in 1944, 1945, and 1951

Tempera underpaint with oil-varnish glaze and wax finish
on composition board, 20 x 26 inches
Purchased through the Julia L. Whittier Fund; P.946.12.2

Well-known for the scenes of everyday life in New York City that he painted from around 1900 to 1920, John Sloan (cats. 59, 60, 61, 113) periodically returned to such imagery in his later years as well. This is one of Sloan's last renderings of the domestic city life he so loved to observe. He worked on the painting at intervals beginning in 1941. During the summer he spent in Hanover in 1951, he changed the color of the building on the right from yellow to brick-pink and heightened the color of the pigeons.

Sloan was particularly drawn to the subject of women hanging out laundry on rooftops. He described his persistent attraction to this theme as "an urge to record my strong emotional response to the city woman, any woman running up colors of a fresh clean wash. Sun, wind, . . . blowing hair, unconscious grace give me great joy." The pigeons swooping above add to the animated, cheerful atmosphere and attract the gaze of the rooftop inhabitants, including the pigeonkeeper at lower left. Keeping homing pigeons has long been a popular hobby for city inhabitants, who sometimes use them even today to send messages or engage in races. The hobby provides one more reason to escape to a city roof for a taste of the outdoors. Full of light, movement, and brilliant color, this ebullient image stands in sharp contrast to some of Sloan's more introspective works (cat. 59) and the strident political illustrations he created earlier in his career (cat. 113). [Elzea 1991: 386; Sloan 1939: 244 (quotation); Zurier et al. 1995]

76. Paul Sample, 1896–1974

Disagreement, c. 1931
Oil on canvas, 16¼ x 20¼ inches
Gift of the artist, Class of 1920; P.983.34.194

Before Paul Sample, Dartmouth Class of 1920 (cats. 77, 78, 79, 84), made his reputation as one of New England's most prominent regionalist painters, he played an active role in the art scene of southern California. He took up painting following his graduation, while recuperating from tuberculosis in upstate New York. He honed his skills as a draftsman at the Otis Institute in Los Angeles in 1925 and just one year later began teaching drawing at the University of Southern California. By the mid-1930s, he was chairman of the art department and exhibiting his paintings nationally.

 Disagreement is one of many oil studies set in the vicinity of Los Angeles that reflect his interest in social realist imagery and architectural forms. In this work a crowd gathers to observe a fistfight

outside a cafe posted as being "for lease" (by 1939 it would become the Purple Duck Café). Sample rendered the figures in a summary, sketchlike fashion to convey gesture rather than individuality. That a crowd gathers so readily in broad daylight hints that some may be unemployed—a theme Sample frequently alluded to in his California street scenes. Here such disheartening social observations are nearly subsumed by the cheery, sun-filled color scheme of bright salmon, yellow, and white, accented with blue. When Sample returned to his alma mater in 1938 as artist-in-residence, he altered his style and palette in response to both changing national aesthetics and the distinct character of the New England landscape.

 Sample left his studio contents and papers to Dartmouth College, and consequently the Hood Museum of Art has the largest public collection of his work, including paintings, watercolors, prints, sketchbooks, and sketches in various media. [McGrath and Glick 1988]

77. Paul Sample, 1896–1974

Waiting, 1935–36
Oil on canvas, 26 x 30¼ inches
Gift of the artist, Class of 1920; P.983.34.185

The narrative meaning of this painting remains somewhat elusive. A closely related and more finished composition by Paul Sample does not feature the woman but includes a young boy with a book under his arm running toward this same Victorian building, clearly indicating that it is a schoolhouse. Here the figure of the boy, who appears almost like a mocking apparition, is partially erased, perhaps suggesting that it is he for whom the stern schoolmarm waits. More likely, the artist probably began to rework the passage and then abandoned the composition. Nonetheless, the painting is engaging for its clean lines and stark setting, which contribute to the slightly surreal quality of the scene. In the manner of his better-known contemporary, Edward Hopper (cat. 133), Sample often featured lone Victorian buildings in nearly empty compositions, conveying a sense of nostalgia and loss. Sample probably painted *Waiting* near Randsburg in the southern California desert, where he made several works around 1935. In 1938, Sample moved from Los Angeles to Hanover, New Hampshire, to assume the position of artist-in-residence at his alma mater, Dartmouth College. For the remainder of his career he would be identified with the landscapes of New England that he painted in his own variant of the style known as regionalism. [McGrath and Glick 1988]

78. Paul Sample, 1896–1974

Beaver Meadow, 1939

Oil on canvas, 40 x 48¼ inches
Gift of the artist, Class of 1920, in memory of his brother, Donald M.
Sample, Class of 1921; P.943.126.1

While Paul Sample (cats. 76, 77, 79, 84) was artist-in-residence at
Dartmouth from 1938 to 1962, he lived primarily across the Con-
necticut River in Norwich, Vermont. This landscape depicts the
small settlement within the rural township of Norwich known
as Beaver Meadow. One of Sample's most admired works, it is an
eloquent expression of the aesthetics and ideals of the regionalist
movement of the 1930s. Its lean, decorative composition, stripped
of extraneous detail, recalls popular illustration, caricature, and
American folk art traditions. In it, Sample celebrates qualities as-
sociated with a stereotypical Vermont village: the harmonious rela-
tionships between humans and nature, as reflected in the tidy fields
and farm buildings nestled in the hills, and among the members
of this apparently idyllic settlement, whose sense of community is
strengthened through weekly worship. Yet the picture also evokes
an undercurrent of unease, and even suspicion, that is suggested
by the rigidity of the figures in the foreground and their detach-
ment from one another. A rather schoolmarmish figure, identified
in a preliminary sketch as "Mrs. Roberts," sits outdoors reading, her
pose taken directly from James McNeill Whistler's famous portrait
of his mother *(Arrangement in Black and Grey: Portrait of the Art-
ist's Mother).* Her male counterpart, a rather gaunt New England
Yankee type, stands looking absently downward, while between the
two a woman seems to retract her gesture of affection toward two
cats. Further beyond, we see two rotund figures facing one another
along the same plane as a pair of stout white pigs. Presumably Sam-
ple's view of his new surroundings and neighbors was more complex
than the all-out boosterism generally associated with the regionalist
aesthetic. [McGrath and Glick 1988]

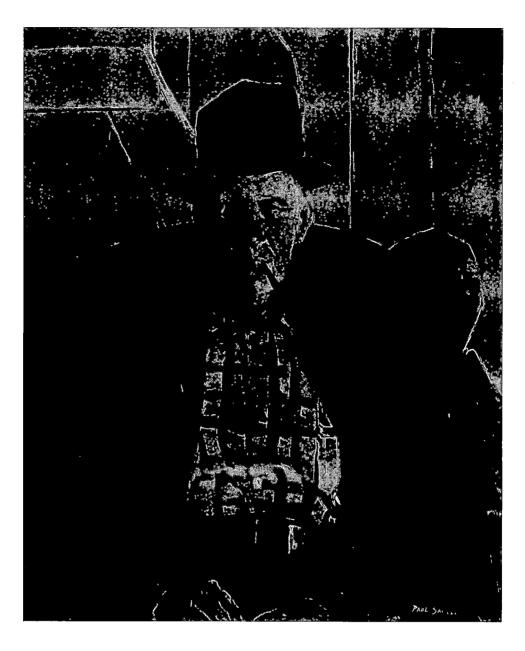

79. Paul Sample, 1896–1974

Will Bond, 1940

Oil on canvas, 30 x 25 inches
Gift of the artist, Class of 1920, in memory of his brother,
Donald M. Sample, Class of 1921; P.943.126.2

In his attempt to convey what was distinctive about New England in his art, Paul Sample (cats. 76, 77, 78, 84) focused on its aged farmers, whose very presence signified a bygone era and whose customs and dress best exemplified the region's "Yankee" character. Beginning with this 1940 portrait, Sample conveyed his affection for his elderly Norwich, Vermont, neighbor, Will Bond, through numerous portrayals, including several drawings, a watercolor, at least one other oil portrait, and a multifigure genre painting. Most of these images depict Bond in work clothes, posed frontally with gaunt features, clenched lips, and a direct gaze. Sample thereby accentuated the stereotypical reticence and underlying force of character

associated with the native New Englander in a manner that recalls Grant Wood's almost comically severe portrayal of a Midwestern farmer in his famous 1930 canvas *American Gothic.* Sample's images of Bond, however, are more individualized and convey a deep underlying fondness and respect for the artist's friend, who boarded his beloved horses and from whom he purchased the land for his home. In several likenesses of Bond, including this one, Sample depicts him seated in an armchair situated inside a barn. For this closely cropped composition, wide barn boards create an abstractly patterned backdrop, revealing Sample's gradual shift away from the rounded stylization of his work of the 1930s toward a more angular, linear manner and a growing interest in interlocking shapes. Such subtle stylistic shifts demonstrate Sample's early efforts to integrate more schematic approaches to form, which he would explore in greater depth in subsequent decades. [McGrath and Glick 1988; MacAdam 2005: 186–87]

80. George L. K. Morris, 1905–1975

Composition—Times Square (Composition de Broadway), 1945

Oil on canvas, 30¼ x 25¼ inches
Bequest of Jay R. Wolf, Class of 1951; P.976.201

George L. K. Morris, known primarily as an influential art critic and writer, was a major American proponent of abstraction from the 1930s onward. The subject matter of this almost totally non-representational painting is indicated only by the title and the few words incorporated into its design—"42 ST," "N.Y.T." (*New York Times*), "CAPITOL," "RIVOLI" (both movie palaces), and "ASTOR" (a grand hotel in the Times Square district). First used as a device by cubist painters to emphasize the two-dimensionality of the painted surface, the inclusion of such words also reflects the ubiquitous presence of advertising and signage in the modern city. Nowhere was this more evident than in Times Square, which then, as now, was dominated by theater marquees and giant billboards. Instead of depicting other identifiable features of the urban landscape, Morris underlines the flatness of the picture plane even further, fracturing it with intersecting lines and arcs and overlapping patches of color and pattern. Although it is tempting to read such images as a kind of cubist cartography, Morris was more interested in expressing what he believed to be the fundamental characteristics of the city: dynamism, movement, and a place where many forces converge.

This painting was willed to the College by Dartmouth graduate Jay Wolf, who died at a tragically early age. He had worked at the prestigious Downtown Gallery in Manhattan and passionately collected twentieth-century American art, leaving the College over one hundred works. [Balken 1992; Lorenz 1982]

81. Jackson Pollock, 1912–1956

Untitled (Bald Woman with Skeleton), c. 1938–41

Oil on smooth side of Masonite attached to stretcher, 20 x 24 inches
Purchased through the Miriam and Sidney Stoneman Acquisitions
Fund; 2006.93

The intense expressiveness of Jackson Pollock's revolutionary drip paintings of the 1940s and 1950s is no less evident in the artist's brooding work from the late 1930s, including this finished oil study, which is possibly a preparatory painting for a never completed larger work or mural. The tortuous iconography reflects escalating world tensions and the particularly dark state of Pollock's psyche during this period. In 1938 he spent four months in a hospital and began to receive psychiatric treatment for his ongoing struggles with depression and alcoholism. The painting also reveals Pollock's significant debt to the Mexican muralists, especially José Clemente Orozco and his *Epic of American Civilization,* which he painted in Dartmouth's Baker Library between 1932 and 1934. In their biography of Pollock, scholars Steven Naifeh and Gregory White Smith report that in 1936 the artist drove with his brother Sanford and friends (including the artist Philip Guston) from New York to Hanover to see the mural cycle firsthand. Although many of Pollock's subsequent drawings (cat. 121) and paintings reference Orozco's Dartmouth mural, none do so as directly as this somewhat later study, which draws from the imposing, savage panel *Gods of the Modern World* (fig. 27). Pollock reversed the presentation of the skeleton in Orozco's mural, added a crouching, bald-headed woman, and rendered the skeleton animal-like. A birdlike shape—possibly two bare-ribbed human bodies—presides over this ferocious melee of carnage and chaos. Although this work also echoes Picasso's great antiwar painting *Guernica* (1937) and some of the darkest paintings of such European masters as Bosch and Goya, its style is uniquely Pollock, full of vigor, primary colors, and rapidly laid down paints, and it is a clear homage to Dartmouth's Orozco mural. [Landau 1989; Naifeh and Smith 1989: 298, 843; O'Connor and Thaw 1978: 177–78; Polcari 1992]

FIG. 27. José Clemente Orozco, Mexican, 1883–1949, *Gods of the Modern World* (panel 17) from *The Epic of American Civilization,* 1932–34, fresco, 120 x 119 inches. Commissioned by the Trustees of Dartmouth College; P.934.13.17.

82. Kay Sage, 1898–1963

The Giants Dance, 1944

Oil on canvas, 12⅛ x 16¼ inches

Gift of the Estate of Kay Sage Tanguy; P.964.127

Kay Sage worked closely with the surrealist art group in Paris before returning to the United States to continue her career at the onset of World War II. *The Giants Dance* characterizes her work in its mysterious, hard-edged structures set within a vacant and seemingly endless landscape. The massive assemblage of angular blocks and slabs extends ominously across the eerie wasteland, populated only by a much smaller distant structure. The dramatic contrast in scale between the two elements suggests domination of one over the other as well as impending misfortune—a sense that is heightened by a deep shadow that falls on the monumental form from some unknown source above. Could a still larger structure—or "giant," as the enigmatic title suggests—loom outside the picture frame? The structures are nonfigural, yet the drapery on one and the implied interaction between the two invoke life.

Sage's psychologically stirring works may reflect the artist's own psyche and troubled life. An abusive and rootless childhood, combined with a series of unhappy male attachments, likely contributed to her sense of displacement and isolation. Despite her considerable talent, she also faced challenges as a woman working in the male-dominated surrealist group, and her career was often unfairly overshadowed by that of her husband, Yves Tanguy, another renowned surrealist. As one scholar has noted, Sage's strong, scaffolding-like structures can be read as "a personal symbol expressing the self—herself—struggling to stand in the void." Following Sage's suicide in 1963, noted surrealist scholar and collector James Thrall Soby directed this painting from her collection to Dartmouth. [Miller 1991: 145 (quotation); Suther 1997]

83. Adolph Gottlieb, 1903–1974

Black Enigma, 1946

Oil on canvas, 25⅛ x 32¼ inches
Bequest of Lawrence Richmond, Class of 1930; P.978.163
Art © Adolph and Esther Gottlieb Foundation / Licensed by VAGA, New York, NY

During the 1940s the abstract expressionist painter Adolph Gottlieb worked closely with fellow artist Mark Rothko to develop the possibilities for expressing mythic content in painting through the use of abstract imagery. In 1943, three years before the creation of *Black Enigma*, Gottlieb and Rothko published a statement of their aesthetic philosophy: "There is no such thing as a good painting about nothing. We assert that the subject is crucial and only that subject matter is valid which is tragic and timeless. That is why we profess spiritual kinship with primitive and archaic art." In a reference to archaic wall painting, he named his series of paintings from the early 1940s pictographs. As seen in this example, he experimented with dividing these canvases into flat, irregular grids (he admired the work of Picasso and Mondrian) that he filled with ghostly, totemic imagery inspired by his interest in Native American and African art and in surrealist images of the unconscious. His pictographs therefore wedded abstraction with Freudian surrealism, objectivity with subjectivity, and Western with non-Western cultures. The somewhat ambiguous, white-on-black signs in *Black Enigma* include rounded breastlike forms, masklike faces, and the suggestion of a soldier's helmet—a reference to the recent world conflict. Such an invocation of diverse modes and cultures reveals Gottlieb's attempt to find what fundamentally unites mankind, and what the nature of evil is—questions all the more urgent as the horrors of World War II were becoming more fully known. [Alloway and MacNaughton 1981: 41 (quotation); Alloway et al. 1994]

84. Paul Sample, 1896–1974

The Return, 1946

Oil on canvas, 36 x 50 inches
Promised gift of Charles Hood, Class of 1951

Paul Sample's response to World War II could not be more different from that of Adolph Gottlieb (cat. 83). Rather than probing the global nature of evil and human conflict through semiabstract compositions, Sample (cats. 76, 77, 78, 79) documented the daily lives of American soldiers in a realistic, figurative style. He had witnessed many aspects of the war firsthand in his role as a war correspondent for *Life* magazine for extended periods from 1942 through 1944—from everyday activities at the base on Pearl Harbor to the invasion of the island of Leyte.

In this work Sample renders the more comforting theme of a soldier's return to his snow-covered hometown. The painting was part of Maxwell House's "American Scene" collection and appeared in a magazine advertisement for their coffee, which, as the ad claimed, was also "part of the American scene." Presumably, family and a welcoming cup of coffee will mark the soldier's true return to America. The dramatic recession of the road, train tracks, and endless telephone poles in this work conveys a sense of the distance he's traveled and perhaps also the uncertainties of life ahead. A preliminary sketch for the painting (fig. 28) indicates that the setting is Wells River, about forty miles north of Sample's own home in Norwich, Vermont. Sample painted another winter landscape previously

owned and used by Maxwell House titled *Coffee Time in America* (also a promised gift of Charles Hood) about 1947–48. Such nostalgic and patriotic images by regionalist artists in the 1930s and 1940s ideally matched the reassuring messages offered by advertisers of consumer goods in the same period. *The Return* received acclaim as a work of art in its own right when it was featured in a 1946 exhibition of American paintings at the Carnegie Institute. [McGrath and Glick 1988]

FIG. 28. Paul Sample, *Wells River, Vermont* (compositional study for *The Return*), graphite on wove paper (in sketchbook), 11¾ x 17⅞ inches. Gift of the artist, Class of 1920; 2000.54.

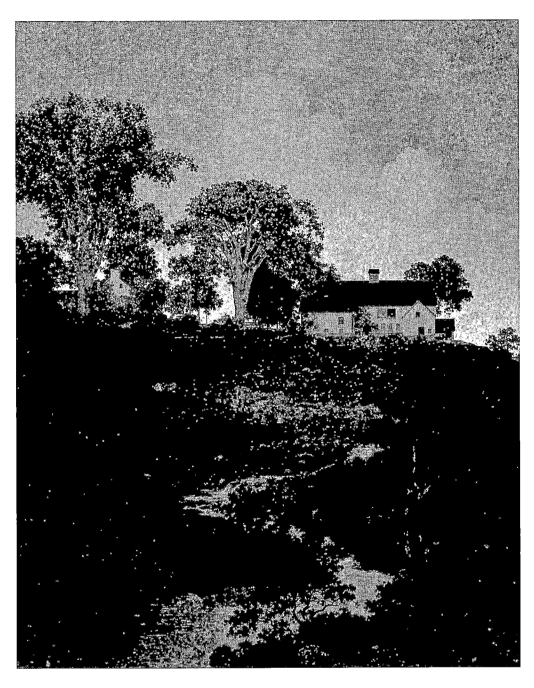

85. Maxfield Parrish, 1870–1966

Hunt Farm (Daybreak), 1948

Oil on Masonite, 23 x 18⅞ inches
Gift of the artist, through the Friends
of the Library; P.950.73
® Maxfield Parrish—licensed by AsaP
Worldwide and VAGA, New York, NY

Through his illustrations for books, magazines, calendars, and greeting cards, Maxfield Parrish became perhaps the most familiar and popular American artist of the first three decades of this century. He gained renown for his meticulously crafted, highly synthetic compositions, which often featured scantily clad women perched on rocks in luminous, dreamlike settings. Despite the popularity of such imagery, he also painted pure landscapes, often for the calendar publisher Brown and Bigelow. The firm reproduced this work, *Hunt Farm,* with the title *Daybreak* as a calendar illustration in 1951 and on playing cards in 1962.

The composition is an elaboration upon a site that Parrish knew in Windsor, Vermont, just across the Connecticut River from his home in Plainfield, New Hampshire. It is one of several views he painted of hilltop farm buildings and stately trees silhouetted against a radiant sky. He achieved his precise forms and glowing surfaces by first delineating an underpainting with black and gray media on a white, reflective ground. Rather than mixing his colors, he applied over the design multiple layers of different-colored transparent glazes, isolated by layers of varnish.

In 1950 a group of supporters of Dartmouth's library and art collections solicited this painting from Parrish, who lived roughly fifteen miles south of Hanover. In a letter to Mr. Price from the Metropolitan Museum of Art dated November 20, 1950, Parrish recalled, "The other day a Committee of Selection from Dartmouth College came down to select one [of my paintings] and pounced upon the one of their choice . . . all in ten minutes and took it away with them. The College couldn't buy such things to be sure, but it was delicately inferred I give it." In 1985 members of the Parrish family donated the artist's extensive papers to Dartmouth as well. [Parrish quoted in Gilbert 1998: 18; Yount 1999]

Sculpture

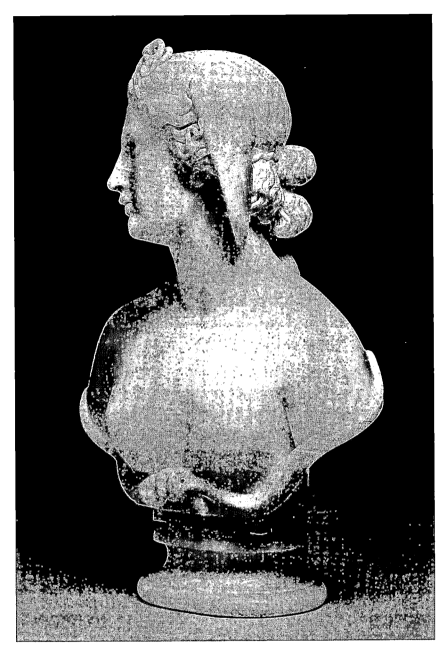

86. Harriet Goodhue Hosmer, 1830–1908

Medusa, c. 1854

Marble, H. 27½ inches
Purchased through a gift from Jane and W. David Dance,
Class of 1940; S.996.24

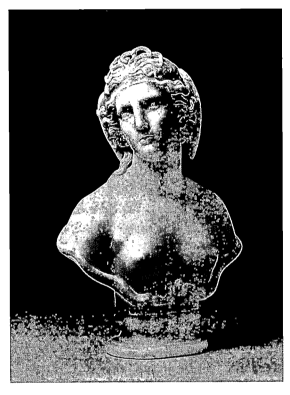

Originally from Watertown, Massachusetts, Harriet Hosmer was the most accomplished and successful of several expatriate women sculptors working in the neoclassical style in Rome during the mid-nineteenth century. As seen in this bust of Medusa, Hosmer's work exemplifies an important stylistic shift in the medium. Although the bust's generalized features and overall simplicity of form are characteristic of the restrained neoclassical style, the parted lips and arched neck add a plaintive, expressive quality that can be seen as looking both back to Hellenistic and late Renaissance sculpture and forward to a more Victorian taste for emotional content.

Medusa is one of Hosmer's several sculptures that depict ill-fated heroines drawn from mythology and romantic literature. It captures the mythological Medusa at the moment of her transformation (by a jealous Athena) from a lovely mortal into a gorgon—a snake-haired monster whose look turned men to stone. Some accounts describe

the gorgons as having wings, which here frame Medusa's head, giving her a majestic aura while emphasizing her otherworldliness. By portraying the transformed Medusa as still beautiful rather than hideous (a model drawn from Hellenistic art), Hosmer emphasizes the complex dual nature of this legendary figure. Seen as both victim and agent, she is beautiful yet repellent, life-giving yet lethal—a reflection, perhaps, of the conflicting cultural attitudes toward womanhood often evidenced in nineteenth-century art and literature. Having faced derision from her male counterparts and from those who disapproved of her masculine dress and deportment, Hosmer may have felt a personal identification with Medusa's victimization. On the other hand, Hosmer's work as a figurative sculptor in marble invoked the gorgon's powers as well, as both women can be said to have transformed people into stone. [Kasson 1990]

87. Thomas Ball, 1819–1911

Daniel Webster, 1853

Bronze, H. 29¾ inches
Hood Museum of Art, Dartmouth College; S.X.112.7

Of the many mid-nineteenth-century sculptures that captured the imposing physiognomy of Dartmouth graduate Daniel Webster (1782–1852; cats. 7, 14, 138, 165, 194), this likeness by Thomas Ball is the best known and certainly the most widely reproduced. Ball, predominantly a self-taught artist, had wished to render Webster's "godlike head" since boyhood. He made several initial attempts, beginning with a small cabinet bust and a life-size plaster bust that he completed just a few days before the statesman's death. The popularity of this 1853 statuette, of which at least forty bronze casts are known, was partially owed to the widespread commemoration of Webster that followed his death.

Rather than depicting Webster in classical dress, Ball gave the work an air of contemporary realism by clothing him in a modern, rather poorly fitted suit. The stack of books and the draped column refer to Webster's learned oratory, while his grave expression and Napoleonic pose signal his seriousness of purpose. Ball sold the rights to the sculpture to a Boston art dealer, C. W. Nichols, who oversaw its reproduction in plaster and bronze. Cast by the Ames Foundry in Chicopee, Massachusetts, Ball's statuette was one of the first American sculptures to be mass-produced and patented in this country. Ball created a colossal version of the statue in 1876 for Central Park in New York.

The extensive collections of Websterania at Dartmouth include multiples of this work in bronze, marble, plaster with various surface finishes, and parian ware, a matte ceramic made to look like marble. Taken as a whole, the group reveals how sculpture could be made and marketed to accommodate nearly every pocketbook and to meet the growing demand for domestically scaled sculpture for the Victorian American home. [Catalogue entry by Jan Seidler Ramirez in Greenthal et al. 1986: 93–98]

88. John Rogers, 1829–1904

Taking the Oath and Drawing Rations, 1866
Painted plaster, H. 23 inches
Hood Museum of Art, Dartmouth College; S.X.993.17.4

John Rogers played a major role in popularizing sculpture for the middle classes in Civil War–era America. By his retirement in 1894, he had created almost ninety compositions, or "groups," and sold more than eighty thousand individual casts for an average price of fifteen dollars. Rather than drawing on traditional classical subjects, he gained inspiration from popular literature and prints of everyday life. He studied sculpture in Paris and Rome in 1858 under two minor sculptors but returned after seven months to pursue his own style, based on narrative and characterization rather than abstract ideals of beauty. His works were celebrated as a thoroughly American, populist antidote to European-influenced neoclassical sculpture.

Patented in 1866, *Taking the Oath and Drawing Rations* was one of Rogers's best known and most culturally relevant compositions.

During this period of reconstruction, citizens living in the southern regions of the country under Union control were required to take an Oath of Allegiance to the United States in order to enjoy civil liberties and rights. The sculpture sympathetically portrays a southern wartime widow who must take the oath in order to draw food rations for herself and her young son. The Union officer who holds the Bible for the oath-taking respectfully removes his hat in the young woman's presence, while an African American child—whose social status lay at the crux of the conflict—observes her tenderly. Having optimistically hoped for reconciliation between the North and the South, Rogers accentuates in this vignette the shared humanity between these representatives of America's fragmented post–Civil War society. [Catalogue entry by Thayer Tolles in Tolles 1999: 125–30; Wallace 1972]

89. Unidentified artist, New York City

Baseball Player (Shop Sign), c. 1880

Painted wood, H. 70½ inches
Gift of Abby Aldrich Rockefeller; S.935.1.113

Abby Aldrich Rockefeller included this baseball figure as part of her large donation of art to Dartmouth in 1935 (also see cats. 46, 74, 90, 115, 116). She had purchased the work from Edith Gregor Halpert, owner of New York's Downtown Gallery and a pioneer in the collecting and marketing of American modernism and folk art. According to notes from Halpert in the museum's curatorial files,

the work came from Bridgeport, Connecticut, where it was likely used as a trade sign for a sporting goods store. The "baseball boy" holds a ball in his right hand and most likely originally clasped a bat with his left, making him a symbol of the sport that by the 1870s was already being called our "national pastime."

The wooden shop-figure tradition grew out of the once-vibrant ship-carver's trade, which declined in the late nineteenth century with the introduction of metal-hulled ships. According to shop-figure authority Ralph Sessions, this particular carving is notable for its relatively rare subject, life-size scale, and naturalistic handling. Although it can be attributed to a New York maker on stylistic grounds, it is difficult to assign the figure to a specific carver or shop, because several individuals generally worked on a single piece. Typically, a master carver would block out the form from a white pine mast and carve the face, while others would do the rest of the carving and the painting. By far the most common subject for shop figures was the American Indian, which traditionally identified a tobacco store; others included fictional characters and, especially in the second half of the nineteenth century, a range of stereotypical urban types. Such variety was driven by shopkeepers who continually tried to beat out the competition's success in luring customers to their businesses. [Sessions 2005]

90. Unidentified manufacturer

General George B. McClellan on a Horse, c. 1865
Zinc and hammered copper, H. 23⅞ inches
Gift of Abby Aldrich Rockefeller; S.935.1.112

Long an important feature of the architectural landscapes of Europe, weathervanes also became ubiquitous on the barns, churches, and private homes of rural America. The earliest American examples took the shape of iron banners, with bold geometric cutout patterns. As the nineteenth century progressed, weathervanes appeared in the form of Native Americans, farm animals, race horses, buggies, and patriotic motifs such as eagles and Liberty figures. They were handmade by individuals until the middle of the nineteenth century, when large companies began to produce a wide variety of models that could be ordered by mail or purchased in hardware stores.

This design may have been a special commission, since no other weathervanes depicting Union General George B. McClellan are known. It was likely based on the images of McClellan that abounded in print form and other media during the Civil War and particu-

larly around the time of his unsuccessful bid for the United States presidency in 1864. As in so much of the popular imagery, he is shown here on horseback, his stature signaled by his erect bearing, epaulette, and sword. McClellan capitalized on his military career during his campaign, despite the fact that his disastrous lack of decisiveness led him to be relieved of his command in 1862.

The hollow body of the horse was formed by hammering copper in a wooden mold, while the figure was probably shaped by hand. The head of the horse and man are cast of solid zinc, which not only captured fine surface details but helped to equalize the weight in front of and behind a weathervane's pivot point. Several bullet holes indicate that someone used it for target practice, probably an ongoing temptation with such pieces.

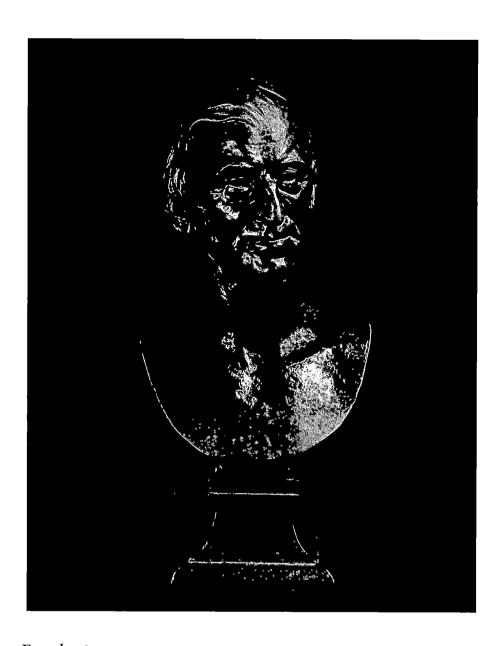

91. Daniel Chester French, 1850–1931

Ralph Waldo Emerson, 1879

Bronze, H. 22½ inches
Gift of the artist; S.921.30

Daniel Chester French, who would become one of the nation's finest Beaux-Arts sculptors, modeled this acclaimed likeness of Ralph Waldo Emerson (1803–1882) when the artist was only twenty-nine. French had held Emerson in high regard since his youth, when French's family moved from New Hampshire to Concord, Massachusetts, and became acquainted with the author. After having studied his craft in Florence for almost two years (1874–76), French settled back in Concord beginning in 1878 and proposed the project to the aged Emerson the following year. He modeled the work "almost daily for a month" in Emerson's home. Faced with Emerson's failing health and faculties, French sought to create a somewhat more youthful semblance for posterity. In doing so, he drew upon his personal memories, and probably photographs of

the literary luminary as well. Emerson's timeworn, craggy face with its vital expression conveys a realistic sense of his deep humanity, while the classical bust format signals his iconic status in American culture. French must have anticipated the financial rewards that such a sculptural project, if successful, might realize. He replicated the work first in plaster, then in marble and bronze, slightly modifying the bust's base and shaft over its many years of production.

French distributed many of the busts as gifts to public institutions. He donated this bronze cast on the occasion of the College's 1916 exhibition of the Cornish, New Hampshire, art colony, which included this bust and an ideal head in bronze by the artist. French had spent the summers of 1892 and 1894 in Cornish before he purchased his summer residence, Chesterwood, in the Berkshires. [Catalogue entry by Susan Dodge-Peters Daiss in Searle 2006: 96–99; essay and extended entry by Michael Richman in Wasserman 1975: 219–57; French quoted in catalogue entry by Thayer Tolles in Tolles 1999: 329]

92. Augustus Saint-Gaudens, 1848–1907

Robert Louis Stevenson, 1899 (cast from 1900 on)

Bronze relief, H. 17 inches
Purchased through the Phyllis and Bertram Geller 1937 Memorial
Fund; S.963.155

Considered the most prominent American sculptor of the late nineteenth century, Augustus Saint-Gaudens was a master of every scale and format—from small coins and intimate portrait reliefs to imposing private memorials and public monuments. This relief is a reduction of Saint-Gaudens's third portrayal of the Scottish novelist, travel writer, poet, and essayist Robert Louis Stevenson (1850–1894). Saint-Gaudens first modeled Stevenson, who suffered from tuberculosis, in the writer's New York hotel room in 1887. The sculptor recalled, "All I had time to do from him then was the head, which I modeled in five sittings . . . These were given me in the morning, while he, as was his custom, lay in bed propped up with pillows." Saint-Gaudens and Stevenson became friends and kindred artistic spirits, despite their different media. Before Stevenson gave Saint-Gaudens an advance copy of his book *Underwoods,* he inscribed the flyleaf: "Each of us has his own way / I with ink and you with clay." Saint-Gaudens modeled his second version of the likeness in the form of a medallion, which he had cast in several variants. The third version, upon which this is based, originated in

an 1894 commission from the Church of St. Giles, Edinburgh, and was completed in 1903. The composition captures the writer in convalescence, yet deep in thought with pen in hand. The inscription across the background is taken from his poem *Songs of Travel, XV.* Its sentiments transform this version of the relief, which was modeled after the author's death, into an especially poignant memorial:

> Bright is the ring of words
> When the right man rings them,
> Fair the fall of songs
> When the singer sings them.
> Still they are carolled and said—
> On wings they are carried—
> After the singer is dead
> And the maker buried.

[Saint-Gaudens quoted by Dryfhout 1982: 173; Stevenson quoted in catalogue entry by Emmanuel Héran in Musée de Augustin 1999: 164]

93. Frederick William MacMonnies, 1863–1937

Diana, 1890 (cast 1894)
Bronze, H. 18⅝ inches
Gift of Jane and W. David Dance, Class of 1940;
S.992.41

At the time Frederick MacMonnies modeled this work, one of his earliest, he had already apprenticed with Augustus Saint-Gaudens (cat. 92) and was an assistant in the Paris studio of Jean-Alexandre-Joseph Falguiere. Falguiere had a profound and lasting influence on the younger artist, and Falguiere's *Diana* (1882) was an important prototype for this work. MacMonnies's life-size plaster *Diana* won him an honorable mention at the 1889 Paris Salon, and its critical acclaim helped to launch his career. In it he captured the goddess's fluid prance as she touches down on one foot and extends her lithe arms, having just released an arrow. The sculpture's blend of decorative refinement and naturalism ensured its continued popularity through the production of this reduced bronze format and another version that was just over thirty inches tall.

Long a favored artistic motif, the mythological huntress and goddess of the moon resurfaced as a popular subject among late-nineteenth-century European and American sculptors. The theme provided an opportunity to sculpt an idealized female nude in motion—a nude further legitimized through her ties to classical mythology and revered Renaissance prototypes. Other Beaux-Arts artists who modeled her included Antonin Mercié, Paul-Jean-Baptiste Gasq, and Augustus Saint-Gaudens. The latter's famous eighteen-foot *Diana* (1892–93) originally graced the top of Madison Square Garden in New York.

MacMonnies went on to create a number of lighthearted life-size fountain figures for country residences, as well several bronze statuettes and large-scale sculptures and public monuments, including his enduring *Bacchante and Infant Faun* (1893, Metropolitan Museum of Art), which initially drew criticism for its indecorous nudity and perceived endorsement of drunkenness. [Smart 1996; catalogue entry by Thayer Tolles in Tolles 1999: 428–31]

94. Paul Manship, 1885–1966

Lyric Muse, 1912
Bronze with green-brown patina, H. 13½ inches
Purchased through the Mrs. Harvey P. Hood W'18
Fund; S.991.35

In the 1920s and 1930s, Paul Manship was America's most famous art deco sculptor, known for streamlined small bronzes, medals, garden statuary, and such large-scale work as his gilded bronze fountain sculpture *Prometheus* (1933–38), the focal point of Rockefeller Plaza in New York City. *Lyric Muse* is the most important of Manship's early works, produced in Rome shortly before he returned to the United States in 1912. It reflects his interest in developing a stylized sculptural manner that emphasizes broad planes, smooth surfaces, and a linear articulation of the surface—all elements that would characterize his mature art deco work. At the same time it represents his awareness of the art of Archaic Greece and the Near East, as well as the new, more planar style of contemporary European sculptors.

The sculpture likely represents the muse Erato, one of the nine daughters of Zeus and Mnemosyne, who inspired lyric love poetry

and mime. Here she opens her mouth in song and extends her arms, preparing to stroke the lyre, her emblem. Her pose, with head facing forward and legs viewed in profile, derives from Greek and Etruscan art, as do her stylized facial features and hair, held in place with a fillet. In contrast to the contained stillness of her lower body, her open mouth, twisted torso, and outreaching arms give a sense of vitality and movement. Prominent art collector and author Paul Magriel (1906–1990) formerly owned this cast, which is from an edition of fifteen.

Because of Manship's friendship with Cornish art colony artists Barry Faulkner and Charles A. Platt, he spent the summers of 1915 through 1917 and 1927 in Cornish, New Hampshire, and he exhibited four pieces in the 1916 Dartmouth College exhibition of the Cornish colony. [Colby and Atkinson 1996; Harry Rand in Minnesota Museum of Art 1985: 18–33]

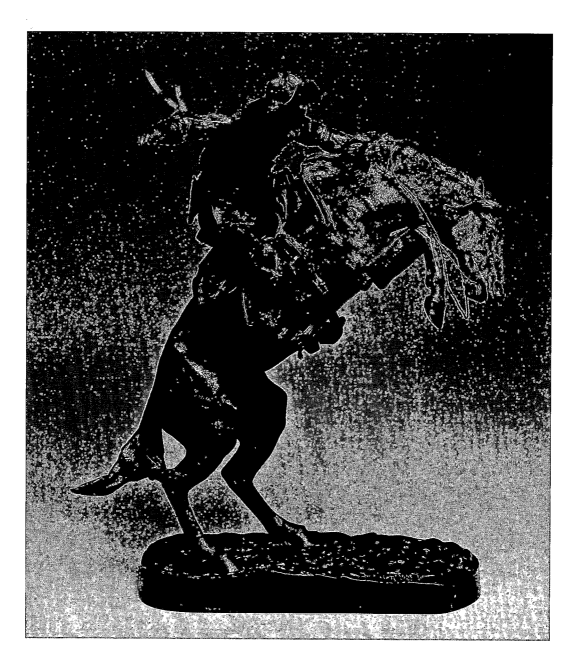

95. Frederic Remington, 1861–1909

Bronco Buster, original 1895; cast no. 262, c. 1919–20

Bronze, H. 22½ inches

Gift of Lawrence Marx Jr., Class of 1936; S.960.13.2

With little formal art training, and previous experience only in illustration, Frederic Remington first turned his energies to sculpture in 1895. He found that he enjoyed the process, and after about three months of sculpting he wrote to his friend, the novelist Owen Wister, "My watercolors will fade—but I am to endure in bronze— even rust does not touch. . . . I am doing a cowboy on a bucking broncho [*sic*; referring to this sculpture] and I am going to rattle down through all the ages." Remington's boastful prediction has been borne out fully, since *Bronco Buster* continues to be his most popular work. The first seventy or so castings of this sculpture— his first effort in the medium—were made by the Henry-Bonnard

Bronze Company. After this foundry burned in 1898, Remington had his sculpture produced by the Roman Bronze Works, which made about three hundred castings of *Bronco Buster* over a period of about twenty years.

This sculpture fed into the popular romanticization of the American cowboy at the turn of the twentieth century and drew acclaim for its riveting stop-action realism. Remington's rugged Western imagery held particular appeal for men in Eastern cities who wistfully imagined that the cowboy and his life on the ever-shrinking frontier epitomized true masculinity and American self-reliance. Remington captures the cowboy and horse held together in a peak moment of physical exertion and extension, as they appear about to fly off of the base. As much as they strain against one another, they are locked together, invoking the eternal struggles between mankind and nature. [Catalogue entry by Brian W. Dieppe in Searle 2006: 123–27; Shapiro 1981: 40 (quotation)]

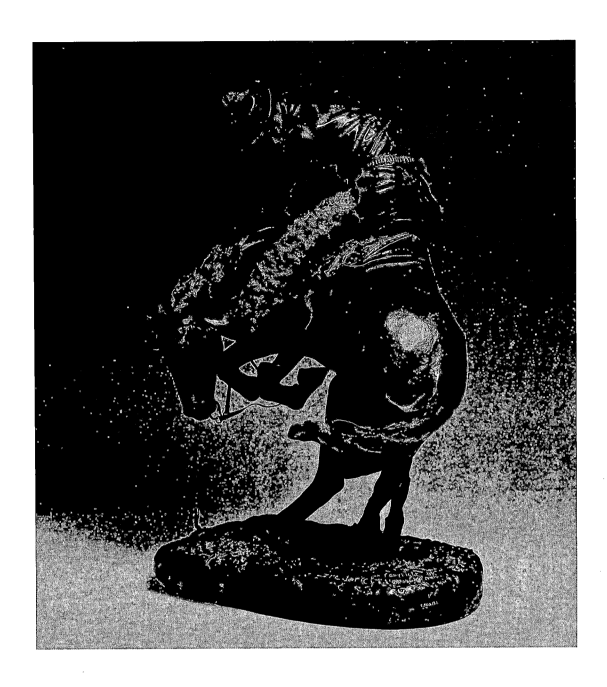

96. Frederic Remington, 1861–1909

The Rattlesnake (Snake in the Path), original 1905;
cast no. 99, c. 1919–20

Bronze, H. 24 inches
Gift of Lawrence Marx Jr., Class of 1936; S.960.13.1

The Rattlesnake was Frederic Remington's twelfth statuette, and like his first, *Bronco Buster* (cat. 95), it reveals his mastery of form, line, and dramatic action. Here the cowboy and horse appear to spiral in on themselves as they respond to the threatening rattlesnake that is wound up and ready to spring from the ground. Remington modeled his first version of *The Rattlesnake* in 1905. Dissatisfied with the result, he reworked and enlarged the form for another casting in 1908. This second and final version differs more from its original model than any of his several recast sculptures. Among the changes, he increased the forward lean of the rider, heightening the integral relationship between the cowboy and the horse. This not only adds to the compositional unity of the piece but accentuates the close, intuitive bond between man and horse—a theme also prominent in his paintings of the same period. Only about twenty casts of *The Rattlesnake* were made during the artist's lifetime, but Roman Bronze Works went on to cast about ninety copies of this larger version posthumously. Next to the *Bronco Buster,* this was his most popular statuette. [Greenbaum 1996; Shapiro 1991]

123

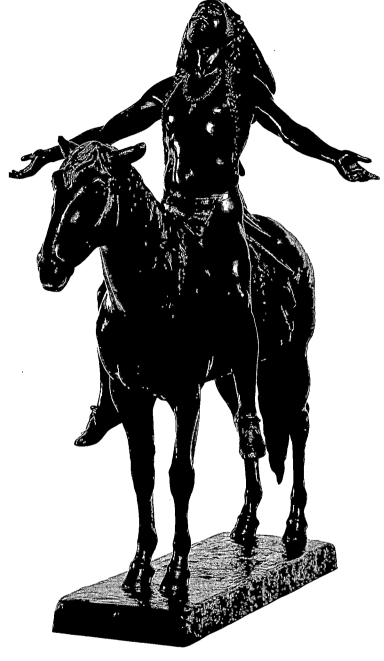

97. Cyrus Edwin Dallin, 1861–1944

Appeal to the Great Spirit, 1912; cast c. 1922
Bronze, H. 39¾ inches
Purchased through a gift from the Honorable Leslie P. Snow,
Class of 1886; S.928.15

Cyrus Dallin was born in Utah, and from his childhood friendships with Ute children he developed an enduring appreciation for Native Americans and their traditions. Although he was not immune to the romanticized objectification of American Indians that was commonplace in his era, Dallin attempted through his heroic sculpture to make better known the gross injustices inflicted upon Native Americans by non-Natives. This is the last in a series of magisterial equestrian sculptures that Dallin created to portray the evolving relationship between Native Americans and settlers in the American West. According to the artist these works display the four sequential aspects of this relationship: *The Signal of Peace,* or "the welcome" (1890); *Medicine Man,* or "the warning" (1899); *The Protest,* or "the defiance" (1904); and *Appeal to the Great Spirit* (1909), which refers to "the last hope of the Indian" as he turns to a higher authority in utter despair. In this, Dallin's most famous work, he portrays the stereotypical pan-Indian warrior, his arms raised skyward in supplication. The fixed stance of the horse echoes the balanced, contemplative pose of its rider. Despite Dallin's sympathetic intent, the work reinforces common nineteenth-century stereotypical romantic views of Native Americans—that their sup-

posed freedom from the trappings of civilization made them fundamentally innocent and noble and that they were, as a race, defeated and on the verge of extinction.

This bronze is a reduced version of the monumental cast of the work that stands in front of the entrance to the Museum of Fine Arts in Boston. One of nine of this particular size, this reduction was originally lent to the College for exhibition in the newly opened Baker Library in 1928 (see fig. 14). The College purchased it later that year with funds donated by alumnus Judge Leslie P. Snow. [Ahrens 1995; Francis 1976]

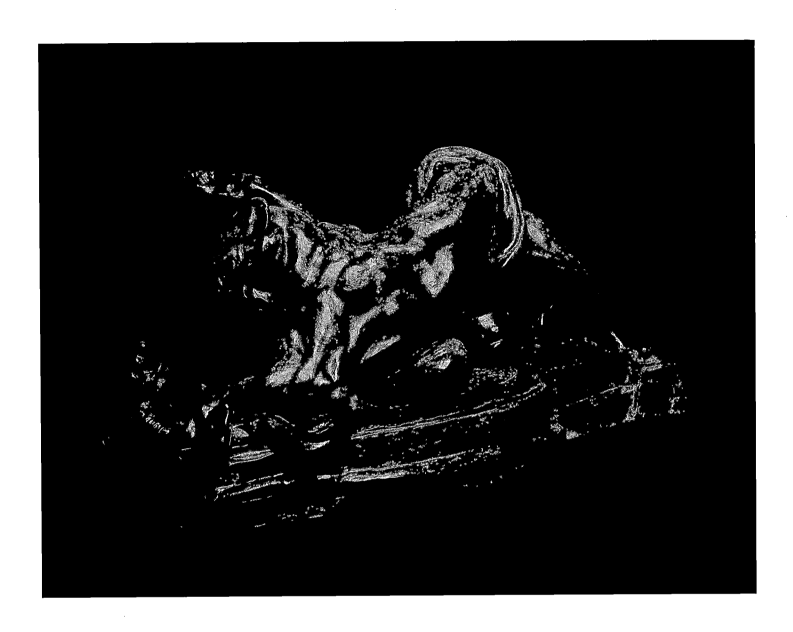

98. Arthur Putnam, 1873–1930

Puma and Snakes, 1906

Bronze, H. 11½ inches
Gift of Peter H. Voulkos; S.2001.51.2

One of California's foremost sculptors, Arthur Putnam established his reputation through his animated sculptures of wild animals, particularly the puma. He drew inspiration from the lively animal sculptures of Antoine-Louis Barye (1796–1875) and the sinuous modeling of Auguste Rodin (1840–1917), who admired Putnam's work when he saw it at the Paris Salon of 1906. Putnam's fascination with animals began at an early age and developed further through his experience observing and sketching wildlife as a teen living on a ranch outside San Diego. He studied under painter Julie Heyneman at the Art Students League in San Francisco, with sculptor Rupert Schmidt, and briefly, around 1898, with the animal sculptor Edward Kemeys in Chicago. In 1905–6 he gained important experience and artistic inspiration abroad, especially in Rome and in Paris, where the

Alexis Rudier Foundry cast this bronze. His sculpting career ended prematurely when he became paralyzed in 1911 following brain surgery.

Pumas were Putnam's favorite subject. He captured them at rest and, more often, locked in a death struggle with their victims. In this work Putnam effectively modeled the puma's taut, muscular body and the complex, almost illegible physical interweaving of predator and prey. Putnam has arrested a climactic moment, in which the puma and the two snakes pinned beneath him face each other with fierce, gaping jaws. Despite the formidable defenses of the huge snakes, the puma remains dominant, with one paw raised for the final blow. As Alexander Nemerov has noted, Putnam's obsession with the life-and-death struggles of the mysterious, nocturnal puma—itself almost hunted to extinction—points to wider societal anxieties and to his own fatalistic world view of "eccentric morbidity." [Nemerov 2002: 38 (quotation)]

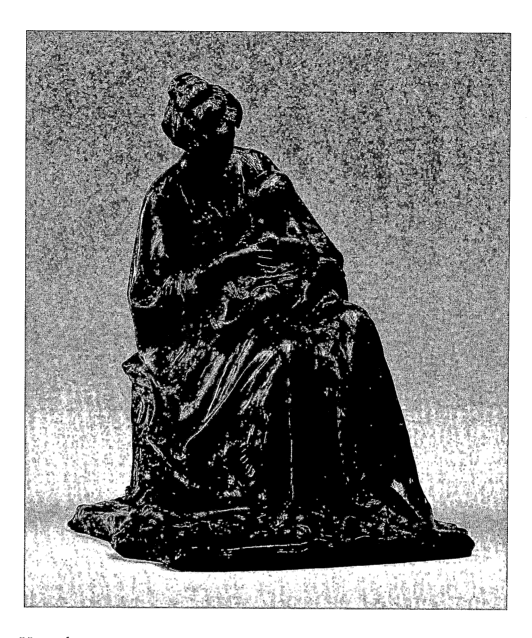

99. Bessie Potter Vonnoh, 1872–1955

Mother and Child (Mother and Babe), 1902

Bronze, H. 10¾ inches
Purchased through the Phyllis and Bertram Geller 1937 Memorial
Fund; S.964.57

This diminutive genre statuette on a maternal theme characterizes
the type of work that brought Bessie Potter Vonnoh popular suc-
cess and critical approbation at the turn of the twentieth century.
Impressionistic in its light touch and intimate mood, the sculpture
relates to paintings of the same period, many of which also por-
trayed modern-day Madonnas embracing their babies or children.
The seated pose focused on the tender interaction between mother
and child and showcased Vonnoh's skill in rendering the folds of the
woman's gown as they cascade to the floor around her.

Bessie O. Potter began her studies at the Art Institute of Chi-
cago under Loredo Taft, an established sculptor who worked on a
monumental scale. Just one year after serving as his assistant at the
Columbian Exposition of 1892, she established her own studio and
devoted herself to creating "a sort of delicate domesticity" through
her endearing family groups. Her most popular bronze, *The Young
Mother,* received a bronze medal at the Paris Exposition Univer-
selle of 1900 and an honorable mention the following year at the
Pan-American Exposition in Buffalo. After marrying American im-
pressionist painter Robert Vonnoh in 1899, she lived in New York,
Connecticut, and southern France, remaining active as a sculptor
through the 1920s. Later in life, having no children of her own, she
remarked, "I have only my bronze and marble babies, but I love
them as much as if they were flesh and blood."

Taft accorded his former pupil the honor of featuring her in his
groundbreaking publication *The History of American Sculpture,*
published in 1903. To represent her contributions he reproduced
what appears to be the clay model for this work, which he termed "a
dainty portrait study, a recent production." [Aronson 1995: 241 (Von-
noh quotation); Taft 1903: 450]

100. Augusta Savage, 1892–1962

Gamin, modeled 1929, plaster by 1940

Painted plaster, 9¼ inches
Purchased through the Florence and Lansing Moore 1937 Fund, the
Stephen and Constance Spahn '63 Acquisition Fund, and the Hood
Museum of Art Acquisitions Fund; 2006.75

Gamin is the best-known work by Augusta Savage, the most ad-
mired and influential woman artist associated with the Harlem
Renaissance and one of the first African American sculptors to por-
tray African American physiognomy. She was raised in Florida and
moved to New York in 1921, where she completed in three years
a four-year course of sculpture at the tuition-free Cooper-Union
in New York. This sculpture, *Gamin,* would play a pivotal role in
advancing her career. The life-size version of the work, modeled in
1929 (bronze, Schomburg Center, New York Public Library; related
painted plaster, Cleveland Museum of Art), generated an extremely
positive response from the scholarship committee of the Julius Ros-
enwald Fund, which consequently awarded Savage two fellowships
to study in Paris from 1929 to 1931. Although this work has invoked
for viewers the ubiquitous street boys of Harlem, Savage actually
modeled the sculpture after her nephew and fellow Harlem resident

Ellis Ford, who had earned the nickname "gamin" for his spirited,
defiant nature. She sensitively modeled her subject in contempo-
rary dress, with a jaunty but somewhat vulnerable expression that
lends the work its poignancy. In addition to the two life-size exam-
ples of the work cited, at least one nine-inch bronze and seventeen
nine-inch plasters—of which this is one—are known. This cast is of
particular interest because of its fine condition, its lustrous surface,
and the signature and date of presentation (1940) scratched in by
the artist underneath the piece. Upon her return to Harlem, Savage
began her role as an influential teacher and informal salon host by
establishing the Savage Studio of Arts and Crafts, which served as
an important gathering place for black art students, established art-
ists, and intellectuals, who met regularly to discuss artistic, racial,
and political issues. [Bibby 1988; Leininger-Miller 2001: 162–201]

101. John Bernard Flannagan, 1895–1942

Head, 1927

Marble, H. 9 inches
Purchased through a gift from Jane P. and W. David Dance,
Class of 1940; S.992.7

John Bernard Flannagan was a key figure associated with the early-twentieth-century rise of the direct carving tradition. In this approach to sculpture, there is no model; the form evolves from the process of carving and the inherent qualities of the material. Flannagan drew upon primitivism and Jungian symbolism to uncover the primordial and natural essence of his subjects and materials. As he wrote in 1941, "To that instrument of the subconscious, the hand of a sculptor, there exists an image within every rock. The creative act of realization merely frees it." Although Flannagan had studied painting for several years at the Minneapolis School of Art, he was essentially self-taught as a sculptor. After carving initially in wood, he experimented with a range of stones, including smooth marble, as seen here. He soon worked exclusively in more rustic "natural" stones, such as fieldstones, which he would pick from the ground during "stone hunts." Working with a light, graphic touch, he would carve away as little stone as possible in order to release his subject. He drew on archetypal imagery that had long traditions in ancient and non-Western sculpture, especially women and animals, often set within womblike forms. In its oblong head and stylized hair and features, *Head* has the simplicity and timelessness of archaic sculpture. Its large, pupil-less eyes are minimally carved, giving the work a mysterious aura. Flannagan wrote in the late 1930s, "My aim . . . is to create . . . sculpture with such ease, freedom and simplicity that it hardly seems carved but to have endured always." [Flannagan quoted in Michael E. Lein and Robert J. Forsyth in Minnesota Museum of Art 1973: n.p.]

102. Henry W. Bannarn, 1910–1965

Midwife (Breath of Life), c. 1940

Mahogany or walnut, H. 16⅝ inches
Purchased through the Katharine T. and Merrill G. Beede 1929 Fund
and the Florence and Lansing Porter Moore 1937 Fund; 2006.31

Henry "Mike" Bannarn was an influential, academically trained African American artist intimately associated with the Harlem Renaissance in the 1930s. In addition to his widely exhibited art in various media, he, like Augusta Savage (cat. 100), was revered for his role as a mentor to other African American artists. Together with fellow artist Charles Alston, he ran a studio/workshop at 306 West 141st Street (dubbed "306"), which served not only as a vital training ground for aspiring artists but as an informal salon for the exchange of ideas among African American artists, writers, entertainers, and political figures.

In this arresting work, Bannarn depicts a midwife slapping the first breath of life into the infant she holds upside-down in her arms. The blocky, frontal presentation of the figure, the stylized facial features, and the rough-hewn surface reveal Bannarn's primitivist aesthetic and his particular reverence for African sculpture. The figure's compact, monumental form and powerful gaze also suggest the important role of the midwife in African American culture. In

many African societies midwives were held in awe as healers and ritual specialists who assisted with birthing and reproductive health and often prepared the dead for burial, and they were thought to have supernatural powers. In America during the 1930s, midwives were still commonplace in rural areas and in poorer urban neighborhoods, including Harlem, New York. Bannarn's work dates to the very period in which the medical establishment was attempting to eradicate—or at least control—the practice of midwifery in this country. This work would therefore seem to uphold the midwife as an emblem of African American culture in the face of challenges from the dominant white establishment. Bannarn's embrace of African art and culture was shared by many black artists of the period, who actively explored their racial identity and heritage and sought to make it integral to their art. [Bearden 1993; Fraser 1998]

Drawings and Watercolors

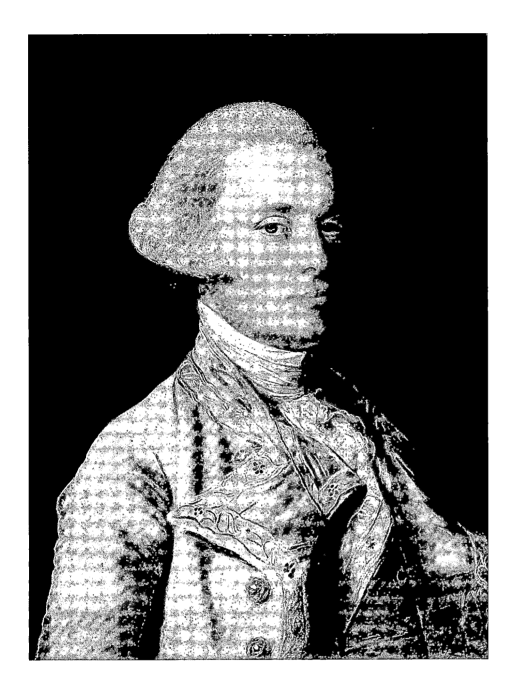

103. John Singleton Copley,
1738–1815

Governor John Wentworth, 1769
Pastel on laid paper, mounted on canvas,
23½ x 17¾ inches
Gift of Mrs. Esther Lowell Abbott in memory
of her husband, Gordon Abbott; D.977.175

John Singleton Copley is generally acclaimed as the greatest artistic talent of the American colonial period. Despite his lack of formal training, his extraordinary skill as a portraitist brought him prestige and prosperity in both America and England, where he spent the last forty years of his life. Although Copley expressed a preference for the delicate medium of pastel, only about fifty-five such works are known among the hundreds of likenesses he completed during his lifetime. In this composition he silhouettes the handsome Royal Governor John Wentworth (1737–1820) against a dark gray background, which projects the figure forward and sets off the delicate tones of his fair complexion, powdered hair, and light gray suit. The work reveals Copley's full mastery of the pastel medium and its versatile textural effects. He delineated the sitter's wig with layers of controlled fine lines; suggested the details of the costume with broad, energetic strokes; and meticulously modeled Wentworth's

elegant features by thoroughly blending individual strokes of pastel in a painterly fashion. Copley deftly rendered the most stylish features of the governor's apparel—the silver buttons, lace jabot, and embroidered lapel—without detracting from the drawing's primary focus: Wentworth's direct and assessing gaze.

Wentworth's elegant dress and magisterial bearing befit his standing as one of the wealthiest, highest-ranking government officials in the colonies. He was initially popular among New Hampshire colonists for sympathizing with their opposition to the heavy taxes imposed by the British parliament. He granted Eleazar Wheelock (cat. 5) the charter for Dartmouth College in 1769, the same year he sat for this portrait. Wentworth eventually took a stand against the colonists' resistance to the British and fled to England at the outbreak of the American Revolution, never to return to his native soil. [Adapted from MacAdam 2005: 50–53]

104. Benjamin West, 1738–1820

Archangel Gabriel of the Annunciation, 1784

Pen and ink over black chalk with touches of red and blue chalk on laid paper, 17½ x 12⅛ inches

Purchased through the Julia L. Whittier Fund; D.959.104

Benjamin West (cat. 2, 122) was the first American-born artist to pursue artistic studies abroad and achieve international standing in his profession. Although he spent most of his career in England—where he won the patronage of no less a figure than King George III—he exercised a tremendous influence on American art through the work of the many artists who studied with him overseas.

Although West typically created many preparatory drawings for his paintings, the size and degree of finish in this work, along with the presence of a signature, suggest that it was conceived as an independent composition. West created many such large-scale, highly worked drawings during the 1780s, a particularly fruitful and successful period in his career. Known initially for his portraits and theatrical history paintings, he had turned his attention increasingly to

biblical subjects beginning in the 1770s. In this elegant work, which reveals in its restrained passages an emerging neoclassicism, a single fine line of ink outlines the angel's profile, and orderly networks of hatched chalk markings model the face, neck, and hands. By contrast, sweeping calligraphic strokes of the pen delineate further details and add a sense of energy and verve to the composition.

In the biblical narrative, God sent the archangel Gabriel to announce to Mary that she was to be the mother of Christ. While there is no documentation supporting the early identification of this angel as Gabriel, his rapt attention, heavenward gaze, and tender gesture could suggest the receipt of such an important sacred message. [Adapted from MacAdam 2005: 54–55]

105. John James Audubon, 1785–1851

American Buzzard or White Breasted Hawk . . . Falco Leverianus, c. 1810–20
Pastel, graphite, chalk, and white opaque watercolor on medium-weight wove [J. Whatman] paper, 20⅞ x 16¹⁵⁄₁₆ inches
Purchased through the Katharine T. and Merrill G. Beede 1929 Fund and the Mrs. Harvey P. Hood W'18 Fund; D.2003.52

John James Audubon, widely acclaimed as America's most innovative and influential artist-naturalist, drew this work before he undertook his famous illustrated publication *The Birds of America* (1826–38). This double-elephant folio of 435 handcolored prints after Audubon's original watercolors and drawings is one of the great achievements of American art and natural science. Although self-taught as a naturalist, Audubon's extended, direct experience in the wilds afforded him an intimate understanding of ornithological behavior that in many ways surpassed the dry, taxonomic approach of more learned scientists and artist-naturalists.

This image, inscribed "drawn from Life . . . at Henderson K.Y.," actually depicts a juvenile red-tailed hawk, not a new species as Audubon had thought when he titled it *American Buzzard.* The life-size work already exhibits his naturalistic approach to rendering

birds. Here the hawk stretches its neck down and forward, opens its beak as if ready to feed, and lifts the leg that clasps its faintly drawn prey. The incomplete drawing of the small bird in the hawk's grasp shows us how Audubon began all of his drawings by "outlining" his subjects in graphite. He then used a variety of marks in pastel and graphite—his primary media until he switched predominantly to watercolor about 1821—to build up the forms and create the varied colors and textures of the plumage. He highlighted the legs with opaque white watercolor, which he then articulated with graphite to simulate their scaly texture. Through his close observation and complex technique, Audubon finessed a bold image of stunning realism that exemplifies his vital contributions to the fields of both science and art. [Adapted from MacAdam 2005: 56–57]

106. John William Hill, 1812–1879

High Bridge, c. 1848

Watercolor over graphite on wove paper, 21¹⁵⁄₁₆ x 31⅞ inches
Purchased through the Katharine T. and Merrill G. Beede 1929 Fund;
W.999.6

This watercolor features an especially early depiction of the elevated conduit High Bridge, which formed a key component of the Croton aqueduct that conveyed upstate water across the Harlem River to Manhattan. Under construction from 1839 to 1848, High Bridge represented an enormously ambitious and costly engineering project within a much larger, state-of-the-art aqueduct system. Engineer John B. Jervis designed High Bridge in the form of a Roman aqueduct, with stone arches spanning the Harlem River from the Westchester mainland (now the Bronx) to Manhattan at what is now 173rd Street. Stylistically reminiscent of a Roman aqueduct, High Bridge suggested continuity with great civilizations of the past as well as American technological innovation. John William Hill nestles the aqueduct into a picturesque landscape that also features two figures—one European American and one African Amer-

ican—engaged in quotidian rural labor. It is not clear what the relationship between the figures is or whether their inclusion was intended as a commentary during this period of regional tensions regarding slavery. Given Hill's background as a topographic artist, he may well have based this vignette on personal observation of an actual scene. The agrarian regions surrounding New York City had supported an especially large African American population dating back to the eighteenth century, when New York State had been the heaviest user of slave labor north of the Mason-Dixon Line.

John William Hill's extensive work in watercolor made him a pioneer amid the growing interest in the medium. This is most likely the watercolor titled *High Bridge* that he featured alongside oil paintings in the 1848 exhibition of the American Art-Union. Its large size signals the growing ambitions for the medium, which previously had been associated with either amateur or scientifically inclined illustrators. [Adapted from MacAdam 2005: 76–79]

107. William Trost Richards, 1833–1905

Beach Scene, c. 1870

Transparent and opaque watercolor over graphite on tan wove paper,
6 9/16 x 13 5/8 inches
Partial purchase through gifts from Richard and Diana Beattie and
partial gift of Theodore and Ellen Conant; W.997.11

Philadelphia artist William Trost Richards was a forerunner of the American watercolor revival of the late 1860s and 1870s. Encouraged by the writings of British critic John Ruskin, who advocated the medium in his *Elements of Drawing* of 1857, Richards remained steadfast in his belief in the artistic legitimacy of watercolor.

Richards's intensive work in watercolor coincided with a new stylistic direction for the artist and an emerging fascination with shoreline subjects that he would explore for the rest of his career. In the early 1870s he painted primarily along the New Jersey shore, where, as his son recalled, he "stood for hours ... with folded arms, studying the motion of the sea, until people thought him insane." Richards rendered the spare design elements of this scene in characteristically precise detail but capitalized on the transparency of the watercolor medium to convey the moist, hazy atmosphere of the coast. Instead of the almost obsessive hairline hatchings of wa-

tercolor used by several other American disciples of Ruskin's "truth to nature" philosophy, Richards favored a broader wash on lightly toned paper. The tan color of the sheet shows through some areas of the thinly applied pigment and is left exposed in others, contributing to the diffuse summer glow and overall tonal harmony of the work. The colored, absorbent sheet required him to use touches of opaque watercolor (also known as gouache, or body color) for highlights, as seen in the distant sail, breaking waves, and wispy clouds. Three faintly drawn distant gulls soar against the sky, bringing the taut work into exquisite balance. The horizontal format, spare composition, near-monochromatic palette, and diffuse, aerial glow are qualities associated with the luminist aesthetic that came to prominence at this time. [Ferber 1973, 1989; adapted from MacAdam 2005: 96–97]

108. Howling Wolf (Ho-na-nist-to), Southern Cheyenne, 1849–1927

Untitled (self-portrait), c. 1874–75

Pen, graphite, and colored pencil on blue-lined ledger paper,
5¾ x 7⅛ inches
Purchased through the Hood Museum of Art Acquisitions Fund;
D.2006.51

With the nineteenth-century influx of European Americans to the Plains region, Plains Indian pictorial representation shifted from imagery painted with natural pigments on buffalo hides, rock walls, and tipis to drawings done in such media as ink, graphite, and watercolor on ledger book paper acquired from white settlers. This vital male tradition of drawing on ledger (and other) paper emerged among Plains Indians at least by the 1860s and continued into the early twentieth century. The resulting works served to preserve native history, chronicle daily activities, and record major transitions in Plains Indian culture brought on by warfare, captivity, and physical dislocation.

This drawing is the only known self-portrait of Howling Wolf, a southern Cheyenne warrior and gifted ledger book artist. Howling Wolf's participation in battles with United States military forces resulted in his imprisonment, along with more than seventy other Native American hostages, at Fort Marion in Saint Augustine, Florida, from 1875 to 1878. Howling Wolf scholar Joyce Szabo believes this work may predate the artist's drawings done in captivity, based on its less accurate rendering of figural proportions. In contrast to another Hood ledger book drawing that captures a dramatic event—a warrior's valor in the face of hostile fire (cat. 109)—this composition is more static and formal, emphasizing the proud, erect bearing and colorful regalia of Howling Wolf and his horse. Howling Wolf's achievements are not described literally but by means of his heraldic dress, which signifies his personal, tribal, and societal affiliations and specific acts of bravery. Although the artist often used a pictographic name glyph of a howling wolf to sign his works, this sheet bears what appears to be his signature. He may have signed the work at a later date, because he likely did not learn to write until he was schooled at Fort Marion. [Szabo 1994; Thompson 2004]

109. Vincent Price Ledger Artist [C?], possibly Cheyenne, nineteenth century

Untitled (Drawing No. 138), c. 1875–78

Graphite and colored pencil on blue- and red-lined ledger paper,
5¾ x 11¹¹⁄₁₆ inches
Purchased through the Hood Museum of Art Acquisitions Fund;
D.2004.9

This drawing comes from a ledger book named after its collector, actor Vincent Price (1911–1993), who collected Native American art and purchased the book in the early 1960s. Its eighty-six drawings, now dispersed, are believed to have been created by four Cheyenne warrior artists tentatively identified as artists A, B, C, and D. The images mainly depict battles between Cheyenne warriors and European Americans during the Indian Wars of the 1860s and 1870s, in contrast to the social scenes more typical of early-reservation-period representational art.

In this work, the warrior protagonist dodges bullets shot at him from weapons seen along the righthand edge of the ledger paper. A line of curved marks representing hoofprints extends behind and

beneath him, evoking the path of his flight. The steed's extended legs and flying tail add action to the scene, as do the airborne bullets and blasts emanating from the guns. The presence of long-range firearms in lineup formation—a U.S. martial technique—suggests that the drawing depicts an event that took place later in the Indian Wars, during the mid- to late 1870s. Its style, however, is still imbedded in traditional Plains pictographic conventions: the mounted warrior is shown without reference to his spatial environment, the action moves from right to left, and the balance of scale and perspective is secondary to the importance of the action. As in many ledger drawings, personal adornment and accoutrements identify the warrior, who could be the artist himself, and his tribal and societal affiliations, as does the wolflike glyph floating in the upper left corner. This artist's style is specifically identifiable by the long nose of the thin warrior and the "seahorse" appearance of his mount's head. [McCoy 1987; Thompson 2004]

137

110. James McNeill Whistler,
1834–1903

Maud Reading in Bed, 1883–84
Opaque and transparent watercolor and pen
and brown ink over graphite on tan cardboard,
9⅞ x 7 inches
Gift of Mr. and Mrs. Arthur E. Allen Jr.,
Class of 1932; W.971.26

Perhaps the most influential artist of his generation, James McNeill Whistler spent most of his career in Paris and London. His association with vanguard artists and his keen interest in modern aesthetic theories led him to create a distinctive stylistic approach that favored decorative artifice over faithful description. Whistler also led the way in his embrace of media that had formerly been judged insignificant in comparison to oil painting, including etching, pastel, and watercolor, all of which he worked on in a small scale.

This elegant watercolor captures Maud Franklin, Whistler's model and mistress during the 1870s and 1880s. He featured her in about sixty works, many of them made around the same time and showing her in similarly languid poses, absorbed in her reading or her own thoughts. Some scholars believe that Maud was convalescing from a pregnancy or serious illness during this time. Whether or not this is the case, it is obvious that Whistler was utterly taken

with portraying an imaginatively engaged, unselfconscious woman. Such a subject gives us access to a candid, private moment of the sort valued by Whistler and the impressionists. But her act of reading seems less an indication of Maud's intellectual pursuits than an artistic device that enhances the watercolor's informal, contemplative mood.

Derrick Cartwright speculated in a catalogue entry on this work that Whistler may have placed his butterfly monogram in close proximity to Maud—just above the bed—to suggest a degree of supervision of her activity, or perhaps to reflect his deep affection and imply a sense of possession as well. Significantly in this regard, Whistler referred to his portraits of Maud as "artist's pictures, impressions of my own." [Catalogue entry by Derrick R. Cartwright in MacAdam 2005: 114–17]

III. Mary Cassatt, 1844–1926

Drawing for "Evening," 1879–80
Conté crayon on thin, light wove paper, 7⅞ x 8⅝ inches
Purchased through gifts from the Lathrop Fellows; D.2003.16

This remarkably innovative study for a print dates from an especially formative and experimental period in Mary Cassatt's career, one in which she explored subjects and approaches to design that would prove central to her art. It was also during this time that Cassatt earned widespread acceptance by prominent patrons and leading French impressionist artists, especially Edgar Degas, who became a close friend and mentor. He invited her to exhibit with the French impressionists and also encouraged her efforts in printmaking.

In 1877, Cassatt took in her aging parents and her sister, Lydia, who by 1879 had been diagnosed with a terminal illness of the kidneys. The artist's increasing familial responsibilities led her to focus on her family and the domestic sphere in her art. Set in her home in Paris, this meditative work captures the artist's mother reading and her sister sewing—productive engagements that reflect their intelligence and education. In this drawing, Mrs. Cassatt's strong fingers press upward against her temple in concentration, as if pointing to the source of her intellect. Lydia is equally engaged in her knitting or sewing. Despite the intimate domestic setting and close proximity of the women, who share the light of the lamp, they do not face each other. The lamp radically divides the composition and further asserts the separate physical and psychological spaces occupied by each figure. Also rather abruptly cropped and spatially compressed, this work reveals the avant-garde influence of Degas and the compositional strategies associated with the Japanese woodblock prints that both artists collected. Cassatt apparently admired the final soft-ground etching, for it was one of eight prints she exhibited in the fifth impressionist exhibition in 1880. [Barter et al. 1998; adapted from MacAdam 2005: 104–7]

112. George Wesley Bellows, 1882–1925

The Boardwalk (The Merry-Go-Round), c. 1915

Black, salmon, and blue crayon and tan wash over graphite on slightly textured cream wove (Natoma) paper, 16⅛ x 22 inches
Gift of A. Conger Goodyear; D.940.20

One of the greatest realists of the twentieth century, George Bellows frequently drew artistic inspiration from public amusements, where ethnic and social classes mingled and he felt most keenly the gritty vitality of modern life. Bellows first honed his reportorial eye under the guidance of Robert Henri (cats. 58, 114), his instructor at the New York School of Art and the intellectual leader of the progressive urban realist artists. Like others in Henri's circle, including John Sloan (cats. 59, 60, 61, 75, 113), William Glackens, and Everett Shinn, Bellows found artistic inspiration in his everyday surroundings, especially in New York.

Although he was based in the city, Bellows made several sum-

mer trips to the Maine coast between 1911 and 1916. Here he depicts the boardwalk at Old Orchard Beach, Maine, setting up a contrast between the gaily lit concessions and the dark, slightly forbidding atmosphere outside. Bellows only faintly rendered the enclosed carousel itself, emphasizing instead the apparent vulnerability of the two respectably dressed women who stroll the boardwalk, huddled together. From the carousel entryway a loitering man appears to leer at the women, while the youngsters behind the concession stand also shoot glances their way. One of the female strollers, as if assessing the security of her surroundings or the intentions of the male onlookers, warily directs her gaze out and back. Echoing perhaps these more veiled human investigations, a trotting beagle, nose to the ground, openly prowls the boardwalk ahead. Bellows may have used this drawing as a study for a painting that was never completed, but its degree of finish and bordered placement on its sheet suggest that the artist valued it for itself as well. [Adapted from MacAdam 2005: 138–39]

113. John Sloan, 1871–1951

Ludlow, Colorado (Class War in Colorado), 1914, drawing for an illustration in the *New York Call,* April 25, 1914

Lithographic crayon on wove paper, 18¾ x 12½ inches
Gift of John and Helen Farr Sloan; D.952.44

Since its initial publication as a cover illustration, both for a so-cialist newspaper, the *New York Call,* and soon thereafter for the magazine *The Masses,* John Sloan's drawing of a coal miner's suicidal vengeance after the murders of his wife and children has become an icon of American labor history. It is an enduring memorial to the twenty individuals—thirteen of them women and children—who were shot at or burned to death when Colorado National Guards-men fired upon an undefended union tent colony on April 20, 1914, in what was quickly dubbed the Ludlow Massacre. This watershed event dramatized the abuse of unregulated authority by industrial-ists and their agents and won widespread national support for the cause of the miners.

With its powerful strokes of black crayon, Sloan's drawing shows a miner silhouetted against the inferno of his burning tent, protec-tively straddling the bodies of his family while clutching his dead child to his chest. The remains of his makeshift home are symbol-ized by a stove, kettle, and chair; everything else has been consumed by fire. In a radical stance of resistance, the miner shoots back with his pistol, most likely to meet his own death. He therefore embraced the motto of the *New York Call*: "The emancipation of the Working Class must be accomplished by the workers themselves." Sloan later distanced himself from socialism and is more often remembered for his ebullient images of working-class city street life (see cats. 59, 60, 61, 75 for other examples of Sloan's works). [Adapted from catalogue entry by Mark D. Mitchell in MacAdam 2005: 132–35]

114. Robert Henri, 1865–1929

Where the Trees Are Dying, 1918

Pastel on heavy wove paper, 12½ x 19⅞ inches
Gift of Mr. and Mrs. Jack Huber, Class of 1963; D.2004.39

Best known as the dynamic leader of the Ashcan school, a circle of early-twentieth-century urban realists, Robert Henri (cat. 58) also produced important landscapes and marine scenes, particularly during summer sojourns along the Maine coast. He created this pastel during his productive 1918 visit to Maine's rugged and picturesque Monhegan Island. Henri first discovered Monhegan in 1903 and, like many artists, was taken with its mix of pounding surf, soaring cliffs, and secluded woodlands. He extolled the island's artistic virtues in a letter to his parents: "It is a wonderful place to paint—so much in so small a place one can hardly believe it." He returned in 1911 and again in 1918. During this final visit, he sketched a series of

bold, almost abstract, pastels set within the island's dense Cathedral Woods.

The closely cropped, horizontal format of *Where the Trees Are Dying* flattens out the picture plane and accentuates the rhythmic groupings of barren tree trunks struck with flickering light. Rather than the delicate pastel tints generally associated with the medium, Henri relied primarily on deep earth tones that vividly set off the silvery trunks and contribute to the introspective mood. As noted by the work's elegiac title, the trees—one of which has partially fallen—bear few signs of life. Patches of bright green undergrowth, however, enliven the palette and offer the promise of renewal. In his book *The Art Spirit,* Henri advised artists to capture "the essence" of a subject, and to combine observation with imagination. In *Where the Trees Are Dying,* he succeeded in creating what he termed an "emotional landscape . . . like something thought, something remembered." [Catalogue entry by MacAdam in Hood Museum of Art 2005]

115. George Ault, 1891–1948

Back of Patchin Place, 1927

Graphite on heavy wove paper, 15¾ x 11¹¹⁄₁₆ inches
Gift of Abby Aldrich Rockefeller; D.935.1.98

George Ault is generally considered within the context of such American precisionists as Charles Sheeler and Preston Dickinson (cat. 63), who from the 1920s through the 1940s celebrated modern technological progress with their pristine, reductive urban and industrial landscapes. Like them, Ault distilled or "crystallized" his urban surroundings in an attempt to convey the city's underlying geometric structure. By contrast, however, he often imbued his architectonic compositions with a psychological intensity and otherworldliness that gave them a haunting, surrealist edge. The disquieting mood cast by some of his works may be rooted in the artist's intense personal struggles—for example, he suffered the death of both parents and the suicides of three brothers within a relatively short period of time—and his deep concerns about the social implications of the city. He once referred to New York's skyscrapers, for

instance, as "tombstones of capitalism." Ault finally abandoned the city in 1937 for a more rural lifestyle in Woodstock, New York.

By identifying the locale of this work in its title, George Ault capitalizes on the fame of Patchin Place, a Greenwich Village alley that has been home to such literary figures as e. e. cummings and Theodore Dreiser. Rather than the alley's quaint nineteenth-century façades, however, Ault depicts the back of one of the buildings, with its more utilitarian, streamlined fenestration, tubular railings, and angular structural additions. Against this rigid geometry he silhouettes the gracefully curving, smoothly modeled ailanthus branches that lend the work its lyrical, melancholy quality. The end result is a subtle interplay between realism and abstraction, organic and architectural form, line and tone. [Adapted from MacAdam 2005: 152–53]

116. Stuart Davis, 1894–1964

Statue, Paris, 1928

Opaque watercolor over graphite indications on tan wove paper,
14⅝ x 15⅝ inches
Gift of Abby Aldrich Rockefeller; W.935.1.15
Art © Estate of Stuart Davis / Licensed by VAGA, New York, NY

Having explored the aesthetic modes of urban realism and a range of European modernist traditions in the 1910s, Stuart Davis emerged as a pioneer of cubist-inspired abstraction during the mid-1920s. Having recently completed his famous abstract *Eggbeater* series, Davis reoriented his art during a yearlong visit to Paris in 1928–29. There he employed a more figural, naturalistic mode to depict the city's historic quarters. He later reflected, "In Paris, the actuality was so interesting I found a desire to paint it just as it was." However, he in fact stylized his surroundings considerably, converting street scenes into stage set–like constructions of flattened planes

and broad expanses of color and pattern. Nonetheless, he included enough literal details to clearly invoke his Parisian setting.

The equestrian statue of King Henry IV that stands on the tip of Paris's Ile de la Cite provided the immediate inspiration for this work, but Davis took liberties with both the location and the statue itself. He gave the figure a heroic, sword-raised pose but a comically unimposing silhouette and a sway-backed horse. Moreover, he surrounds the statue with recently constructed buildings, including the new Samaritaine department store surmounted by tricolor flags flapping in the breeze. Davis's depiction of Paris utilized a composite approach of surrealist and cubist techniques to create a playfully ironic commentary on the role of history in modern France, as one of the nation's greatest leaders salutes its reigning bastions of commerce. Davis generally lightened his palette in all of his Parisian paintings, but the delicate pastel tints of opaque watercolor (or gouache) give this work a particularly lyrical tone. [Hills 1996: 86 (quotation); adapted from catalogue entry by Mark D. Mitchell in Mac-Adam 2005: 158–59]

117. Joseph Stella, 1877–1946

Dying Lotus, c. 1930–32

Pastel, colored crayon, metalpoint (probably silver-point), and possibly graphite over an artist-prepared ground on wove paper, 15⅞ x 11¾ inches
Gift of Helen Farr Sloan; D.952.133

Although best known as America's foremost futurist painter, Italian-born Joseph Stella was also an indefatigable draftsman who produced a large and diverse body of works on paper throughout his career, including preparatory drawings for his paintings as well as independent works in charcoal, silverpoint, crayon, and pastel.

Flowers, which appeared in his paintings beginning around 1919, became a truly predominant theme in his drawings, reflecting his profound fascination with the subject. Aside from their cheering visual appeal, flowers served as an expressive vehicle for Stella's deeply held, often conflicting personal passions: his sensual nature and his drive for spiritual transcendence. Stella was no doubt aware of the significance of the lotus, the subject of this work, in the context of diverse cultures and religious traditions, from ancient Egypt to Buddhist and Hindu India. The lotus has been associated variously with the resurgence of life, fertility, enlightenment, the sun, and

purity. Here we look down into the tilted blossom, which reveals its luminous yellow stamen—the pollen-producing male organ of the specimen—thereby allowing a sensual reading as well. Stella magnifies the blossom's importance and visual impact by nearly filling the sheet with its cupped petals, which twist and arch upward, set against the rich blues he so often favored. Stella noted over the years his positive associations with the color blue, which for him signified serenity, the heavens, and "the pure blue of the Dawn of our life." Here he used it to describe what is likely an Iranian porcelain bowl while manipulating it more suggestively in the background, where it conveys the sense of an energized aura radiating from the splayed petals. Despite the apparent vigor of the cut blossom, the inscription on the reverse provides the title *Dying Lotus,* which foretells the inevitable. [Adapted from MacAdam 2005: 160–61]

118. Rex Brandt, 1914–2000

California Coast, 1936

Transparent watercolor over graphite indications on wove paper,
15⅜ x 22½ inches
Partial and promised gift of Philip H. Greene in memory of his wife
and co-collector, Marjorie B. Greene; EL.2007.6.1

Rex Brandt was a key member of the so-called California school of
watercolor painting, an informal but closely knit group of artists
that was most active from the 1920s through the mid-1950s, pri-
marily in southern California. They received national recognition
for capturing the distinctive character of their western environs in
a manner that was bold and expressive, yet representational. Many
of the artists had close ties to the Chouinard School of Art and the
Otis Institute, both in Los Angeles, and the California Water Color
Society, which was founded in 1921 and mounted local and traveling
exhibitions that raised the group's profile nationally. Brandt studied
at Chouinard as a teenager and later Riverside (California) Junior
College and the University of California at Berkeley. In 1936 he re-

turned to southern California, where he assumed a variety of teach-
ing positions and wrote several books on watercolor technique, the
medium for which he became best known.

Brandt painted this coastal subject in Laguna Beach in August
1936 and included it in the fourth annual watercolor show of the
Oakland Art Gallery that same year. He later credited the wood
engravings of California printmaker Paul Landacre as an important
influence on this particular work and his overall stylistic approach at
the time. As in Landacre's graphically strong coastal images, Brandt
adopted a high horizon that accentuates the coastline's dramatic to-
pography and creates strong tonal contrasts, in this medium by us-
ing broad, sweeping strokes of dark, saturated washes to model the
stylized hills and add depth to the luminous sea. Reflecting the era's
regionalist tradition, which celebrated the distinct character of the
nation's diverse geographic areas, the two men fishing suggest a lo-
cal means of livelihood and recreation, while the modest farmstead
subtly references the workaday lives of rural Californians. [Anderson
1988; Brandt 1996; Karlstrom 1996; McClelland and Last 1985]

119. Millard Sheets, 1907–1989

Camp Near Brawley, 1938

Transparent watercolor over charcoal indications on very thick wove
[Arches] paper, 16 x 22¾ inches
Partial and promised gift of Philip H. Greene in memory of his wife
and co-collector, Marjorie B. Greene; EL.2007.6.12

Prolific and versatile in his artistic production and influential
through his teaching, Millard Sheets played a leadership role among
the "California-style" watercolorists (see cat. 118). He practiced wa-
tercolor while still a student at the Chouinard School of Art, from
which he graduated in 1929, and went on to teach at Chouinard
from 1929 to 1935 and to serve as a professor, then director of art, at
Scripps College in Claremont from 1938 to 1955.

This is one of eight watercolors by Sheets that appeared in an
April 1939 article in *Fortune* magazine, "Migratory Labor: A So-
cial Problem ("I Wonder Where We Can Go Now)." The article
exposed the destitute living conditions of the thousands of people
from America's heartland who had come to California in search of
work and lived in makeshift camps, often with inadequate food,
water, and sanitation. A series of photographs documenting camp
conditions, many of them taken by Dorothea Lange (cat. 145), fol-
lowed the article. Painted at a camp in the Imperial Valley, this wa-
tercolor's accompanying caption read "Near Brawley: I'd sure like
to have a trailer 'stead of a tent, especially when it rains." Although
recording the area's parched soil and the camp's crude, improvised
housing, this sun-filled, colorful watercolor is so visually appealing
that its social content seems almost secondary. From his low van-
tage point, Sheets accentuated the sprightly, rhythmic silhouette
of tents and vehicles set against the radiant sky. Pale washes and
reserved patches of the bright white paper set off the rich, saturated
colors, adding to the work's graphic impact and rich textural effects.
Its fresh, seemingly spontaneous handling appears to reflect a deep
pleasure in the artistic process and an optimistic faith in the human
spirit, even in the face of economic hardships. [Anderson 1988; La-
guna Beach Museum of Art 1983; McClelland and Last 1985]

120. Bill Traylor, c. 1854–1949

House with Figures and Animals, 1939
Colored pencil and graphite on cardboard,
22 x 14¼ inches
Purchased through the Florence and Lansing
Porter Moore 1937 Fund; D.2003.53

Bill Traylor was born into slavery, worked on a plantation most of his life, and only began to draw at the age of eighty-five, while he was homeless in Montgomery, Alabama. With an almost obsessive drive, he created about twelve hundred drawings in just a few years. This work conveys Traylor's humorous storytelling abilities, masterful sense of design, and haunting vocabulary of stylized forms. He described the events in the top portion of his drawing: "Goose grabs little boy's penis through fence / boy ties himself to the calf who dashes / through a hole in fence—little boy caught." In the center, Traylor imaginatively conflated the front and side elevations of a propped-up "double pen" house—a common vernacular building type of the South—distinguishing its structural sections with different colors. The rattlesnake that undulates across the composition segregates the lower enigmatic vignette from the primary narrative and marks a distinct shift in mood, as we view a boy pointing to the crotch of a one-legged man.

In Traylor's work such recurring motifs as snakes, birds on roofs, birdlike people, and people chasing or probing each other with sticks suggest the artist's relentless exploration of particular stories, observations, and perhaps spiritual metaphors. Although Traylor's specific African roots remain undocumented, his motifs and photographic approach to design point to a deep familiarity with African visual, oral, and spiritual traditions. His stylized birds, for instance, recall the iron birds that crown Yoruba staffs honoring Orish Oko, the deity of farming. They could also represent messengers to the spirit world—or simply be mischievous farmyard chickens. Although embedded in the African American culture of the South, Traylor's pictographic language is also elemental and timeless, recalling such diverse expressions as prehistoric cave drawings and modernism. [Adapted from MacAdam 2005: 176–77]

148

121. Jackson Pollock, 1912–1956

Untitled (Number 37),
c. 1939–40
Pen and brown and black ink, graphite,
and orange colored pencil on smooth
coated paper, 14 x 11 inches
Purchased through a gift from Olivia H.
and John O. Parker, Class of 1958, the
Guernsey Center Moore 1904 Memorial
Fund, and the Hood Museum of Art
Acquisitions Fund; D.986.8
© 2007 The Pollock-Krasner Foundation/
Artists Rights Society (ARS), New York

This work is one of a group of Jackson Pollock's "psychoanalytic drawings," so named because they were created over a period of eighteen months in 1939 and 1940 when Pollock underwent Jungian psychoanalysis in an attempt to deal with his alcoholism and crippling emotional instability. Pollock used drawing as an outlet during this period but also as a means for experimenting with representations of images that he saw in real life and in his imagination. Pollock created this work in several successive media, gradually resolving and sharpening the contours of his emergent forms and ideas in pen and ink from the looser orange pencil and graphite underdrawings. Some of the forms never cohere, but the central image resolves itself as a sort of man-beast composite that draws upon Pablo Picasso's 1937 antiwar painting *Guernica* and the skeletal figure in the panel *Gods of the Modern World* from José Clemente Orozco's

1932–34 mural *The Epic of American Civilization* at the Dartmouth College Library. As is even more evident in the Pollock oil study recently acquired by the museum (cat. 81), Pollock certainly knew Orozco's mural and reportedly went so far as to drive from New York to Hanover to see it in person in 1936. The skeleton motif offers a modernist's vision both of what Orozco called the "dead hand of the Academy" and of scholars' indifference to contemporary social injustice. In this particular manifestation of Pollock's early experiments, the intersection of Orozco's message and Picasso's forms portrays the young artist's lingering debt to contemporary masters even as he began to look inward for the vitality and spontaneity that would become his trademarks. [Adapted from catalogue entry by Mark D. Mitchell in MacAdam 2005: 158–59; Naifeh and Smith 1989: 298, 843]

Prints and Photographs

Re is not here : for he is risen at.

122. Benjamin West, 1738–1820

The Angel of the Resurrection, from
Specimens of Polyautography, 1801
Pen-and-tusche lithograph on wove paper, on
support sheet with brown aquatint border,
12¾ x 9 inches (image)
Purchased through the Guernsey Center Moore
1904 Memorial Fund; PR.958.40

This rare print is considered to be the first lithograph of artistic merit done in any country. Alois Senefelder, a Bavarian playwright living in Munich, developed the lithographic technique in 1798 while searching for an inexpensive means of reproducing his plays. The earliest artistic lithographs appeared in England a few years later, when publisher Philipp André issued a series of albums known as *Specimens of Polyautography,* printed between 1803 and 1807. The initial album's earliest dated lithograph, or "polyautograph," was this example by American-born Benjamin West (cats. 2, 104), who worked for most of his career in London and was president of the Royal Academy. The album also included pen lithographs by such British artists as James Barry, Henry Fuseli, and Thomas Stothard.

West's image dramatically depicts the angel of the resurrection, who, as described in the gospel of Matthew (King James version), descended from heaven in "a great earthquake" and "rolled back the stone from the door [of Christ's tomb] and sat on it." With his "countenance like lighting, and his raiment white as snow," the angel proclaimed to Mary Magdalene and the Virgin Mary, who had come to see the sepulcher, "He is not here: for he is risen" (Matthew 28: 2–6). West inscribed this message along the lower edge of the print and reinforced its significance through the figure's exclamatory expression and pose: one arm points to the dark tomb and the other to the radiant heavens above. Rather than modeling forms with the broader shadings possible with the lithographic crayon, which had not yet come into use, West applied his pen lines with hatchings and cross-hatchings that recall engraving techniques. His animated strokes and rich tonal contrasts dramatize the setting and accentuate the angel's forceful appearance and signal message, which describes a cornerstone Christian event. [Beall 1980]

123. Alexander Lawson, 1773–1846,
after Alexander Wilson, British,
1766–1813; Publisher: Bradford and
Inskeep, Philadelphia

*1. Wood Thrush. 2. Red-Breasted
Thrush or Robin. 3. White-Breasted
Black-Capped Nuthatch. 4. Red-
Bellied Black-Capped Nuthatch,* from
American Ornithology, 1808–14

Handcolored engraving on wove paper,
13¾ x 8⅞ inches (plate)
Hood Museum of Art, Dartmouth College;
PR.X.300.1

This is a plate from Alexander Wilson's multivolume series *American Ornithology,* the first book published in America on American birds and the first monumental color-plate book printed in this country. The work brought Wilson international recognition as an artist-naturalist and greatly elevated the status of ornithology as a science. It featured seventy-six plates drawn by Wilson and engraved and colored under the supervision of Philadelphia printer Alexander Lawson. *American Ornithology* remained the definitive study of American birds until the publication in 1827 of John James Audubon's magnificent *Birds of America,* which immediately overshadowed Wilson's great achievement.

Wilson emigrated from Scotland in 1794 and, after teaching for several years in New Jersey, took a teaching post in 1802 in Philadelphia, where he absorbed that city's burgeoning enthusiasm for art and science. He informally studied ornithology and the art of drawing birds under the famed naturalist William Bartram and fre-

quently rendered birds from a large collection of mounted specimens in the museum of Philadelphia artist Charles Willson Peale. Lawson also emigrated from Scotland and became one of Philadelphia's most prolific and talented printmakers. Wilson's *American Ornithology* reflected the naturalist's keen eye for anatomical detail, but his groupings of birds on a page proved somewhat arbitrary and, compared to those of Audubon, provided scant information on a species' specific habitat and behaviors. This page presents a harmonious arrangement of a wood thrush, a red-breasted thrush (or robin), and two nuthatches, all of whom perch improbably close to one another along a short section of branch. The composition is graphically strong, with the sharp-edged profiles of the birds set against a stark white background. This effect may derive from Lawson's alleged practice of composing pages by arranging cutouts of Wilson's individual specimen drawings before transferring a final design to an engraving plate. [Cantwell 1961; Meyers 1998]

N°.12. PLATE LVI.

BOS AMERICANUS, GMEL.
AMERICAN BISON OR BUFFALO.
MALE.

124. John T. Bowen, about 1801–1856, after John James Audubon, 1785–1851

Bos Americanus, American Bison or Buffalo, plate 56 from *The Vivaparous Quadrupeds of North America*, 1845

Handcolored lithograph on wove paper, 19 x 24¾ inches (image)
Purchased through the Julia L. Whittier Fund; PR.954.35.1

After the acclaimed publication of his monumental *Birds of America* series (1827–38), John James Audubon (cat. 105) set out to create the equally ambitious series *The Vivaparous Quadrupeds of North America*, which he published in stages from 1845 through 1854. This artistic and scientific achievement offered by far the most complete study of American mammals to date and represented a landmark in American publishing. Whereas Audubon's *Birds of America* was printed in London, *The Quadrupeds* could be dubbed a "Great National Work," conceived and completed on American soil. The project became an increasingly collaborative venture as Audubon's physical and mental health deteriorated. He completed about half

of the final 150 plates by 1846, when his failing condition necessitated that his sons, particularly John Woodhouse, complete the remainder. Naturalist John Bachman composed the volume's accompanying text, drawing in part on Audubon's voluminous writings.

This is one of two plates from the Imperial Folio edition of *Quadrupeds* that depict the American bison. Whereas the subsequent image, plate fifty-seven, depicts a family of buffalo and is believed to have been drawn by John Woodhouse Audubon, the careful modeling and detail in this image reflects the elder Audubon's higher level of workmanship. In keeping with traditions in scientific illustration, the bison's rather static profile pose presents a full view of the specimen's anatomy. Audubon observed bison by the thousands during his 1843 study trip up the Missouri River and greatly admired the "noble" species. He decried the large-scale hunting of buffalo for sport and anticipated the species' near-extinction, which would occur by the mid-1870s. The buffalo already had strong national associations and would have resonated with Audubon's audience for its close association with Native American culture and the vanishing West. [Boehme 2000; Rhodes 2004]

153

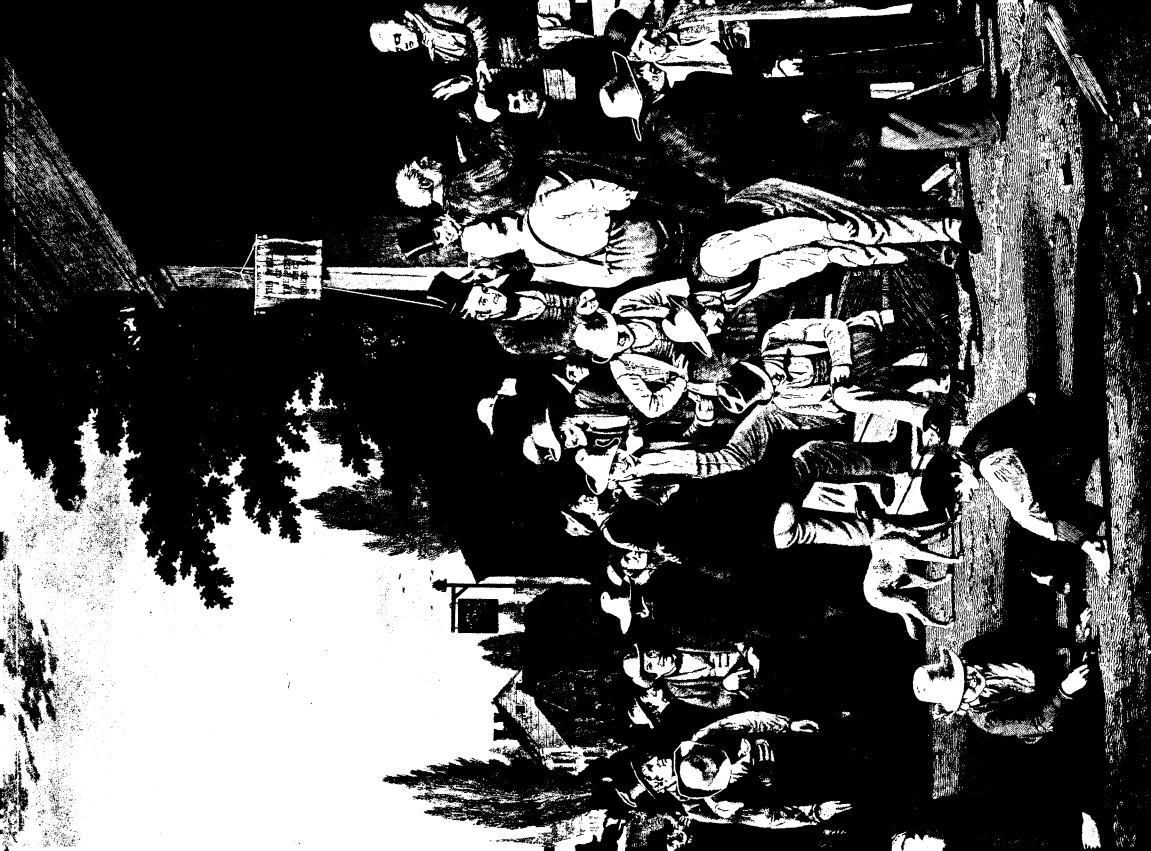

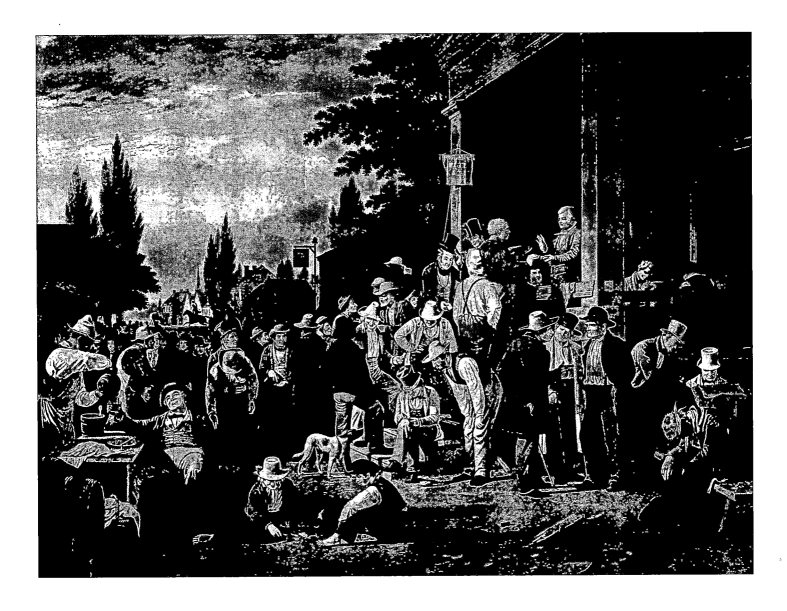

125. John Sartain, 1808–1897, after George Caleb Bingham, 1811–1879; Publisher: Goupil & Co.

The County Election, 1854

Handcolored engraving, mezzotint, and etching with stippling on wove paper, 22¼ x 30¼ inches (image)
Purchased through the Julia L. Whittier Fund; PR.951.4

One of George Caleb Bingham's greatest accomplishments was the trio of images known as his "Election Series," which celebrated the principles of the democratic process and universal suffrage despite the human foibles of the electorate. He began with the painting that was the basis for this print, The County Election (1851–52). This would become the central image of the narrative sequence, situated thematically between Stump Speaking (1853–54) and The Verdict of the People (1854–55). After completing The County Election, Bingham contracted with engraver John Sartain of Philadelphia and the international publishing firm of Goupil & Co. to issue this print, a superb example of mezzotint engraving.

Clearly inspired by the satirical election prints of British artist

William Hogarth, The County Election is masterfully composed, drawing the viewer's eye through crowds of congregating figures and up the steps of an open porch. There, voters cast their ballots orally after having sworn that they have not voted elsewhere. Members of the assembled crowd include men of diverse age, occupation, race, and apparent level of education and political interest. Some read newspapers and engage in serious discussions while others are visibly intoxicated—one to the extent of being carried toward the polling place by a friend who will almost certainly "guide" his vote. As a former politician in his native Missouri—and one whose popular election to the state legislature was contested in 1847—Bingham knew all too well the vicissitudes and flaws of American politics. Nevertheless, a banner leaning against the building proclaims "The Will of the People the Supreme Law," summarized Bingham's fervent belief that, as Nancy Rash has observed, a popular election out in the open—even with all of its imperfections—is far preferable to the partisan decisions reached from behind the closed doors of the legislature. [Rash 1991]

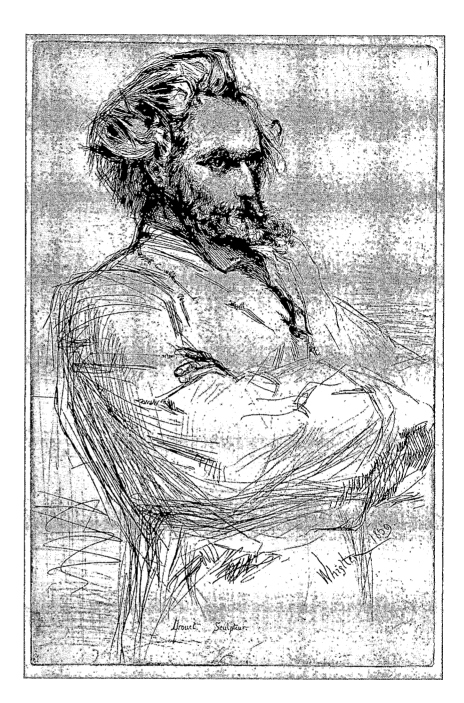

126. James McNeill Whistler, 1834–1903

Drouet, 1859

Etching and drypoint on laid paper, state ii/II,
8⅞ x 6 inches (plate)
Gift of Alden Guild, Class of 1952; PR.979.22

American expatriate James McNeill Whistler (cats. 48, 110, 127) was the single most important force in the artistic revival of the etching process in the second half of the nineteenth century. He drew inspiration initially from some of the mid-century French Barbizon artists exploring the medium, especially Charles Jacque, and from Rembrandt etchings collected by his brother-in-law, Seymour Haden. Whistler published his first group of etchings, known as the "French Set," in 1858. He went on to create more than 450 etchings and inspired countless other artists to take up the art.

In the autumn of 1859 Whistler worked for a period in Paris, where he concentrated primarily on self-portraits and likenesses of his artistic and literary compatriots. Here he depicts the sculptor and collector Charles L. Drouet (1836–1908), a friend from Whistler's student days. It is a vivid portrait that dramatically conveys

the sculptor's intense, penetrating stare and assertive stance. Whistler modeled Drouet's sharp features, curly beard, and disheveled mane by carefully building up a network of lines—from the faintest etched marks to patches of rich, velvety drypoint that add tonal richness and sculptural depth. By contrast, he minimally sketched the sculptor's clothing with long, energetic strokes, leaving large expanses of the paper visible and drawing the viewer's eye to the subject's swarthy, leonine head. Notorious for cultivating his own colorful artistic persona, Whistler in this work further reinforced popular impressions of the modern artist as a forceful yet somewhat aloof figure.

The Hood Museum of Art has been fortunate to acquire through gift and purchase more than ninety Whistler etchings and lithographs. [Dorment and MacDonald 1995]

156

127. James McNeill Whistler, 1834–1903

Nocturne, from *The First Venice Set,* 1879–80
Etching and drypoint on laid paper, state iv/V, 7⅞ x 11½ inches (plate)
Gift in memory of Mrs. Harvey Fisk by her children; PR.974.387

As James McNeill Whistler (cats. 48, 110, 126) developed his mature style in the 1870s and 1880s, he brought to the etching medium a restrained aestheticism derived in part from his exposure to Japanese approaches to composition. He also pushed his etching practice to new levels of creativity. By experimenting endlessly with different inks and papers (including Japanese and old Dutch examples), and by selectively wiping his etched plates, he made the preparation and printing of plates a critically important phase of the imaginative process.

Whistler made this evocative etching during his fourteen-month stay in Venice beginning in September 1879. He arrived with a commission to create a mere dozen etchings of the city for London's Fine Art Society but extended his visit, during which he created some of his most innovative work in a range of media. Whistler avoided Venice's frequently painted public monuments, preferring to portray back canals and eerie nocturnes set on the lagoon. As he wrote, "I have learned to know a Venice in Venice that the others seem never to have perceived." During this visit he fully developed his tonal approach to printing, using surface ink to create painterly atmospheric effects. In this plate he etched but a few short vertical lines to describe the distant buildings along the horizon (including the dome of Santa Maria della Salute and San Giorgio Maggiore), the ship, gondolas, and their watery reflections. The rich, moody atmosphere of this nighttime scene derives less from the scant etched lines than from the warm-toned film of ink on the plate, which Whistler hand-wiped to create the glowing highlights along the horizon and subtle vertical striations in the foreground. The result is that this impression—like every other one—is unique, essentially a monotype. [Whistler quoted by Richard Dorment in Dorment and MacDonald: 179]

128. William H. Bradley, 1868–1962

The Chap Book ("Pegasus"), 1895
Color lithograph on wove paper, 19⅞ x 13⅜ inches (image)
Hood Museum of Art, Dartmouth College; PS.973.30

The development of commercial color lithography helped to spur the widespread production of colorful, stylish posters at the turn of the twentieth century. The "poster craze," which took hold initially in Paris and soon spread throughout Europe and the United States, offered an important creative outlet and source of income for some of the leading artists and graphic designers of the period. In order to create bold, eyecatching designs, artists drew from a range of contemporary stylistic trends, including art nouveau, the Arts and Crafts aesthetic, symbolism, and the large unbroken planes of color, asymmetrically cropped compositions, and stylization of form associated with Japanese prints.

One of the most adept American poster designers, Will Bradley established his reputation in 1894 with twelve cover designs for Chicago's *Inland Printer,* a journal for the printing trade. That same year he produced the first poster for *The Chap Book,* which began by promoting books issued by its Chicago publisher, Stone

and Kimball, and quickly developed into an important small literary magazine. This is Bradley's sixth *Chap Book* cover and one of his most complex compositions. Whereas many of his designs exhibit the sweeping, curvilinear lines of art nouveau, the medieval imagery of the red knight (upon which is superimposed a black Pegasus at the upper right) and allover ornamental patterning of this poster owe more to the Arts and Crafts movement. In the face of late-nineteenth-century mass production of decorative goods, proponents of the Arts and Crafts movement held in particularly high regard the strong handcraft guilds, literary and printing traditions, and flattened, stylized approach to design associated with the medieval period.

The Hood Museum of Art has extensive holdings of posters from the 1890s as well as posters relating to World War I and World War II.

129. Edna Boies Hopkins, 1872–1937

Datura, c. 1910

Color woodcut on wove paper, 10⅞ x 7⅜ inches (image)
Purchased through the Virginia and Preston T. Kelsey
1958 Fund; PR.997.47.1

The introduction of Japanese color woodblock prints to Western markets in the latter half of the nineteenth century exerted a tremendous influence in European and American art. The impact of their asymmetrical, tightly cropped compositions and stylized forms was perhaps nowhere more direct, however, than in the resulting genesis of a vital Western practice of color woodblock printmaking. Edna Boies Hopkins participated actively in this tradition, which she came to through a key American practitioner of the medium and proponent of Japanese design principles, Arthur Wesley Dow, with whom she studied at New York's Pratt Institute in 1899. She further developed her enthusiasm for Japanese art and culture through an extended stay in Japan in 1904.

This image is typical of Hopkins's early color woodblock prints in its monumental, asymmetrical presentation of a single blossom, a portion of which is cut off along one edge of the composition. In the Japanese tradition she applied her personal seal or "chop"—a stylized peapod—in the lower left corner. Her translucent watercolor pigments allowed the grain of the woodblocks (one for each color) to appear on the pellucid impressions, adding subtle texture and tonal variation. As she wrote, "The most important part of the process is the printing, which is done on moist paper with watercolors. The ink or color is applied with a brush, and printing effected by hand pressure. . . . By varying the depth of the color, the degree of moisture with which it was applied to the block, the degree of pressure and the use of paper of greater or less absorbent quality, it was possible to obtain tones so subtle, varying and transparent that no wash of watercolor laid on with a brush could approach them."
[Mary Ryan Gallery 1986: 2 (quotation)]

130. Childe Hassam, 1859–1935

Washington's Birthday—5th Avenue and 23rd Street, 1916

Etching on wove paper, 12⅞ x 7 inches (plate)
Gift of Mrs. Hersey Egginton in memory of her son,
Everett Egginton, Class of 1921; PR.954.20.237

The impressionist painter Childe Hassam was one of the first academically trained American artists to turn to New York subjects in the late nineteenth century, and from early on he took a special interest in daily life along one of the city's most majestic thoroughfares, Fifth Avenue. Between 1916 and 1919, Hassam created a series of about a dozen paintings of the avenue decked with flags of the Allies during World War I. In 1915, in the midst of a successful career as a painter, Hassam began to exhibit etchings and drypoints as well, which he continued to make throughout the remainder of his life. In this, one of his most admired etchings and the print most closely related to his flag paintings, he expresses in a graphic medium the impressionist interest in light, movement, and atmo-

sphere more commonly applied to rural subjects. As the critic Royal Cortissoz noted in 1925, Hassam's etchings convey "his painter-like feeling, which transmutes into black and white much of both the body and subtlety of color." The famed Flatiron Building anchors the composition in the distance, yet the diffuse light softens the skyscraper's architectural details and gives the scene a romantic, otherworldly character. The atmospheric approach also relates to the soft-focus pictorialist photographs of urban subjects from the early twentieth century, particularly Edward Steichen's famous 1905 view of the Flatiron Building from a nearly identical vantage point. [Cortissoz 1925: vii]

131. Howard Norton Cook,
1901–1980

Chrysler Building (Chrysler Building in Construction), 1930

Wood engraving on Japanese paper,
10⅛ x 6¹¹⁄₁₆ inches (image)
Purchased through a gift from the Estate of
Russell Cowles, Class of 1909, and by
exchange; PR.990.48

Although printmaker Howard Cook traveled extensively, he had a special fascination for the serrated skyline of New York, which he believed to be the most exciting modern city in the world. In this view of the Chrysler Building, Cook's vantage point accentuates the lofty presence of the skyscraper (shown still under construction, before the addition of its art deco crown) and the sharp-edged profiles of surrounding buildings, creating a complex configuration of stacked rectangular blocks. The glow that radiates from its tower suggests that the building is charged with all of the dynamism associated with the metropolis, but the inward tilting structures, absence of human life, and stark contrast between lights and darks give the work a somewhat menacing edge that contrasts with some of the more celebratory images of urban life by the so-called precisionist artists (cat. 63).

The Chrysler Building was an icon of New York and of the art deco style. For a few months the 1,048-foot office tower, designed by William Van Alen, was also the tallest building in the world, until the completion of the Empire State Building in 1931. [Duffy and Duffy 1984]

132. George Wesley Bellows, 1882–1925

Solitude, 1917

Lithograph on thin tissue, 17¼ x 15⅜ inches (image)
Purchased through the Class of 1935 Memorial Fund; PR.987.23

Around 1916, urban realist painter George Bellows (cat. 112) began to add lithography to his artistic repertoire. He used the print medium not only for his characteristic views of quotidian urban life, including his famous boxing images, but also for portraits, nudes, and a series of searing commentaries on war atrocities. Until 1919, Bellows produced lithographs with the technical assistance of George Miller, who had extensive experience as a commercial printer and, after his initial work with Bellows, began to aid other artists wishing to work in the medium. Between 1916 and his death in 1925, Bellows produced almost two hundred images on stone and eight thousand impressions. Together with Miller, he played an influential role in reviving lithography as an artistic medium.

Bellows described this print, his only nocturne in lithography, as

"Central Park on a Spring night. Love genuine and make believe." The title *Solitude,* however, draws the viewer's attention away from the prominent couple at center to the solitary man to the far left, whose isolation is especially poignant amidst the congregation of embracing couples. The lithographic medium effectively conveys the rich tonalities and atmospheric effects of this nocturne, softly illuminated by street lights. To achieve middle values, Bellows employed lighter applications of crayon and the very selective use of a subtractive method. He scratched through passages of the lithographic crayon with a sharp tool, creating fine networks of hatched white lines, seen especially on the face and torso of the central woman. As he often did, Bellows based this print on an earlier drawing, in this case *The Strugglers,* 1913 (Boston Public Library), which had been published in the socialist magazine *The Masses* in June of that year. [Myers and Ayres 1988]

162

133. Edward Hopper, 1882–1967

Evening Wind, 1921

Etching on wove paper, 6⅞ x 8¼ inches (plate)
Purchased through the Julia L. Whittier Fund; PR.956.26.5

One of the most admired artists of the twentieth century, Edward Hopper is renowned for his evocative paintings of lone, seemingly alienated figures in urban settings. He received his primary artistic instruction from Robert Henri (cats. 58, 114) and Kenneth Hayes Miller at the New York School of Art from 1900 to 1906. While trying to develop his reputation as a painter over the next few years, he earned his living as a commercial magazine illustrator and made several trips to Europe to study the old masters and the impressionists. With the technical assistance of his printmaking friend Martin Lewis, Hopper took up etching in 1915 and eventually produced about seventy etchings and drypoints. It was not his paintings but his prints that brought Hopper his earliest public recognition. They depict scenes common to his paintings—landscapes, nudes, interiors, and coastal subjects—and are often endowed with a similar sense of solitude and the passage of time.

As is evident in *Evening Wind* and many of his interiors, Hopper was drawn to windows and other liminal spaces that mediate indoors and outdoors, the private and public realms. While the window in this spare composition suggests exteriority on the one hand, its stark whiteness offers not the barest glimpse of the outside world. It instead acts more like a mirror for the figure's contemplation or a blank screen for her imaginative projections. Propelled by an evening breeze, the curtains billow into the room, suggesting a spiritlike presence emanating from beyond. Intensifying the unsettling mood, the nude's thick dark hair obscures her face, giving no hint of her features or emotions. Hopper's characteristic use of the blackest inks and whitest papers available heightens the visual and psychological impact of *Evening Wind*. While still a relatively early work, it exhibits the artist's signature reductive realism and detached, introspective mood. [Hollander 1981; Levin 1979]

163

134. Thomas Hart Benton, 1889–1975

Jesse James, 1936

Lithograph on wove paper, 16¼ x 21⅞ inches (image)
Gift of Robert McGrath; PR.973.240
Art © T. H. Benton and R. P. Benton Testamentary Trust / UMB Bank
Trustee / Licensed by VAGA, New York, NY

While American art has long concerned itself with issues of national identity, at no time was this focus more apparent than in the art of the 1930s. Widespread poverty, drought, and escalating political tensions abroad gave a greater sense of urgency to the quest to identify archetypal American themes and promote them through the arts. Many artists rejected modernist abstraction as being too elitist, too tied to its foreign origins, and too removed from the exigencies of contemporary life to serve this mission and speak to the issues of the day. They sought instead to create a more "democratic" art, using representational imagery of identifiably American subjects that would be meaningful to a wide audience. Consequently, large-scale murals for public buildings and large-edition, highly affordable prints were the favored media of the so-called regionalist artists, who felt that America's identity was rooted in its rural, regional traditions rather than its modern, homogeneous, corporate identity.

Thomas Hart Benton, along with Grant Wood (cats. 70, 135), was among the foremost midwestern regionalists. This print derives from one section of his famous Missouri State Capitol murals, which chronicle significant events in the state's social history. Here he drew on one of the state's most notorious outlaws, Jesse James, whom some hailed as a Robin Hood figure. This composition conflates two different robberies committed by James and his brothers—one of a railroad and the other of a smalltown bank. Jesse, in particular, became a hero of American folklore and inspired the classic "Jesse James" musical ballad, written soon after his assassination in 1882 and popular to this day. Benton's image initially sparked controversy, as not everyone in Missouri wished to be remembered for bandits, but it has come to be treasured as a key image in one of the artist's most significant mural series. [Fath 1979]

135. Grant Wood, 1892–1942

January, 1938

Lithograph on wove paper, 9 x 11⅞ inches (image)
Purchased through the Julia L. Whittier Fund; PR.938.4
Art © Estate of Grant Wood / Licensed by VAGA, New York, NY

This lithograph, like that by Thomas Hart Benton (cat. 134), is a result of one of the Great Depression's most innovative and successful print publishing ventures. Fed by a desire to make fine art more readily available to a cash-strapped populace, the Associated American Artists in New York, founded by Reeves Lewenthal and Maurice Liederman, paid American scene artists to create lithographs that would be marketed via department store and mail order sales generally for five dollars apiece. Like many of his colleagues, Grant Wood (cat. 70), the best known of the American regionalists, welcomed the income and endorsed the populist ideal of bringing art into the homes of average Americans. This is one of nineteen lithographs he produced for the initiative over four years; it was printed by master printmaker George C. Miller (see cat. 132).

Particularly famous for his painting *American Gothic* (1930, Art Institute of Chicago) and his painstakingly precise views of agrarian life, Grant Wood spent most of his life living and working in Iowa. In this print Wood expresses the hushed stillness of Iowa's cornfields during the depths of winter, when both the farmers and the land are given a respite from activity. The only sign of recent movement is the line of tracks left by a rabbit that evidently sought shelter in a snug corn shock. Wood's love of pattern is revealed in the precise rows of soldierlike shocks and the rabbit tracks repeating endlessly into the distance. The rhythm of the seasons and their effect on the midwestern landscape and rural life were important themes in Wood's work. [Flint 1981]

136. Stow Wengenroth, 1906–1978

Manhattan Gateway, 1948

Lithograph on wove paper, 24½ x 20%16 inches (image)
Purchased through the Julia L. Whittier Fund; PR.949.89

Stow Wengenroth was one of the most masterful crayon lithographers of his generation. He was born in Brooklyn, raised in Bayport, Long Island, and educated at the Art Students League (1923–25) and the Grand Central School of Art (1925–27) in New York City. He made his first lithographs in 1931, based on drawings he had made at the Eastport Summer School of Art in Maine the previous two summers. He settled in Manhattan in order to be close to his talented printer George Miller (cat. 132) but returned to the New England coast, and especially Maine, for summers thereafter. Aside from his several New York City images, coastal subjects made up the largest portion of his oeuvre. Wengenroth helped to popularize lithography through both his works, which were widely exhibited and published, and his writings. His prints are especially admired for their assured draftsmanship and subtle tonal gradations, which accentuate the granular surface of the lithographic stone.

In this print Wengenroth portrays one of the most historic landmarks of New York City, the Brooklyn Bridge, which was designed by John A. Roebling and opened in 1883. His partial view of the bridge does not accentuate, however, the monumental elements of the structure, such as the height of its great arches or the span of its cables, but rather the textural details that would be experienced by the pedestrian: the play of streetlights on its rusticated piers and the glow of the nighttime skyline in the distance. By the time the artist executed this print, the Brooklyn Bridge served less as a resonant symbol of the new age than as a testament to the technical achievements of the past. In this peaceful, pristinely rendered image Wengenroth approaches his subject with the sort of quiet reverence usually accorded a historic monument. [Stuckey et al. 1974]

137. Jolán Gross-Bettelheim, 1900–1972

Furnaces (Smeltery), about 1947

Lithograph on wove paper, 17½ x 13⅞ inches (image)
Purchased through a gift from the Cremer Foundation in memory of J. Theodor Cremer; PR.991.11

Although completed considerably later than the pioneering work of such precisionist artists as Preston Dickinson (cat. 63) and Charles Sheeler, this lithograph shares their interest in conveying the dynamism of modern industry. The print's forceful composition is structured on intersecting diagonals and features monumental, highly stylized imagery relating to industry, communication, and transportation. Whereas Dickinson can be viewed as embracing such technological "advances" wholeheartedly, the row of faceless, humanoid furnaces in Gross-Bettelheim's work suggests a darker reading of her imagery, one colored perhaps by her leftist leanings and the experience of the recent world war in Europe.

Jolán Gross-Bettelheim was born in Hungary. Following studies in Vienna, Berlin, and Paris, she moved with her Hungarian American husband to Cleveland in 1925 and exhibited her work in that city and in Chicago. By the 1940s she was living in New York City,

where her artistic activities and allegiances are less well documented. Her distinctive style, with its strong contrasts, emphatic lines of force, and multiple perspectives, appears to draw from various international sources, ranging from futurism, cubism, and expressionism to Russian constructivism. Whereas Gross-Bettelheim had worked in painting and pastel while abroad, she turned more to printmaking in the 1930s and 1940s. She made about forty prints, primarily lithographs that accentuate the dehumanizing aspects of labor, industry, the war economy, and urbanization. Like many artists of her era, she was a member of the Communist Party and the John Reed Club. She also signed the first call for the American Artists' Congress and published her images in the *New Masses.* With the rising conservative politics of the 1950s and the sudden death of her husband, Gross-Bettelheim returned to Hungary in 1956, where she remained for the rest of her life. [Hegyi 1988; Stamey 2001]

ACTUAL SIZE

138. Southworth & Hawes (Albert Sands Southworth, 1811–1894, and Josiah Johnson Hawes, 1808–1901), active 1843–1861

Daniel Webster, April 22, 1850

Daguerreotype, ninth plate, 2⅜ x 2 inches
Gift of the artists, PH.856.2

Albert Sands Southworth and Josiah Johnson opened a daguerreotype portrait studio together in Boston in 1843—just a few years after the daguerreotype process arrived in the United States—and quickly became the favored photographers of celebrities. Before the invention of the daguerreotype, the social elite depended on portrait painters to immortalize their eminences. The new medium, however, allowed those of distinction and wealth—as well as the middle classes—to obtain realistic likenesses in short order. Unlike many studios working in the nascence of daguerreotype technology, Southworth & Hawes considered their work high art. They used nuanced lighting and highly individualized poses to create likenesses that were accurate, sympathetic, and visually satisfying.

Southworth and Hawes donated this daguerreotype of Daniel Webster (cats. 7, 14, 87, 165, 194) to the College in 1850, already recognizing by this date his historical importance to Dartmouth. Like other photographs of Webster, this image formed the basis of portraits of the statesman in other media, many of which would also find their way to Dartmouth. Its distinctive full-profile view, taken at close range, emphasizes Webster's large cranium, nobly bald pate, and commanding presence, as he stares into the distance with the serious expression expected of a distinguished statesman. Webster was known by the public for his large head and significant brow, both indicators of strong intelligence in the age of phrenology—the "science" developed in the mid- to late eighteenth century that studied the shape of the head in order to determine a person's character traits. Such compelling and technically accomplished portraits as this fulfilled the desire of a consuming public for unfeigned visual representations of the famous, while allowing the sitter to reveal, in the concreteness of the daguerreotype, the "inner character" of his or her being. [Romer and Wallis 2005; Sobieszek 2000]

139. George N. Barnard, 1819–1902

City of Atlanta, Ga., No. 2, c. 1865
Albumen print, 10⅛ x 14¼ inches (image)
Purchased through the Julia L. Whittier Fund; PH.999.48.4

Beginning in 1861, only a few decades after the popular introduction of the photographic process, the American Civil War was the first war to be photographed intensively from start to finish. For American families who had loved ones involved in the war, photographs enabled an unprecedented encounter with horrifically vivid images of the front lines of battle. Moreover, the public perception of photographs as an unmediated presentation of reality fueled the desire to "factually" record the conflict through photography.

George Barnard originally recorded the war while employed by the well-known photographic entrepreneur Mathew Brady, but he left Brady's studio in 1863 to pursue independent work. As a U.S. Army photographer for the Division of the Mississippi, Barnard accompanied General William T. Sherman on much of his 1864 March to the Sea, which was later acknowledged as one of the largest military victories in American history. Soon after, Barnard deduced that there would be interest in photographs of Sherman's march and published a series of his works in an 1866 album entitled *Photographic Views of the Sherman Campaign*. Rushed by Sherman's breakneck speed and possibly disturbed by the violence of the campaign, Barnard took many of the album's images during repeat visits to the region. This ghostly image of a nearly abandoned downtown area of Atlanta dates to sometime between the city's 1864 capture and 1866. The faint traces of train tracks and the bombed-out shells of buildings suggest the previous violence, in contrast to the city's incongruously peaceful landscape setting. The eerie light cast over the scene by Barnard's careful use of double-printed clouds (clouds from another negative printed directly on the existing photograph) signals the photographer's desire to present his photos as works of aesthetic, as well as historical, merit. Barnard's visually complex and poignant views of battlefields and ruined cities appealed to viewers for their haunting aesthetic beauty as well as their commemoration of the nation's devastating civil conflict. [Bailey 2003: 91; Davis 1990]

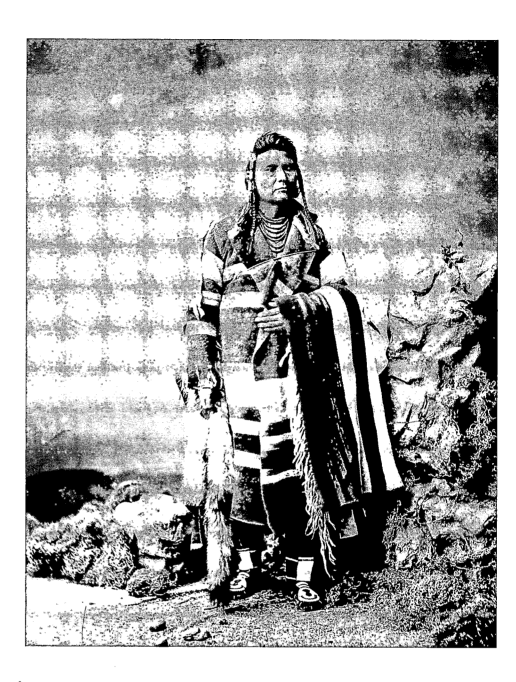

140. Charles Milton Bell,
1848–1893, formerly attributed
to William Henry Jackson,
1843–1942

Chief Joseph of the Nez Perce,
January 1879
Albumen print, 19⅞ x 15⁵⁄₁₆ inches
Gift of Mrs. William M. Leeds; 13.13.25440

Although many American prints and paintings depicted Native Americans in the early nineteenth century, photography took precedence over these mediums beginning in the 1850s as dozens of Native American delegations visited the nation's capital during a period of Indian treaties and land negotiations. Charles Milton Bell was one of several Washington studio photographers who documented Native American dignitaries. He took some of these portraits for his own commercial purposes but produced the majority for the Smithsonian Institution and Ferdinand V. Hayden of the U.S. Geological Survey of the Territories.

This image depicts Hinmaton Yalakit of the Nez Perce, also known as "Chief Joseph" to European Americans. Forced to move from their native lands in Oregon to a reservation in Idaho in violation of existing treaties, the Nez Perce, under the leadership of Hinmaton Yalakit, waged an 1877 war against the federal government. The tribe was eventually coerced to surrender and was sent

to prison, where many died, including Hinmaton Yalakit's six children. Months later, the leader pleaded his case to President Rutherford B. Hayes and was hosted in Washington, D.C., by William M. Leeds, a clerk of the Indian Bureau who would resign during the dignitary's visit.

Mrs. Leeds gave this photograph to Dartmouth in 1913, after her husband's death. It pictures Hinmaton Yalakit amidst the papier-mâché rocks of Bell's studio, wearing characteristic high-ranking Nez Perce clothing and looking defiantly into the distance. Mrs. Leeds noted in her inscription on the photograph that while in Washington, "Chief Joseph" delivered "a thrilling address upon the wrongs suffered by his people." He is often quoted as saying on that occasion, "I have asked some of the Great White Chiefs where they get their authority to say to the Indian that he shall stay in one place, while he sees white men going where they please. They cannot tell me." [Collins 1989: 14–16; Hampton 1994]

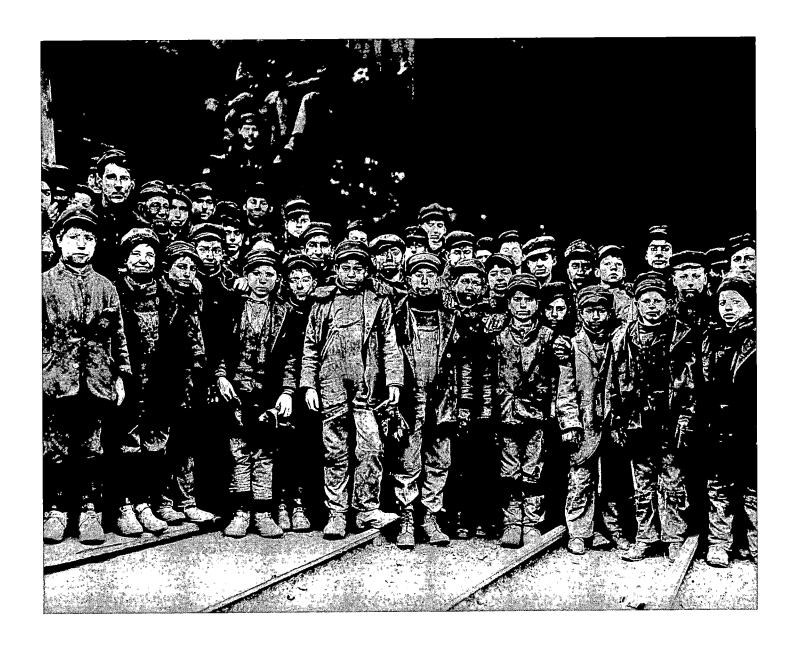

141. Lewis Wickes Hine, 1874–1940

Breaker Boys, 1911; print 1911–30

Gelatin silver print, 7¼ x 9⅞₆ inches
Purchased through the Katharine T. and Merrill G. Beede
1929 Fund; 2005.12

Around the turn of the twentieth century, America was home to a merciless economic system that trapped unskilled and uneducated workers in low-paying jobs. It was in this climate that Lewis Hine began his photographic career with the progressivist aim of calling attention to social injustice. After finishing a degree in sociology, Hine began to study urban economic and social conditions by recording the arrival of immigrants at Ellis Island. These photographs encouraged the National Child Labor Committee (NCLC) to hire Hine in 1906 to document the illegal work of young children as part of their campaign to depict child labor as unsafe and morally unfit for children.

Hines photographed *Breaker Boys* during one of his lengthy travels through the coalmining region of eastern Pennsylvania for the NCLC. The so-called breaker boys worked outside the mines in a constant cloud of coal dust, picking out slate and refuse from the broken and washed coal. There was a tacit understanding among those employed in the coal industry that the job in the coal breaker was the most dangerous of all mining occupations. According to coroner reports, there were more deaths among breaker boys than inside a mine itself. The boys in this image stand somberly, covered in coal dust and clad in clothes that are too large for their young bodies. Clumped together, each boy's individual character is subsumed into the misery of the whole. Hine crops his photograph as if the group continues on each side, which serves as a reminder of the magnitude of the child labor problem. Hine's photographs and writings shocked and angered the American public, resulting in swifter government action and the passage of stricter laws banning the employment of underage children. [Freedman 1998; Panzer 2002]

142. Ralph Steiner, 1899–1986

Typewriter Keys, 1921–22; print
c. early 1970s
Gelatin silver print, 8⅛ x 6⅛ inches
Purchased through the Harry Shafer Fisher
1966 Memorial Fund; PH.975.34
Courtesy Ralph Steiner Estate

Ralph Steiner began his photographic career at Dartmouth College, where he took informal photography classes under the tutelage of a biology professor. Shortly after graduating in 1921 and publishing a collection of images of the campus and its surroundings, he obtained more formal training at the well-known Clarence H. White School of Photography in New York City. Steiner originally chafed at what he perceived to be the school's rules and formulae for proper composition. Nonetheless, White's attention to shape and line encouraged the development of Steiner's modernist aesthetic, which imbued his early work as a photographer and filmmaker.

Despite this photograph's banal function as a design exercise in White's school, *Typewriter Keys* is representative of Steiner's photographs from the 1920s, which emphasize the formal complexities of everyday objects and scenes. Like other photographers working in the early twentieth century, especially Paul Strand, Steiner isolated elements of machines, street scenes, buildings, and advertisements for compositional effect. Here, the anonymous design of a typewriter is rendered almost abstract by Steiner's extreme close-up vantage point, emphasis on geometric forms, and stark contrasts between lights and darks. His peopled street scenes from the same period use similar techniques to create a visual conversation between organic and mechanical forms—an approach that influenced later "straight" photography.

Steiner moved from New York City to Thetford, Vermont, in the early 1970s, and Dartmouth held exhibitions of his work in 1975 and in 1979, when he served as artist-in-residence. In 1986, just before his death, Steiner guest-curated the Hood exhibition *In Spite of Everything, Yes*. This collection of over one hundred life-affirming photographs by other artists reflected the more emotive, celebratory approach Steiner took toward his own art later in life. [Steiner 1922, 1978, 1979]

143. Laura Gilpin, 1891–1979

Indian Bake Ovens, Taos,
September 26, 1926

Platinum print, 8¾ x 6¾ inches
Gift of Dr. and Mrs. Calvin Fisher,
Class of 1932; PH.982.51.6
© 1979 Amon Carter Museum,
Fort Worth, Texas

A distant relative of the explorer William Gilpin and the niece of William Henry Jackson, Laura Gilpin first became familiar with photography through these familial relationships. In 1916 she left her native Colorado for New York City to study at the Clarence White School of Photography. White emphasized strong principles of modern design combined with a painterly, emotionally expressive approach to photography associated with the pictorialist aesthetic. Gilpin applied many of White's lessons to photographing the Southwest after she returned to Colorado in 1917. Like many American artists of her generation, including Georgia O'Keeffe (cat. 65), Gilpin was drawn to the sculptural forms of the southwestern landscape and its Native American art and architecture, as well as the exotic "difference" of Native American cultures.

Although in her later career Gilpin moved toward the harder lines of "straight" photography, in her earlier work, such as this photograph, the romantic soft-focus influence of her pictorialist training is clear. The diagonal play of light and dark angles in the photograph offsets the soft, almost bodily curves of the bread ovens and adobe buildings. For Gilpin, photographing Native Americans and their architecture was a way of getting close to a people who she felt had a more meaningful set of histories and traditions than her own. While Gilpin's attitude could be seen as patronizing, she believed the landscape played a powerful role in the lives of its people and understood her photography as a record of the relationship between the material culture of Native Americans and the land that inspired them. This photograph was given by Gilpin to Mr. and Mrs. Arthur Fisher, for whom she worked in the mid-1920s, recording the architecture of the prominent Fisher and Fisher firm of Denver, Colorado. [Norwood and Monk 1997; Sandweiss 1986]

144. James Van Der Zee,
1886–1983

*At Home (Woman with
Flower Baskets)*, 1934

Gelatin silver print, 9½ x 7½ inches
Purchased through the Harry Shafer
Fisher 1966 Memorial Fund;
PH.986.47

Self-taught in his craft, James Van Der Zee was raised in Lenox, Massachusetts, and opened his first photography studio in 1916 on 135th Street in Harlem. Working in other Harlem locations over the next fifty years, he created innumerable studio portraits of middle- and upper-class African Americans and community luminaries and documented such social events as parades, weddings, and funerals. Van Der Zee was known for the careful attention he took to ensure that each customer was well-dressed and posed with props that captured his or her distinct personality and sense of personal pride. In addition to their function as rich social documents, the resulting highly individualized and celebratory portraits helped to counteract the stereotypical and damaging depictions of Harlem and African Americans that were prevalent during this time.

This photograph depicts Josephine Becton, widow of George Wilson Becton (1890–1933), one of the most charismatic evange-

lists in Harlem during the 1920s and early 1930s. Through his fiery sermons Becton attracted thousands to his World Gospel Feast Party, Inc., and exhorted his parishioners to contribute a dime a day to the cause. His resulting wealth enabled him to acquire extensive real estate holdings throughout Harlem, but he was gunned down in 1933 by gangsters in Philadelphia because of his pulpit indictments of gambling rackets. His widow, known as a medium, mystic, and philanthropist, established the Becton Spiritualist Chapel as a memorial to her husband. Taken a year after her husband died, this photograph shows her well-dressed and seated at the piano in their apartment, which was legendary for its luxuriousness. The upholstered furniture, silver tea service, baskets of flowers, and large open box of chocolates complete the sense of abundance, while her proud and pleased expression would seem to suggest a happy occasion. [Greenberg 1997; Willis 1993; Wintz and Finkelman 2004]

174

145. Dorothea Lange, 1895–1965

White Angel Breadline, San Francisco, 1932; print 1940s

Gelatin silver enlargement print,
13⅞₁₆ x 10½ inches
Purchased through gifts from the
Class of 1955; 2005.14
© Dorothea Lange Collection, the Oakland
Museum of California, City of Oakland.
Gift of Paul S. Taylor.

White Angel Breadline marks a key turning point in the career of Dorothea Lange. Throughout the 1920s, Lange focused mainly on portraiture for a wealthy clientele. Following the onset of the Great Depression, she became increasingly aware of America's failing system of distributive justice and turned to the poor, hungry, and depressed as her subject matter. Labor demonstrations and breadlines that formed in her San Francisco neighborhood first compelled Lange to work outside the studio. She took this photograph in 1932 on her first day in the streets, as part of an initial attempt at social realism. It marked her move away from the studio and toward a career as a documentary photographer.

The so-called White Angel Breadline was named to honor its publicly anonymous founder. The breadline's sponsor earned the sobriquet "White Angel" for her charity and generosity in the establishment of a food service in San Francisco to aid those unable to afford sustenance. In this image Lange focuses on one poverty-stricken man, his arms wrapped around a food cup and his hands clasped together almost as if in prayer. He is the one person in the picture facing the viewer, and his light-colored hat draws us to the face, cup, and hands. His obscured eyes, however, and the rails in front of him bar us from entering his world and deny any specific identification. He thus becomes a universal symbol for suffering and an iconic example of Lange's extraordinary ability to convey a visual language of physical weariness. This photograph brought Lange cultural and popular acclaim and encouraged the Farm Security Administration to hire her as one of its photographers from 1935 to 1942. [Borhan 2002]

146. Walker Evans, 1903–1975

Stables, Natchez, Mississippi,
1935; print by 1973
Gelatin silver print, 10 x 8 inches
Purchased through the Harry Shafer Fisher
1966 Memorial Fund; PH.973.5

Walker Evans took this 1935 photograph during a pivotal time in his career, his first extended photographic expedition through the American South. Through this and subsequent trips to the region—many of them under the auspices of the New Deal's Resettlement Administration and Farm Security Administration—Evans created his most famous, psychologically resonant works. These included hauntingly beautiful images of vernacular buildings and objects that characterized what he termed a "lyric documentary" style. He achieved this unsentimental, yet poignant, manner through carefully crafted compositions, a keen awareness of light and shadow, and the consistent use of a frontal, eye-level vantage point that minimized the presence of the artist.

Evans's two-month 1935 tour was commissioned by wealthy businessman Gifford Cochran, who hired him to photograph southern Greek revival architecture for a book that never materialized. Evans frequently diverged from his official subject, as seen in this image of the peeling façade of a livery in Natchez, Mississippi. The deliberate flattening of the subject matter accentuates the basic geometry of the façade's unusual fenestration while providing a detailed view of its distinctive handpainted signs. Evans's focus on signage and architecture and his penchant for visual crispness would become persistent characteristics of his influential oeuvre. While he did take photographs of people, he preferred to trace the bits of human history and life found in such inanimate built environments. Some have labeled his approach cold or detached, but these photographs work in much the same way as Edward Hopper's paintings of deserted streets, poetically reflecting the concerns and lives of his unseen human subjects with exceptional economy.

Dartmouth College purchased this photograph from the artist in 1973, following his term as artist-in-residence the previous fall. [Hambourg et al. 2000; McDannell 2004]

147. Berenice Abbott, 1898–1991

Talman Street #57–61, Brooklyn, N.Y., 1936

Gelatin silver print, 8 x 10 inches
Purchased by funds made available through a gift from the Estates of
Lulu C. and Robert L. Coller, Class of 1923; PH.988.37

In 1929, Berenice Abbott, formerly a portrait photographer, re-
turned from an eight-year stay in Europe consumed by a passion to
document New York, which had undergone a dramatic transforma-
tion in her absence. She received much-needed financial support
for her mission in 1935 through the Federal Art Project, a division
of the Works Progress Administration. Abbott took an expansive,
Whitmanesque view of her subject: "Everything in the city is prop-
erly part of its story—its physical body of brick, stone, steel, glass,
wood, its lifeblood of living, breathing men and women." The pub-
lication of the project's final product, a 1939 book entitled *Chang-
ing New York,* offered a rich and detailed contemplation of the city's

modern evolution. It also provided factual information to city plan-
ners and functioned as a thorough "archeological" record for the
future.

This photograph, which did not appear in the book, depicts a
portion of Talman Street in a lower-class neighborhood in Brook-
lyn. Often referred to as "Irishtown," this neighborhood began at-
tracting African Americans during the Depression. While racial
tensions were common in other parts of Brooklyn, there was report-
edly little resistance to people of color in this neighborhood, as is
suggested by the African American man and white woman standing
together in the doorway. Through the slow and deliberate process
of large-format photography, Abbott juxtaposes rundown nine-
teenth-century tenements with an industrial façade painted with
an oversized, cartoonlike billboard. This discordant contrast of old
and new appears frequently in Abbott's unsentimental observations
of a rapidly changing New York City. [Abbott cited in Van Haaften
1989: 26; Yochelson 1997]

177

148. Margaret Bourke-White, 1904–1971

The American Way, 1937; print before 1971
Gelatin silver print, 9¾ x 13½ inches
Purchased through the Harry Shafer Fisher 1966 Memorial Fund;
PH.972.65

Margaret Bourke-White was a photojournalist for both *Fortune* and *Life* magazines during the 1930s and 1940s; in fact, one of her photographs graced the cover of the inaugural issue of *Life* in 1936. Taking the photodocumentary approach of such Farm Security Administration photographers as Dorothea Lange (cat. 145) and Walker Evans (cat. 146), Bourke-White typically added a stylized, journalistic element to her images, which came to characterize the visual approach of the mass-circulation picture magazines that proliferated in the 1940s and 1950s.

This comparatively "straight" photograph varies from much of Bourke-White's more dramatic magazine work, which often aggrandized industrial subjects through the use of unusual vantage points, and it appealed to a depression-era public eager for the concreteness of photo reportage. In January 1937 the Ohio River flooded, killing or injuring nine hundred people in one of the worst natural disasters in American history. Bourke-White was sent by the editors of *Life* to document the damage in the devastated city of Louisville, Kentucky, and the resulting photographs ran as the magazine's lead story. Here, a seemingly never-ending line of working- and middle-class black men and women line up at a flood relief center before a billboard of a smiling white family. The straight-on composition and sharp cropping of the photograph isolate the figures from any distracting details and enable an easy juxtaposition between the saccharine subject of the billboard and the horizontal line of people below. Bourke-White's negatives confirm that she shot this scene several times, rearranging her subjects until she felt that she had most effectively framed the visual tension and glaring irony of the situation. While the photograph is not a representation of unemployment or welfare, it is one of Bourke-White's most iconic images and is frequently employed to illustrate poverty and inequality. [Brown 1972; Goldberg 1986]

149. Mike Disfarmer, 1884–1959

Homer, Laura, and Alton Jackson,
1940
Gelatin silver print, 5⅜ x 3⅜ inches
Gift of Harley and Stephen S. Osman,
Class of 1956, Tuck 1957; 2005.83.17

The reclusive Arkansas photographer Mike Meyer grew up in rural Arkansas in a family of German immigrants. Because the modern German *Meier* means "dairy farmer," Meyer legally changed his surname to "Disfarmer" in an attempted linguistic rejection of his heritage and the Arkansas farming community of Heber Springs, where he worked for forty years. Disfarmer reputedly believed that he had been switched at birth and originally was of a much higher and more cultured class of people than the Meyers and his fellow townspeople. Despite his eccentricity and attempts to distance himself, he became a prominent photographer in his local community. In his posthumous fame, he is best known for hauntingly direct studio images from the late 1930s and early 1940s that capture the awkwardness and human frailties of ordinary people facing hard times and the onset of World War II.

Disfarmer did not seek to create glamorous celebrity portraits or document the plight of the rural poor in the manner of his Farm Security Administration contemporaries. Instead, for fifty cents a sitting he posed his neighbors in everyday garb against stark backgrounds. He often labored long to create the right lighting and composition, but as one subject recalled, "Instead of telling you to smile, he just took the picture. No cheese or anything." Here a young farmer and his wife have not even removed their overcoats as they stand with their baby before a plain, dark backdrop. The husband's sober, penetrating gaze suggests that their happiness as new parents may be mitigated by workaday concerns. This vintage photograph—one of the eighty Disfarmer photographs recently donated to the museum—was printed as a postcard and inscribed: "From Laura and Family to Amy and / Family. With Love. Made Feb. 26, 1940." [Houk et al. 2005]

179

150. George Hurrell, 1904–1992

Joan Crawford, about 1932

Gelatin silver print, 9¼ x 7¹³⁄₁₆ inches
Gift of Robert Dance, Class of 1977, in honor
of Maurice Rapf, Class of 1935; PH.2001.29.2
Courtesy of HurrellPhotos.com

In the late 1920s, George Hurrell opened a portrait studio in Los Angeles, where his ability to bring out the glamour and sex appeal in socialite mavens and fledgling movie stars quickly drew the attention of the Hollywood movie studios. Over the next decades, Hurrell worked for MGM, Warner Brothers, and Columbia, taking glamorous portraits of their major stars and then mass-producing these images to be used worldwide for magazines, newspapers, cinema displays, and fan mailings. By accompanying these photographs with titillating stories, studios were able to generate public interest with minimal money. While appealing to a depression-era public hungry for luxury and dreamy escapism from the brutal social reality, studio photography also allowed the public to stay in touch with the latest fashions of the stars.

Joan Crawford was reputedly Hurrell's favorite subject. Her long-running appearance in his photographs was also fueled in part by her own fear that she had to provide fans with a steady stream of images of herself in an infinite variety of poses and dress or lose public interest. This photograph is a publicity still made for Crawford's 1934 film *Sadie McKee.* Here, Hurrell has carefully lit Crawford's face to play with shadow and create skin so perfected and glossy that it almost resembles wax. Hurrell also pays close attention to Crawford's wardrobe, emphasizing the graphic contrast of black and white and mimicking the herringbone texture of the shirt in the placement of her hands. The photograph typifies Hurrell's close-up and highly stylized portraits, polished clean of any imperfections. The overall effect of this and other Hurrell portraits was the creation of an otherworldly but surprisingly accessible Hollywood star on which an infatuated public could project their own fantasies and desires. [Kobal 1987; Vieira 1997]

151. Lotte Jacobi, 1896–1990

Louise Nevelson, 1943

Gelatin silver print, 13⅞ x 10⅞ inches
Purchased through the Harry Shafer Fisher
1966 Memorial Fund; PH.977.196
© The Lotte Jacobi Collection, University
of New Hampshire

Lotte Jacobi came from four generations of photographers, including a great-grandfather who learned the art from Louis Jacques Mande Daguerre, the inventor of the first photographic process. She took over her father's photographic studio in Berlin in 1927 and became one of the best-known photographers in Germany, particularly noted for her portraits of celebrities and artists. In 1935 she was forced to flee Nazi Germany and opened a studio and gallery in New York City, where she continued to pursue portraiture while freelancing as a photographer for *Life* magazine. In her studio work, Jacobi refrained from touching up any blemishes or relying on props and backgrounds. She instead presented her subjects in a straightforward manner, free of the stiff, posed look often associated with the portraiture of the period. Jacobi's amiability and lack of contrivance served her well, allowing her to take intimate portraits of notoriously difficult and reclusive personalities.

Jacobi met the artist Louise Nevelson through art dealer Karl Nierendorf and shortly afterward took this portrait. Here, Jacobi's careful lighting and angling of the face enhances the texture and luminosity of Nevelson's visage, which looks sympathetically toward the camera. In 1950, Jacobi exhibited some of Nevelson's etchings and sculptures in her portrait studio at a time when Nevelson could only list fifteen owners of her work. Nevelson's career ascended in the late 1950s, however, when an exhibition at the New York Grand Central Moderns gallery brought critical acclaim to her large-scale sculptures of found objects. Around the same time, when her midtown studio was demolished to make way for Rockefeller Center, Jacobi left New York City to join her son in Deering, New Hampshire. Jacobi loved her new environs, where she became well known. In 1978, Dartmouth College presented an exhibition of her work entitled *Jacobi Place.* [Lisle 1990; Moriarty 2003]

181

Decorative Arts

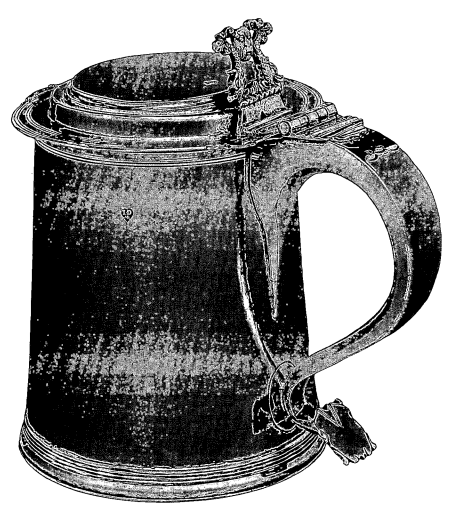

152. Jeremiah Dummer, Boston, 1645–1718

Tankard, c. 1710

Silver, H. 7⅝ inches
Gift of Louise C. and Frank L. Harrington,
Class of 1924; M.970.77

Silver has long been valued for its purity and lustrous sheen, and because it is durable yet easy to work. It could be "raised" from flattened sheets into almost any shape by hand-hammering the metal against stakes of various sizes. It could also be cast, soldered, or drawn out into thin wire and ornamented by means of chasing or engraving. Especially when adorned with engraved inscriptions, silver also commemorated individuals, events, and personal rites of passage, and it bore witness to many intergenerational presentations between family members.

Jeremiah Dummer is the earliest American-born silversmith (or goldsmith, as he would have described himself) whose work has survived. He learned his trade from John Hull and Robert Sanderson Sr., both of whom were born and trained in England and came to the Massachusetts Bay Colony in the 1630s. This tankard, with its broad, squat proportions and exuberant cast ornament, is characteristic of seventeenth-century silver made in the colonies and in Eng-

land. Its earliest known owner was Rebecca Russell (1692–1771), reminding us that the ownership of tankards was not restricted to men.

With the exception of the Daniel Henchman monteith (cat. 162) and the Webster tea service (cat. 165), all of the silver in this catalogue was collected and donated by Frank L. Harrington, Dartmouth College Class of 1924. Mr. Harrington was president of the Paul Revere Life Insurance Company in Worcester, Massachusetts, for over twenty years. His interest in Revere led him to Massachusetts silver more broadly. He formed an extensive corporate collection of Revere silver (now owned by the Worcester Art Museum) and collected primarily silver by other New England makers for himself and his wife. A loyal Dartmouth alumnus, Mr. Harrington served as a College trustee from 1962 to 1971 and became one of the museum's most generous donors. [Buhler 1965: 11–20; Kane et al. 1998: 385–97; MacAdam 1989]

153. John Coney, Boston, 1655/56–1722

Salver, c. 1705
Silver, D. 9 inches
Gift of Louise C. and Frank L. Harrington, Class of 1924; M.971.23

More than 225 pieces of silver by John Coney survive, attesting to his reputation as one of the most productive and versatile silversmiths of his time. He produced a tremendous variety of silver, simple or heavily ornamented, for both domestic and church use. He learned his trade from Jeremiah Dummer (cat. 152), with whom he would remain a close colleague.

Thomas Blount's *Glossographia* of 1661 defined a salver as a "new fashioned peece of wrought plate broad and flat, with a foot underneath, and is used in giving Beer or other liquid things to save the Carpit and Cloathes from drops." The heavy reeding on the rim and foot of this salver is characteristic of the baroque style, which emphasized weighty proportions and rich, shimmering surface ornament. By this time, a period of great economic prosperity in Boston, silver had become an increasingly popular, and ever more opulent, form of displaying one's wealth. Coney created some of the

most beautiful and complex pieces of his era. This one is engraved with the Checkley family's coat of arms. Demonstrating how silver often moved from the domestic to the ecclesiastical sphere, a later owner, Mrs. C. D. Wolfe, donated it in 1833 as a communion paten to Zion's Church (St. George's Church) in Newport, Rhode Island.
[Buhler 1965: 23–27; Kane et al. 1998: 315–34; Ward and Ward 1979]

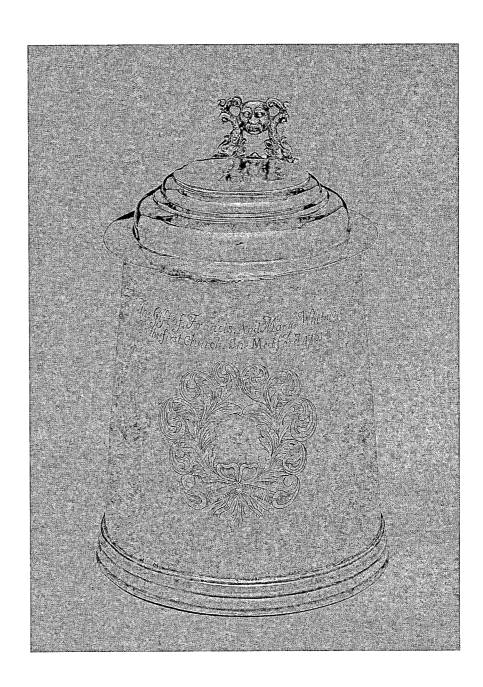

154. Henry Hurst, Boston, c. 1666–1717/18

Tankard, c. 1710

Silver, H. 7¼ inches
Purchase made possible through the generosity of
Frank L. Harrington, Class of 1924; M.987.43

This example's "grotesque" cast ornaments and "rat-tail" extension at the upper handle joining are common features of Boston tankards from this period. The vessel enjoyed several years of domestic service before it was presented in 1761 to the First Church in Medford, Massachusetts. It initially commemorated the union of John Parker and Mary Hancock, as noted by the three partially rubbed initials in the engraved cartouche. It was given to the Medford church by Mary Parker's second husband, John Francis Whitmore, and Mary Whitmore (in name, as she had died the previous year). Thus the tankard performed various social functions over time. It commemorated two marriages, served as a domestic drinking vessel for several decades, and later had a ceremonial role in communion services. The adoption of an obviously domestic form for sacramental use in a reformed church would appear to be an intentional rejection of the consciously elaborate ritual style of the Anglican and Roman Catholic churches. This aversion to lavish ecclesiastical tradition was also evidenced by the humility and starkness of conventional meetinghouse architecture.

Henry Hurst was born in Sweden and probably trained in Stockholm before working as a journeyman in London and immigrating to Boston in 1699. Perhaps because of his foreign birth and lack of social connections, he seems to have worked primarily as a jobber for other silversmiths rather than as an independent producer and merchant, despite his considerable talent. Only three pieces bearing his mark are known. [Buhler 1972: vol. 1, 76–78; Jones 1913: 272; Kane et al. 1998: 622–25]

155. John Burt, Boston, 1692/93–1745/46

Salver, c. 1728

Silver, D. 5¾ inches

Gift of Louise C. and Frank L. Harrington, Class of 1924; M.971.22

This diminutive hexafoil-shaped salver with a trumpet base was used to serve wafers, biscuits, mints, or drinks. It is believed to be the only one of this shape among documented American silver. While English hexafoil salvers of this period usually had three or four feet, John Burt's example retains the trumpet base used more than twenty years earlier by John Coney (cat. 153), with whom Burt likely trained. In contrast to the heavier ornamentation featured in the earlier example, this work's visual appeal lies more in its pleasing hexafoil shape. Such an emphasis on clean, curvilinear forms was characteristic of the Queen Anne style that gained popularity in America during the second quarter of the eighteenth century.

Burt, a native of Boston, produced mostly hollowware, including communion plate for New England churches and commissions from Harvard College. His considerable success enabled him to speculate in real estate (he purchased several parcels in Boston and Maine). He trained several apprentices as well as three of his sons—Samuel, William, and Benjamin—to follow his profession. Benjamin Burt (cats. 160, 163), in particular, enjoyed an especially long and prolific career. [Buhler 1965: 38–43; Kane et al. 1998: 246–60]

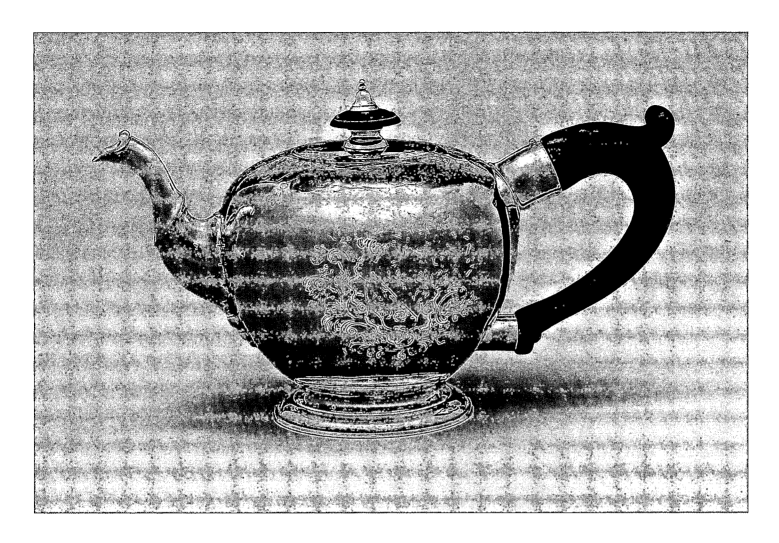

156. Jacob Hurd, Boston, 1702/03–1758

Teapot, 1745
Silver, H. 5¼ inches
Gift of Louise C. and Frank L. Harrington, Class of 1924; M.967.42

This globular teapot is one of seventeen that Jacob Hurd is known to have made. Teapots were virtually nonexistent in the Western world until the end of the seventeenth century. In fact, few were used in America until the middle of the eighteenth century. The diminutive size of this piece is typical of teapots from this early period—a reflection of the fact that tea was both scarce and expensive, and therefore brewed only in small quantities. This teapot is noteworthy for bearing the first documented rococo decoration in Boston silver. Its simple globular shape is Queen Anne in form, but the asymmetrical engraving, composed of C-scrolls and foliage, points to the more curvilinear aesthetics associated with the rococo manner (the engraved band around the shoulder remains baroque, however). The Fayerweather armorial cartouche may have been copied from an English bookplate or other printed source. The teapot's inscription tells us that it was given by Edward Tyng Esquire to Hannah Fayerweather on December 9, 1745, the day before her wedding to Farr Tollman, a Boston bookbinder. Tyng knew Hurd's work well.

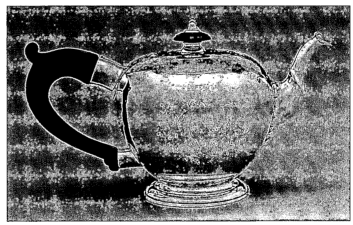

The previous year he received a magnificent two-handled cup (Yale University Art Gallery) by the goldsmith as a gift from leaders of Boston's merchant community for his capture of French privateers off the Massachusetts coast—the first naval engagement of King George's War.

An enormously talented and prolific silversmith, Jacob Hurd produced more than half of the surviving silver made in Boston during his generation. He likely apprenticed with John Burt (cat. 155) and went on to train two of his fourteen children, Nathaniel and Benjamin, to carry on the silversmithing trade. [Buhler 1965: 57–60; Kane et al. 1998: 93, 578–615; Heckscher and Bowman 1992: 84]

157. Thomas Dane, Ipswich and Boston, Massachusetts, 1726–1759

Chafing Dish, c. 1750–55

Silver, wood, L. 13⅜ inches
Gift of Louise C. and Frank L. Harrington, Class of 1924; M.970.68

Silver chafing dishes, or braziers, were used to keep food hot by means of a bed of coals contained in the bottom well, and they were often made in pairs. They enjoyed popularity for only a relatively brief period in the first half of the eighteenth century. The elaborate piercings that allowed the heat to escape also serve as design elements in these exceptionally ornate pieces. In this example, the piercings include heart, scroll, and checkerboard patterns. Later in the century, dish rings and dish crosses supplanted the chafing dish.

Thomas Dane was originally from Ipswich and moved to Boston about 1754. Little is known of his training or that of his younger brother, James, who was also a goldsmith. Dane's career lasted just over a decade, and only a dozen pieces marked by him are known to have survived. The diversity of forms he produced and the quality of his workmanship suggest, however, that he was a craftsman of significant talent. Among his known works are candlesticks, canns (bulbous mugs), a sugar bowl, a snuffbox, a creampot, and a tankard. [Buhler 1965: 75–76; Kane et al. 1998; 363–66]

158. Samuel Edwards, Boston, 1705–1762

Pair of Sauceboats, c. 1740

Silver, L. 8¾ inches
Gift of Louise C. and Frank L. Harrington, Class of 1924,
in honor of Kathryn C. Buhler; M.984.63.1–2

Sauceboats, or "butter boats," as they were sometimes called, were introduced in America in the first half of the eighteenth century. These examples by Samuel Edwards are distinguished by their ample proportions and uncharacteristic arrangement of cast feet. By fitting two feet in front and one in back, Edwards reversed the standard placement of feet on sauceboats. Also atypical is the tubular extension that joins the base of each handle to the body in order to accommodate the foot below. The result is an inventive treatment of a sophisticated form.

Boston silversmith Samuel Edwards was born into a family of distinguished silversmiths. Together with his brother, Thomas, he learned his craft from his father, John Edwards, who was well known for his production of church silver. Samuel Edwards's estate inventory reveals that he was involved in the production and sale of a wide variety of metal goods, ranging from toys and jewelry to wrought silver and goldsmith tools. He was also active in community affairs as an assessor and with the Brattle Street Church. Known silver by Edwards is generally simple in form and decoration. His obituary in the *Boston Gazette* described him as "a Man of Integrity; exact and faithful in all his Transactions." In a business that centered on buying and selling such valuable commodities as silver and gold, trustworthiness was considered an essential character trait.

Frank L. Harrington donated these sauceboats in honor of Kathryn C. Buhler, a noteworthy silver authority and curator at the Museum of Fine Arts, Boston, who advised him on many of his silver acquisitions. [Kane et al. 1998: 427–51, 429 (quotation)]

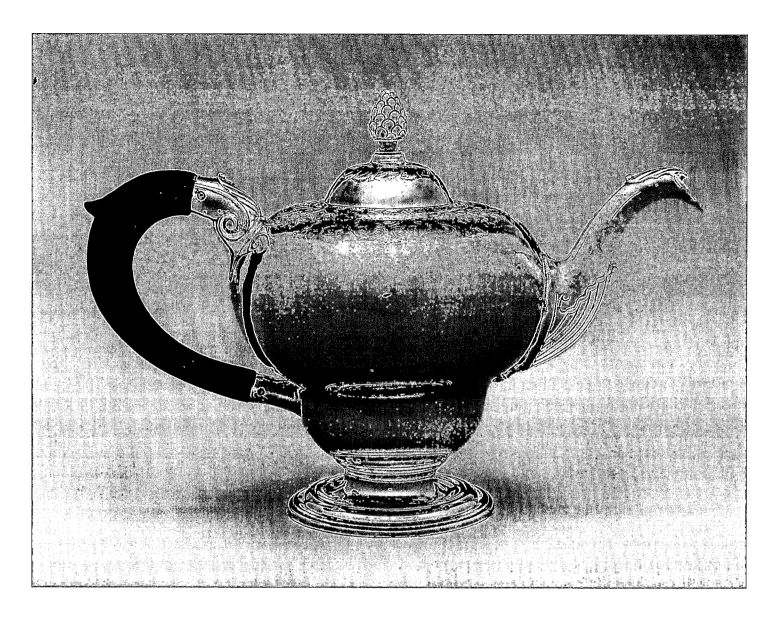

159. Samuel Casey, Little Rest, Rhode Island, c. 1724–1780

Teapot, c. 1755
Silver, H. 6⅜ inches
Gift of Louise C. Harrington in honor of
Frank L. Harrington, Class of 1924; M.989.30

Little Rest, known as Kingston since 1825, was the second center for silversmithing to develop in Rhode Island, and there Samuel Casey was the most prominent silversmith of his day. Despite his apparent success in attracting patrons, Casey eventually yielded to what was likely a temptation for many silversmiths—counterfeiting silver coinage. In 1770 he was arrested for counterfeiting Portuguese and Spanish coins and sentenced to hang. The night before his scheduled execution, a band of supporters broke into the jail and freed Casey, who swiftly fled the colony. He never returned to his home and his activities following his imprisonment are unknown.

Casey's talents as a legitimate silversmith were beyond question,

as evidenced by this graceful teapot. Probably dating from around 1755, this teapot is of the inverted pear form that epitomizes the mid-eighteenth-century preference for curvaceous top-heavy or asymmetrical designs and naturalistic ornamentation in the rococo manner. The ordered engraving surrounding the domed lid, featuring strapwork and grotesque masks, is more typical of earlier teapots, notably those made by Boston silversmith Jacob Hurd (cat. 156). Although some scholars have speculated that Casey apprenticed under Hurd, no documentary evidence links the two silversmiths. [Buhler 1972, vol. 2: 562–66; Kane et al. 1998: 614n25; Miller 1928]

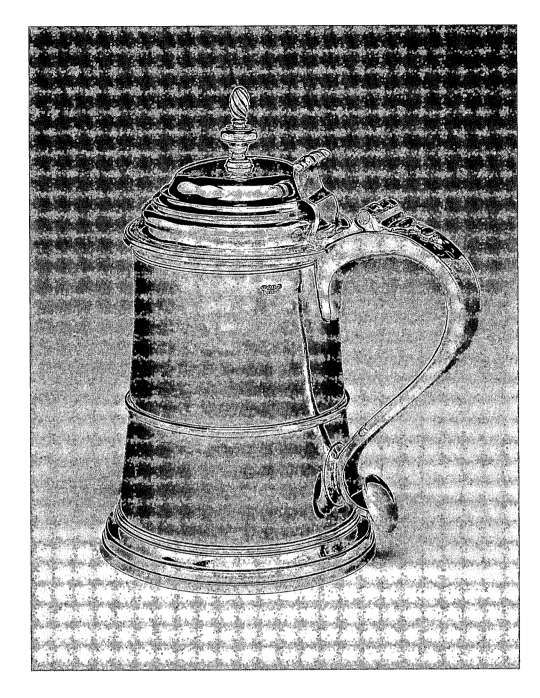

160. Benjamin Burt, Boston,
1729–1805

Tankard, c. 1760

Silver, H. 8⅝ inches
Gift of Louise C. and Frank L. Harrington,
Class of 1924; M.968.40

Tankards continued to serve as popular drinking vessels for household and ceremonial use until the end of the eighteenth century, gradually evolving from a squat, flat-topped form (cat. 152) to the more slender, vertical proportions seen in this example by Benjamin Burt. This elegant tankard has a domed top crowned with a twisted-flame finial, and tapering sides strengthened by the addition of a midband. The flame finial is considered a rococo feature and echoes the finials that surmount large case furniture of the same period. By the end of the eighteenth century, more swollen domed lids would give this form even greater verticality before tankards became outmoded. This tankard belonged to Isaac and Elizabeth (Day) Dodge, who were married in 1755 and whose initials appear on the handle.

Benjamin Burt produced silver of high quality and was active in political and civic affairs. After the death of his silversmith father, John Burt, in 1746, Benjamin Burt completed his apprenticeship under his brothers Samuel and William. Highly regarded as a craftsman, he also participated in town affairs, serving on various committees. He evidently earned the admiration of his peers as well, as he led the goldsmiths and jewelers who participated in the procession honoring George Washington's visit to Boston in 1789 and was asked to lead the goldsmiths in Washington's memorial procession in 1800. Burt was described in one account as "a very large man—he weighed three hundred and eighty pounds . . . [He was] very pleasant, . . . well-respected and beloved." [Buhler 1965: 76–83, 78 (quotation); Kane et al. 1998: 224–45]

161. Zachariah Brigden, Boston, 1734–1787

Cann, c. 1780

Silver, H. 4⅛ inches

Gift of Louise C. and Frank L. Harrington, Class of 1924; M.969.76

Typical of mid-eighteenth-century design, this cann swells gracefully from its flared lip into a voluptuous, pear-shaped body terminating in a splayed foot. Its curved lines and double-scroll handle reflect the rococo aesthetic, while its acanthus grip and symmetrical, contained engraving demonstrate the onset of neoclassical taste in Boston. The crest is that of the Cunningham family. Both this cann and its mate (Wadsworth Atheneum) were formerly owned by the prominent silver collector Philip H. Hammerslough.

Zachariah Brigden was born in Charlestown, Massachusetts, and probably served his apprenticeship in Boston under Thomas Edwards, who was the older brother of Samuel (cat. 158) and whose daughter Brigden married. According to a 1764 newspaper advertisement, Brigden operated a goldsmith's shop, where he imported and sold jewelry, household goods, tools, and supplies for other craftsmen. Because many of his personal papers have survived, his business practices are better documented than those of many of his peers. It is clear, for instance, that he relied on other craftsmen, such as jewelers and engravers, to provide certain skills. He also did a good deal of repair work for other jewelers and goldsmiths. More than 120 pieces from his shop are known, including a number of communion vessels for church use. [Buhler 1965: 97–98; Kane et al. 1998: 208–18]

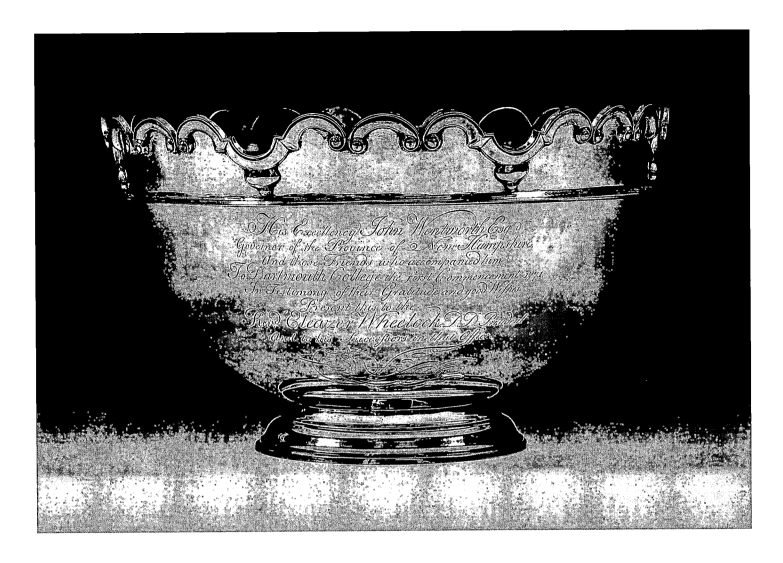

162. Daniel Henchman, Boston, 1730–1775; engraved by Nathaniel Hurd, Boston, 1729–1777

Monteith, 1772–73

Silver, D. (rim) 10¾ inches

Gift of John Wentworth, Royal Governor of New Hampshire, and Friends; M.773.1

Engraved: *His Excellency John Wentworth Esq^r. / Governor of the Province of New Hampshire, / And those Friends who accompanied him / To Dartmouth College the first Commencement 1771. / In Testimony of their Gratitude and good Wishes / Present this to the / Rev^d Eleazer Wheelock, D.D., President, / And to his Successors in that Office.*

As the grantor of Dartmouth College's charter, Royal Governor John Wentworth followed the school's development with special interest. He recognized that its first commencement ceremony in 1771, modest though it was, marked a significant achievement on the part of the institution's founder, Eleazar Wheelock (cat. 5). To commemorate the event Wentworth chose to honor Wheelock and his presidential successors with a silver monteith fashioned by Boston silversmith Daniel Henchman and engraved by Henchman's brother-in-law, Nathaniel Hurd. It was paid for by subscription by Wentworth and, as the inscription reads, "those Friends who ac-

companied him" to Dartmouth's first commencement, including Samuel Moody, headmaster of Dummer Academy in Byfield, and Dr. Ammi Ruhamah Cutter of Portsmouth, the governor's closest friend and personal physician. Completed and presented in 1773, the monteith was the first object of artistic and historic value to enter the College's collection.

A monteith is a large bowl with a notched rim that in the eighteenth century was used to chill wine glasses or rinse them between courses. Although the form was popular in England during the late seventeenth and early eighteenth centuries, only two other colonial American monteiths are known, both of them made by Boston silversmith John Coney. Dartmouth's monteith is unusual in that it is equipped with a removable rim that enables the vessel to serve as a conventional punchbowl as well. The bowl is regarded as the undisputed masterpiece of Daniel Henchman's career and as one of the finest examples of colonial American silver.

With its respectful tribute to President Wheelock, this vessel has come to symbolize Dartmouth's highest office. As such, each outgoing president presents it to his successor during the College's inaugural ceremonies. [Hoefnagel and Close 1995: 3 (quotation); Kane et al. 1998: 538–44; MacAdam 1985]

163, 164. Benjamin Burt, Boston, 1729–1805

Pair of Beakers, 1797

Silver, H. 3½ inches
Gift of Louise C. and Frank L. Harrington, Class of 1924;
M.966.115.1–2

Paul Revere II, Boston, 1735–1818

Pitcher, 1804

Silver, H. 6¼ inches
Gift of Louise C. and Frank L. Harrington, Class of 1924; M.966.116

The engraved beakers by Benjamin Burt were made for Major John Bray (about 1761–1829) as part of a set of eight. Tradition holds that they were used with the water pitcher by Paul Revere II, which was also engraved "BRAY." Both forms exemplify the Roman and Greek ideals of symmetry and simplicity that formed the basis of the neoclassical style. The shape of the elegantly proportioned pitcher undoubtedly was inspired by transfer-printed creamware jugs exported from England and popular in America after 1800. Twelve of Revere's pitchers of this type are known today, and, over the centu-

ries, others have copied the form nearly as often as his well-known Sons of Liberty bowl of 1768. At the end of the eighteenth century, the introduction of the plating mill, which made thin sheets of silver that could be cut and seamed, allowed silversmiths to greatly increase production while cutting costs.

Both Benjamin Burt (see also cat. 160) and Paul Revere II would dominate the silver trade in Boston during the last half of the eighteenth century and vied for some of the most important commissions to originate in that city and surrounding towns. Burt, however, never achieved the fame of Boston patriot Revere, who was six years his junior. The son of the French-born Apollos Rivoire, from whom he learned his trade, Revere was the most prolific silversmith of his era and achieved renown for his skill as an engraver as well as for his silversmithing. Less well known are his business activities in selling hardware and picture framing or his experiments with rolling and milling copper and casting bells at his foundry on Lynn Street. [Buhler 1965: 76–83, 99–107; Kane et al. 1998: 224–45, 795–848]

165. Woodward and Grosjean, for Jones, Ball & Poor, Boston, mid-nineteenth century

Tea Service, 1846–52

Silver, H. 14¼ inches (kettle-on-stand)
Gift of Judge Bailey Aldrich in commemoration of a warm friendship
with Frank L. Harrington, Class of 1924; M.975.80.1–6

Daniel Webster (1782–1852), Dartmouth Class of 1801 (see also cats. 7, 14, 87, 138, 194), enjoyed a distinguished career as a lawyer and a statesman, serving as a congressman and a senator and as secretary of state under President Millard Fillmore. Webster purchased this tea service toward the end of his life, possibly for the new house he erected in 1846 on his Franklin, New Hampshire, estate, where he frequently entertained. Although he did not keep regular accounts, existing records from 1847 to 1849 indicate that he purchased numerous household furnishings, including several items from Jones, Ball & Poor (now Shreve, Crump & Low), which retailed this tea service. A small Boston silversmith firm, Woodward & Grosjean, actually made the set, and their initials are stamped on each piece together with the retailer's mark. Though probably not a special order, the service is personalized by the engraved "W" and the Webster crest of a horse's head on each piece.

The exuberant ornamentation of this tea service reflects the popularity of rococo design motifs in American decorative arts of the mid-nineteenth century. Rather than merely adopting the curvilinear outlines of the style, nineteenth-century craftsmen frequently covered the entire surface of an object with elaborate naturalistic design elements. Note here, for example, the rustic handles cast in the shape of tree branches, the stylized raised, or *repoussé,* floral design, and the applied trailing vines and leaves. Of particular interest are the curious agrarian figures—perhaps Native Americans—that serve as finials on the four lidded pieces. The pear-shaped bodies of the vessels and convex fluting on the upper section of each piece are reminiscent of the earlier empire style. [Moody 1981: 49]

195

166. John Will, New York City, 1696–c. 1775

Tankard, 1752–c. 1775
Pewter, H. 7⅛ inches
Gift of Katharine T. and Merrill G. Beede,
Class of 1929; M.991.39.5

Pewter was widely used for tableware and other household imple-
ments in American homes from the seventeenth century through
the first half of the nineteenth century. An alloy that contains vary-
ing proportions of lead, copper, antimony, and bismuth, pewter was
more fashionable than wood and far less costly than porcelain or
silver. It was also sturdier than the pottery with which it competed
and, if damaged or outmoded, could be melted down and recast
into different forms.

Unlike American silver tankards, pewter tankards originated
primarily in New York rather than New England. This flat-topped
tankard by John Will, with its squat, architectural proportions, ro-
bustly curved handle, and lid with an overhanging serrated lip, is a
fine example of this classic form. American flat-topped pewter tan-
kards persisted long after their counterparts in silver (cats. 152, 154)
had evolved into more slender, vertical vessels (cat. 160). Because
pewter is not raised and shaped with hand tools but cast in expen-
sive molds, pewterers postponed making new molds as long as pos-
sible and thereby responded to stylistic change more slowly.

John Will immigrated at the age of fifty-six from Herborn, a
town on the Rhine, to New York City. There, in addition to pursu-
ing his craft, he became active first in the Reformed Dutch Church
and then in the Reformed German Congregation. His sons, Henry,
John, Philip, and William, all pursued the pewterer's trade, making
the Will family an important force in the history of the craft.

This tankard is said to have formerly been part of the commu-
nion service in the Union Dale (Pennsylvania) Presbyterian Church,
along with the beakers by an unknown maker, marked "G.C." (fig.
29). Pewter communion sets were often assembled through gifts of
unmatched pieces formerly used in domestic setting, as had been
the case with ecclesiastical silver (cat. 154). [Montgomery 1978; Laugh-
lin 1981, vol. 3: 101–4]

FIG. 29. Unidentified artist "G.C.," probably American, beakers, late eigh-
teenth century, pewter, H. 4½ inches. Gift of Katharine T. and Merrill G.
Beede, Class of 1929; M.991.39.3–4.

167, 168, 169. John Danforth, Norwich, Connecticut, 1741–1799, active 1773–93

Porringer, 1773–93

Pewter, D. (rim) 5⅝ inches
Gift of Katharine T. and Merrill G. Beede,
Class of 1929; M.991.39.2

David Melville, Newport, Rhode Island, 1755–1793, active 1776–93, or Thomas Melville, Newport, Rhode Island, 1779–1824, active 1793–96

Porringer, 1793–96

Pewter, D. (rim) 5 inches
Gift of Katharine T. and Merrill G. Beede,
Class of 1929; M.991.39.14

William Calder, Providence, Rhode Island, 1792–1856, active 1817–56

Porringer, 1817–56

Pewter, D. (rim) 5¼ inches
Gift of Katharine T. and Merrill G. Beede, Class of 1929;
M.991.39.13

Pewter porringers were used for both eating and drinking and remained popular in America from the colonial period through the early nineteenth century. The wide range of porringer handle styles and, to some degree, the shapes of their bowls point to regional differences. The handle types shown here all appeared in Rhode Island, some almost exclusively. The porringer by Connecticut pewterer John Danforth, on the left, has a flat bottomed, basin-style bowl with an exceptionally well-cast dolphin handle—a design more often found in Rhode Island than Connecticut. The other two porringers exhibit the more common, slightly domed bottom and curved walls. The plain handle with trefoil outline seen in the central example is characteristic of the Melvilles of Newport, Rhode Island, and bears some similarity to the more squared-off tab handle design associated with Pennsylvania porringers. The right-hand porringer by William Calder of Providence exhibits the so-called flowered handle, characterized by thirteen irregularly shaped piercings, including a quatrefoil at the tip. This lively, rococo-style handle type has a particularly strong association with Rhode Island, which boasted an early and distinctive pewter-making tradition. [Montgomery 1978: 145–56; Pewter Collectors Club of America 1984: 72–90]

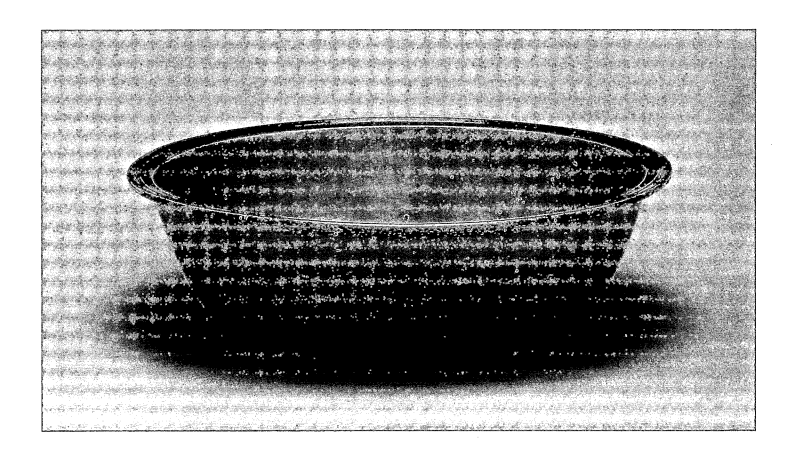

170, 171, 172, 173. Richard Lee Sr., 1747–1823, or Richard Lee Jr., 1775–1830, Grafton, New Hampshire (1788–90), Ashfield, Massachusetts (1790–93), Lanesborough, Massachusetts (1794–1802), Springfield, Vermont (1802–c. 1816)

Basin, c. 1790–1816 (above)
Pewter, D. (rim) 7¾ inches
Gift of Katharine T. and Merrill G. Beede, Class of 1929; M.985.33.1

Porringer, c. 1790–1816 (near right)
Pewter, D. (rim) 3¾ inches
Gift of Katharine T. and Merrill G. Beede, Class of 1929; M.985.33.2

Porringer, c. 1795–1816 (far upper right)
Pewter, D. (rim) 2¼ inches
Gift of Katharine T. and Merrill G. Beede, Class of 1929; M.991.39.1

Porringer, c. 1795–1816 (far lower right)
Pewter, D. (rim) 2¼ inches
Gift of Katharine T. and Merrill G. Beede, Class of 1929; M.985.33.3

Richard Lee was an itinerant pewterer who, like many craftsmen, combined his trade with other vocations. According to his own account, he also served at various times as a preacher, a tanner, a merchant, and an herb doctor. In his later years in Springfield, Vermont, Lee peddled pewter and brass for his son, Richard Jr. The various touchmarks used by the Richard Lees are yet to be firmly attributed to father or son, since it is possible that they exchanged dies. The mark on the inside bottom of the basin, however, is believed to have been used primarily by Richard Lee Sr. Although fairly rare survivals today, basins, like plates, were sometimes termed "sadware," indicating that they were one-piece vessels of mediocre alloy cast in two-part molds and sold by the pound.

The Lees made many small porringers that may have been used as toys or wine tasters. The handle designs on Lee porringers are unusually varied, suggesting that they made their own handle molds of soapstone rather than brass and replaced them frequently. Especially noticeable on the example to the left is the linen mark inside the bowl at the handle joining, which is evidence that the handle was cast onto the finished body rather than cast as one. To cast a handle, molten metal was poured through a mold shaped to match the contours of the bowl exactly, while fabric-covered metal tongs held the bowl in place and prevented the hot metal from melting through the vessel's walls. An impression from the linen generally remained where the metal walls had softened. [Laughlin 1981, vol. 1: 121–24; Montgomery 1978: 133–44; Pewter Collectors Club of America 1984: 73]

174. T. D. and S. Boardman (Thomas Danforth Boardman, 1784–1873, and Sherman Boardman, 1787–1861), Hartford, Connecticut, in partnership c. 1807–54

Flagon, c. 1807–54
Pewter, H. 14 inches
Gift of Katharine T. and Merrill G. Beede, Class of 1929; M.991.39.6

Although America's wealthiest churches generally preferred silver communion sets, pewter sets were common in more modest places of worship and arguably better reflected the Calvinist values of humility and reserve. As with silver, ecclesiastical forms in pewter were initially interchangeable with domestic pieces but became standardized in the late eighteenth century. A set typically consisted of one or two flagons, a couple of chalices, an alms basin, and sometime a large paten. Flagons were by far the showiest pieces, and examples of this form by T. D. and S. Boardman are particularly so. This piece, with its double-scroll handle, flared base, tapered body with midband, and finial-topped lid, reveals the majestic silhouette for which Boardman flagons are revered. Unlike basins (cat. 170), flagons necessitated the use of multiple molds in their construction process. This example, for instance, appears to have been made by joining eleven separate pieces. [Laughlin 1981, vol. 1: 128–130, vol. 3: 84–87; Montgomery 1978: 58–88]

175. Israel Trask, Beverly, Massachusetts, 1786–1867, active c. 1813–c. 1856

Coffeepot or Teapot, c. 1813–56

Britannia metal (pewter variant), H. 11⅛ inches
Gift from the collection of Ethel and Robert E. Asher, Class of 1931; M.991.7.4

In late-eighteenth-century England, pewterers marketed Britannia, a new variant of the alloy that had a high tin content and no lead. It was harder, thinner, and brighter than traditional pewter and, because it necessitated less metal, could be sold more cheaply. For tableware, Britannia still could not compete with the inexpensive pottery that was more widely available, but it proved to be a less expensive alternative, both here and abroad, to forms conventionally made of silver. Britannia remained popular until about 1850, when commercially produced silverplate was introduced.

This tall, so-called lighthouse-shaped coffeepot illustrates the popularity of "bright-cut" engraving, which imitated an engraving style that first appeared on silver of the late eighteenth century. In fact this coffeepot's maker, Israel Trask, initially trained as a silversmith. Bright-cut engraving consisted of sharply engraved designs, generally geometric, that were picked out with a graver to create a shimmering effect. This piece was formed from commercially rolled Britannia sheet metal, seamed along a vertical line at the spout. The horizontal bands that encircle the body add visual interest while strengthening the thin metal. [Laughlin 1981, vol. 2: 114–15, vol. 3: 191–93; Montgomery 1978: 178–79]

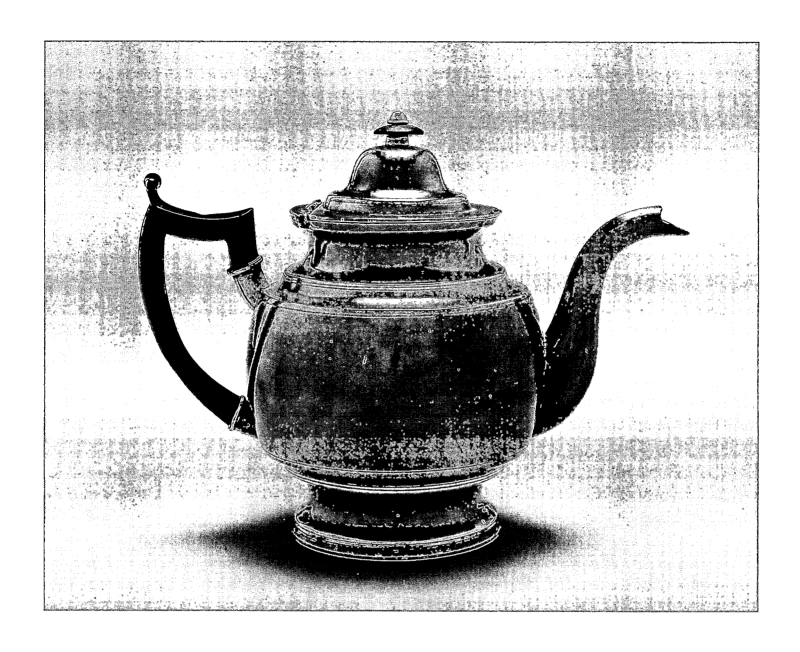

176. Hiram Yale, Wallingford, Connecticut, 1799–1831, active 1822–31

Teapot, 1822–31

Britannia metal (pewter variant), ebonized insulator and handle,
H. 7⅝ inches
Gift from the collection of Ethel and Robert E. Asher, Class of 1931;
M.991.7.3

Hiram Yale was prominent in the early production of Britannia. Originally from Meriden, Connecticut, he set up shop in Wallingford after possibly having apprenticed with Samuel Danforth at Rocky Hill. Charles Yale later joined his brother's firm to create H. Yale and Company. Hiram apparently imported workmen from England to teach his apprentices the art of producing Britannia, and his shop was among the first—probably in the mid-1820s—to form Britannia pieces by means of spinning the metal on a lathe

against a chuck to create the desired shape. Like other pewterers, however, he also continued to rely on the casting method throughout the Britannia period. Teapots were among the earliest forms made in Britannia metal. This one closely follows the shape of English Staffordshire teapots of the same period. As Britannia became more common, a range of forms appeared in the new alloy, including lamps, spittoons, communion sets, and a variety of tableware.

Although the Yales were previously believed to have apprenticed with Danforth, a critical anonymous account of the career of their competitors, the Boardmans (cats. 174, 177), claimed that the Yales "never served an apprenticeship to the pewterers trade," purchased "the old tools of Mr. Saml. Danforth and went about hiring away the men from other shops—much to the annoyance of those having competent workmen—to teach and start them in the business!" [Evans 1965: 168 (quotation)]

177. T. D. and S. Boardman (Thomas Danforth Boardman, 1784–1873, and Sherman Boardman, 1787–1861), Hartford, Connecticut, in partnership c. 1807–54

Covered Pitcher, c. 1835

Britannia metal (pewter variant), H. 11¼ inches
Gift from the collection of Ethel and Robert E. Asher, Class of 1931;
M.991.7.5

This handsome pitcher derives its form from Staffordshire pottery pitchers imported during the first two decades of the nineteenth century. It was probably used for holding water or cider and is rare for its large size—at least a gallon. Its makers, Thomas Danforth Boardman and Sherman Boardman, were brothers who made and sold pewter for almost fifty years on Main Street in Hartford, Connecticut, which became the headquarters for what was probably the largest pewter business in America. Pewterers traditionally sold their wares out of their shops and through traveling peddlers. Some enterprising makers, however, expanded their sales by partnering with retailers in major metropolitan areas. The combination of marks on this piece indicates that it was probably made by T. D. and S. Boardman in Hartford and retailed by their New York partners and fellow manufacturers Boardman and Hart (managed by Lucius D. Hart, 1803–1871). In 1844 the Boardmans opened another branch store in Philadelphia, Boardman and Hall, run by Sherman's son, Henry S. Boardman (1820–1895), and Franklin D. Hall (dates unknown). [Laughlin 1981, vol. 3: 86, 177; Montgomery 1978: 130–132]

178. Attributed to the glassworks of Henry William Stiegel, Manheim, Pennsylvania, active 1764–74

Pocket bottle, 1769–74

Amethyst nonlead glass, mold-blown, H. 5⅛ inches
Purchased through the Julia L. Whittier Fund and the Hood Museum of Art Acquisitions Fund; 2007.7

Most attempts at establishing American glass factories during the colonial period were short-lived, generally because they could not compete with the imports from England, Ireland, and central Europe that made up the vast majority of the glassware used in the colonies. Because American-made pieces imitated imported examples, they are usually difficult to identify.

This flask, which is mold-blown in a distinctive diamond daisy pattern, represents one of the few forms that can be confidently attributed to the glassworks of Henry William Stiegel (1729–1785), based on samples excavated from the site of his Manheim, Pennsylvania, factory. Stiegel immigrated to Philadelphia from his native Cologne, Germany, in 1750, and soon settled in Lancaster County, where he began his career first as an iron master, then as a glass manufacturer. He initially produced primarily green bottles and window glass made with the assistance of imported German craftsmen. When English glass was removed from the market in response to the Townshend taxes of 1767, Stiegel attempted to produce more glass in the English style and hired English glassblowers.

The design of this flask derives from glassmaking traditions in southern Germany and Bohemia. In addition to the aesthetic appeal of these well-crafted bottles, which in the eighteenth century generally held alcohol, glass collectors have long been attracted to the legendary, flamboyant personality of Stiegel himself. His financial success initially supported a colorful and extravagant lifestyle, but his profligate expenditures eventually left him penniless. Early-twentieth-century collectors were so eager to acquire Stiegel glass that, aware of his German origin, they were willing to accept almost any examples of eighteenth-century glass made in the Germanic tradition as bonafide products of his factory. Even today this foreign glass is still commonly represented in the American antiques marketplace as "Stiegel type." [Palmer 1993: 361–63; Hunter 1950]

179, 180. Unknown, English or American

Cream jug, 1770–1820
Colorless lead glass, H. 4¾ inches
Gift of Elizabeth E. Craig, Class of 1944W; G.2002.30.8

Salt cellar, 1780–1810
Blue lead glass, H. 3¼ inches
Gift of Elizabeth E. Craig, Class of 1944W; G.2002.30.9

Both of these pieces were mold-blown, meaning that the glass was inserted or blown into a dip or part-size mold for a design that was then expanded by additional blowing. The sprightly pitcher is eye-catching both for its complex, mold-blown decoration and for its handsome proportions. It was patterned using a single mold with twenty vertical ribs. After a first impression of the ribs was made, the gather was removed from the mold and twisted to give the ribs a slanting or swirling direction. The gather was then reinserted into the same mold to superimpose vertical ribs over the swirling ones. (Notice that the diamonds do not have a symmetrical shape, as they would have if the two sets of ribs had swirled in opposite directions.) The gather was then expanded and worked into its finished shape. The graceful outward flare of its tooled pouring lip effectively bal-

ances the proportions of the applied pedestal foot, while the upward curl of its handle terminus further contributes to the pitcher's dynamic silhouette.

The salt cellar, made in a mold with twenty-six ribs, has the added appeal of color. Colored glass was achieved through the addition of mineral oxides and metallic compounds such as cobalt, which yielded the blue glass seen here. The scarcity of salt at various points in our history made it a valued commodity. Tradition holds that salt cellars were usually placed in the middle of a table and that a guest's proximity to the host, who sat at the head of the table—"above the salt" or "below the salt"—reflected his or her status. After moisture-absorbing agents were added to salt beginning early in the twentieth century, it could be sold ground and served in salt shakers rather than open dishes. [Palmer 1993: 148–180, 259–261; Wilson 1994, vol. 1: 161–71]

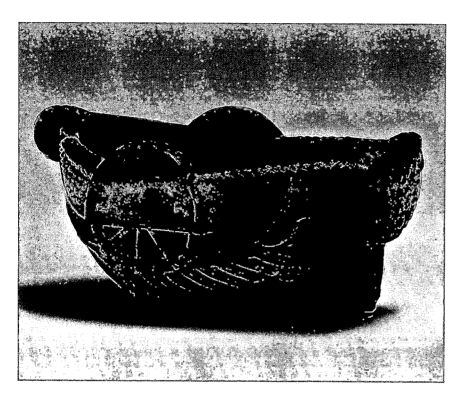

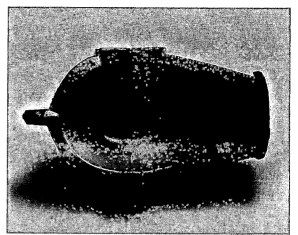

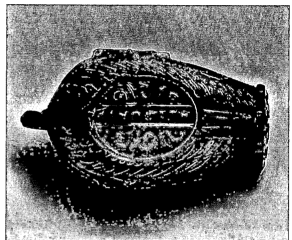

181. Boston and Sandwich Glass Company, Sandwich, Massachusetts, active 1825–87

Boat Salt Dish, c. 1830

Mottled opaque dark and light blue lead glass, pressed, H. 1⁹⁄₁₆ inches
Purchased through the Hood Museum of Art Acquisitions Fund;
2006.87

The production of pressed glass is considered one of the most important American contributions to the history of glass. Developed in the mid-1820s, the technique involved shaping and decorating glass in molds in conjunction with lever-operated presses, which allowed for the standardization of forms and increased output at lower costs. Deming Jarves, the founder of the Boston and Sandwich Company (cats. 182, 184), has been associated more than any other individual with the production of early pressed glass. He patented a variety of technical improvements to the process in 1828, 1829, and 1830. The revolutionary importance of this new method of manufacturing was quickly recognized. James Boardman, an English visi-

tor to the fair of the American Institute of the City of New York in 1829, wrote: "The most novel article was the pressed glass, which was far superior, both in design and execution, to anything of the kind I have ever seen in either London or elsewhere. The merit of its invention is due to the Americans, and it is likely to prove one of great national importance."

Glass pressing facilitated the production of sharply delineated patterns in complex shapes, as evidenced by this charming boat salt dish. Commemorating the Revolutionary War hero Marquis de Lafayette, who had toured the nation in 1824, it takes the shape of a side-wheeled steamboat embossed "LAFAYET" (*sic*). In an era during which most glass was unmarked, the several Sandwich variants of the form are noteworthy for being embossed with their manufacturer's name on the base and stern. This particular design (Neal pattern "BT-8"), produced in a range of colors, is distinguished from others by its serrated rim and the appearance of the word "SAND-WICH" on both the upper and lower surfaces of the base. [Neal and Neal 1962; Nelson 1992: 8; Spillman 1981: 14–15 (quotation)]

182. Boston and Sandwich Glass Company, Sandwich, Massachusetts, active 1825–87

Decanter, c. 1830
Colorless lead glass, mold-blown, H. 10¼ inches
Purchased through the Hood Museum of Art Acquisitions Fund;
2006.40

This decanter was made by the Boston and Sandwich Glass Company, one of the largest and most versatile American glass houses of the nineteenth century. Although the firm became famous for its production of pressed glass (see cats. 181, 184), it manufactured blown, mold-blown, cut, and enameled glass as well. One popular category of mold-blown glass produced during the 1820s and early 1830s is known as "blown three-mold." It features elaborate, often geometric designs created by blowing a bubble of hot glass into a full-size, hinged mold. Often the molds were assembled using three parts, hence the term "three-mold."

Blown three-mold glass was studied extensively by the father-daughter team of George and Helen McKearin, who published their massive tome titled *American Glass* in 1941. Of the many three-mold glass pattern variations catalogued therein, the authors identified the design represented by the present decanter as one of

the most desirable. Before expanding the gather of hot glass into the full-size mold, it was given an initial impression of vertical ribs in a dip mold. This "double-patterned" approach is extremely rare in blown three-mold glass. The trailed decorative thread, or "snake," that encircles the neck of the decanter was applied after the glass was removed from the mold and gives the form an especially artful flourish.

This particular decanter (in McKearin pattern "G.III-5") has an illustrious history. It was formerly owned by the McKearins and illustrated in *American Glass.* Previously it had been shown in the famous 1929 "Girl Scout Loan Exhibition," a landmark event and publication that signaled a burgeoning national appreciation for American decorative arts. [American Art Galleries 1929: no. 346; McKearin 1941: 266 and plate 103, no. 9; Nelson 1992: 7]

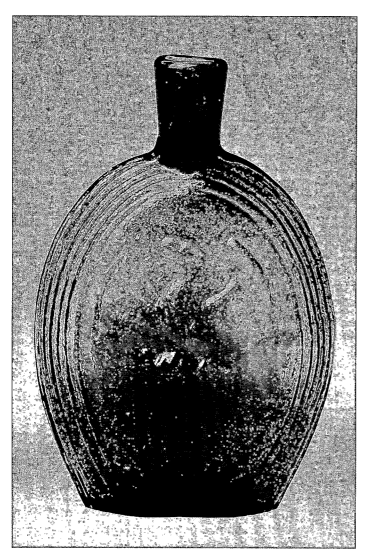 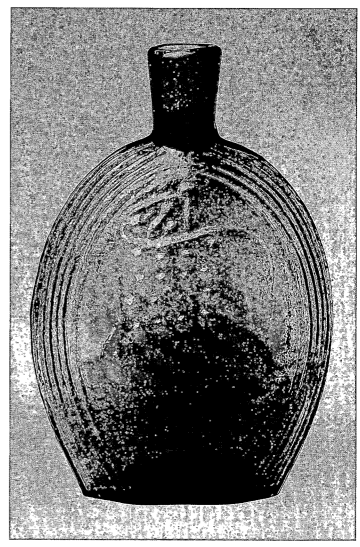

183. Coffin and Hay, Hammonton or Winslow, New Jersey, active c. 1836–47

Flask with American Eagle Design, c. 1836–47
Olive amber non-lead glass, H. 7¼ inches
Hood Museum of Art; 2006.94

Manufactured primarily in America for the American market, figured flasks or pocket bottles were generally intended to hold spirits. At least eighty-two glass houses made as many as 750 patterns of this extremely popular form—a testament to the high rate of alcohol consumption as well as the rapid growth of the American glass industry in the new republic. Many of the patterns made during the first half of the nineteenth century featured patriotic symbols. This flask, for instance, sports an eagle with olive and laurel branches on one side and a flag with twenty stars furled around a standard and the slogan "FOR OUR COUNTRY" on the other (McKearin's "G.II-54" pattern). It was made in a full-size mold in two vertical sections that formed body and base. [McKearin 1941: 545; Wilson 1994, vol. 1: 91–96 and 123 no. 73]

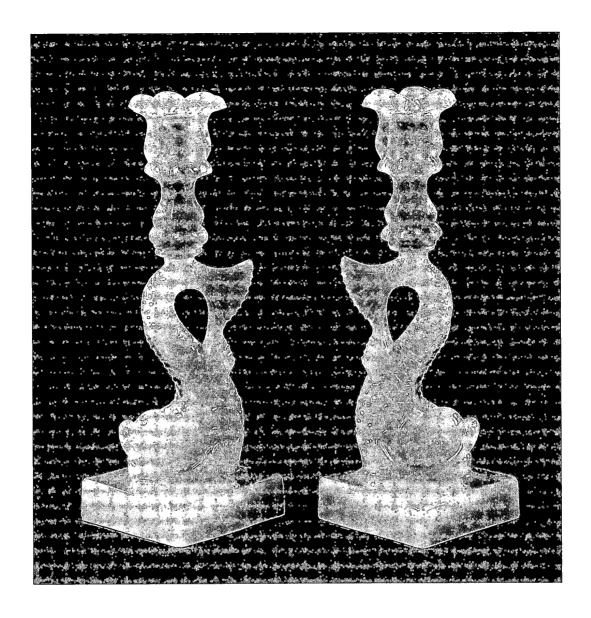

184. Boston and Sandwich Glass Company, Sandwich, Massachusetts, active 1825–87

Pair of Dolphin Candlesticks, c. 1860
Translucent white and translucent light green lead glass, pressed,
H. 10½ inches
Hood Museum of Art Acquisitions Fund; 2007.3.2–3

The dolphin candlesticks produced by the Boston and Sandwich Glass Company in the mid-nineteenth century are often considered the epitome of the firm's pressed-glass designs. The form represents the popularity of the Renaissance revival style in American decorative arts during this period. The Renaissance association is to the Italian glass dolphin stems of the sixteenth century, but the dolphin motif can be traced back to classical antiquity. In contrast to the handworked Italian examples, American dolphins illustrate the impressive capability of the glass press to quickly shape glass into full-relief, representational forms—one of the revolutionary advantages of the new technology.

Sandwich produced candlesticks in a wide variety of base and socket combinations and in an array of colors geared to a broad market. Among the early patrons of Sandwich glass, two-toned dolphin candlesticks were very popular. This pair represents a combination of translucent white glass, referred to as "alabaster" by glassmakers of the period, with one of the great rarities in Sandwich color, a soft, pale green. The two sections were made separately and joined by a wafer of molten glass. Although most closely associated with Sandwich, dolphin candlestick designs were later made by several other glass houses in the East and Midwest. They were in such demand by early collectors of pressed glass that they were reproduced extensively beginning in the 1920s. [Nelson 1992; Palmer 1993: 309]

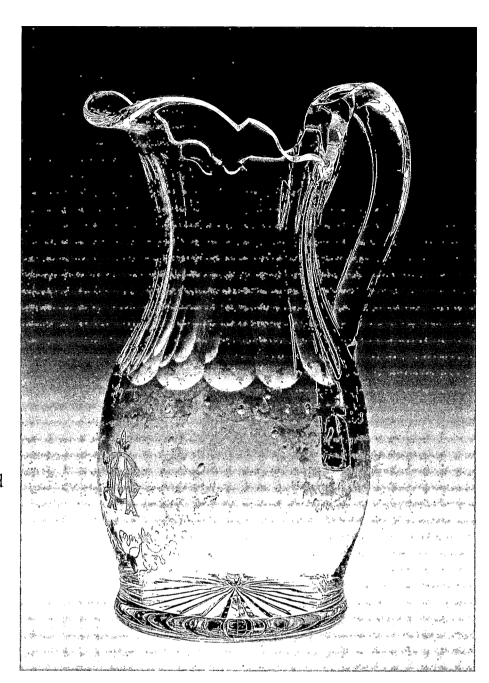

185. New England Glass Company,
East Cambridge, Massachusetts,
active 1818–88; engraving attributed
to Louis Vaupel, 1824–1903

Pitcher, c. 1870
Colorless lead glass, blown, cut, and engraved,
H. 10¼ inches
Hood Museum of Art Acquisitions Fund;
2007.3.1

The largest manufacturer of glass tableware in New England, the New England Glass Company in East Cambridge, Massachusetts, gained particular renown for creating blown, cut, and engraved glass that rivaled the finest examples imported from Europe. The company consistently brought home awards from the most prestigious fairs and exhibitions for the quality of their glass, which was often colored, richly ornamented, and tailored for an upper-class market. In 1888 the firm relocated to Toledo, Ohio, where it changed its name to the now-famous Libbey Glass Company.

Through its workmanship, provenance, and publication in Lura Woodside Watkins's 1930 history of the New England Glass Company, this pitcher is one of relatively few examples that can be positively attributed to the firm. After the pitcher was blown into its general shape and annealed, the cutting process formed its notched rim, neck flutes, and starburst pattern on the base. The quality and

character of the engraving, which includes the monogram "AD" for the Dalton family, points to it having been worked by one of the most highly regarded engravers in nineteenth-century America, Louis Vaupel. Vaupel immigrated to the United States from present-day Germany as an experienced engraver in 1850 and worked for the New England Glass Company from 1851 until its closing in 1888. Strengthening the Vaupel attribution, the exact design for this pitcher's engraved motif of a trailing vine with bright-cut berries appears in Vaupel's personal sketchbook, now in the collection of the Museum of Fine Arts, Boston (pattern no. 368, illustrated in Ferland 1995/1996). Having kept a detailed account of his professional and personal life, Vaupel is one of the most thoroughly documented immigrant craftsmen of the nineteenth century. [Ferland 1995/1996: 99; Maycock 1995/1996; Nelson 1996: 564–73; Watkins 1930: plate 49]

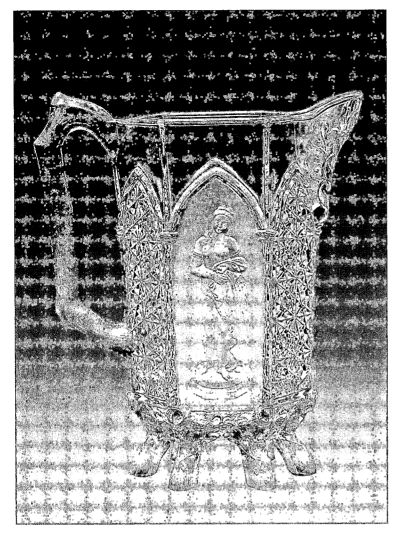
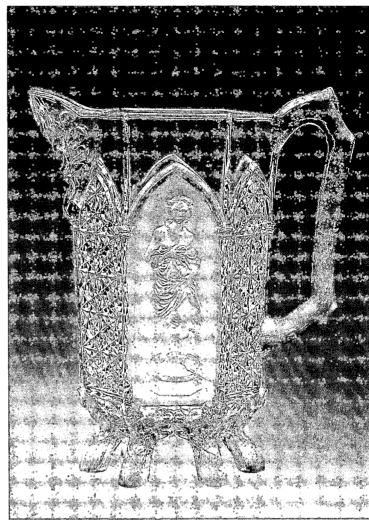

186. Gillinder & Sons, Philadelphia,
active 1867–early 1900s

Water Pitcher, c. 1882

Colorless non-lead pressed glass, Classic pattern, H. 9¹⁵⁄₁₆ inches
Purchased through the Hood Museum of Art Acquisitions Fund;
2006.60

Refined glass-pressing and mold-making techniques during the lat-
ter half of the nineteenth century allowed for more elaborate deco-
ration, which ideally suited the taste of Americans during the Vic-
torian era. Matched services of drinking glasses and serving pieces
became more plentiful and within the financial reach of an expand-
ing middle class.

 This water pitcher reflects the frequent combination of eclectic
design sources in Victorian decoration. Produced in what is now
known as the "Classic" pattern, its ornamentation combines Gothic
arches that emerge from neoclassical columns; rusticated, branch-
like handles and log feet; and two classically derived female nudes.
On the obverse (left) is an acid-etched relief decoration after *The
Tinted Venus,* 1851–56, which was first exhibited by British neoclas-
sical sculptor John Gibson in 1862 (to mixed critical reception, Gib-
son painted the work in the belief that all ancient Greek sculpture
had been originally painted). On the reverse (right) is a standing
female figure derived from a Venus Pudica (Venus of Modesty),
such as the Capitoline Venus at the Capitoline Museum, Rome.
The "Classic" design is among the most sophisticated and skillfully
rendered glass patterns pressed during the late nineteenth century,
with most of the serving pieces featuring different classically de-
rived figures (rather than simply repeating the same figure through-
out the service). Considering this pattern's art historical references
and higher cost of production owing to the complexity of its molds,
it was likely aimed at a sophisticated clientele. [Lader 1990; Spillman
1981: 13–20, 279 no. 1099; Wilson 1994, vol. 1: 280–81]

DETAIL

187. Annette Woodward, 1787–1824

Mourning picture for Bezaleel
Woodward (1745–1804), c. 1810
Silk satin embroidered with silk thread, handpainted,
21⅝ x 16½ inches (support); 19¼ x 14 inches (image)
Gift of Mrs. John Howes Waters in memory of her husband; T.933.13

In early-nineteenth-century America, decorative needlework served as an important reflection of a young woman's education and suitability for marriage. Such elaborate needlework pictures as this were almost always made in private academies that catered to young women from upper-class homes. Most often a print source or needlework picture made by the teacher served as a model from which the students would copy. As a result, different schools became associated with particular needlework designs and styles. Expressed in neoclassical guise, mourning imagery initially appeared in needlework during the period of national mourning following the death of George Washington in 1799. Thereafter, young women made such works in memory not only of Washington and other famous

leaders but also of deceased relatives or friends. Generally, however, a school assignment formed the impetus for such a composition rather than the recent death of a loved one. We do not know for certain where Annette Woodward worked this embroidery, but it is similar in composition to some examples made in the celebrated Boston school run by Susanna Haswell Rowson. It also resembles such works in the use of dark needlework—rather than paint—to fill in the gaps between the branches and leaves. As was generally the practice, a professional painter probably painted the face and background.

In this exquisitely worked and well-preserved textile, Annette Woodward honored the memory of her father, Bezaleel Woodward (1745–1804), who served as Dartmouth's first librarian (1773–1777), as trustee (1773–1804), as treasurer (1780–1803), and as the College's first professor of mathematics and natural philosophy (1782–1804). His wife, Mary Wheelock, was daughter of Dartmouth's founder, Eleazar Wheelock. In 1817, Annette married Thomas Colman Searle, Dartmouth Class of 1812. [Ring 1993]

213

188. Apphia Amanda Young
(Canterbury, New Hampshire), 1822–1910

Sampler, 1838

Linen embroidered with silk thread,
17⅜ x 17⅜ inches
Purchased through the Julia L. Whittier
Fund, the Guernsey Center Moore 1904 Memorial Fund, and
the Phyllis and Bertram Geller 1937 Memorial Fund; 2006.77

In the eighteenth and nineteenth centuries, the making of samplers
gave girls and young women the opportunity to practice a variety of
embroidery stitches and to reinforce rudimentary lessons in spelling
and penmanship. This colorful, finely worked example is typical of
the samplers made in the vicinity of Canterbury, New Hampshire,
from 1786 until at least 1838, the date of this sampler. It exhibits
many of the hallmarks of this regional style, most notably a central
urn or basket of flowers in the lower border, flanked by blossom-
sprouting hillocks, songbirds, and evergreens at each corner.

Although regional embroidery styles usually reflect the influ-
ence of a teacher associated with a private school, it seems likely
that these samplers formed part of the public school education of
Canterbury-area girls for at least part of the period in which the
style flourished. Ruthy Foster, for example, a member of the family
that seems to have developed the style, worked her sampler (private
collection) at the age of twenty in 1800, a year in which she taught
in the Canterbury schools. It quite possibly served as a model for
her students.

Little is known of Apphia Amanda Young, who made this sam-
pler, other than that she was born of Maria Morrill and Solomon
Young in Canterbury. She married William Forrest Sargent (1817–
1878) in 1847, and they had two sons. Five years earlier, at age eleven
(her "twelfth year"), she had worked a more elementary sampler
(fig. 30). Comparing the two embroideries reveals the impressive
progress she made with her needle over the intervening years. The
more accomplished 1838 example—the latest Canterbury sampler
known—suggests that this regional style remained vital later than
formerly understood. [Garrett 1990: 7; Lyford 1912: 301, 344]

FIG. 30. Apphia Amanda Young, 1822–1910, sampler, 1833, linen embroi-
dered with silk thread, 10 x 17⅜ inches. Promised gift of Joanne Foulk.

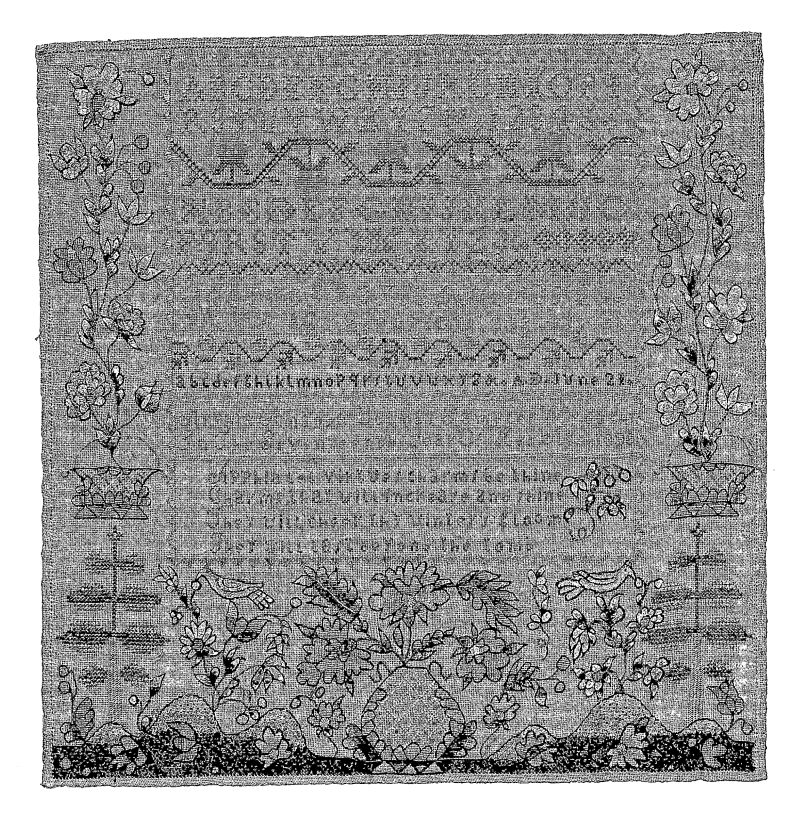

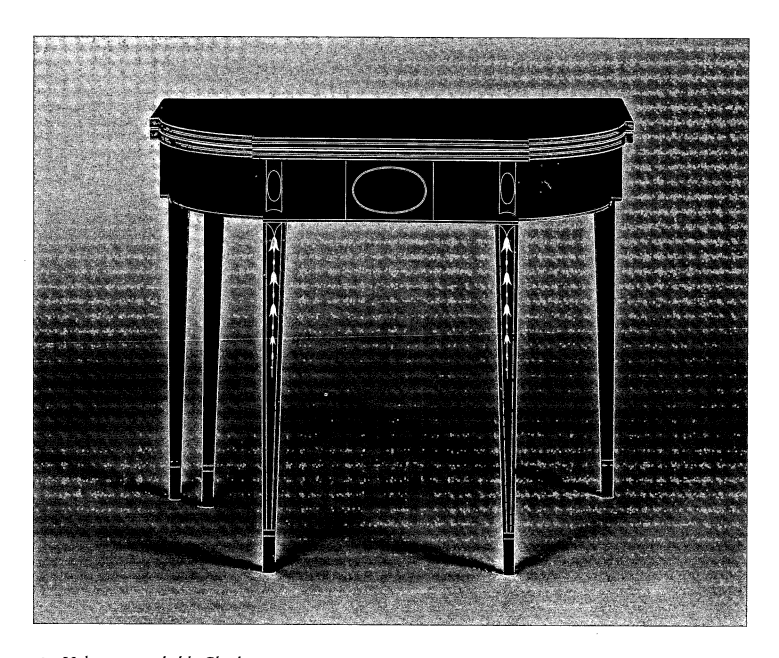

189. Unknown, probably Charleston, South Carolina

Card Table, c. 1795–1805

Mahogany and holly [?], Eastern white pine, 28 x 17½ inches
Gift of Margaret W. Hayward; F.954.158

During the late eighteenth and early nineteenth centuries, the taste for neoclassical design predominated in Europe and America, exerting a strong influence on the fine and decorative arts. The earliest phase of neoclassicism in this country, often called the federal style, began in 1790 and was based largely on British interpretations of Roman decorative motifs. In this federal card table, the pendant bellflowers and fine string inlay outlining geometric shapes exemplify the elegant, orderly decorative schemes associated with neoclassical fashions. The table descended in the family of Dr. Nathan Smith (1826–1908), founder of the Dartmouth Medical School and honorary member of Dartmouth's Class of 1798. An inscription beneath the table ("[illegible] / Smith / Charleston [?] NC [*sic*]"), combined with such design details as the popular oval motif here placed within a central rectangular panel and outflaring bellflowers, suggests the piece's origins in the South. One can only speculate as to how it would have ended up with Smith, who had no apparent connections with that region. Charleston was an especially cosmopolitan center during the early years of the new republic, owing to the continuing arrival of British and German cabinetmakers and to the city's active coastal trade. In exchange for cash crops, northern manufactured goods—from Philadelphia, New York, and particularly Massachusetts—arrived in growing quantities, especially after the Revolution. Consequently, many Charleston pieces reflect design features from the Massachusetts Bay area as well as from Britain. Although heavily refinished, the table is noteworthy as a relatively rare example of southern neoclassical furniture. [Hurst and Prown 1997; Montgomery 1966]

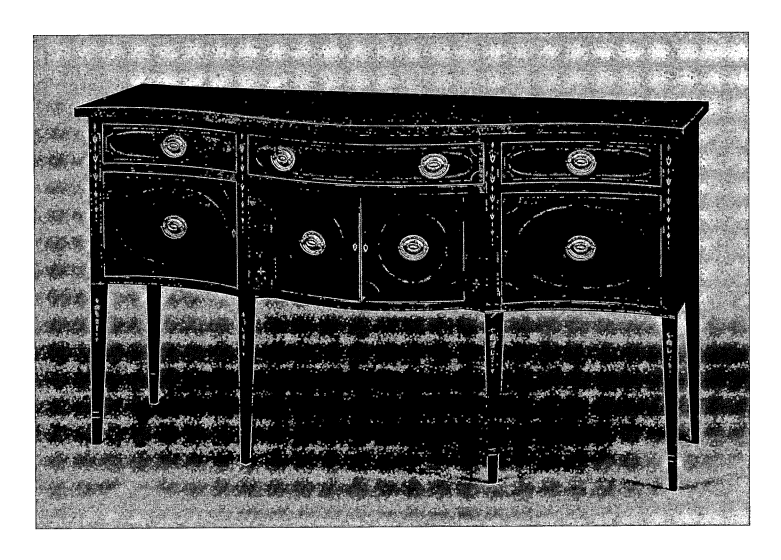

190. Possibly Julius Barnard, Hanover, New Hampshire, 1769–after 1812

Sideboard, c. 1800

Mahogany and birch veneers on white pine and spruce,
40 x 74 x 27½ inches
Bequest of Philip H. Chase, Class of 1907; F.980.64

This sideboard belonged to Mills Olcott (1774–1845), treasurer of Dartmouth College from 1816 to 1822 and a prominent Hanover lawyer and businessman. Julius Barnard, who briefly operated a cabinetmaking shop in Hanover in 1801, could well be the maker. According to the Olcott papers in Dartmouth's Rauner Library, in 1801 the two men frequently exchanged goods and services. In 1802, Barnard moved his trade to Windsor, Vermont, where, in 1805, he advertised the production of "sash-cornered, commode & strait-front sideboards." In 1809 he moved to Montreal, Canada. He terminated his business in 1812 and sold his stock, which according to the *Montreal Herald,* included "an elegant mahogany Sideboard . . . Sopha, with arms . . . a curled Maple Secretary, 35 new eight day Clocks, with and without cases . . . Mahogany 4 post Beadsteads with curtains . . . compleat assortment of Cabinet, Joiners and Carpenters tools. . . . Several hundred pieces of boards, among which are

mahogany, curled Maple & Cherry." Since documented furniture by Barnard dates to an earlier period, it is difficult to solidify the Barnard attribution on the basis of construction details or style.

The innovative arrangement of inlays on this piece—such as the bellflower blossoms that turn up, rather than down—places it within the rural cabinetmaking tradition of the Connecticut River Valley. Its elegant outlines and sophisticated craftsmanship, however, demonstrate that its maker was also attuned to the high-style furniture fashions emanating from larger urban centers, especially Hartford, Connecticut. The link to Hartford styles, which is especially evident in the inlay designs on the legs of this piece (but not their arrangement), would be plausible in the case of Barnard. He originally apprenticed with Eliphalet Chapin in nearby East Windsor and worked in Northampton, Massachusetts, in the 1790s. [Kugelman et al. 2005: 521 (quotation 2)]; Moody 1981: 23 (quotation 1)]

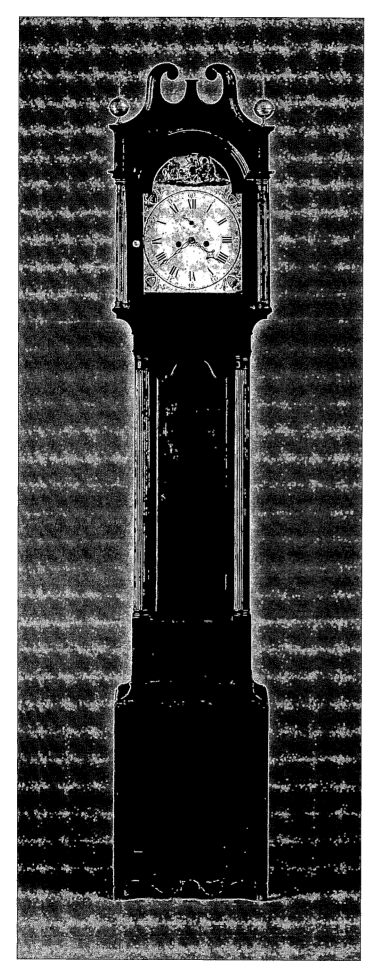

191. Attributed to Phinehas (Phineas) Bailey (1787–1861), active 1810–16, Chelsea, Vermont; maker of case unknown, probably Vermont

Tall Case Clock, c. 1816 (case 1820 or later)
Mahogany and mahogany veneers on white pine, brass, iron, steel, 95 x 18 x 10 inches
Gift of Lynda Boak Redington and John Skinner Redington, Class of 1928, in memory of his father, John Chase Redington, Class of 1900; F.946.30

A handwritten label inside the door of this clock inscribed "P. Bailey / Chelsea, Vermont / 1817" and a history of ownership by the Redington family, which settled in Chelsea in 1798, suggest this clock's Vermont origins. Like many examples of northern New England furniture, however, it represents a hybridization of different regional styles, both urban and rural. Certain features, such as its broken swan's neck pediment, are most often associated with New York examples, and the engaged freestanding columns with their slight entasis represent a time-consuming and unexpectedly sophisticated elaboration on the part of a presumably rural cabinetmaker. By contrast, the pediment's unusually vertical, compressed silhouette and unembellished surface give the work a more idiosyncratic and rustic appearance.

Phinehas (Phineas) Bailey apprenticed with John Osgood, a clocksmith, silversmith, and jeweler in Haverhill, New Hampshire. Having completed his apprenticeship in 1809 at the age of twenty-one, he worked less than a year as a journeyman clockmaker in Hanover, New Hampshire, with Jedidiah Baldwin. In 1810 he settled in Chelsea, Vermont, about twenty-five miles to the northwest, where he worked in partnership with a former clockmaker, Nathan Hale from Windsor, who supplied Bailey his shop and tools. Like many makers of brass clock movements, however, Bailey could not compete with the abundance of cheap wooden clock works that began to flood the market, and he quit the business in 1816 (a fact that calls into question the "1817" date on the clock's label). He later developed his own phonetic shorthand system ("Phonography"), which he published in 1821, and studied on his own to become a minister. He took charge, successively, of churches in Richmond and Berkshire, Vermont, as well as in Beekmantown, Ticonderoga, and Hebron, New York, returning eventually to Berkshire in 1845.
[Carlisle 1970; Lathrop 1995; Moody 1981: 29]

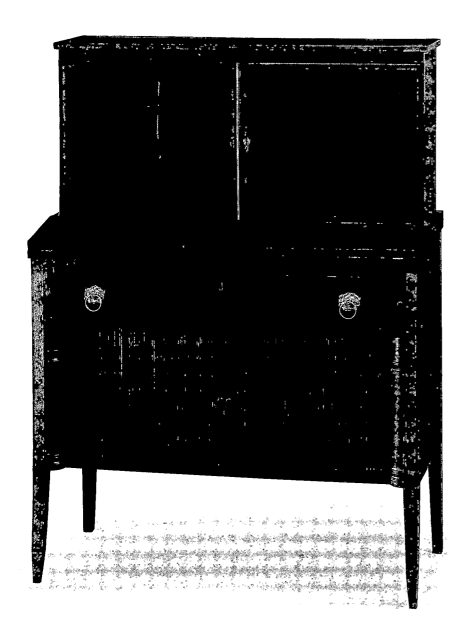

192. Mark Pitman, Salem,
Massachusetts, 1779–1829

Secretary, c. 1800–1810
Mahogany and birdseye maple inlay, Eastern
white pine, oak, brass, bed ticking (to back the
tambour door), 52¼ x 38¼ x 19 inches
Purchased by funds made available through a
gift from the Estates of Lulu C. and Robert L.
Coller, Class of 1923; F.984.19a–b

This federal-style secretary, which still bears its original maker's la-
bel, is one of relatively few firmly documented examples of coastal
Massachusetts cabinetmaking (see detail of label). Mark Pitman
worked in Salem from around 1800 to around 1827. This desk
from his shop, with its patterned inlaid borders and tambour door
construction, is characteristic of federal furniture made in Salem
and parts of northern New England. Less typical—although not
unique—is the use of tambour doors for a lower, rather than upper,
cabinet, and a minimal use of contrasting veneers. As was often the
case with Pitman's work, this secretary's richly figured mahogany
veneers provide its chief decorative effect. Although introduced in
the late eighteenth century, this writing table form only gradually
gained favor over the sturdy, slant-front "bureau desks" that had
been popular since about the 1740s. The large numbers of secretar-
ies in various forms from this period remind us of the importance of

written correspondence—the only means of long-distance commu-
nication—among the educated upper classes in early-nineteenth-
century America. [Montgomery 1966: 329, 372, 481–82]

219

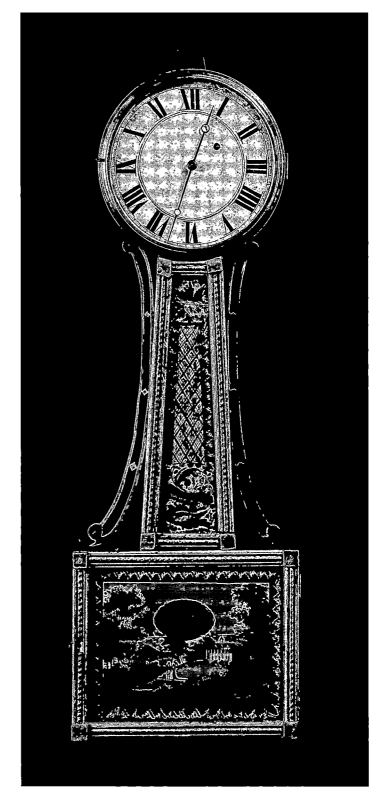

193. Attributed to Simon Willard, Roxbury, Massachusetts, 1753–1848

Patent Timepiece, c. 1810

Pine, gilt, reverse painting on glass, 32⁹⁄₁₆ x 10¼ x 3⅞ inches

Museum purchase; F.944.145

Simon Willard was the most innovative of the four Willard brothers who dominated clockmaking in New England from the late eighteenth through the early nineteenth centuries. The Willards not only created new types of clocks but also, by using specialized workmen and pre-cast parts, converted the manufacturing process from a trade to an industry. The family originally gained fame for their "Roxbury" tall clocks, which they typically finished with English faces or dials and housed in locally made cases with intricate fretwork that surmounted the bonnets.

Simon Willard experimented with smaller clock types that could be displayed on walls or on shelves. He is best known for inventing the wall-mounted eight-day patent timepiece in 1802. This form, seen here, gained him fame and prosperity and was widely copied by other clockmakers. As Willard described the timepiece's features, "The power of motion is a weight [which falls fifteen inches in eight days] instead of a spring which is the case in all regulators and time pieces smaller than the clock." The various reverse painting on glass designs that ornamented the lower tablets of these clocks—whether geometric, as in the earliest examples, or pictorial, as seen here—

gave them their distinctive visual appeal. The scene of Mount Vernon here—a subject that frequently adorned the top portion of looking glasses from this period—reflects the enthusiasm for imagery related to George Washington in the decades following the first president's death in 1799. Although much of the original gilding on this timepiece's case has been painted over, it remains an important survival of one of the most influential clock designs in the history of horology. [Zea and Cheney 1992: 43 (quotation)]

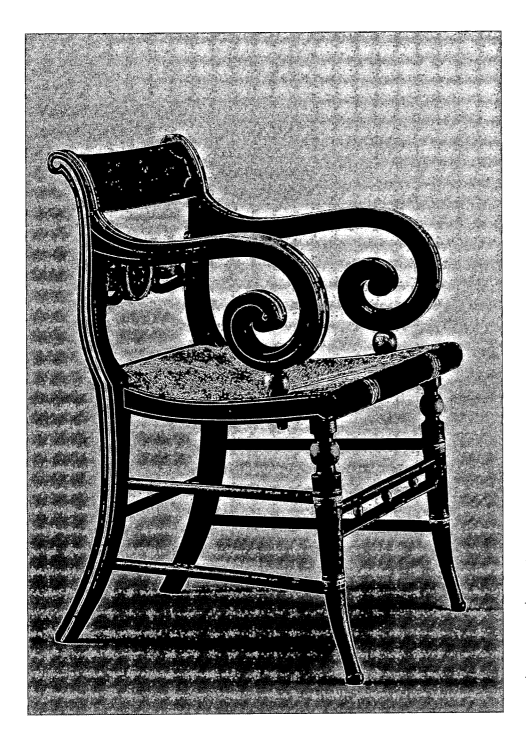

194. Unknown, possibly
Washington, D.C., or Baltimore

Armchair, c. 1825

Maple, pine, paint, rush seat,
32¼ x 22¼ x 21 inches
Gift of Vicki Donlan in memory of
Jane Gilman Hopkins; 2005.33

This commodious, robustly designed armchair was, according to longstanding family tradition, formerly used as an office chair by renowned statesman and orator Daniel Webster, Dartmouth Class of 1801 (see cats. 7, 14, 87, 138, 165). Its stately proportions and exuberant curving outlines link it to the later tradition of neoclassical "fancy chairs," so named for their ornamental painted surfaces. In contrast to the more feminine, often light-colored and diminutive fancy chairs of the federal period, the scale and decoration of this chair are in keeping not only with late neoclassical taste but also with the more masculine décor of a gentleman's office or library. The paint scheme on this chair is especially complex, with its gold striping and foliate decoration applied above a layer of false graining. The spheres that join the arms to the seat are a particularly distinctive feature sometimes associated with painted chairs from Baltimore. Given the statesman's extended visits and long periods of residency in Washington, D.C.—as a congressman (1813–17) and senator (1827–39 and 1845–50), and as secretary of state (1844–42)—it would not be surprising if the chair's origins were closer to that city than to Webster's Massachusetts home. The armchair descended in the Gilman family of Exeter, New Hampshire. [Cooper 1993: 224–30; Hurst and Prown: 179–81]

195. Unknown, Boston, possibly Thomas Emmons and George Archibald, active 1813–25

Pier Table (One of a Pair), c. 1820

Mahogany veneer, mahogany, chestnut, white pine, marble top,
gilt brass (with much of the gilding worn off), mirrored glass,
34 x 45 x 21 inches
Gift of Mrs. William Dexter; F.965.90.9

This table reflects a later and more monumental expression of neo-classical taste, often referred to as the empire style, which flourished in the early decades of the nineteenth century and was derived from French adaptations of Greek, Roman, and Egyptian antiquities. One of a pair, this table is part of a group of distinguished neoclassical furnishings originally from the library of George Ticknor, a member of Dartmouth's Class of 1807 and a prominent resident of Boston (see cats. 12, 196, 197). In 1829 he bought a four-story neo-classical house designed in 1803 by Charles Bulfinch that overlooked the Boston Common from the corner of Park and Beacon Streets. On its second floor the residence featured "a large sunny room, with three long balconied windows," where Ticknor established his large and valuable collection of books. Much of the library's contents, including its furnishings, were given to Dartmouth College in 1946 by Ticknor's descendants.

Pier tables often filled the wall space (pier) between two windows and usually came in pairs. Their columnar supports and heavy marble tops are architectural in form and served to integrate them with the neoclassical features of their surroundings. Gilt brass caps, bases, and decorative foliate mounts—all probably imported from France or England—accentuate the richly veneered mahogany surface of this Boston pier table and its mate, which is also in the Dartmouth collection. Such tables often featured mirrors, which helped to expand the architectural space and add reflected light. Although not marked, the tables formerly owned by Ticknor are very similar to two examples in the Museum of Fine Arts in Boston that bear the stenciled label of Emmons and Archibald (Thomas Emmons and George Archibald), who were partners in the furniture business from 1813 to 1825. [Moody 1981: 38; Cooper 1993; Talbott 1975 and 1976; Talbott 1992]

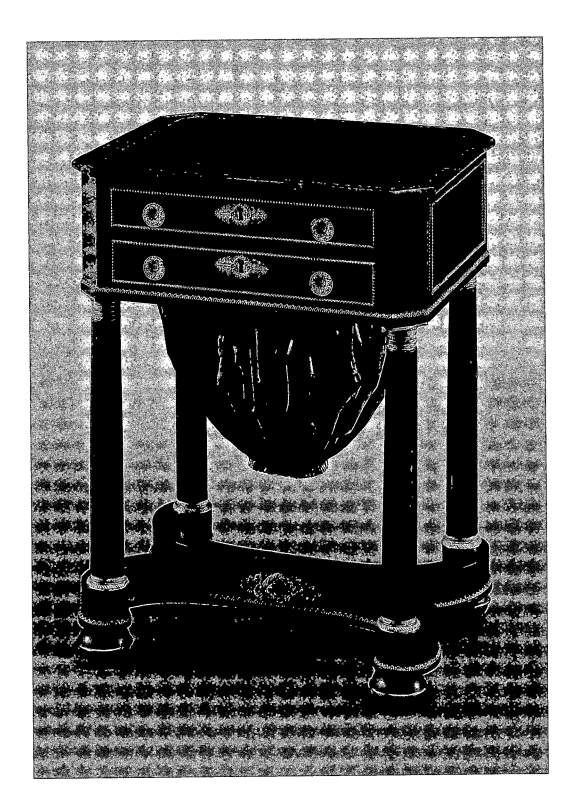

196. Unknown, Boston

Work Table, c. 1820
Rosewood veneer, mahogany, ebony,
chestnut, and gilt brass, reproduction
work bag, 29 x 22 x 18 inches
Gift of Mrs. William Dexter;
F.965.90.22

Work tables, or "pouch tables," as they were sometimes called, were fitted with fabric bags (this one is a reproduction) designed to store a woman's unfinished needlework. As seen here, the bag is typically suspended from the lower drawer, which is open in the center and bordered with compartments for thread and other sewing implements. Like most examples, this one is fit with casters, so that the table could be moved easily to where the user was seated. This highly specialized, elegant furniture form suggests the social, as well as the practical, importance of a woman's accomplishments with a needle in early-nineteenth-century America. Often women of a household would gather in a sitting room and collectively work on needlework, with such a table forming the center of their activities and interactions. George Ticknor (cat. 12) purchased this table for his wife, Anna Eliot, perhaps soon after their marriage in 1821. Like other neoclassical furnishings from Ticknor's home (cats. 195, 197), it is a sophisticated adaptation of French-inspired neoclassical design, meticulously crafted with the finest materials available. [Moody 1981: 39; Cooper 1993: 258–59; Talbott 1975 and 1976; Talbott 1992]

197. Unknown, Boston

Secrétaire à abattant, c. 1820
Mahogany veneer, mahogany, poplar,
and white pine, with mahogany veneers
and gilt brass, 58½ x 37½ x 20¼ inches
Gift of Mrs. William Dexter;
F.965.90.11

The *secrétaire à abattant*, or fall-front desk, is one of the new forms introduced during the latter phase of the neoclassical style and derived from French sources. Such designs were transmitted to America by various means, including the work of immigrant craftsmen, design books, and royal furniture imported after the collapse of the *ancien régime*. The secretary's elegant styling and bold architectural proportions ideally suited the new, more spacious homes of an expanding upper class. This example's highly figured mahogany veneers, crisply carved acanthus leaves on the feet, and brass-mounted columns relate it to a similar secretary that bears the label of Isaac

Vose and Son. Originally known as Vose and Coates, this company produced some of the finest furniture in Boston. Construction details of the piece, however, are extremely close to those of the pier table, work table (cats. 195, 196), and bookcases also formerly owned by George Ticknor of Boston, suggesting that they may have been purchased as a suite and made by a single manufacturer (possibly Emmons and Archibald). [Moody 1981: 37; Cooper 1993; Talbott 1975 and 1976; Talbott 1992]

198. Unknown, Shaker community, Enfield, New Hampshire

Ladderback Chair, c. 1820–45

Birch with caned seat, 40 x 17 x 13 inches
Gift of Frank C. and Clara G. Churchill; 46.22.16386

The United Society of Believers in Christ's Second Appearing, commonly known as the Shakers, evolved in the eighteenth century as a variant of English Quakerism. By 1810, nineteen Shaker communities had been established from Maine to Kentucky, with a combined membership numbering six thousand. Reflecting the faith's strict moral code aspiring toward personal and communal perfection, Shaker-made furniture is typically simple in outline, graceful in proportion, and solidly crafted with an eye toward practicality.

Ladderback chairs made in the Enfield community (active 1793–1923) are considered some of the most delicate examples of Shaker seating. They are admired especially for their arched back slats (which graduate slightly in width from bottom to top slat), their

slender posts, and their symmetrical pommel turnings in the shape of elongated ellipses. They most often have caned seats, as seen here, which contributed to the physical lightness of the design and facilitated the chair's portability. The back of this chair's top slat is stenciled "27" in black paint, which may indicate a room number. Hervey Elkins describes the Enfield Great Stone Dwelling in his 1853 book *Fifteen Years in the Senior Order of Shakers*: "On either side are retiring rooms, all exactly twenty feet square, nine feet high, and of identical furniture and finish rendering it difficult to determine, but by number, one room from another." Sockets that were formerly equipped with tilter balls appear on the back posts. [Muller and Rieman 1984: 44 (quotation)]

199. Unknown, Shaker community,
Enfield, New Hampshire

Lowback Dining Chair, c. 1850
Birch, pine (seat), with red stain, 25½ x 17½ inches
Gift of Frank C. and Clara G. Churchill;
46.22.16387

This chair's turned spindle back, splayed legs, and plank seat derive from the widely popular Windsor chair style. Lowback chairs were used for dining in most Shaker communities. This form was said by Elder Henry Blinn of Canterbury to have first been made in that community by Brother Micajah Tucker in 1834 to replace earlier benches. According to Blinn, the benches "were not convenient, especially if one was obliged to leave the table before the others were ready. All were under necessity of sitting just so far from the table." In addition to their aesthetic appeal, the Shaker lowback chairs had practical virtues. They were lightweight, strong, and easily wiped for cleaning, and they could be neatly slipped under the table when not in use. This feature helped to give the dining rooms an uncluttered, orderly appearance, which was consonant with the Shakers' carefully regulated mealtime routines. Given their proximity, the Canterbury and Enfield Shaker communities were in close communication, and goods made by them often shared very similar features. As is often the case with Shaker furniture, the maker of this chair has not been documented. [Burks 1989: 15 (quotation); Muller and Rieman 1984: 47; Rieman and Burks 2003: 459]

200. Unknown, Shaker community, Enfield, New Hampshire

Sewing Table, c. 1830–40
Pine with red stain, brass
Gift of Frank C. and Clara G. Churchill; 46.22.16381

This small, highly portable sewing table has an unusually low work surface, which suggests its possible use by a child. Although the Shakers practiced celibacy, children arrived either as the offspring of converts or as orphans and formed an important part of Shaker communal life. This sewing table is equipped with a separate gallery of shelves and drawers for the storage of thread and sewing implements. The same maker may have made the upper unit at a slightly later date, as has been documented in similar examples from other Shaker communities. Its drawer construction details also suggest that it was made by the same craftsman who made the double sewing table (cat. 201). Whereas the overall appearance of the lower table is loosely inspired by New England interpretations of the federal style, the shape of its legs is characteristic of Enfield Shaker design. The applied rim around the table's edge is an especially unusual but practical feature that helps to contain stray needles or writing implements. [Meader 1972; Rieman and Burks 2003: 442–48]

201. Unknown, Shaker community, Enfield, New Hampshire

Double Sewing Desk or Work Stand, c. 1830–70

Pine with red stain, brass, 46 x 38 x 22½ inches
Gift of Frank C. and Clara G. Churchill; 46.22.16382

The majority of Shaker sewing desks originated in New England Shaker communities and, unlike some other Shaker forms, had no clear precedents in worldly furniture designs. The frequent appearance of work tables made to accommodate more than one seamstress reflects the communal nature of sewing in Shaker communities. This double work table made in Enfield, New Hampshire, was probably used for sewing garments and linens for use within that Shaker community. Unlike their counterparts in Canterbury, New Hampshire, the Enfield Shakers generally did not produce textiles for sale. Leather straps tacked against the interior wall provide storage space for needles or pencils. The arrangement of work spaces on opposite sides of the desk (rather than back and front) is an ingenious variant on other Shaker examples of this type. Construction details suggest that the same craftsman may have made the small-scale sewing table (cat. 200) as well. [Burks 1989: 2–3; Meader 1972; Rieman and Burks 2003: 438–42]

202. Grueby Faience Company, Boston, 1897–1910

Savin Tree Tiles, c. 1902

Glazed earthenware, 16⅝ x 5 x 1 inches
Gift of William P. Curry, Class of 1957; C.999.34.1–4

Boston's Grueby Faience Company, founded by William H. Grueby, is perhaps the best-known New England art pottery firm and the one most often associated with the Arts and Crafts style. The reformers who led this turn-of-the-century movement—William Morris and Gustav Stickley among them—rebelled against Victorian taste. They instead advocated handcrafted furnishings with clean lines and simple, stylized ornamentation drawn from nature. Grueby's pottery gained international recognition for its velvety matte glazes in rich earth tones. In addition to a range of sturdy handthrown pottery vessels with organic forms and plant-inspired ornamentation (cat. 203), the company produced a variety of glazed architectural and decorative tiles. The examples illustrated here once bordered a fireplace in Dreamwold, a lavish estate built in Scituate, Massachusetts, in 1902. The Grueby Faience Company provided the mansion with tiles for at least nine fireplaces, five bathrooms, and a conservatory. This fireplace facing design, based on a species of

juniper *(Juniperus sabina),* was illustrated in Grueby's tile catalogue with three plain tiles across the top; according to a 1909 price list, the entire set sold for thirty-five dollars. The flattened composition of these tiles reflects the influence of Japanese aesthetics, while their sinuous outlines relate to the European art nouveau style popular at the turn of the twentieth century. [Montgomery 1993, 1994]

203. Grueby Faience Company,
Boston, 1897–1910; modeled by
Annie V. Lingley, born 1873

Vase, c. 1901
Glazed earthenware, H. 15¼ inches
Gift of William P. Curry, Class of 1957;
C.986.78

Typical of Grueby's finest wares, this vase boasts weighty proportions and a tactile matte glaze with silvery veining. Grueby vases were usually handthrown by men and then decorated by women who had graduated from Boston art schools. The applied ornamentation on this vase was the work of Annie V. Lingley, who attended the Massachusetts Normal Art School in the 1890s and later exhibited china painting with the Newark Society of Keramic Arts. She would have ornamented this vessel according to specifications from the firm's chief designer, George Kendrick, employed by Grueby from 1897 to 1902. The inspiration for the shapes and decoration of Grueby's wares was as eclectic as American turn-of-the century taste. This vase, with its imposing proportions and "eared" handles at the shoulder, vaguely recalls ancient Egyptian vessels. Adding an echo of Japanese (and contemporary art nouveau) aesthetics,

an upright iris plant appears on each side, one in yellow, the other purple. Its blossom extends up to the line formed by the handles and shoulder, providing an integration of decoration and form that was central to the Arts and Crafts aesthetic. Like many craftsmen associated with the movement, Grueby's artisans aimed for an intentionally "handmade" look that made each piece unique. This iris vase is one of the firm's rarer forms and is also distinguished by the slipping of its glaze and the expressive veining radiating out from the iris. The end effect is at once tactile and painterly. Other art potteries attempted to create their own green glazes in imitation of Grueby. Although none succeeded in matching Grueby's sophisticated surface effects, their cheaper, often mass-manufactured wares cut in to Grueby's profits and contributed to the firm's closing in 1910. [Montgomery 1993, 1994]

231

SELECTED BIBLIOGRAPHY

Ahrens, Kent. *Cyrus E. Dallin: His Small Bronzes and Plasters.* Corning, N.Y.: Rockwell Museum, 1995.

Aldrich, Bailey. Letter to Frank L. Harrington. December 11, 1975. Hood Museum of Art (HMA) donor files.

Alexander Gallery. *Sanford R. Gifford.* New York: Alexander Gallery, 1986.

Alice Runyon file. HMA donor files.

Alloway, Lawrence, and Mary Davis MacNaughton. *Adolph Gottlieb: A Retrospective.* New York: Published by the Arts Publisher, in association with the Adolph and Esther Gottlieb Foundation, 1981.

Alloway, Lawrence, Sanford Hirsch, Charlotta Kotik, Linda Konheim Kramer, and Evan Maurer. *The Pictographs of Adolph Gottlieb.* New York: Hudson Hills Press, in association with the Adolph and Esther Gottlieb Foundation, 1994.

American Art Galleries, New York. *Loan Exhibition of Eighteenth and Early Nineteenth Century Furniture and Glass . . . for the Benefit of The National Council of Girl Scouts, Inc.* New York: American Art Galleries, 1929.

Anderson, Nancy K., with contributions by William C. Sharpe and Alexander Nemerov. *Frederic Remington: The Color of Night.* Washington, D.C.: National Gallery of Art, 2003.

Anderson, Ross. *Abbott Handerson Thayer.* Syracuse, N.Y.: Everson Museum, 1982.

Anderson, Susan. *Regionalism: The California View.* Santa Barbara, Calif.: Santa Barbara Museum of Art, 1988.

Arkelian, Marjorie Dakin. *Thomas Hill: The Grand View.* Oakland, Calif.: Oakland Museum, 1980.

Arntzen, Etta. "John Joseph Borie." Unpublished two-page typescript, 1989. HMA curatorial files.

Aronson, Julie Alane. "Bessie Potter Vonnoh (1872–1955) and Small Bronze Sculpture in America." Ph.D. diss., University of Delaware, 1995.

Art Gallery, Plymouth State College, 1985. *Edward Hill: A Man of His Time (1843–1923).* Plymouth, N.H.: Art Gallery, Plymouth State College, University of New Hampshire, 1985.

Atkinson, Scott D., and Nicolai Cikovsky Jr. *William Merritt Chase: Summers at Shinnecock, 1891–1902.* Washington, D.C.: National Gallery of Art, 1987.

Baas, Jacquelynn. "The Fisherman and the Mermaid—A New Acquisition and an Old Story." *The Quarterly* 1 (Summer 1983): 22–23.

————. "A History of the Dartmouth College Museum Collections." *Treasures of the Hood Museum of Art, Dartmouth College.* New York: Hudson Hills Press, in association with the Hood Museum of Art, 1985. 10–20.

Bailey, Anne J. *War and Ruin: William T. Sherman and the Savannah Campaign.* Lanham, Md.: Rowman & Littlefield, 2003.

Bales, Jack. *Kenneth Roberts.* New York: Twayne Publishers, 1993.

Balken, Debra Bricker. *Suzy Frelinghuysen & George L. K. Morris: American Abstract Artists, Aspects of Their Work & Collection.* Williamstown, Mass.: Williams College Museum of Art, 1992.

Barber, James, and Frederick Voss. *The Godlike Black Dan: A Selection of Portraits from Life in Commemoration of the Two Hundredth Anniversary of the Birth of Daniel Webster.* Washington, D.C.: Smithsonian Institution Press for the National Portrait Gallery, 1982.

Barratt, Carrie Rebora, and Ellen G. Miles. *Gilbert Stuart.* New York: Metropolitan Museum of Art; New Haven, Conn.: Yale University Press, 2004.

Barter, Judith, with contributions from Erica E. Hirshler, George T. M. Shackelford, Kevin Sharp, Harriet K. Stratis, and Andrew J. Walker. *Mary Cassatt: Modern Woman.* Chicago: The Art Institute of Chicago, in association with Harry N. Abrams, 1998.

Beall, Karen F. "The Interdependence of Printer and Printmaker in Early 19th-Century Lithography." *Art Journal* 39, no. 3 (Spring 1980): 195–201.

Bearden, Romare, and Harry Henderson. *A History of African-American Artists from 1792 to the Present.* New York: Pantheon Books, 1993.

Bibby, Dierdre L. *Augusta Savage and the Art Schools of Harlem.* New York: Schomburg Center for Research in Black Culture, New York Public Library, 1988.

Blumenthal, Arthur R. *Portraits at Dartmouth.* Hanover, N.H.: Dartmouth College Museum and Galleries, 1978.

————. *Treasures of the Cornell Fine Arts Museum.* Winter Park, Fla.: The George D. and Harriet W. Cornell Fine Arts Museum, 1993.

Boehme, Sarah E. *John James Audubon in the West: The Last Expedition: Mammals of North America.* New York: Harry N. Abrams, in association with the Buffalo Bill Historical Center, 2000.

Bolton-Smith, Robin, and William H. Truettner. *Lilly Martin Spencer, 1822–1902: The Joys of Sentiment.* Washington, D.C.: Smithsonian Institution Press for the National Collection of Fine Arts, 1973.

Borhan, Pierre, ed. *Dorothea Lange: The Heart and Mind of a Photographer.* Boston: Little, Brown, and Co., 2002.

Brackett, Truman H. Jr. Letter to Dr. and Mrs. Calvin Fisher. September 25, 1972. HMA donor files.

Brandt, Rex. Letter to Philip H. Greene. December 5, 1996. HMA curatorial files.

Brown, Theodore M. *Margaret Bourke-White: Photojournalist.* Ithaca, N.Y.: Andrew Dickson White Museum of Art and Cornell University, 1972.

Buckley, Laurene. *Joseph DeCamp: Master Painter of the Boston School.* Munich: Prestel, 1995.

Buhler, Kathryn C. *Massachusetts Silver in the Frank L. and Louise C. Harrington Collection.* Worcester, Mass.: Barre Publishers, 1965.

————. *American Silver 1655–1825 in the Museum of Fine Arts, Boston.* Two vols. Boston: Museum of Fine Arts, 1972.

Burks, Jean. *Documented Furniture: An Introduction to the Collections.* Canterbury, N.H.: Shaker Village, Inc., 1989.

Burns, Sarah. "The Courtship of Winslow Homer." *The Magazine Antiques* 161 (February 2002): 68–75.

Campbell, Catherine H., with Marcia Schmidt Blaine. *New Hampshire Scenery: A Dictionary of Nineteenth-Century Artists of New Hampshire Mountain Landscapes.* New Canaan, N.H.: Published for the New Hampshire Historical Society by Phoenix Publishing, 1985.

Cantwell, Robert. *Alexander Wilson: Naturalist and Pioneer; A Biography.* Philadelphia: J. B. Lippincott Company, 1961.

Carbone, Theresa A. *American Paintings in the Brooklyn Museum: Artists Born by 1876, vol. 1.* Brooklyn: Brooklyn Museum, 2006.

Carbone, Theresa A., and Patricia Hills. *Eastman Johnson: Painting America.* New York: Brooklyn Museum of Art, in association with Rizzoli International Publications, 1999.

Carlisle, Lilian Baker. *Vermont Clock and Watchmakers, Silversmiths, and Jewelers.* Burlington, Vt.: [Distributed by the Stinehour Press, Lunenburg, Vt.], 1970.

Childs, Francis Lane. "Mr. Tuck 75 Years after Graduation." *Dartmouth Alumni Magazine* 29 (June 1937): 9–12.

Churchill, Frank C. "The Mascoma." *The Lebanonian* (Lebanon, N.H.), August 10, 1898.

Cikovsky, Nicolai Jr., and Franklin Kelly, with contributions by Judith Walsh and Charles Brock. *Winslow Homer.* Washington, D.C.: National Gallery of Art; New Haven, Conn.: Yale University Press, 1995.

Clayton, Douglas. *Floyd Dell: The Life and Times of an American Rebel.* Chicago: Ivan R. Dee, 1994.

Colby, Virginia Reed, and James B. Atkinson. *Footprints of the Past: Images of Cornish, New Hampshire, and the Cornish Colony.* Concord, N.H.: New Hampshire Historical Society, 1996.

Collins, Kathleen. "C. M. Bell Studio Collection: History of the Photographic Studio, Washington, D.C., 1873–1909." In *Washingtoniana Photographs: Collections in the Prints and Photographs Division of the Library of Congress.* Washington, D.C.: Library of Congress, 1989.

Cooper, Wendy A. *Classical Taste in America, 1800–1840.* Baltimore, Md.: The Baltimore Museum of Art; New York: Abbeville Press, 1993.

Corn, Wanda. *Grant Wood: The Regionalist Vision.* New Haven, Conn.: Published for the Minneapolis Institute of Arts by Yale University Press, 1983.

Cortissoz, Royal. "New Pictures by the Ten." *New York Tribune,* March 19, 1915.

———. *Catalogue of the Etchings and Dry-points of Childe Hassam, N.A.* New York: Charles Scribner's Sons, 1925.

The Dartmouth (Hanover, N.H.), March 27, 1891, p. 242.

Davis, Keith F. *George N. Barnard: Photographer of Sherman's Campaign.* Kansas City, Mo.: Hallmark Cards, Inc., 1990.

DeLue, Rachael Ziady. *George Inness and the Science of Landscape.* Chicago: University Press of Chicago, 2004.

Dewing, Maria Oakey. "Flower Painters and What the Flower Offers to Art." *Art and Progress* 6 (June 1915): 255–62.

Dijkstra, Bram. *Idols of Perversity: Fantasies of Feminine Evil in Fin-de-Siècle Culture.* New York: Oxford University Press, 1986.

Dorment, Richard, and Margaret F. MacDonald. *James McNeill Whistler.* London: Tate Gallery Publications, 1995.

Dreisbach, Janice T. "The Oil Sketches of Thomas Hill." *American Art Review* 9 (August 1997): 86–95.

Driscoll, John Paul. *John Frederick Kensett: An American Master.* Worcester, Mass.: Worcester Art Museum; New York: W. W. Norton, 1985.

Dryfhout, John. *The Work of Augustus Saint-Gaudens.* Hanover, N.H.: University Press of New England, 1982.

Duffy, Betty, and Douglas Duffy, with an essay by Janet A. Flint. *The Graphic Work of Howard Cook.* Bethesda, Md.: Bethesda Art Gallery, 1984.

Dugan, Sheila. "Ernest Lee Major." In *Ernest Lee Major, 1864–1950.* Boston: Vose Galleries of Boston, 1995. 3–11.

Elzea, Rowland. *John Sloan's Oil Paintings: A Catalogue Raisonné,* part 1. Newark, Del.: University of Delaware Press, 1991.

Evans, Nancy Goyne. "Britannia in America: The Introduction of a New Alloy and a New Industry." *Winterthur Portfolio* 2 (1965): 168.

Fabian, Monroe H. *Mr. Sully, Portrait Painter: The Works of Thomas Sully (1783–1872).* Washington, D.C.: Published for the National Portrait Gallery by the Smithsonian Institution, 1983.

Fath, Creekmore, comp. and ed. *The Lithographs of Thomas Hart Benton.* Austin: University of Texas Press, 1979.

Faugno, Rachel. *Reflections on a Silver Collector: Frank L. Harrington.* Privately printed, 2002.

Ferber, Linda. *William Trost Richards: American Landscape and Marine Painter, 1833–1905.* Brooklyn, N.Y.: Brooklyn Museum, 1973.

———. "William Trost Richards (1833–1905): Watercolor Painter." In *Watercolors by William Trost Richards.* New York: Berry-Hill Galleries, 1989. 4–7.

Ferber, Linda, and William H. Gerdts. *The New Path: Ruskin and the American Pre-Raphaelites.* Brooklyn, N.Y.: Brooklyn Museum, 1985.

Ferland, Donald. "Elegant Simplicity as Created by Louis Friedrich Vaupel, Master Copper-Wheel Engraver." *The Acorn: Journal of the Sandwich Glass Museum* 6 (1995/1996): 91–116.

Flint, Janet. *Art for All: American Print Publishing between the Wars.* Washington, D.C.: Smithsonian Institution Press, in association with the National Museum of American Art, 1981.

Foshay, Ella M. *Reflections of Nature: Flowers in American Art.* New York: Knopf, in association with the Whitney Museum of American Art, 1984.

Francis, Rell G. *Cyrus E. Dallin: Let Justice Be Done.* Springville, Utah: Springville Museum of Art, 1976.

Fraser, Gertrude Jacinta. *African American Midwifery in the South.* Cambridge, Mass.: Harvard University Press, 1998.

Freedman, Russell. *Kids at Work: Lewis Hine and the Crusade Against Child Labor.* New York: Clarion Books, 1998.

Freundlich, August L. *William Gropper: Retrospective.* Los Angeles: W. Ritchie Press, 1968.

Gallati, Barbara. *William Merritt Chase.* New York: Harry N. Abrams, in association with the National Museum of American Art, Smithsonian Institution, 1995.

Garrett, Elisabeth Donaghy. "Canterbury Tales: Notes on a New Hampshire School of Needlework." In *Lessons Stitched in Silk: Samplers from the Canterbury Region of New Hampshire.* Hanover, N.H.: Hood Museum of Art, Dartmouth College, 1990. 3–11.

George Ault Papers. Archives of American Art, Smithsonian Institution, Washington, D.C.

"George Breed Zug, Professor of Art." Obituary. *New York Times,* February 13, 1943, p. 11.

Gerdts, William H. Jr. Letter to author regarding Edith Cook. March 1, 1989. HMA files.

———. *Painting and Sculpture in New Jersey.* Princeton, N.J.: D. Van Nostrand Company, 1964.

Giese, Lucretia H. "Winslow Homer's Civil War Painting *The Initials*: A Little-Known Drawing and Related Works." *American Art Journal* 18, no. 3 (1986): 4–19.

Gilbert, Alma. *Maxfield Parrish: The Landscapes.* Berkeley, Calif.: Ten Speed Press, 1998.

Goldberg, Vicki. *Margaret Bourke-White: A Biography.* New York: Harper and Row Publishers, 1986.

Goodrich, Lloyd, edited and expanded by Abigail Booth Gerdts. *Record of Works by Winslow Homer.* Vol. 2: 1867 through 1876. New York: Spanierman Gallery, 2005.

Greenbaum, Michael D. *Icons of the West: Frederic Remington's Sculpture.* Ogdensburg, N.Y.: Frederic Remington Art Museum, 1996.

Greenberg, Cheryl Lynn. *Or Does It Explode?: Black Harlem in the Great Depression.* New York: Oxford University Press, 1997.

Greenthal, Kathryn, Paula M. Kozol, and Jan Seidler Ramirez. *American Figurative Sculpture in the Museum of Fine Arts, Boston.* Boston: Museum of Fine Arts, 1986.

Grimes, Nancy. *Jared French's Myths.* San Francisco, Calif.: Pomegranate Artbooks, 1993.

Gropper, William. "Gropper Visits Youngstown." *The Nation* (July 3, 1937): 14–15.

Hambourg, Maria Morris, Jeff L. Rosenheim, Douglas Eklund, and Mia Fineman. *Walker Evans.* Princeton, N.J.: Princeton University Press, in association with the Metropolitan Museum of Art, 2000.

Hampton, Bruce. *Children of Grace: The Nez Perce War of 1877.* New York: Henry Holt and Company, 1994.

Harlow, Thompson R. "The Life and Trials of Joseph Steward." *The Connecticut Historical Society Bulletin* 46 (October 1981): 97–164.

Harrison, William Preston. Letter to Churchill P. Lathrop. June 5, 1938. HMA curatorial files.

Heckscher, Morrison H., and Leslie Greene Bowman. *American Rococo, 1750–1775: Elegance in Ornament.* New York: The Metropolitan Museum of Art; Los Angeles: Los Angeles County Museum of Art, 1992.

Hegyi, Loránd. Introduction. *Gross-Bettelheim Jolán Retrospektiv Kiállítása.* Budapest: Budapest Galéria, 1988.

Hills, Patricia. *Stuart Davis.* New York: Harry N. Abrams, 1996.

Hirshler, Erica. *Dennis Miller Bunker: American Impressionist.* Boston: Museum of Fine Arts, 1994.

Hobbs, Susan A. "Nature into Art: The Landscapes of Abbott Handerson Thayer." *American Art Journal* 14 (Summer 1982): 4–55.

———. "Maria Oakey Dewing's Flowers and Figures." *The Magazine Antiques* 165 (January 2004): 152–59.

Hoefnagel, Dick, and Virginia L. Close. "Journey to Hanover, August 1771." *Dartmouth College Library Bulletin* 36 (November 1995): 2–16.

Holcomb, Grant. "John Sloan and 'McSorley's Wonderful Saloon.'" *American Art Journal* 15 (Spring 1983): 4–20.

Hollander, John. "Hopper and the Figure of Room." *Art Journal* 41 (Summer 1981): 155–60.

Hood Museum of Art, Dartmouth College. *John Sloan: Paintings, Prints, Drawings.* Hanover, N.H.: Hood Museum of Art, Dartmouth College, 1981.

———. *On All Fronts: Posters from the World Wars in the Dartmouth Collection.* Hanover, N.H.: Hood Museum of Art, Dartmouth College, 1999.

———. *Celebrating Twenty Years: Gifts in Honor of the Hood Museum of Art.* Hanover, N.H.: Hood Museum of Art, Dartmouth College, 2005.

Hopkins, Ernest M. Letter to Henry C. Jackson. March 8, 1917. Treasurer's Papers, Dartmouth College Library. "Gifts," folder 6 of box 17 (DA-2).

———. Letter to Leslie P. Snow. October 8, 1928. Dartmouth College Library.

Houk, Edwynn, Richard B. Woodward, and Michael P. Mattis. *Disfarmer: The Vintage Prints.* New York: PowerHouse Books, in association with the Edwynn Houk Gallery, 2005.

Houston, Jourdan. "Francis Seth Frost (1825–1902): Beyond Bierstadt's Shadow." *American Art Review* 6 (August–September 1994): 146–57.

Howat, John K. (introduction), with essays by Kevin J. Avery, Oswaldo Rodriguez Roque, John K. Howat, Doreen Bolger Burke, and Catherine Hoover Voorsanger. *American Paradise: The World of the Hudson River School.* New York: Metropolitan Museum of Art, 1987.

Hull, David Stewart. *James Henry Cafferty, N.A. (1819–1869).* New York: The New-York Historical Society, 1986.

Hunter, Andrew. *Lawren Stewart Harris: A Painter's Progress.* New York: The Americas Society, 2000.

Hunter, Frederick William. *Stiegel Glass.* New York: Dover Publications, 1950.

Hurst, Ronald L., and Jonathan Prown. *Southern Furniture 1680–1830: The Colonial Williamsburg Collection.* Williamsburg, Va.: The Colonial Williamsburg Foundation, in association with Harry N. Abrams, 1997.

Janson, Anthony F. *Worthington Whittredge.* Cambridge: Cambridge University Press, 1989.

Johns, Elizabeth. *Thomas Eakins: The Heroism of Modern Life.* Princeton, N.J.: Princeton University Press, 1983.

———. *American Genre Painting: The Politics of Everyday Life.* New Haven, Conn.: Yale University Press, 1991.

Johnson, Malcolm. Letter to Kenneth Roberts. June 26, 1940. Photocopy, HMA curatorial files.

Jones, Alfred E. *The Old Silver of American Churches.* Letchworth, England: Privately printed for the National Society of Colonial Dames of America at the Arden Press, 1913.

Jones, Barbara L. *Nature Staged: The Landscape and Still Life Paintings of Levi Wells Prentice.* Blue Mountain Lake, N.Y.: The Adirondack Museum, 1993.

Kane, Patricia E., with contributions by Jeannine J. Falino, Deborah A. Federhen, Patricia E. Kane, Barbara McLean Ward, and Gerald W. R. Ward. *Colonial Massachusetts Silversmiths and Jewelers: A Biographical Dictionary Based on the Notes of Francis Hill Bigelow & John Marshall Phillips.* New Haven, Conn.: Yale University Art Gallery, 1998.

Kao, Deborah Martin, Laura Katzman, and Jenna Webster. *Ben Shahn's New York: The Photography of Modern Times.* Cambridge, Mass.: Fogg Art Museum, Harvard University Art Museums, 2000.

Karlstrom, Paul J., ed. *On the Edge of America: California Modernist Art, 1900–1950.* Berkeley: University of California Press, 1996.

Karpiscak, Adeline Lee. *Ernest Lawson, 1873–1939.* Tucson: University of Arizona, Museum of Art, 1979.

Kasson, Joy S. *Marble Queens and Captives: Women in Nineteenth-Century American Sculpture.* New Haven, Conn.: Yale University Press, 1990.

Katzman, Laura. "The Politics of Media: Painting and Photography in the Art of Ben Shahn." *American Art* 7 (Winter 1993): 61–87.

Kennedy, Brian P. "Pollock and Dartmouth: A Visual Encounter." *Hood Museum of Art Quarterly* (Spring 2007): 6–7.

Kilmer, Nicholas. Letter to Barbara J. MacAdam. October 22, 2002. HMA curatorial files.

Kilmer, Nicholas, and Linda McWhorter, with contributions by Virginia Mecklenburg, David Sellin, and H. Barbara Weinberg. *Frederick Carl Frieseke: The Evolution of an American Impressionist.* Savannah, Ga.: Telfair Museum of Art; Princeton, N.J.: Princeton University Press, 2001.

Kirstein, Lincoln. *Paul Cadmus.* New York: Imago Imprint, 1984.

Kobal, John. *The Art of the Great Hollywood Portrait Photographers, 1925–1940.* New York: Harrison House, 1987.

Kornhauser, Elizabeth Mankin. *Ralph Earl: The Face of the Young Republic.* New Haven, Conn.: Yale University Press; Hartford, Conn.: Wadsworth Atheneum, 1991.

Kugelman, Thomas V., and Alice K. Kugelman, with Robert Lionetti, foreword by Patricia E. Kane, and essays by Susan P. Schoelwer, Robert F. Trent, and Philip D. Zimmerman. *Connecticut Valley Furniture: Eliphalet Chapin and His Contemporaries, 1750–1800.* Hartford: Connecticut Historical Society Museum, 2005.

Lader, Melvin P. "Classic: A Study in Early American Pattern Glass." *The Glass Club Bulletin* (Fall 1990): 3–16.

Laguna Beach Museum of Art. *Millard Sheets: Six Decades of Painting.* Laguna Beach, Calif.: Laguna Beach Museum of Art, 1983.

Landau, Ellen G. *Jackson Pollock.* New York: Harry N. Abrams, 1989.

Lane, Harlan L. *A Deaf Artist in Early America: The Worlds of John Brewster Jr.* Boston: Beacon Press, 2004.

Lathrop, Churchill P. "To Promote Interest in Education in Art." *Dartmouth Alumni Magazine* 43 (January 1951): 12–18, 82–84.

———. Letter to Frank L. Harrington. January 14, 1963. HMA donor files.

Lathrop, Donn. "Phinehas J. Bailey, Vermont Clockmaker, and His Associations with Jedidiah Baldwin, John Osgood, and Nathan Hale." Unpublished typescript, 1995. HMA curatorial files.

Laughlin, Ledlie Irwin. *Pewter in America: Its Makers & Their Marks.* Three vols. in one. New York: American Legacy Press, 1981.

Leeds, Valerie Ann. *My People: The Portraits of Robert Henri.* Orlando, Fla.: Orlando Museum of Art, 1995.

———. "Ernest Lawson in a New Light." In *Ernest Lawson.* New York: Gerald Peters Gallery, 2000. 11–43.

Leininger-Miller, Theresa. *New Negro Artists in Paris: African American Painters and Sculptors in the City of Light, 1922–1934.* New Brunswick, N.J.: Rutgers University Press, 2001.

Levin, Gail. *Edward Hopper: The Complete Prints.* New York: W. W. Norton & Co., in association with the Whitney Museum of American Art, 1979.

Lipton, Leah. *A Truthful Likeness: Chester Harding and His Portraits.* Washington, D.C.: National Portrait Gallery, Smithsonian Institution, 1985.

Lisle, Laurie. *Louise Nevelson: A Passionate Life.* New York: Summit Books, 1990.

Little, Nina Fletcher. "John Brewster, Jr., 1766–1854, Deaf-Mute Portrait Painter of Connecticut and Maine." *Connecticut Historical Society Bulletin* 25 (October 1960): 97–127.

———. *Paintings by New England Provincial Artists, 1775–1800.* Boston: Museum of Fine Arts, 1976.

Lorenz, Melinda A. *George L. K. Morris: Artist and Critic.* Ann Arbor, Mich.: UMI Research Press, 1982.

Lozowick, Louis. *William Gropper.* Philadelphia. Art Alliance Press; New York: Cornwall Books, 1983.

Lubowsky, Susan. *George Ault.* New York: Whitney Museum of American Art, 1988.

Lyford, James Otis. *History of the Town of Canterbury, New Hampshire, 1828–1912.* Canterbury, N.H.: Canterbury Historical Society, 1912; reprinted 1973.

Lynes, Barbara Buhler. *Georgia O'Keeffe: A Catalogue Raisonné.* New Haven, Conn.: Yale University Press, 1999.

Lynes, Barbara Buhler, Lesley Poling-Kempes, and Frederick W. Turner. *Georgia O'Keeffe and New Mexico: A Sense of Place.* Princeton, N.J.: Princeton University Press; Santa Fe, N.M.: Georgia O'Keeffe Museum, 2004.

MacAdam, Barbara J. "Dartmouth's Legacy in Silver: 'The Wentworth Bowl.'" *Dartmouth Alumni Magazine* 77 (June/July 1985): 44–45.

———. *New England Silver at Dartmouth College: A Tribute to Frank L. Harrington, Class of 1924.* Hanover, N.H.: Hood Museum of Art, Dartmouth College, 1989.

———. "A Likeness of Our Best Friend: Thomas Sully's Portrait of General Sylvanus Thayer at Dartmouth College." *Thayer School of Engineering Directions* 4 (Fall 1989): 24–26.

———. *Picturing New York: Images of the City, 1890–1955.* Hanover, N.H.: Hood Museum of Art, Dartmouth College, 1992.

———. *Looking for America: Prints from the 1930s and 1940s.* Hanover, N.H.: Hood Museum of Art, Dartmouth College, 1994.

———. *Winter's Promise: Willard Metcalf in Cornish, New Hampshire, 1909–1920.* Hanover, N.H.: Hood Museum of Art, Dartmouth College, 1999.

MacAdam, Barbara J., with an essay by John Wilmerding and contributions by Mark D. Mitchell; catalogue entries by Derrick R. Cartwright, Katherine W. Hart, Barbara J. MacAdam, Mark D. Mitchell, and Barbara Thompson. *Marks of Distinction: Two Hundred Years of American Drawings and Watercolors from the Hood Museum of Art.* Hanover, N.H.: Hood Museum of Art; New York and Manchester, Vt.: Hudson Hills Press, 2005.

Manthorne, Katherine. *Tropical Renaissance: North American Artists Exploring Latin America, 1839–1879.* Washington, D.C.: Smithsonian Institution Press, 1989.

Marsh, George Perkins. *Man and Nature; or, Physical Geography as Modified by Human Action*. New York: Charles Scribner, 1864.

Martin, Constance. *Distant Shores: The Odyssey of Rockwell Kent*. Berkeley: University of California Press; Stockbridge, Mass.: Norman Rockwell Museum, 2000.

Mary Ryan Gallery. *Edna Boies Hopkins: Color Woodcuts, 1900–1923*. New York: Mary Ryan Gallery, 1986.

Matheson, Susan B. *Art for Yale: A History of the Yale University Art Gallery*. New Haven, Conn.: Yale University Art Gallery, 2001.

Maycock, Susan E. "Louis Vaupel: His Life and Work at the New England Glass Company." *The Acorn: Journal of the Sandwich Glass Museum* 6 (1995/1996): 3–21.

McClelland, Gordon T., and Jay T. Last. *The California Style: California Watercolor Artists, 1925–1955*. Beverly Hills, Calif.: Hillcrest Press, 1985.

McCoy, Ronald. Unpublished evaluation of Vincent Price Ledger, 1987. HMA curatorial files.

McDannell, Colleen. *Picturing Faith: Photography and the Great Depression*. New Haven, Conn.: Yale University Press, 2004.

McGrath, Robert L. "New Hampshire Observed: The Art of Edward Hill." *Historical New Hampshire* 44 (Spring/Summer 1989): 30–47.

———. *Gods in Granite: The Art of the White Mountains of New Hampshire*. Syracuse, N.Y.: Syracuse University Press, 2001.

McGrath, Robert L., with an extended chronology by Paula F. Glick. *Paul Sample: Painter of the American Scene*. Hanover, N.H.: Hood Museum of Art, Dartmouth College, 1988.

McGrath, Robert L., and Barbara J. MacAdam. *"A Sweet Foretaste of Heaven": Artists in the White Mountains, 1830–1930*. Hanover, N.H.: Hood Museum of Art, Dartmouth College, 1988.

McKearin, George S., and Helen McKearin. *American Glass*. New York: Crown Publishers, 1941.

Meader, F. W. *Illustrated Guide to Shaker Furniture*. New York: Dover Publications, 1972.

Meyers, Amy R. W., ed. *Art and Science in America: Issues of Representation*. San Marino, Calif.: Huntington Library, 1998.

Miller, Stephen Robeson. "In the Interim: The Constructivist Surrealism of Kay Sage." In Mary Ann Caws, Rudolf E. Kuenzli, and Gwen Raaberg, eds., *Surrealism and Women*. Cambridge, Mass.: MIT Press, 1991. 123–47.

Miller, William Davis. *The Silversmiths of Little Rest*. Kingston, R.I.: Privately printed, 1928.

"A Mini-Seminar on Two Hood Pieces: Dartmouth Curators and Professors Tell What They See in These Paintings." *Dartmouth Alumni Magazine* 88 (May 1996): 48–49.

Minnesota Museum of Art. *John B. Flannagan: Sculpture/Drawings, 1924–1938*. Saint Paul: Minnesota Museum of Art, 1973.

———. *Paul Manship: Changing Taste in America*. Saint Paul: Minnesota Museum of Art, 1985.

Mitchie, Thomas. "Portraits of Lawyers in the Dartmouth College Case." *Boston Bar Journal* 27 (October 1983): 13–22.

Montclair Art Museum. *Precisionism in America, 1915–1941: Reordering Reality*. New York: Harry N. Abrams, in association with the Montclair Art Museum, 1994.

Montgomery, Charles F. *American Furniture: The Federal Period*. New York: Viking Press, 1966.

———. *A History of American Pewter*. New York: E. P. Dutton, 1978.

Montgomery, Susan J. *The Ceramics of William H. Grueby: The Spirit of the New Idea in Artistic Handicraft*. Lambertville, N.J.: Arts & Crafts Quarterly Press, 1993.

———. *Grueby Pottery: A New England Arts and Crafts Venture; The William Curry Collection*. Hanover, N.H.: Hood Museum of Art, Dartmouth College, 1994.

Moody, Margaret J. *American Decorative Arts at Dartmouth*. Hanover, N.H.: Dartmouth College Museum & Galleries, Hopkins Center, 1981.

———. "American Furniture at Dartmouth College." *The Magazine Antiques* 120 (August 1981): 326–33.

Moriarty, Peter. *Lotte Jacobi: Photographs*. Boston: David R. Godine, 2003.

"Mounted Statue Presented to College by Judge Snow." *The Dartmouth* (Hanover, N.H.), vol. 90, no. 44, November 9, 1928, p. 1.

Moure, Nancy Dustin. *William Louis Sonntag: Artist of the Ideal, 1822–1900*. Los Angeles: Goldfield Galleries, 1980.

Muller, Charles R., and Timothy D. Rieman. *The Shaker Chair*. Canal Winchester, Ohio: Canal Press, 1984.

Musée de Augustin. *Augustus Saint-Gaudens, 1848–1947*. Toulouse: Musée national de la Coopération franco-américaine, Château de Blérancourt, 1999.

Myers, Jane, and Linda Ayres. *George Bellows: The Artist and His Lithographs, 1916–1924*. Fort Worth, Tex.: Amon Carter Museum, 1988.

Naifeh, Steven, and Gregory White Smith. *Jackson Pollock: An American Saga*. New York: C. N. Potter, 1989.

Neal, L. W., and D. B. Neal. *Pressed Glass Dishes of the Lacy Period, 1825–1850*. Philadelphia: Privately printed, 1962.

"Necrology, Horace Russell." Typescript, c. 1913. Horace Russell alumni file. Dartmouth College Library.

Nelson, Kirk J. *A Century of Sandwich Glass from the Collections of The Sandwich Glass Museum*. Sandwich, Mass.: Sandwich Glass Museum, 1992.

———. "The 'Short Biography' of the Glass Engraver Louis Vaupel." *The Magazine Antiques* 149 (April 1996): 564–73.

Nemerov, Alexander. "N. C. Wyeth's Theater of Illustration." *American Art* 6 (Spring 1992): 37–57.

———. "Vanishing Americans: Abbott Thayer, Theodore Roosevelt, and the Attraction of Camouflage." *American Art* 11 (Summer 1997): 50–81.

———. "The Dark Cat: Arthur Putnam and a Fragment of Night." *American Art* 16 (Spring 2002): 36–59.

New Hampshire Historical Society. *Consuming Views: Art & Tourism in the White Mountains, 1850–1900*. Concord, N.H.: New Hampshire Historical Society, 2006.

North, Percy. *Max Weber: American Modern*. New York: Jewish Museum, 1982.

———. "Bringing Cubism to America." *American Art* 14 (Fall 2000): 58–77.

Norwood, Vera, and Janice Monk. *The Desert Is No Lady: Southwestern Landscapes in Women's Writing and Art*. New Haven, Conn.: Yale University Press, 1987.

O'Connor, Francis V., and Eugene V. Thaw. *Jackson Pollock: A Catalogue Raisonné,* vol. 1. New Haven, Conn.: Yale University Press, 1978.

O'Leary, Elizabeth L. *At Beck and Call: The Representation of Domestic Servants in Nineteenth-Century American Painting.* Washington, D.C.: Smithsonian Institution Press, 1996.

"Our Art Gallery and a New Hall." *The Dartmouth* (Hanover, N.H.), November 6, 1880, pp. 129–30.

Palmer, Arlene. *Glass in Early America: Selections from the Henry Francis du Pont Winterthur Museum.* Winterthur, Del.: Henry Francis du Pont Winterthur Museum, 1993.

Panzer, Mary. *Lewis Hine.* New York: Phaidon, 2002.

Pearson, Harlan C. "Benjamin Ames Kimball '54." *Dartmouth Alumni Magazine* 13 (November 1920): 9–11.

Peluso, Anthony J. Jr. *The Bard Brothers: Painting America Under Steam and Sail.* New York: Harry N. Abrams, 1997.

Perlman, Bennard. *Robert Henri: His Life and Art.* New York: Dover Publications, 1991.

Perry, Claire. *Young America: Childhood in 19th-Century Art and Culture.* New Haven, Conn.: Yale University Press, in association with the Iris and B. Gerald Cantor Center for Visual Arts, Stanford University, 2006.

Pewter Collectors Club of America. *Pewter in American Life.* Providence, R.I.: Printed by Mowbray Company, 1984.

Polcari, Stephen. "Orozco and Pollock: Epic Transformations." *American Art* 6 (Summer 1992): 36–57.

Rash, Nancy. *The Painting and Politics of George Caleb Bingham.* New Haven, Conn.: Yale University Press, 1991.

Rhodes, Richard. *John James Audubon: The Making of an American.* New York: Alfred A. Knopf, 2004.

Richmond, Lawrence. Letter to Albert I. Dickerson. October 26, 1956. HMA donor files.

Rieman, Timothy D., and Jean M. Burks. *Encyclopedia of Shaker Furniture.* Atglen, Penn.: Schiffer Publishing Ltd., 2003.

Ring, Betty. *Girlhood Embroidery: American Samplers & Pictorial Needlework: 1650–1850.* Vol. 1. New York: Alfred A. Knopf, 1993.

Robert Hull Fleming Museum. *George Loring Brown: Landscapes of Europe and America, 1834–1880.* Burlington, Vt.: The Robert Hull Fleming Museum, 1973.

Roberts, Kenneth. Letter to Daniel Longwell. February 22, 1933. Photocopy, HMA curatorial files.

Romer, Grant B., and Brian Wallis, eds. *Young America: The Daguerreotypes of Southworth and Hawes.* New York: International Center of Photography; Rochester, N.Y.: The George Eastman House; Gottingen, Germany: Steidl Publishers, 2005.

Sandweiss, Martha. *Laura Gilpin: An Enduring Grace.* Fort Worth, Texas: Amon Carter Museum, 1986.

Searle, Marjorie, ed. *Seeing America: Painting and Sculpture from the Collection of the Memorial Art Gallery of the University of Rochester.* Rochester, N.Y.: University of Rochester Press, 2006.

Sessions, Ralph. *The Shipcarvers' Art: Figureheads and Cigar-Store Indians in Nineteenth-Century America.* Princeton, N.J.: Princeton University Press, 2005.

Sewell, Darrel, with contributions by Kathleen Foster, Nica Gutman, William Inness Homer, Elizabeth Milroy, Douglass W. Paschall, Marc Simpson, Carol Troyen, Mark Tucker, H. Barbara Weinberg, and Amy B. Werbel. *Thomas Eakins.* Philadelphia: Philadelphia Museum of Art; New Haven, Conn.: Yale University Press, 2001.

Shapiro, Michael Edward. *Cast and Recast: The Sculpture of Frederic Remington.* Washington, D.C.: Smithsonian Institution Press, 1981.

Sloan, John. *Gist of Art: Principles and Practice Expounded in the Classroom and Studio, Recorded with the Assistance of Helen Farr.* New York: American Artists Group, Inc., 1939.

Slocum, Charles Elihu. *History of the Slocums, Slocumbs, and Slocombs of America.* Vol. 2. Defiance, Ohio: Published by the author, 1908.

Smart, Mary. *A Flight with Fame: The Life and Art of Frederick MacMonnies (1863–1937).* Madison, Conn.: Sound View Press, 1996.

Sobieszek, Robert A. *A Ghost in the Shell: Photography and the Human Soul, 1850–2000.* Cambridge, Mass.: Los Angeles County Museum and MIT Press, 2000.

Soria, Regina. *Elihu Vedder: American Visionary Artist in Rome (1863–1923).* Rutherford, N.J.: Fairleigh Dickinson University Press, 1970.

Sotheby's, New York. *Important American Paintings, Drawings and Sculpture.* May 29, 1986 (Sale 5463).

Spillman, Jane Shadel. *American and European Pressed Glass in the Corning Museum of Glass.* Corning, N.Y.: Corning Museum of Glass, 1981.

Staiti, Paul J. *Samuel F. B. Morse.* Cambridge: Cambridge University Press, 1989.

Stamey, Emily. *Jolán Gross-Bettelheim: The American Prints.* Grinnell, Iowa: Print and Drawing Study Room of the Faulconer Gallery, Burling Library, Grinnell College, 2001.

Stebbins, Theodore E., with contributions by William H. Gerdts, Erica E. Hirshler, Fred S. Licht, and William L. Vance. *The Lure of Italy: American Artists and the Italian Experience, 1760–1914.* Boston: Museum of Fine Arts; New York: Harry N. Abrams, 1992.

Steiner, Ralph. *Dartmouth.* Brooklyn, N.Y.: Albertype Co., 1922.

———. *A Point of View.* Middletown, Conn.: Wesleyan University Press, 1978.

———. *Ralph Steiner: A Retrospective Exhibition.* Hanover, N.H.: Dartmouth College Museum, Jaffe-Friede, Strauss and Barrows Galleries, 1979.

Stier, Margaret Moody, ed. *The New England Image: Nineteenth-Century Landscapes from the College Collection.* Hanover, N.H.: Carpenter Gallery, Dartmouth College, 1982.

Suther, Judith D. *A House of Her Own: Kay Sage, Solitary Surrealist.* Lincoln: University of Nebraska Press, 1997.

Szabo, Joyce M. *Howling Wolf and the History of Ledger Art.* Albuquerque: University of New Mexico Press, 1994.

Taft, Loredo. *The History of American Sculpture.* New York: MacMillan Company, 1903.

Talbott, Page. "Boston Empire Furniture." Parts 1 and 2. *The Magazine Antiques* 107, 109 (May 1975, May 1976): 878–87, 1004–13.

Talbott, Page. "The Furniture Trade in Boston, 1810–1835." *The Magazine Antiques* 141 (May 1992): 842–55.

Time. "Practically a Frenchman." November 17, 1930.

Thompson, Barbara. *Picturing Change: The Impact of Ledger Drawing on Native American Art.* Hanover, N.H.: Hood Museum of Art, Dartmouth College, 2004.

Tolles, Thayer, ed., with contributions by Lauretta Dimmick and Donna J. Hassler. *American Sculpture in The Metropolitan Museum of Art.* Vol. 1. New York: The Metropolitan Museum of Art, 1999.

Tuck, Edward. *Some Works of Art Belonging to Edward Tuck in Paris.* London: J. M. Dent & Sons, 1910.

Tyack, David B. *George Ticknor and the Boston Brahmins.* Cambridge, Mass.: Harvard University Press, 1967.

Van Haaften, Julia, ed. *Berenice Abbott, Photographer: A Modern Vision.* New York: New York Public Library, 1989.

Vedder, Elihu. *The Digressions of V., Written for His Own Fun and That of His Friends.* Boston: Houghton Mifflin, 1910.

Vieira, Mark A. *Hurrell's Hollywood Portraits: The Chapman Collection.* New York: Harry N. Abrams, 1997.

Von Erffa, Helmut, and Allen Staley. *The Paintings of Benjamin West.* New Haven, Conn.: Yale University Press, 1986.

Wallace, David H. "The Art of John Rogers: 'So Real and So True.'" *American Art Journal* 4 (Nov. 1972): 59–70.

Ward, Barbara McLean, and Gerald W. R. Ward, eds. *Silver in American Life.* Boston: David R. Godine, in association with the Yale University Art Gallery and the American Federation of Arts, 1979.

Wasserman, Jeanne L., ed. *Metamorphoses in Nineteenth-Century Sculpture.* Cambridge, Mass.: Fogg Art Museum, 1975.

Watkins, Lura Woodside. *Cambridge Glass, 1818–1888.* New York: Bramhall House, 1930.

Weber, Bruce. *The Apple of America: The Apple in 19th-Century American Art.* New York: Berry-Hill Galleries, 1993.

Webster, Caroline LeRoy, with an introduction by Claude M. Fuess. *"Mr. W. and I," Being the Authentic Diary of Caroline Leroy Webster, During a Famous Journey with the Hon. Daniel Webster to Great Britain and the Continent in the Year 1839.* New York: Ives Washburn, 1942.

Weidner, Ruth Irwin. *George Cochran Lambdin, 1830–1896.* Chadds Ford, Penn.: Brandywine River Museum, 1986.

Weiss, Ila. *Poetic Landscape: The Art and Experience of Sanford R. Gifford.* Newark, Del.: University of Delaware Press; Cranbury, N.J.: Associated University Presses, 1987.

Weschler, Jeffrey. *The Rediscovery of Jared French.* New York: Midtown Payson Galleries, New York; Amherst, Mass.: Mead Art Museum, 1992.

White, Philip A. "Tenth Anniversary Report of the Carpenter Galleries." Typescript. July 1939. HMA archives.

Wien, Jake Milgram. *Rockwell Kent: The Mythic and the Modern.* Manchester, Vt.: Hudson Hills Press, in association with the Portland Museum of Art, Portland, Maine, 2005.

Willis, Deborah. *James Van Der Zee, Photographer, 1886–1983.* New York: Harry N. Abrams, 1993.

Wilson, Kenneth M. *American Glass, 1760–1930: The Toledo Museum of Art.* Two vols. New York: Hudson Hills Press, in association with the Toledo Museum of Art, 1994.

Wilson, Raymond L. "Painters of California's Silver Era." *American Art Journal* 16 (Autumn 1984): 42–55.

Wintz, Cary D., and Paul Finkelman, eds. *Encyclopedia of the Harlem Renaissance.* Vols. 1–2. New York: Routledge, 2004.

Yochelson, Bonnie. *Berenice Abbott: Changing New York.* New York: New Press and the Museum of the City of New York, 1997.

Yount, Silvia. *Maxfield Parrish, 1870–1966.* New York: Harry N. Abrams, in association with the Pennsylvania Academy of the Fine Arts, 1999.

Zea, Philip, and Robert C. Cheney. *Clock Making in New England, 1725–1825.* Sturbridge, Mass.: Old Sturbridge Village, 1992.

Zug, George Breed. Letter to Mr. Knapp (probably Waldo Gray Knapp). January 23, 1916. Dartmouth College Library.

———. "Exhibition of Cornish Artists." *Art and Archaeology* 3 (April 1916): 207–11.

Zurier, Rebecca. *Art for The Masses: A Radical Magazine and Its Graphics, 1911–1917.* Philadelphia: Temple University Press, 1988.

Zurier, Rebecca, Robert W. Snyder, and Virginia M. Mecklenburg. *Metropolitan Lives: The Ashcan Artists and Their New York.* Washington, D.C.: National Museum of American Art; New York: Norton, 1995.

INDEX OF ARTISTS AND TITLES